W9-AWD-859

W9-AWD-859

For Gordon, our Deerfielder

With so many memories and so much love,

Daddy-O! and Mom-oh. oh

Historic Deerfield

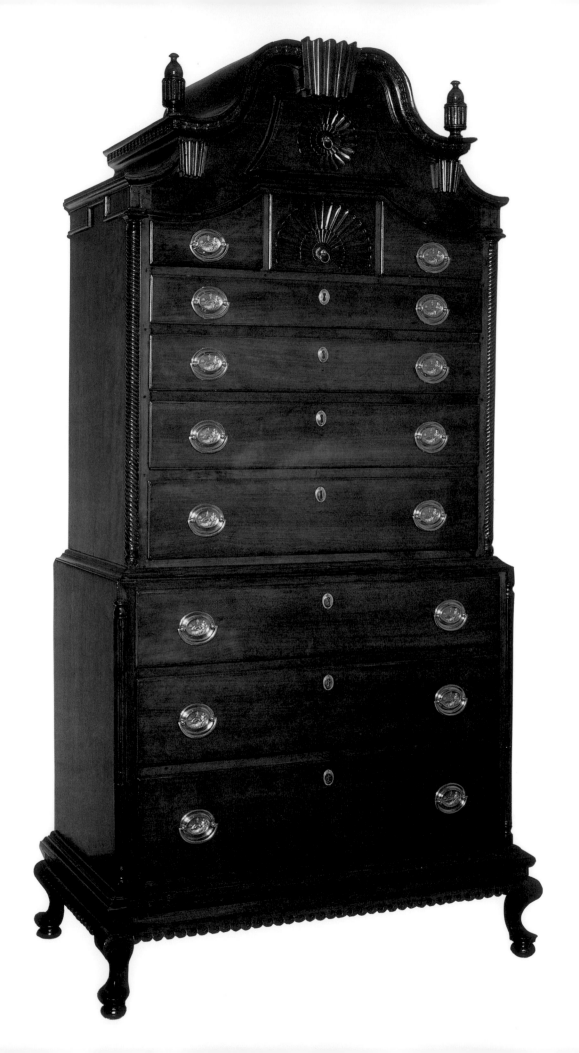

Historic Deerfield

A PORTRAIT OF EARLY AMERICA

Elizabeth Stillinger

Color photographs by Arthur Vitols

Dutton Studio Books
New York

(Overleaf) Chest-on-chest labeled by Jonathan Smith, Jr., of Conway, Massachusetts. The label states that this cherry chest-on-chest was made "for Lydia Bachelder who married Simon DeWolf in Dec. 1803."

DUTTON STUDIO BOOKS

Published by the Penguin Group
Penguin Books USA Inc., 375 Hudson Street,
New York, New York, 10014, U.S.A.

Penguin Books Ltd, 27 Wrights Lane,
London W8 5TZ, England

Penguin Books Australia Ltd, Ringwood,
Victoria, Australia

Penguin Books Canada Ltd, 2801 John Street,
Markham, Ontario, Canada L3R 1B4

Penguin Books (N.Z.) Ltd, 182–190 Wairau Road,
Auckland 10, New Zealand

Penguin Books Ltd, Registered Offices:
Harmondsworth, Middlesex, England

First published by Dutton Studio Books, an imprint of Penguin Books USA Inc.

First printing, June, 1992
10 9 8 7 6 5 4 3 2 1

Copyright © Elizabeth Stillinger, 1992
All rights reserved

Library of Congress
Catalog Card Number: 92-71073

Printed and bound by Dai Nippon Printing Co., Ltd., Tokyo, Japan
Book designed by Marilyn Rey

Without limiting the rights under copyright reserved above, no part of this publication may be reproduced, stored in or introduced into a retrieval system, or transmitted, in any form, or by any means (electronic, mechanical, photocopying, recording, or otherwise), without the prior written permission of both the copyright owner and the publisher of the book.

ISBN: 0-525-93436-7

For my mother
Dorothy Schmid Harper
With love
and
For Joseph Peter Spang
With many thanks

Acknowledgments

This book was Grace Friary's dream long before I came onto the scene. She pointed out that museums like Winterthur and Colonial Williamsburg were the subjects of beautifully illustrated books that showed architecture and collections and told the story of their acquisition, and she was anxious for Historic Deerfield's notable holdings to receive similar treatment. Aside from providing the idea, Grace and her husband, Historic Deerfield's Executive Director Donald Friary, have been gratifyingly supportive of this work on both personal and professional levels, ensuring that my trips to Deerfield were invariably productive and pleasant. Don was willing to talk over ideas and problems throughout the project, and in the final stages of finishing and polishing the manuscript he read each section with care. I am grateful indeed for his observations, additions, and corrections.

If Grace Friary is responsible for the dream, Peter Spang made possible the reality. Without his detailed memories of the Flynts, his knowledge of the collections and of the town and its people, and his fact-and-opinion-packed tours of the old street and its houses, I could not have come close to meeting my deadline. He suggested sources, lent rare and hard-to-find books, and cheerfully and carefully read drafts. In a sense, this is Peter's book as much as it is mine, although of course the final point of view and any errors are my own.

Philip Zea was another mainstay. He helped substantially with the selection of subjects to photograph, was present at photography sessions whenever possible, and provided a great deal of caption and other important information. He is also a singularly quotable curator, and I have used his words often to add zest to the narrative. He, too, read nearly all sections of the manuscript carefully and thoughtfully.

Henry N. Flynt, Jr., was also an important contributor to this work. Without his permission to read family letters and his good will and assistance in numerous other instances, I could not have completed my research nearly so quickly nor so efficiently. I am most grateful for his support.

Amanda Merullo single-handedly researched, organized, and made copy prints of the black-and-white photographs from Historic Deerfield's archives, and I am more grateful to her than I can say. Janine Skerry and Iona Lincoln were very helpful in choosing subjects to photograph and in giving information about their respective specialties, silver and textiles. Registrar Bruce Moseley kindly provided necessary facts about the collection.

David Proper and Amelia Miller were unfailing sources of pertinent facts and information, of which I am most appreciative. Assistant Librarian Sharman Prouty also responded quickly and helpfully to my requests for assistance in the library. Among former and present guides, Lee Boyden and Jennie Danielski reminisced about the Flynts and the "old days" to give me an idea of the flavor of the Flynts' Deerfield. Volunteer Kim Gregory's help was invaluable in making tapes with Peter Spang. Everybody on the Historic Deerfield staff, in fact, was pleasant and helpful throughout my work on this book, and I owe them many thanks.

No one could have photographers who were easier, pleasanter, or more professional to work with than Arthur Vitols and his son and assistant, Karl. They made our photography sessions times of humor and companionship. Others who contributed importantly to the book include Robert E. Kaufmann, Headmaster of Deerfield Academy, who very kindly granted me access to the Academy Archives and allowed me to quote from them freely. Tina Cohen, Academy Archivist, was also most helpful in identifying and pulling the appropriate material. Alice Winchester was, as always, enormously helpful—on several occasions she recalled her personal and professional relationships with Helen and Henry Flynt for my benefit. Ralph Carpenter, who belonged to the Flynts' circle of collectors, very kindly dug out photographs of one of his gala birthday parties for Katharine Murphy and had them copied for use in this book. Christopher Monkhouse told me about his days as a student at Deerfield Academy under Frank Boyden and about his participation—even then—in Heritage Foundation events. Bernard Levy reminisced about Helen and Henry Flynt as customers of Ginsburg & Levy, and provided some good stories of their antiques-collecting days. Harold Sack of Israel Sack, Inc., and Chinese Export porcelain dealer Elinor Gordon also discussed the Flynts' era of collectors and dealers with me. I am grateful to them both.

My agent, Susan Urstadt, and my editor at Dutton, Cyril I. Nelson, have both been unfailingly efficient and helpful, and they, too, have my heartfelt thanks. My husband, Bill Guthman, and my daughters, Alice and Amy Stillinger, were supportive from beginning to end. They were always willing to talk over approaches, comment on copy, and hold my hand through difficult times. Bill also suggested and lent books and catalogues from his amazing library, and Alice devoted a summer to background research on Deerfield. Each of them has, as always, my love and my thanks.

Contents

Note to the Reader

In some sections of this book, particularly in those devoted to the individual houses and collections, I have included numerous quotations from Peter Spang and Philip Zea. In order not to burden the reader with recurring references to their identities, I am noting herewith that Peter Spang was Assistant Curator of Historic Deerfield (as the Heritage Foundation became in 1971) from 1959 to 1969 and Curator from 1969 through 1986, and Philip Zea was Assistant Curator from 1981 through 1986 and has been Curator since 1987.

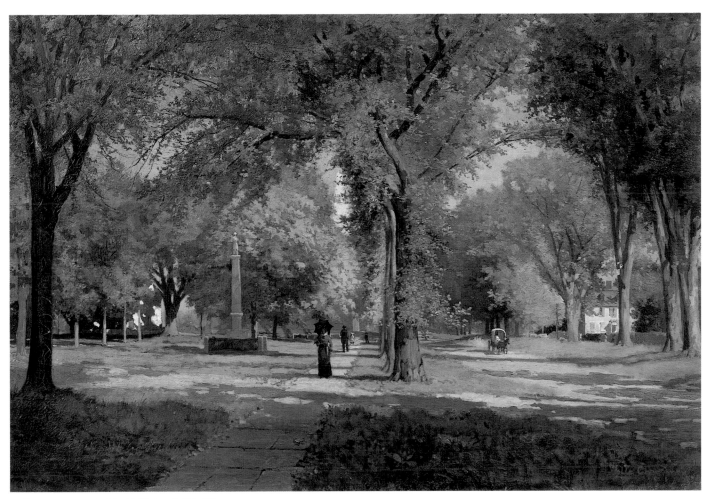

Village of Deerfield, 1877, by J. W. Champney.

A Sense of Place

Writers and artists, as well as others who express themselves less tangibly, have often been strongly moved by a sense of place. In New England, stories and legends stemming from the Bloody Brook Massacre of 1675 and the French and Indian attack of 1704 have lured travelers from their journeys to inspect the sites of these tragedies near Deerfield, Massachusetts. As early as 1728 Dudley Woodbridge, a Harvard student, paid a visit to the Bloody Brook monument, which even then was in need of repair. In 1793 the Reverend William Bentley, distinguished diarist of Salem, Massachusetts, wrote of his second visit to Deerfield, "We saw the house which alone escaped the flames when Deerfield was taken, and the door of which is preserved as a specimen of the attack on it." Bentley was referring to the Old Indian House, the place whose tomahawk-battered door evoked vividly the terror of the 1704 attack.[1]

The Old Indian House (and, after it was torn down in 1848, its door, which still may be seen in Deerfield's Memorial Hall Museum) elicited more than recognition of its historical importance. It called forth, as well, respect and patriotic acclaim for the pioneers who had fought on the frontier and settled it, admiration for the courage of colonists living in a world so precarious that a door stoutly constructed of thick oak planks and wrought-iron nails was necessary, and a more generalized nostalgia for "the good old days" when courage and fortitude were part of everyday life.

Caught up in the legends and stories of eighteenth-century Deerfield and fascinated by Indian relics of previous periods, George Sheldon determined to write a thorough history of the town. Descendant of Ensign John Sheldon, one of Deerfield's earliest settlers, owner of the Old Indian House, and the man who led captured citizens

1

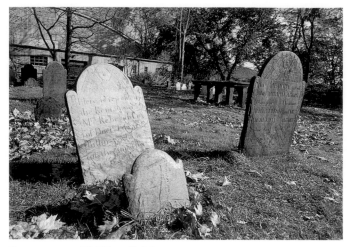

Gravestones, Old Deerfield.

back to Deerfield from Canada where they had been taken after the 1704 raid, George was steeped in family and town history. He spent nearly half of his ninety-eight-year life researching every aspect of the village and its early inhabitants, finally producing a hefty two-volume work. Entitled *A History of Deerfield, Massachusetts*, it was published by the Pocumtuck Valley Memorial Association (PVMA, another of Sheldon's projects) in 1895–1896.

Sheldon's second wife, Jennie Maria Arms Sheldon, wrote that her husband had been inspired by a vision of producing "a memorial of the men, women, and children of early New England, especially of the valley of the Pocumtuck [Deerfield]." Delving into letters and diaries of Deerfield families and records of all kinds at local, county, and state levels, Sheldon "tried to accomplish what his contemporaries valued highly: a local history based upon comprehensive sources, accurately used."[2] He succeeded splendidly: praise came from all sides, ranging from local newspapers to the distinguished historian Francis Parkman. Any educated New Englander who had somehow escaped knowing of Deerfield's stirring history was now fully informed.

Henry Flynt told the story of the founding of the Pocumtuck Valley Memorial Association in a letter to his family:

Its roots go back to 1869. In that year, three or four men were standing on a street corner in nearby Greenfield (which you know was originally a part of Deerfield) talking about the bloodstained history of Deerfield, with special reference to the famous raid by the French and Indians of February 29, 1704. They were commiserating on the fate of Deerfield captives and the burning of the Village. They spoke of the tragic death of Mrs. Williams, wife of the Rev. John Williams. They noted that she had been killed near Greenfield by the stroke of an Indian tomahawk as she struggled to keep up with the sorrowful band of captives being marched to Canada.

Those three or four men talking on that street corner resolved that in some way the spot where she fell should be permanently marked.... That street corner discussion was the seed from which the Memorial Association sprang as a fitting tribute not only to Mrs. Williams, but the other victims of the 1704 massacre.[3]

A notice went out calling upon all antiquarians of Franklin County to "lay aside your business for one short day; leave your farms and merchandise," and join with others in finding ways to "honor the times and lives" of those who had founded Deerfield. In May of 1870 a charter was obtained stating that the PVMA's purpose was also to collect and preserve "memorials, books, papers and relics [that] would illustrate and perpetuate the history of the early settlers and of the race which vanished before them."

Not surprisingly, George Sheldon, one of the men on the street corner, was elected chairman of the new association. He took the office so seriously that people were almost afraid to leave home, for fear Sheldon would ransack their attics before they returned. Sheldon wrote of himself: "A certain horse and wagon became a familiar sight in the country round about, and the driver was allowed to forage at will by the long-suffering house-wives."[4] Since the PVMA didn't have its own building for several years, Sheldon's house was soon overflowing with books and manuscripts, furniture, ceramics, and Indian relics, which he had gathered on behalf of the PVMA.

The brick building that was to become the home of the PVMA, designed by Asher Benjamin and built in 1798, was originally constructed to house Deerfield Academy. When that institution moved to a new building on the town common, the historical society was delighted to acquire the original structure for its museum. After

Old Indian House door, Memorial Hall.

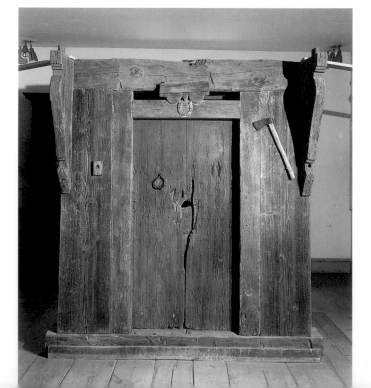

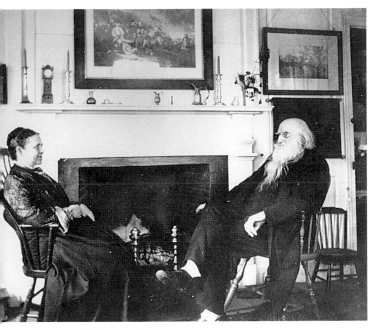

Jennie and George Sheldon.

modest renovation, the PVMA opened the doors of Memorial Hall, as it named the old school building, in 1880. "Not a single article is here preserved on account of its artistic qualities," wrote George Sheldon proudly. "The Collection is founded on purely historical lines, and is the direct memorial of the inhabitants of this valley, both Indian and Puritan."[5]

Inside were exhibits containing the objects George Sheldon had been soliciting and gathering assiduously for ten years, including what are believed to be the earliest American period rooms in a museum setting—a kitchen, a parlor, and a bedroom. (The period rooms created over twenty-five years later at the Essex Institute in Salem, Massachusetts, and often previously designated the earliest such displays, included the same three rooms— kitchen, parlor, and bedroom.) Local furniture, pewter, paintings, tools, textiles, and Indian artifacts were among the categories on view. Memorial Hall was widely visited and was often praised in print. In 1920, in a talk summing up the PVMA's first fifty years, Herbert Parsons said, "Memorial Hall has come to the renown of holding America's most complete exposition of the features of colonial life."[6]

Toward the end of the nineteenth century, Deerfield

Memorial Hall.

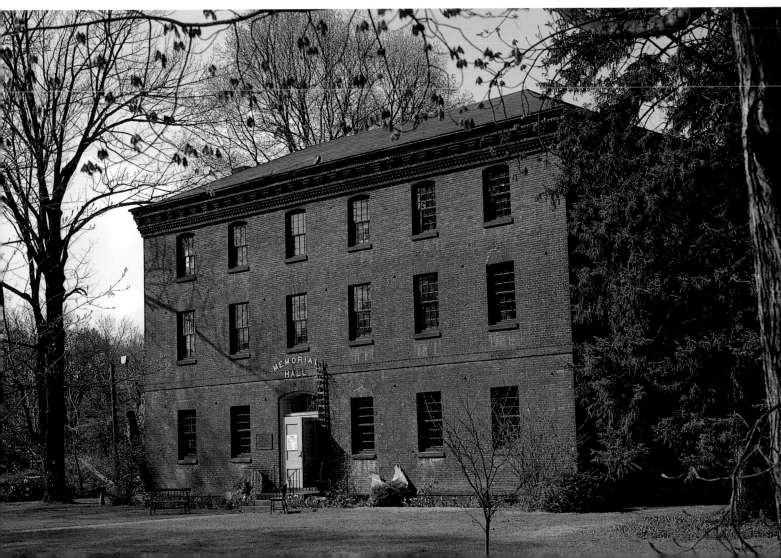

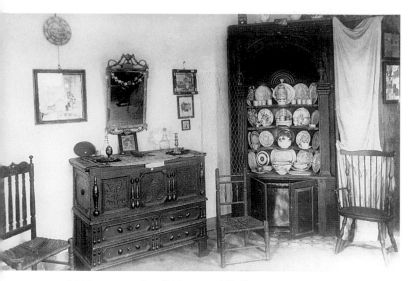

"Old-time parlor," Memorial Hall.

represented a broader past than that of the French and Indian War period. Because progress had bypassed it in favor of other local towns, Deerfield retained its eighteenth- and early nineteenth-century look. Its mile-long elm-shaded street was lined with early houses and barns and fringed with meadows and woodlots. In its rural tranquility many found the order and civility they felt were lacking in much of the rest of America. A number of houses along the old street were occupied by cultivated women, some year-round residents, some summer only. For them, Deerfield was a beautiful and historic oasis filled with congenial friends. Among the earliest were C. Alice Baker and her companions Susan Minot Lane and Emma Lewis Coleman, Madeline Yale Wynne and her companion Annie C. Putnam, the Miller sisters, the Whiting sisters, and the Allen sisters.

Artists James Wells Champney and George Fuller also lived in or near Deerfield for part of the year, and in the 1880s Luther J. B. Lincoln made Deerfield "a gathering place for writers and readers and all sorts of interesting and interested people" with his Summer School of History and Romance.[7] Almost daily lectures, readings, or discussions on a topic relating to American literature were held throughout the month of July; lecturers included well-known writers and editors of the day such as George Washington Cable and Charles Dudley Warner. Luther J. B. Lincoln, who had been born and brought up in Deerfield, clearly felt that the town's vivid history and present tranquility would draw cultivated visitors to his Summer School.

In 1898, Margaret Whiting and Ellen Miller founded the Deerfield Society of Blue and White Needlework to revive that lost eighteenth-century art. They based patterns and stitches on examples of eighteenth-century American needlework in Memorial Hall and on other

early pieces they sought out in the neighborhood. They taught Deerfield women the necessary stitches, supplied the patterns and thread, and made certain each item produced met their high standards. Soon, inspired by their example, other people began to revive early crafts, and Deerfield became a noted center of Arts and Crafts productions. Weavers produced rag rugs and linens; weavers of another sort turned out handmade "Pocumtuck" baskets of raffia, grasses, and palm leaves; and the village blacksmith began making wrought-iron lamps, fire tools, candlesticks, and other useful objects. Madeline Yale Wynne, who lived in The Manse, one of Deerfield's most elegant early houses, made jewelry of silver, copper, and semiprecious stones, as did her friend Annie Putnam, who also painted and wrote art criticism. The artist/photographers Mary and Frances Allen, who occupied the venerable Allen House, added their atmospheric scenes and portraits to the artistic output.

By the turn of the century, Deerfield was renowned for its history, its dignified architecture, its splendid rural views and serene atmosphere, and its discriminating and artistic citizens. In 1908, at the time of the annual exhibit of Arts and Crafts productions, the *New York Sun* reported that six thousand people had registered at the Memorial Hall museum and stated that "many more than that have visited Deerfield."[8] This was a high point of industry and activity in Deerfield.

The town's once revered educational institution, Deerfield Academy, had gone downhill, however. Plagued by a succession of unqualified teaching applicants and a declining enrollment, the Academy took a chance in 1902 on a young man just out of Amherst College. When Frank Learoyd Boyden took over as headmaster, there were only fourteen students, and one official who welcomed him to town confessed that he didn't know whether the school needed a new headmaster or an undertaker. But Boyden saw in the dignified old town a place that could nurture students—could teach them the virtues and values that had created and built New England.

Having grown up in a small Massachusetts town himself, Boyden understood Deerfield and the farmers who lived in and around it. He hitched horse to buggy and drove into the surrounding countryside to convince farmers to send their children to the Academy. He promised them a good, solid education and time off during crucial planting and harvest times. His plan worked, and by 1904 enrollment had risen dramatically; there were then sixty-two students. "He continued to recruit students in this way for something over twenty years," wrote John McPhee in an engrossing portrait of Mr. Boyden. "His school evolved naturally, gradually, and surprisingly. He had no plan and no theory, but he proved himself to be an educator by intuition.... By the late nineteen-thirties, it had become clear that he was one of the greatest headmasters in history, and for many years he

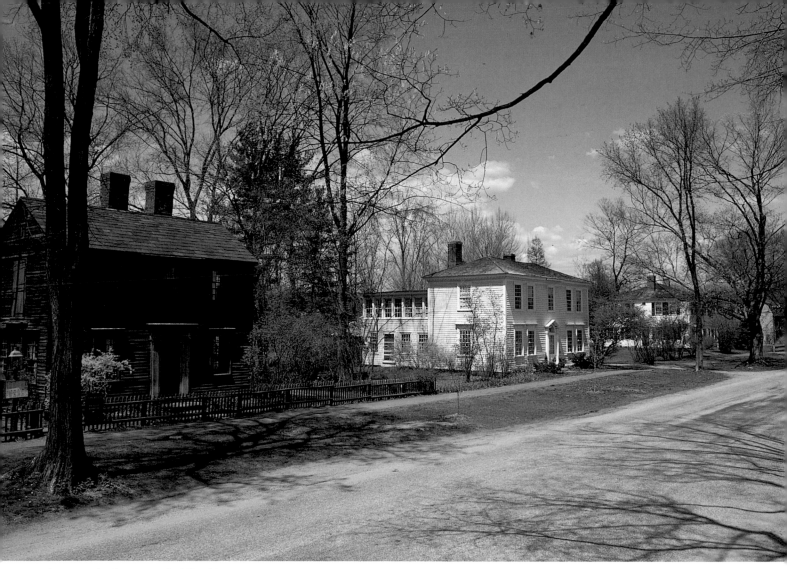

Looking north along Deerfield's old street.

Artist J. W. Champney with students.

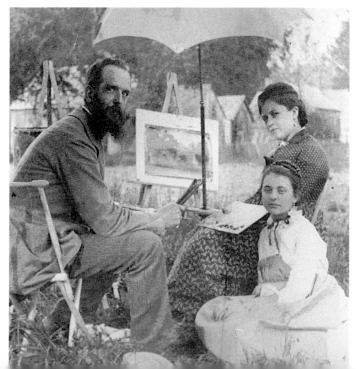

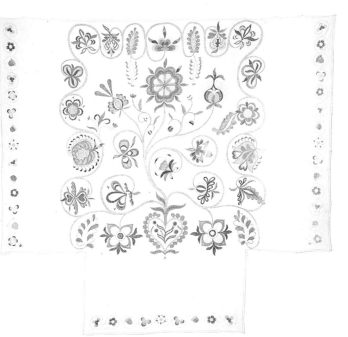

Bedcover, made by the Deerfield Society of Blue and White Needlework.

5

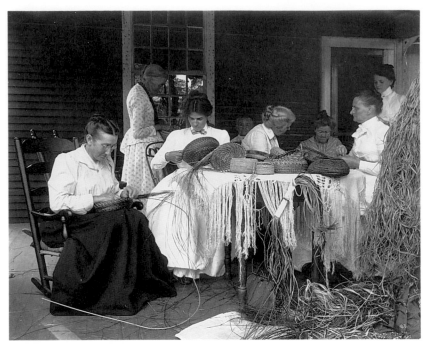

Basket weaving in Old Deerfield.

Deerfield Academy building, demolished 1930.

Frank Boyden.

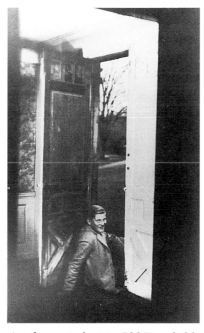

Academy student in Old Deerfield doorway.

has stood alone as, in all probability, the last man of his kind."[9]

Boyden's high standards and appreciation of the town endeared him to many of Deerfield's important citizens and he became a favorite among the ladies, many of whom actively supported his efforts at the Academy. It may well be that together, Frank Boyden, the Sheldons, and the energetic, artistic women of Deerfield saved the town from slow disintegration on the one hand and from commercialization on the other. It was their shared sense of the importance of preserving Deerfield's history and traditions that caused them to resist "progress" and to value the old houses, the towering avenue of elms, and the open fields.

In a handsome fundraising book gotten out for the Academy in 1929, the sense of Deerfield as a place distinguished by its "worn and weathered" colonial houses, magnificent old trees, and splendid vistas was as important as the factual material it contained. In describing the school and the town, which are inextricably intertwined in this presentation, the text relies heavily on the sense of place: "The whole atmosphere is rich in the traditions of courage and of character which made

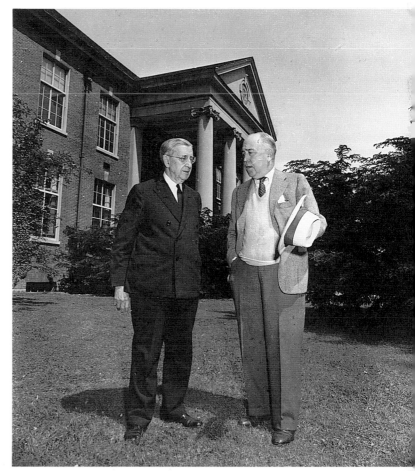

Frank Boyden and Henry Flynt at the Academy.

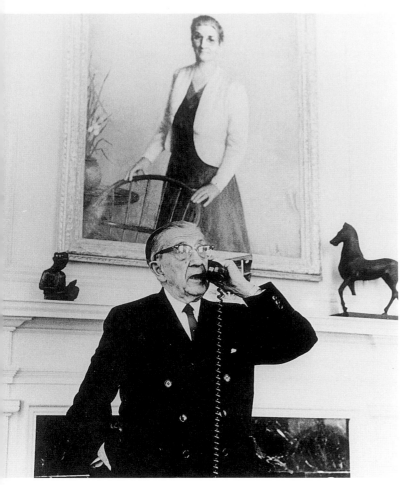

Frank Boyden standing under Helen's portrait.

The Flynts also "liked the Boydens and the entire set up." They were pleased to have Hank at Deerfield and enjoyed going to see him. "We were fortunate to be able to visit Deerfield frequently over the next four years," he wrote. "On each visit we were continually impressed with the Academy. The character of the boys, their thoughtfulness and politeness, their singing, their appearance and general spirit are all happy recollections."

Contact with the headmaster was pleasant but somewhat hectic: "Our talks with Mr. Boyden were frequent, yet always short and continually interrupted by something else he seemed to be obliged to get on with, or somebody else to see, or he was just leaving for Amherst, Boston or somewhere." Over the years, however, Boyden managed to impress the Flynts with the fact that the Academy was in need of a number of things—"squash courts, tennis courts, new dining hall, a store for sodas and ice cream, a library, money to send the faculty on vacation trips when they were tired or overtaxed. 'You know,' Boyden would say, 'handling boys, fine though they are, is rather wearing after a few years, and so-and-so really should get away before he breaks down.'"

Looking back on those days, Flynt continued, "Our fondness for the Academy, the town, the Boydens and others increased, and before we hardly realized how we were becoming involved [Helen Geier Flynt] had given Mr. Boyden a couple of checks to be used at his discretion for faculty vacations. She, with the Harold Lloyds, gave the school the squash courts, and [she] and I finished off a part of the gymnasium building by installing the store. Mr. Boyden's charm and personality had begun to work."

Even earlier, about 1938, Frank Boyden had approached Henry Flynt at a reception and asked whether he'd be interested in becoming a trustee of the Academy. After some thought and discussion with his wife, Flynt agreed, although he asked that his appointment be kept quiet while Hank was still at school. His first board meeting surprised Flynt, who remembered that everything was "informal and vague" and that all matters were simply referred to Frank Boyden for action. It was characteristic of Boyden that he kept the reins of both the school and its board of trustees firmly in hand. "He knew about control," said a former student. There were no class officers—all boys were equal and Boyden was the head, the father figure.

This insistence on equality among the boys led to a pleasantly democratic environment. Everyone waited on table and performed other chores, including cleaning up the campus. Sophomores were required to carry out Mr. Boyden's decree that the campus always be neat and clean by moving across the lawns in a line, picking up trash, and putting it in their wastebaskets.

"Appearance was everything" to Frank Boyden, says

America." And again: "An investment in Deerfield...is an investment in that strong character which has its roots in the New England hills, and out of which America was built." One former Deerfield Academy student remembers that Boyden "was always talking about the environment and the architecture. 'Look to the hills, boys,' he would say. We made fun of his saying that, but we *did* look to the hills." Bruce Barton, the man who had put together the 1929 fundraising book, went so far as to declare, "Somehow the granite of those hills has bred itself into the being of men of New England birth or training."[10]

A few years later another important player in the Deerfield story came on the scene. "Deerfield really came into our lives in 1936," wrote Henry Needham Flynt, "because Hank [Henry N. Flynt, Jr.] entered the Academy as a student. Events from then on moved rather imperceptibly toward a crescendo with the finale not yet in sight...I hope." Like Frank Boyden, Henry Flynt had grown up in a small rural New England town, and this aspect of the Academy's situation appealed to him. In thinking back, Flynt recalled that life in Monson, Massachusetts, his home town, was never dull. "In fact," he said, "I think you are fortunate not to have been brought up in a big city, because country life is so much

the former student. "Appearance told the story." Besides the clean campus, Boyden insisted that there be no letter sweaters for Deerfield boys, for fear someone would misbehave when off campus and give the school a bad name. Only the best boys were sent to play on the school's most visible athletic fields, so that visitors would be impressed by their skill.

In some ways, Frank Boyden and Henry Flynt were two of a kind, and the former student observed that "both were very committed to the school and to the town." Boyden fostered Flynt's feelings about Deerfield and the Academy and Flynt expressed his gratitude for being a part of both in a letter of June, 1940:

There are certain places one goes from time to time which are an inspiration and at the same time there is stirred within oneself a feeling of real friendship and devotion. Deerfield is such a place with us, due largely to the quiet stately elms no doubt, in no small part to the real bit of England—as Dr. Pomeroy said—set down in New England—the sun shining

through the trees etc., and to many other causes, but, when you try to sum it all up, it is the result of the spirit of the place which you two [Frank and his wife, Helen Childs Boyden] have so forcibly caused to be so manifest. We are forever grateful to you not alone for your hospitality to us when there, for giving us an opportunity to feel as though we really were a part of the place and to, in a small way, help carry on the best of Deerfield spirit....

To sum up: Flynt and Boyden shared similar New England backgrounds and a belief in the importance of the steadfast character that a New England upbringing produced. They shared a belief in the importance of the appearance of things and a sense of the importance of Deerfield as the epitome of oldtime, small-town New England. This led to the development of a plan for the preservation of Deerfield as they knew it. It is the story of the evolution of that plan—in ways that neither Frank Boyden nor Henry Flynt could have anticipated—that makes up the rest of this book.

Looking from Deerfield to Mt. Toby.

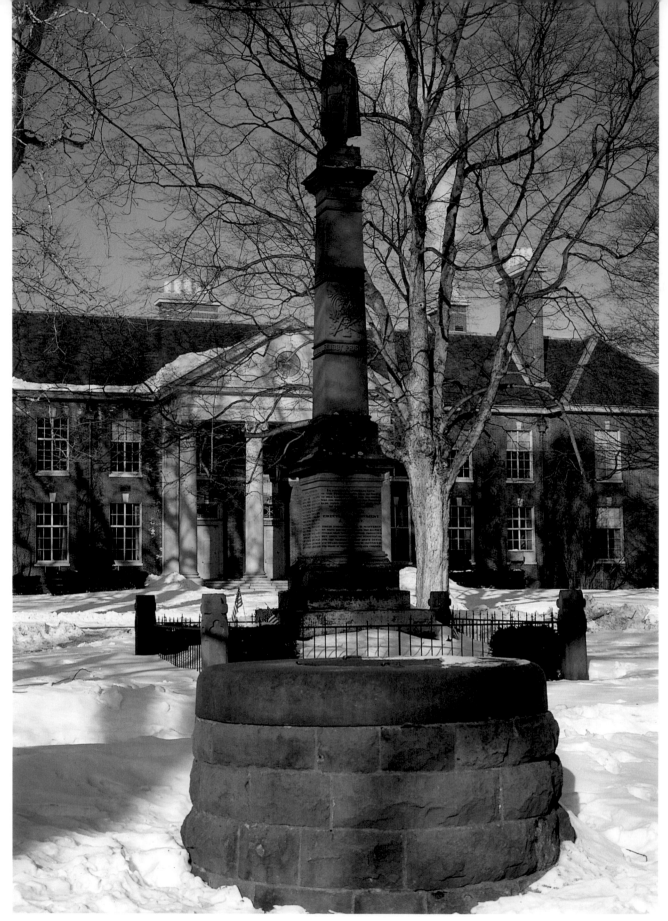

Deerfield common with Civil War monument and main Deerfield Academy building.

Preserving a School, a Town, and a Way of Life

"We sensed an opportunity to help perpetuate the great traditions of the Village educationally, historically, and practically," wrote Henry Flynt in explanation of his and Helen Flynt's more than thirty-year involvement with Deerfield.[1] It was their connection with Deerfield Academy, first as parents, then as financial contributors, and finally Henry's involvement as a trustee, that led to the Flynts' eventual preservation and museum work in Deerfield. One longtime Deerfield resident thinks that Frank Boyden had had his eye out for a couple like the Flynts for some time. "When Henry Flynt went on the board of trustees [of Deerfield Academy]," she says, "it was still very local—old Amherst College buddies of Frank Boyden's, a banker from Springfield. Mr. Boyden was delighted to have a millionaire from Greenwich."

Frank Boyden's desire for new blood on the Academy's board of trustees had increased as a result of a situation that had occurred in Deerfield in the early 1920s, some years before the Flynts appeared on the scene. As a result of a new state law, Deerfield Academy and Dickinson High School, private and public entities that operated as one school, were required either to merge permanently or to separate entirely. Boyden wanted to separate, and to keep the Academy a private independent school (Dickinson was legally the local public high school). The matter involved money and control of local education, and the town divided over the issue. Boyden won the right to keep the Academy independent, but even after the affair was settled, bad feeling endured among townspeople for many years.

After the fight was over, Boyden needed private support to expand his school and to build new facilities. He did amazingly well, and by the 1930s he had enlarged the school enormously. He had increased his dormitory space by then but desperately needed sports and many other types of facilities. The Flynts were interested and affluent, and they were also very generous to the Academy in the late 1930s. But it wasn't just money Boyden needed, it was support for his plans and energy to see them through. Henry Flynt, it seemed, was his man in all respects.

Henry Flynt had grown up in the little town of Monson, Massachusetts, and he used to say he'd offer a nickel to anyone who knew where Monson was (it's on the Connecticut line between Springfield and Sturbridge).

His was one of the town's leading families—his father and uncle had inherited the local granite works—and Henry was their heir. "I think it's ironic," says Peter Spang, "that with that background [in granite] and with the name Flynt, Mr. and Mrs. Flynt in due time restored a village entirely built of wood and brick."[2]

Henry wrote that his father "was active for years in the Granite Quarry started by his ancestors, and in the Flynt Building and Construction Company." The elder Flynt was, alas, "not too successful and the quarry ran into hard times because of the competition with cement and concrete...." Also unfortunately, wrote Flynt, "neither Mother or Father had much of a sense for the care or use of money. Largely because of their generous tendencies, they both seemed to be continually hard pressed." This was a lesson to young Henry, who was careful with money all his life.

Despite his business reverses due to new products like cement and concrete, the elder Flynt was enthusiastic about progress and was instrumental in introducing electricity, the telephone, and trolleys to Monson. He had

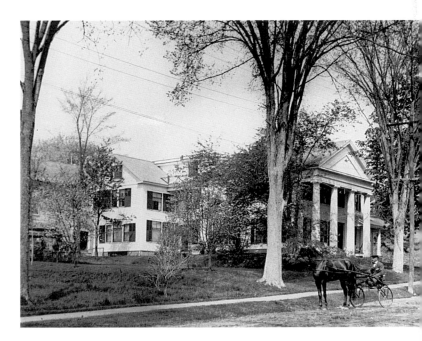

Henry Flynt's family home, Monson, Mass.

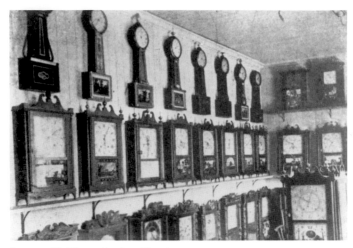

Lyman C. Flynt clock collection.

a wonderful sense of humor, according to his son, and loved to tell stories and to play practical jokes—traits that he passed on to Henry. He also loved all kinds of animals, particularly dogs and horses, and he drove the latter "in races around at various country fairs with reasonable success." During the last fifteen years of his life, Henry reported, his father

> was quite interested in American antiques, had quite a collection and bought and sold many kinds of things in this field. He and his brother Lyman had a remarkable collection of clocks. Uncle Lyman used to tinker with them and get them to running. Father was not much of a mechanic but seemed to have the nose for finding these time pieces for his brother to work on in his barn. When Father died we were not interested in American antiques so had three auctions to dispose of them.[3]

Although his mother didn't share her husband's and brother-in-law's interest in antiques, she did like other kinds of art. "She knew the best pictures," wrote her son, "as she read a great deal, visited museums and enjoyed being with people of like tastes." The elder Mrs. Flynt's family, the Needhams, were from nearby Wales, Massachusetts, but as her father practiced law in New York City, the family lived in Brooklyn during most of the year. Although she was musical and "it was her ambition to sing in grand opera," Henry's mother "gave up her music to go to Monson to live after marrying my father." Henry told Peter Spang that the Needhams, too, were collectors, and that he inherited such items as buffalo robes, polar-bear skins, and large stamp and coin collections from that side of the family. He escaped inheriting the Brooklyn Dodgers, however, as his uncle's negotiations for the team were unsuccessful.[4]

Young Henry attended the local day school, Monson Academy, but upon graduation he declined to go on to Amherst College as his family expected. Instead, he insisted on attending Williams, Amherst's arch rival. His years there proved eminently rewarding, and he remained an active and devoted alumnus (and later, a trustee) all his life. The same cannot be said for his feelings about Monson Academy, however. Peter Spang relates that

> Deerfield benefited from a circumstance that happened in Monson.... Henry Flynt used to say how important Monson Academy was to the Flynt [family] tradition. He would go on to say that when his father died, [Henry Flynt] gave the school the beautiful Greek Revival house that he grew up in. He also gave them a park which had always been used for their playing fields. The school happily accepted these ... and when the Flynts went back a year later the Greek Revival house had been demolished and because someone by another name had given the school a baseball diamond, they changed the name of the park to that of the other family.

Henry Flynt was displeased with Monson Academy's callous behavior. He cut off his support and was, when the time came, more than happy to contribute to the cause of Deerfield Academy. Henry had known Deerfield even as a boy, for he and his mother had sometimes entertained guests by taking them to Deerfield on an all-day trolley excursion. "While the older people were looking at and perhaps even buying some of the blue and white embroidery or other fabrics made by the local ladies, or looking at the old houses, I popped over to Memorial Hall to look at the Indian relics," he wrote. "Those days were my initiation to the Village." Later on, he had gone to Deerfield Academy with the Monson Academy basketball team, of which he was manager. Frank Boyden, who was already headmaster during those days, claimed to remember Henry Flynt from his trips with the team.[5]

Helen Geier Flynt was born and brought up in Cincinnati, Ohio. In 1889 her father, Fred A. Geier, founded the extremely successful machine-tool manufacturing firm Cincinnati Milling Machine Company (now Cincinnati Milacron). Fascinated by the possibilities of machine tools, from which "come all other tools, instruments, machinery and equipment," Geier and a small crew of machinists steadily built the business into a major corporation.[6] Although products, methods, and customer service always received first priority, Geier and his associates realized that the health and welfare of employees is as important to business success as any other factor, and the firm pioneered in programs of all kinds to benefit employees. The company strove, as well, to keep employees on during hard times.

Such benevolent policies proved profitable as well as responsible, and Helen grew up in "conventional, if splendid, Victorian surroundings in two successive houses in Cincinnati."[7] Helen's mother died when she and her

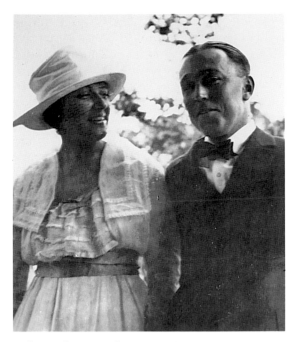

Helen and Henry Flynt, c. 1920.

sister and brother were quite young and eventually her father remarried. He and his new wife bought decorative English antiques from the New York firm of Ginsburg & Levy.

In 1912, Helen's brother Frederick went to Williams College and two years later she followed him east to attend Vassar. There she met his roommate, Henry Flynt, whom she found interesting and attractive. The two young men graduated from Williams in 1916 and both served in World War I. After the war, Henry went on to Columbia University Law School and Frederick went home to enter the family business (of which he became president upon his father's death in 1934). Helen graduated from Vassar in 1918 and she and Henry were married in 1920.

Henry, having come from a family of "gatherers," as he called his father and uncle, suggested to Helen that they make a pact not to collect during their married life. His father had had one hundred clocks, he said, and would buy a whole room full of furniture just to get another one. "I told my wife never to let me start collecting anything," he said later on, "or I might well become a 'gatherer' of heroic proportions."[8] Helen agreed to the noncollecting pact, and all went well until, a few years later, Henry was seized by a need to collect that he couldn't shake off. "If a book or a stamp is a precious personal item, how much more so is a letter or a manuscript or a signed document," he wrote. He felt that letters revealed the personality of the writer and his era far more clearly than books. In the beginning, he said, his purpose in collecting was to illu-

minate the "lesser known side of our country's development" as it was revealed in signed letters by the chief justices of the United States Supreme Court. Having completed that collection, he moved on to presidential autographs, then to subjects related to the formation of the Declaration of Independence, the Constitutional Convention, and the debates preceding the acceptance of the Constitution by the Colonies.[9]

Loath to admit that he had succumbed to the collecting bug, Henry pursued his new hobby in secret for several years. As he later pointed out, his selection of letters and other manuscripts made concealment easy, for it is much simpler to slip a slim volume into the bookcase without being discovered than it is to introduce a camelback sofa or a blockfront desk into the house. His collection grew to include major items, such as a letter and a copy of the first printing of the Declaration of Independence that John Hancock sent to Governor Cooke of Rhode Island to persuade him to join the Union. "Then," says Peter Spang, "a very important thing came along, although it was only a single document. Henry Flynt used to tell the story that the item was too big for his briefcase and instead was in an elaborately wrapped package. For some reason the whole family met him at the front door that night, and they all wanted to know what was in the package. He decided it was time to show them."[10] What Henry Flynt produced was George Washington's own copy of the first printing of the Declaration of Independence, with his autograph and corrections in his own hand. So the secret was out, and Henry had to admit that he had not overcome the family collecting obsession.

It seems likely, however, that the collecting urge Henry Flynt regarded as a family disease may have been simply a need to use up the enormous amounts of physical and mental energy he, his father, and his uncle must have had. In Henry's case, his supply of energy is indicated by his voluminous correspondence, his enthusiasm for serving on boards and committees, and his habit of working in the evening after dinner when there were no guests or other diversions. He loved to be involved in projects, and didn't seem to mind attending to all the details involved. The horseback trips he organized for his family in the mid-1930s are an example. Henry, Hank, and Judy, the Flynts' older daughter, rode on horseback while Helen Flynt and Marjorie, the youngest child, rode in an open touring car. Starting from their home in Greenwich, Connecticut, they traveled north on dirt roads through New England toward the Canadian border each of two summers. They averaged, as Henry Flynt wrote to Frank Boyden, six and one-third miles per hour and the trip took three weeks. At the end of each trip they were met and the horses were sent home by van. Flynt later recorded details of their adventures in *On Horseback from Connecticut to Canada*, a booklet that was a precursor of those he and

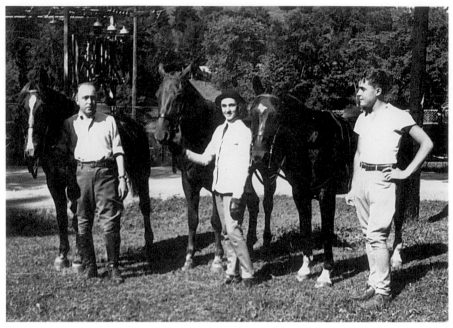

Flynt family trip on horseback, 1938.

George Sheldon's birthplace (now Sheldon-Hawks House).

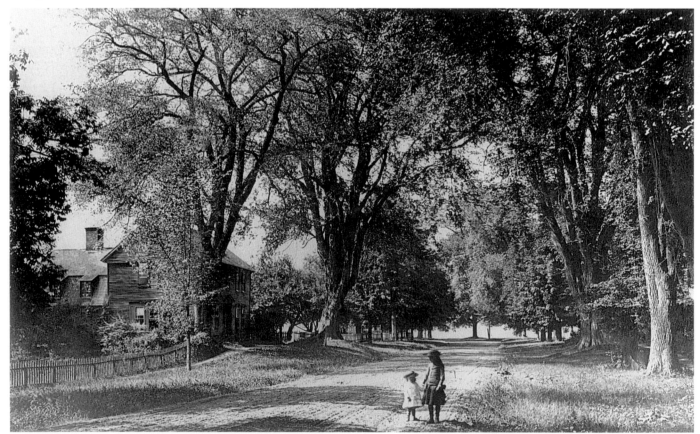

Helen were to produce about various buildings they restored in Deerfield.

<center>🙢 🙢 🙢</center>

Henry Flynt, then, started off in Deerfield with enthusiasm for the school, the Boydens, and the faculty. His abundant energy and his affinity for projects must have been apparent to Frank Boyden, who would also have known of Flynt's small-town New England background and love of American history. These factors, combined with the fact that the Flynts were comfortable financially and had leisure time, made Henry Flynt an ideal associate for Frank Boyden in carrying out his plans for the Academy.

As early as 1924, Boyden had written to William Sumner Appleton, founder of the Society for the Preservation of New England Antiquities (SPNEA), telling him that the Academy had just bought a second eighteenth-century house to restore and use as a dormitory. He also mentioned buying "another old house adjoining our property," which, he said, he hadn't wanted but had bought because he was afraid it would be taken over by outsiders if he didn't.[11] Boyden continues,

> Really, somehow there should be found some way of securing money to buy these old houses as they are thrown upon the market.... Each time as I stop and think of the number of people who have visited Deerfield and have gone into ecstasies over the old-time atmosphere, I feel there should be some way devised for getting the money to preserve Deerfield for the whole country.[12]

According to Amelia Miller (whose husband, Russ, was associated with Frank Boyden as a student from 1928 to 1932 and as a member of the faculty from 1937 until Boyden's retirement in 1968), Boyden focused on preservation in this letter in an effort to enlist Appleton's financial help. Russ Miller felt that Boyden wasn't interested in preservation per se, but rather in saving houses to use as dormitories and faculty living quarters. Boyden loved Deerfield's village life and he loved the old-time traditions and the New Englanders who were part of it. It was these things he wanted to preserve, but he was not a dedicated architectural preservationist like Appleton.[13]

In reply to Boyden's letter, Appleton pleaded with him to make a thorough photographic record of each old house the Academy acquired before they made any changes. He then suggested installing collection boxes in the Memorial Hall museum, on the town common, and perhaps in one or two other places in Deerfield. A sign accompanying the boxes could invite "all of those who have had pleasure in finding that Old Deerfield still looked old to make a voluntary contribution of a piece of silver...." Appleton's final suggestion was that a group of three trustees representing the Academy, the Pocumtuck Valley Memorial Association (PVMA, the local historical society, owner of Memorial Hall), and his own organization, the SPNEA, be formed under a name such as Old Deerfield Trustees. This group would accept donations from the collection boxes and "spend them in whatever way seemed to them wisest in order to bring about the hoped for results."[14]

Boyden never took any of Appleton's suggestions, indicating perhaps that he wasn't as serious about preserving Deerfield's "oldtime atmosphere" as he was about getting money to buy old houses the school could use. When the money failed to materialize, Mrs. Miller suggests, Frank Boyden "lost interest, or rather no longer had to play the role of a dedicated preservationist." Boyden *was* interested in ensuring that the village and the mile-long main street that was its core didn't change in ways he didn't like and didn't consider good for the Academy, however. When Henry Flynt came on the scene, one of the issues he and Boyden considered early on was that

Boyden and Flynt in Sheldon-Hawks doorway, 1962.

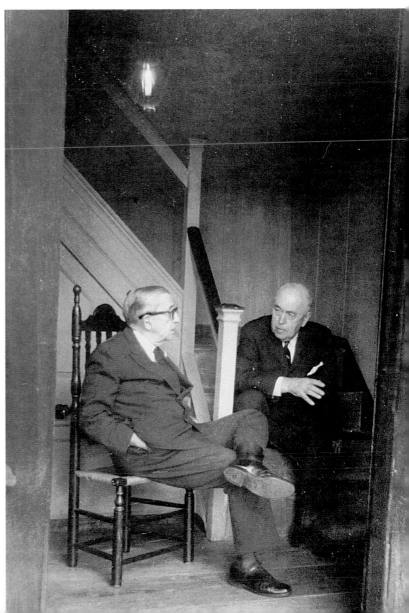

Fall color on Deerfield's old street.

The Deerfield Inn before the Flynts bought it.

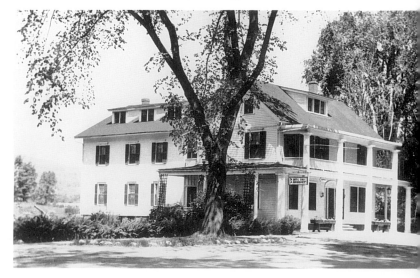

of achieving a position in which they could prevent unwanted changes on Deerfield's old street.[15]

What happened between the two men in the late 1930s and the early 1940s is difficult to interpret at this distance. In 1939, Henry Flynt got in touch with Bela Norton, who was at the time director of public relations for Colonial Williamsburg, the Virginia town whose restoration John D. Rockefeller, Jr., was underwriting. Although Flynt's letters indicate that he believed that he and Frank Boyden shared a point of view about preserving Deerfield's old street as Colonial Williamsburg was being preserved, a former Academy faculty member who knew Boyden well believes that "Frank Boyden would have done anything for the school, and if he had to go along with preservation and restoration to keep Henry Flynt [interested in Deerfield and the Academy]—at least at first—he would have. Boyden regarded the whole town as a backdrop for the Academy."[16]

Flynt apparently outlined his preservation plan in a phone conversation with Norton in early October of 1939. Flynt says in a letter he wrote Boyden shortly thereafter, "Norton was very enthusiastic and vitally interested in working out something along the lines which we have been discussing." Although there is no specific description of the plan, the rest of the letter makes it clear that it involves the whole village of Deerfield and that the early houses are very much a part of it.[17]

Flynt reports that Norton suggested "considerable research work" as a foundation for the Deerfield plan. Norton stated that "definite data" was far preferable to the architects' exercising "their own ideas as to what would be nice" and advised the "acquisition in a quiet way of necessary land"—a recommendation that conveys the strong impression that Flynt planned to *build copies of old houses* as well as to save the old houses that already existed. The focus on Williamsburg, where much reconstruction was done, and Flynt's letter of a couple of years later to Henry Ford, who was also creating a museum village in Dearborn, Michigan, suggest that in fact he was thinking along those lines. In 1944, Flynt again called Boyden's attention to a restoration in which old buildings were liberally mixed with new buildings in the colonial style. This was Stony Brook, Long Island, where Ward Melville had carried out his father's vision of "restoring the community to the simple, harmonious beauty of Colonial days."[18]

Allen House at the turn of the century.

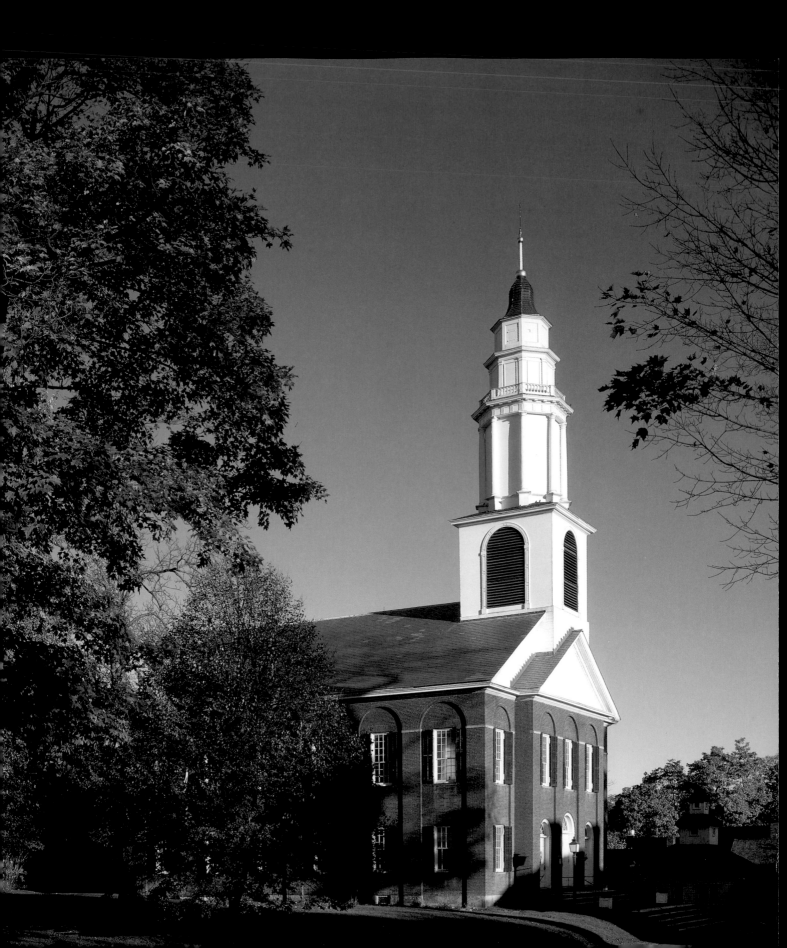

A letter from Flynt to a prospective contributor to the Deerfield cause confirms these indications that early plans included building new houses in the colonial style. Flynt wrote about research he had commissioned on old houses "now being preserved as a protective measure for the school and about other houses which it is hoped may be built *in replica of some of the earlier ones* [italics mine] destroyed at the time of the famous 1704 massacre or at a later date. There are being acquired...parcels of land, some vacant and some with houses which are unfortunately not in the best Deerfield tradition—these, it is hoped, will be torn down and replaced by more appropriate replicas as above noted."[19] These early plans for reproductions of pre-1704 houses never materialized. In a very few cases, old buildings were brought to Deerfield from nearby towns and placed on the main street, but the Flynts never built any new colonial-style houses.

Henry Flynt wrote that while they were considering how to preserve the old street Frank Boyden "had pictures taken of all the houses and lists made showing which should be bought etc., including prices and remarks re various ones." This seems to indicate that almost from the beginning the two men were thinking big and that their plan—perhaps based on that of Colonial Williamsburg—included all the houses on Deerfield's main street. But again Amelia Miller cautions, "Henry Flynt was thinking big—Frank Boyden was keeping Flynt interested." Mrs. Miller also doubts that Frank Boyden would actually have followed through on a plan to take over the entire street. She makes the point that when Frank Boyden, who was a brilliantly persuasive though modest-seeming man, wanted something to happen, it happened. The fact that all the houses on the main street were never taken over suggests that Boyden never intended them to be.[20]

There was some exchange of letters between Williamsburg and Deerfield in the early 1940s, but the war seems to have interrupted everyone's domestic projects. Then in 1946, Kenneth Chorley, president of Colonial Williamsburg, and A. E. Kendrew, head of its architectural department, traveled to Deerfield to meet with Flynt and Boyden. Chorley's thank-you letter to Flynt begins, "Both [Mr. Kendrew and I] were tremendously impressed with the opportunity you have there [in Deerfield] and with the excellent progress you have made in acquiring property and in the preservation of the buildings which you have so far undertaken."[21]

Aside from a few more letters and a short association between the Flynts and landscape architect Arthur Shurcliff, who planned Colonial Williamsburg's gardens, the connection between Deerfield and the Williamsburg planners and builders ended in 1946. During the years they were in touch, the Williamsburg people were encouraging and friendly and gave Flynt and Boyden good advice about how to proceed in Deerfield. Henry Flynt is the one who took their advice to heart, for he very earnestly set about establishing a research program to investigate the history and background of the houses he planned to restore, as both Norton and Kendrew had recommended.

The difference in financial resources available at Deerfield and at Williamsburg—the Flynts were wealthy, but by no means in a class with the Rockefellers—meant that Deerfield's approach was considerably less sophisticated than Williamsburg's. Whereas the Rockefellers could afford to hire the Boston architectural firm of Perry, Shaw, and Hepburn to organize their restoration, the Flynts had to rely on local talent. Although that meant the lack of professional training, at least in the case of architectural design, it also meant that the Flynts remained focused on Deerfield and its history and traditions, which has proved to be a bonus. It is this concentration on Deerfield, in fact, that gives Historic Deerfield its own very special character and sets it apart from other museum restorations.

By the time the Williamsburg people came to visit in 1946, the Flynts had begun to buy old houses along Deerfield's street, and as they bought property, their interest and feeling of proprietorship grew. They were increasingly taking on more financial responsibility for work in Deerfield than they had originally planned, for Henry Flynt had found the ultimate outlet for his ample energies. Here was a project that would engage him for the rest of his life. It fulfilled his needs for physical, mental, and emotional challenges and satisfactions, and it was something in which his wife could participate. It was not, however, the project that Frank Boyden had had in mind for him. Frank and Helen Boyden were totally involved in their plans for the Academy and were interested in houses and furnishings only as they fit into such plans. In any case, their concern with historic preservation extended only to façades and ambience. The Flynts' and the Boydens' goals were beginning to diverge.

ℑℎ ℑℎ ℑℎ

The Flynts' first house purchase took place in 1942, and was very definitely the result of their Academy connection. They bought the Manning house, which they gave to the Academy that same year, and then in 1944 the Rossiter, or "Pink House," so called because of its color, which they repaired and partially furnished and rented to the Academy. Then in 1945 came the Inn and the Ashley property and Allen house. Henry Flynt wrote the Boydens that he and Helen had bought the Allen house "when there was a possibility that a Greenfield Liquor dealer would buy it.... You felt that purchaser might not be a good influence for the Academy and its boys and we agreed."

◀ The Brick Church.

Of the Deerfield Inn, he wrote that they had bought it "when efforts made by the Academy to buy or rent it had failed and at a price which the Academy could not then afford."[22]

"As time went on," continued Flynt, "your housing of boys presented problems and as other houses came on the market we bought them, fixed them over and have made them available for faculty and boys charging a rent which does not cover the carrying charges...."[23] There is no question that the Flynts definitely affected the life of the school by buying old houses and either giving or renting them to the Academy. Some houses were entirely converted for use by the school, while others were eventually divided between museum rooms and faculty apartments. This meant that the Academy had more choice in apartments to offer its staff and could provide more rooms for boarding students. At the same time, the "look" of Deerfield was being preserved and upgraded, for the Flynts always saw to necessary repairs and maintenance. The old street was looking better and better, and that was a definite asset to the Academy.

At the same time that they were buying houses, the Flynts were helping to restore and repair other old buildings, most of which the Academy owned. In the fall of 1940, even before they bought their first Deerfield house, the Flynts had contributed funds to the Brick Church for exterior painting and interior lighting fixtures. It seems probable that Frank Boyden told them of the church's need of assistance, for that building is set prominently on the north end of the common where the Academy's main building stands. Given Frank Boyden's obsession with appearance, it makes sense to surmise that the rundown condition of the Academy's close neighbor would distress him and that he might call upon the Flynts to help him correct things.

Among others they helped with were The Manse, the lovely eighteenth-century mansion across from the Brick Church; the John Williams House; the Hitchcock House, in which the school dining hall was located; and the "Little Brown House on Albany Road." The latter, which had been artist and writer Annie Putnam's studio earlier in the century, had a "big studio window...and was very interesting as a nineteenth-century studio, a relic of when Deerfield was a great center of the arts," says one observer of the Deerfield scene. "But the Flynts restored it to 'ye olde colonial.'" When the Greek Revival Delano House was damaged by fire in the late 1940s, the Flynts supervised and partially paid for its renovation. Here again, however, they chose to strip away the Greek Revival details, which had been added in the 1830s or 1840s and which they saw as less attractive than earlier styles, and restore the house to a colonial appearance.

To aid them in their plan of preserving and renewing the town, the Flynts called upon Miss Elizabeth Fuller, descendant of some of Deerfield's most distinguished families. The Fullers were related not only to the illustrious nineteenth-century painter George Fuller but also to the Williamses, one of Deerfield's most important eighteenth-century families. Elizabeth's mother, Mrs. Mary Fuller, was "Mrs. Deerfield," according to a former neighbor. She was a member of Deerfield aristocracy, but she had "an early sense of the importance of preservation of the past in Deerfield" that impelled her to support the Flynts when other old Deerfield residents would not. Helen Flynt recalled that the first people (besides the Boydens) she and her husband went to visit in Deerfield were "Elizabeth Fuller and her mother, who talked to [us] about Deerfield."[24]

By October of 1945 Henry Flynt was writing to Elizabeth Fuller to tell her how pleased he was that "so much progress was made along the lines of research and development of your wonderful village.... I want to thank you for your and your entire family's interest and helpfulness in getting it started." He goes on to say that he's delighted that Miss Fuller will serve as Director of Research and Development, and states that "your invaluable knowledge, your familiarity with people, events and things, and your willingness to establish the many contacts that are necessary, will be most helpful." Miss Fuller was to be assisted by Miss Jean Campbell, a Smith College graduate whom she had secured as the project's "Research Expert."[25]

Flynt's suggested research topics included determining the exact location and design of the interior of Ashley House, the interior designs of The Manse and Allen House, interior colors and contents of the John Williams House, and the exact location and design of Deerfield's Revolutionary-period liberty pole. He suggested consulting the old maps and pictures, inventories, and diaries that George Sheldon had collected and that were preserved in Memorial Hall, as well as digging for information about early flowers and gardens and stores and industries. He didn't rule out other lines of research, however. He was aware that "running down one item will present others we may not have thought of and we do not need to stick too close to this agenda."[26] Flynt was clearly trying to heed the advice of Colonial Williamsburg people to lay a careful groundwork of research before starting restoration. Miss Campbell did research on the Ashley and Allen Houses, but left to get married in 1947. For some years thereafter, research on the houses was on a more informal basis, though the Flynts did acquire the temporary help of Miss Amelia Fuller in 1947 after Miss Campbell's departure. After her graduation from Smith College, Amelia Fuller married Russ Miller, a master at Deerfield Academy, and came to live in Deerfield. She has pursued her research, mainly into architectural aspects of Deerfield's history, through the years. Her

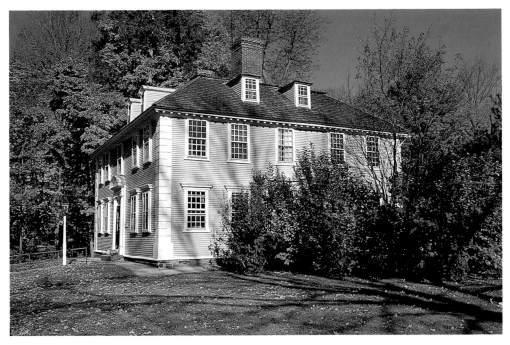

The Manse.

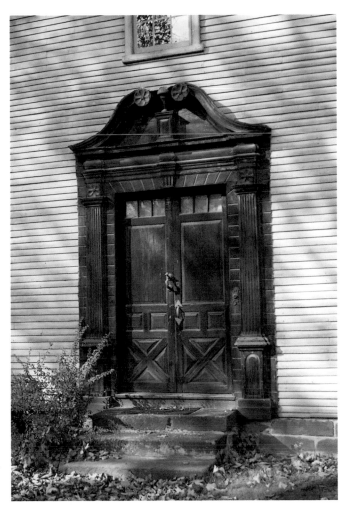

John Williams House with its original eighteenth-century doorway.

Elizabeth Fuller.

without representation" and other policies that led to the American Revolution. When the facts about the location and type of the original pole and flag had been ascertained, Flynt arranged for the creation of replicas, which were raised in 1946 on the same site as the originals. In sponsoring a latter-day liberty pole with flag, Henry Flynt was not only paying homage to the beliefs and courage of the Sons of Liberty who opposed the Crown and erected liberty poles in the early 1770s, he was also making a statement about global politics in his own time. The struggle between freedom and totalitarianism seemed particularly crucial to Flynt after the war, and the liberty flag was a visible symbol of his beliefs.

In another instance of Henry Flynt's conviction that "visual truth speaks louder than words in contradicting propaganda," he entered into a project to produce a book about Old Deerfield with Samuel Chamberlain. Chamberlain was a well-known photographer whose specialty was old houses and antiques presented in his atmospheric black-and-white photographs. The book, published in 1952, was called *Frontier of Freedom* and was subtitled "The Soul and Substance of America Portrayed in one Extraordinary Village." In explaining the purpose of the book more fully, Flynt said, "American taste and culture, American eagerness for learning and respect for the past, all these are summed up in this tranquil community." Aside from Flynt's introductory patriotic and historical essays, the book consisted largely of pictures with captions. It included complete coverage of the houses the Flynts had open to the public, as well as exterior shots of other important and interesting buildings in Old Deerfield. The book has remained in print in updated editions to this day, although its current title is *Historic Deerfield: Houses and Interiors.*

Flynt's already deep conviction about the importance of family, combined in this case with his idealism about

rigorous standards have ensured thorough investigation of many phases of Deerfield and Connecticut Valley history and architecture.

The Flynts' goals at this time were articulated by Henry, who handled virtually all the couple's correspondence relating to Deerfield. They included preserving "some of the fine old houses" and acquiring land to protect Deerfield Academy, as well as preserving Deerfield as an inspiration to future generations. Henry's conviction that Deerfield stood for "the spirit of free enterprise, the spirit of New England, the spirit which needs to go out into the Nation now" convinced him that saving Deerfield would be saving the values that made the Free World free. Flynt's strong anti-Communist and pro-American beliefs, held by many others during the post–World War II period when the United States and Russia were struggling for world supremacy, caused him to see Deerfield as a symbol. Over and over, he speaks of the importance of Deerfield in educating and inspiring all Americans, but particularly young people. "Is it not possible," he asks, "to sum up the strength of this Republic, its vigor and idealism and enterprise, in a single American community?"[27]

Because of his strongly held patriotic beliefs, Henry Flynt sponsored research into the liberty pole and flag that had been erected in Deerfield in 1774. Liberty poles, liberty trees, liberty flags, and liberty caps were important signs of colonists' outrage over "taxation

Liberty pole with flag.

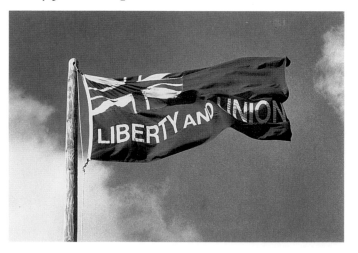

America and its founders, produced a strong motivation to preserve the town of Deerfield and what he believed it stood for. It was during this period that the Flynts, although continuing their allegiance to the Academy, began to channel funds more into the preservation and furnishing of houses than directly to the Academy. Acting on his own, Henry Flynt began trying to raise money to preserve the town of Deerfield for future generations. "We need financial help to fulfill this outstanding and rare privilege of carrying on this atmosphere of culture and forward-looking adventure which has permeated Deerfield," he wrote to a prospective donor. "What greater privilege could we have than being a part of this program?"[28] Henry Flynt was increasingly committing himself, his energies, and his money to the Deerfield cause.

Although the motivation was undoubtedly Henry's in the beginning, it was important to him that Helen also be interested and involved in the Deerfield project. She had contributed generously to various Academy undertakings and was much attached to the Boydens, but her social and athletic pursuits kept her interested and involved in Greenwich and she wasn't in search of a project, as Henry was. She responded to his enthusiasm for the work in Deerfield, however, and backed him up both emotionally and financially. He, in turn, made a point of involving Helen in all aspects of buying and restoring the houses, and deferred to her particularly in matters of taste and decoration. Toward the end of his life, Henry Flynt wrote his wife, "The happiest feature [of our involvement with Deerfield] can be summarized only very inadequately by declaring that because we have worked together so happily over so many years on such a stimulating enterprise is all any man could ever ask or hope for in life. How fortunate I have been compared with several other antiquers we know who have gone their separate ways without the help or perhaps even the helpful interest of their spouses."[29]

꒰ꕥ꒱ ꒰ꕥ꒱ ꒰ꕥ꒱

Buying old houses inspired Helen and Henry Flynt to buy old furniture. After purchasing the "Pink House" in 1944, the Flynts furnished it with antiques that they bought in shops in Greenwich, Boston, and Northampton. The furnishings were to be on loan to the Academy, to whom the Flynts rented the house. The Academy's tenants in this case were the Boydens' son John and his wife. Among the thirty-seven pieces Flynt listed in a letter to Frank Boyden were what sound like representatives of periods from the early eighteenth century to the mid-nineteenth. A "Reproduction Cherry Lowboy" appeared alongside "Early American Maple Banister-back Chairs," "Early American Mahogany Drop Leaf, reeded leg Table with Drawer," andirons, a pine corner cabinet, a mahogany slant-front desk, and an "Early English Chippendale revolving Waiter Fitted as a Floor Lamp."[30]

Their next project was the Deerfield Inn, which they bought in 1945. Henry Flynt and Frank Boyden had discussed the problem of the Inn at least since 1939, when Boyden wrote that "no one can approach Mrs. Carlyle [sic—the owner] on the subject of the Inn." Boyden lamented that "nothing can really be done with her," and confided, "I felt this Commencement more than ever before the need for proper housing in Deerfield."[31] At that time the Inn was open only in summer, and there was no place in Deerfield for parents of Academy students to stay when they visited during the rest of the year.

Henry Flynt described the Inn under Mrs. Carlisle's ownership as "very simple and thoroughly unattractive." Mrs. Carlisle, Flynt told Peter Spang, lived there with a friend who was "a medium or seer who was living very well just being her friend.... You could never tell where he ended and the overstuffed chair began." Whenever she was approached about selling the Inn, Mrs. Carlisle consulted her friend, whose invariable advice was to "hold for another thousand."[32]

Finally, since it seemed increasingly important to acquire the Inn and there were rumors of a big hotel operator's trying to buy it, Flynt decided to approach Mrs. Carlisle again:

> I told Mrs. Carlisle I knew she wanted to sell, that she knew I wanted to buy, that if she sold at her price through a real estate broker the commission would bring her net figure down close to my offer; that I'd be willing to split the difference; that I was late in getting off to Williamstown, that my offer would not hold after I went out of the Inn door, nor would it be renewed.... She said "All right." We shook hands.[33]

Peter Spang recalls Flynt's telling him that when Mrs. Carlisle advised her spiritualist friend that she had finally sold the Inn, he said, "That's all right. I've had a dream that we were going off into the setting sun in a green Dodge anyway." So they bought a green Dodge and set off.[34] After taking title to the Inn, the Flynts threw out nearly everything in it and started anew. They were considerably hampered by the shortages of all kinds of goods that characterized America immediately after the war, so they improvised and made do with what they could. Helen was "ingenious and resourceful in devising twin beds from old double four posters," wrote Henry. "A man in Greenwich she located turned out on his own lathe some attractive beds and Sloanes in New York made a dozen or more small dressers based on a design [she] found. When an especially cheerful yellow wallpaper was insufficient, she suggested lowering the ceiling and putting panelling on one side of the room."[35] Peter Spang recalls Mrs. Flynt's telling of going from shop to shop buying "two of this and three of that," and the Flynts' saying that they

Deerfield Inn lobby, probably 1940s.

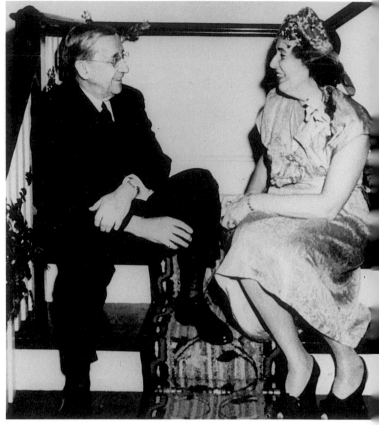

Frank Boyden and Helen Flynt at the Inn, probably 1940s.

Allen House dining room, 1946.

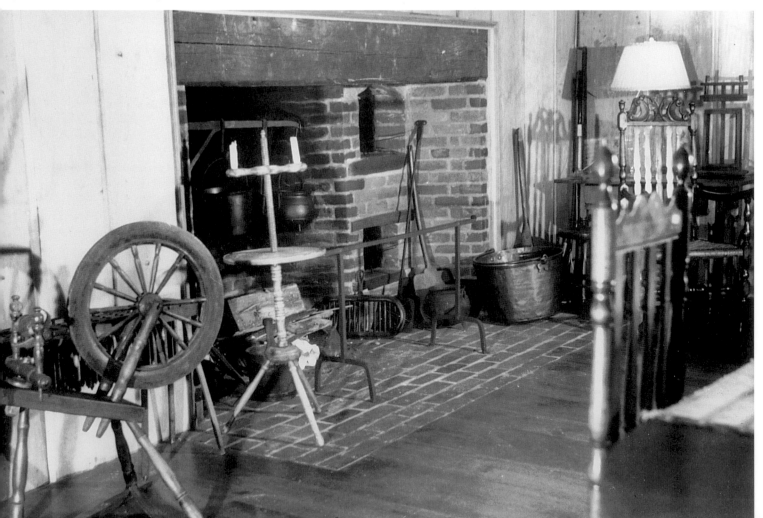

brought some furnishings up from their house in Greenwich.

Renovating and refurnishing the Inn was a truly hands-on cooperative effort, and perhaps it gave the Flynts a taste for such projects. "We all pitched in to hang pictures," wrote Flynt, "set up beds and haul out piles of junk to trucks waiting to go to the town dump." Frank Boyden helped from the beginning, and the general manager of the Academy dining hall helped with selecting dishes and kitchen equipment. "We had many laughs mixed with the really exhausting toil," recalled Flynt, and he remembered that as a practical joke "we sent several of the pictures of Vesuvius to Helen Boyden, [and] an atrocious light to somebody else."[36]

The Flynts called upon Henry's cousin Eudocia Jones and her husband Raymond, who had hotel experience, to return from western Canada to run the Inn. They arrived at the end of 1945 and were on hand to assist in pulling the Inn together before its official opening in February, 1946. "Of all our officers or staff, Ray Jones, undoubtedly, had and even caused the greatest fun around the Inn and town of anybody," reported Henry Flynt. One favorite story was of the time a woman drove her car into one of the pillars in front of the Inn. The woman was nowhere in sight when Ray Jones discovered the damage, so he left a note on the banged-up pillar saying, "Madame, George Washington stopped here, but you did not!"

Ray was also a good manager and his wife, "Docia," was equally endearing. "Docia's stories were legion," wrote Henry, "her enthusiasms exciting, her imagination vivid, her mind continually sparkled...." Although the Inn never made much of a profit during the Flynts' ownership, they were pleased that they had been able to transform it from an uncomfortable and unattractive hostelry to a pleasant and restful oasis for Academy parents and other visitors. Before its official opening to paying guests, the Flynts and the Boydens invited Deerfield residents to "enjoy a little hospitality" at the Inn and to meet Mr. and Mrs. Raymond Jones. This was the first of many receptions the Flynts would give for townspeople before the opening of a newly restored building.[37]

Rejuvenating the Inn was hard work, but it was also enjoyable and satisfying. It is therefore not surprising that later that same year the Flynts bought both the Allen and Ashley Houses with the idea of restoring them. The Boydens, according to the Flynts, also influenced them in these purchases—they wanted the Flynts to buy the Allen House to prevent a Greenfield liquor dealer's buying it. In the case of the Ashley House, the purchase and subsequent moving of the eighteenth-century dwelling to its original location on the main street enabled Frank Boyden to relocate a house of 1869 near the Academy, providing a student dormitory and an apartment for faculty.

Helen Flynt recalled in an informal talk to the Deerfield guides that Helen Boyden's views were also important in their restoration of the Asa Stebbins House, which opened in 1950. "Mrs. Boyden wanted the Asa Stebbins house put back as it used to be," said Helen Flynt. "The yellow paint was sand blasted off, revealing the lovely old red brick you see today. The French windows and porch were removed." Helen Boyden referred to her feelings about the renovation when she gave a little talk after a dinner party one night:

> The Flynts are like fairy godparents. You'd say, "Oh, wouldn't it be nice if that house was gone." And you'd turn around and it was gone. And "Wouldn't it be nice if that ugly color was off that house?" And lo and behold, it would be done. And "Wouldn't it be nice if that porch was missing and you could see the original house?" And it would happen.[38]

By May of 1948, the Flynts had fitted up their own Allen House with antiques and had restored and furnished the Ashley House to the period of Parson Ashley's residence, 1733–1780. Whether choosing Colonial Williamsburg as a partial model for the restoration of Deerfield houses also influenced the Flynts to consider furnishing the houses with antique objects is not clear. Perhaps the antiquing they did in 1945 to provide furnishings for the "Pink House" and the Inn whetted their appetites. Or their visits to Henry Francis du Pont's home, Winterthur (which he sometimes opened to interested visitors upon request) in 1946, and to the Metropolitan Museum's American Wing in early 1947 may have hooked them. Although they didn't meet du Pont on this trip, the Flynts were entranced with Winterthur, which du Pont had filled with early American architectural interiors and antiques. After the visit Flynt wrote du Pont, "The care with which you have assembled your collection, the artistic arrangement and the beauty of it all bespeak a real devotion to the finest things of our noble past.... Our humble little effort to preserve Old Deerfield, Massachusetts, has taken on renewed zeal because of our trip to Winterthur."[39]

Joseph Downs, Curator of the American Wing at the time of the Flynts' visit, was undoubtedly an important personal influence. Downs was one of the two or three most brilliant and authoritative curators of American art of his generation, and by the time he met the Flynts he had had considerable influence on period rooms in the Philadelphia and New York areas.

Downs must have been drawn to the work the Flynts were doing to preserve the houses and ambience of Deerfield, for he wrote of his feelings about the importance of early buildings in an article on the farmhouse he restored in Guilford, Connecticut:

> Because our early buildings are the most tangible evidence that remains of a vital phase of the American way of life, it is disheartening to see the imaginative work of great craftsmen vanishing almost daily in favor of jerrybuilt nonentities.[40]

Downs came up to Deerfield to advise the Flynts on the repair and renovation of the Delano House, The Manse, and other endeavors in 1948, and the Flynts and Downs went to the first Williamsburg Antiques Forum together in 1949. There are references here and there in Flynt's correspondence to Downs's recommending dealers and others to help with restoration and furnishing, and Downs also helped Flynt to set up a cataloguing system for museum accessions based on the one used in the American Wing. In 1949, Joseph Downs left New York to take up a position at Winterthur, which Henry Francis du Pont was preparing to turn into a museum, and Downs's influence on the Flynts no doubt lessened. He died in 1954 at the age of fifty-nine.

Vincent Andrus, Joseph Downs's assistant and, later, Curator of the American Wing, was another advisor and friend on whom the Flynts relied. When the Ashley House was written up in a *New York Times* article, it was reported that "two house painters working on the restorations were brought to the Metropolitan Museum in New York…to make samples of old wall colors"—no doubt on the advice of Downs and/or Andrus.[41]

Henry Flynt revealed another motive for furnishing the Deerfield houses with antiques in an essay he wrote for the catalogue to the 1956 East Side Antiques Show. He speaks of his admiration for:

> The courageous people of several generations who have made this country great. It is not long before you become imbued with a perfectly human desire to see how these people lived in the early days. You want to sit in their chairs, sleep in their beds, cover your sofas with 18th century materials, and, one must then have *bourette* or damask or equally fine hangings at the windows. You begin to wonder whether that modern carpet doesn't spoil the mellowed color of the panelled walls or detract from the Gilbert Stuart portrait.

Like nearly everyone else of their generation, the Flynts chose to think of the colonial inhabitants of their restored houses as important, well-to-do, and refined, and as having living and thinking patterns very like their own. "When we started to collect in earnest," said Helen Flynt, "we tried to do everything in the 18th century style. Some people think things done here are very special and very wonderful. Mr. Flynt and I used to sit in the various rooms of the museum houses and try to think about the people who used to live in the houses—where they would sit, what would suit them."[42]

As a matter of fact, the substantial houses the Flynts restored along Deerfield's main street did belong to prosperous residents. But they lived very differently from twentieth-century Americans and had very different expectations, as the current incarnation of the Wells-Thorn House teaches us. This insight, however, is the result of research conducted in only about the last twenty years.

૭ૐ૦ ૭ૐ૦ ૭ૐ૦

Although the Flynts had employed a contractor from nearby Greenfield to work on the Deerfield Inn, they hired William E. Gass (1902–1986) of South Deerfield to renovate most of their Deerfield houses. Gass had attended Deerfield Academy and gone to work at an early age for his father, who was a building contractor. "I went through all the [building] trades," he said. "I started when I was fifteen years old. I've shoveled cement and I've done everything." Gass said of his ability to understand the proportions of old buildings and to design in the colonial tradition, "That's something…that you can't learn in school. God gives it to you." His evident interest in and affection for old houses endeared him to the Deerfield ladies, and he became good friends with Margaret Whiting, founder of the Blue and White Society and firm supporter of Deerfield tradition. "I learned a lot from her. She was my friend," he said.[43]

In 1929 the firm of William Gass and Sons built a replica of the Old Indian House, the survivor of the 1704 French and Indian attack that had been torn down in 1848. Writing of the house to William Sumner Appleton of the Society for the Preservation of New England Antiquities, Mrs. Jennie M. A. Sheldon said, "The replica of the old Indian house is a remarkably accurate reproduction. Mr. Gass, the father, has not the historic instinct but his son, Wm. Gass, Jr., has it to an unusual degree. The restored old Indian house is really the conscientious work of the son." Young Bill Gass's reputation for work on early houses continued to grow, and by the time the Flynts became involved with Deerfield houses he was recommended to them "as someone who knew old buildings and was a trustworthy builder."[44]

Bill Gass's first jobs for the Flynts involved work on the "Pink House," Allen House, and Ashley House. With the exception of the Asa Stebbins House, he was the designer and contractor for all the other houses they restored, and he was as much responsible for the "Deerfield look" of the 1950s and 1960s as the Flynts themselves. Henry Flynt praised Gass's "unswerving eye and appreciation for proportions; his knowledge of New England styles, design, and construction details have certainly stood us in good stead on all the work we've done with him." Their relationship was not always harmonious, however, for Flynt went on to say that "I always went through the same worries about all jobs Bill did for us. Expense and extended delays apparently become an inevitable part of the routine of construction. We admit, however, that when the job is done it has a charm few other people could attain."[45]

Henry Flynt's correspondence reveals that throughout

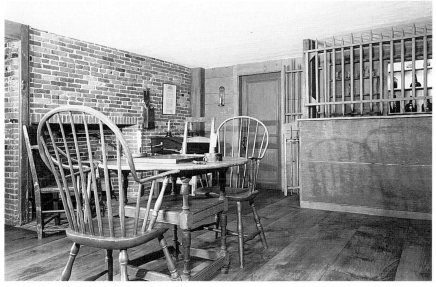

Barroom at Hall Tavern.

Kitchen, Memorial Hall, 1890s.

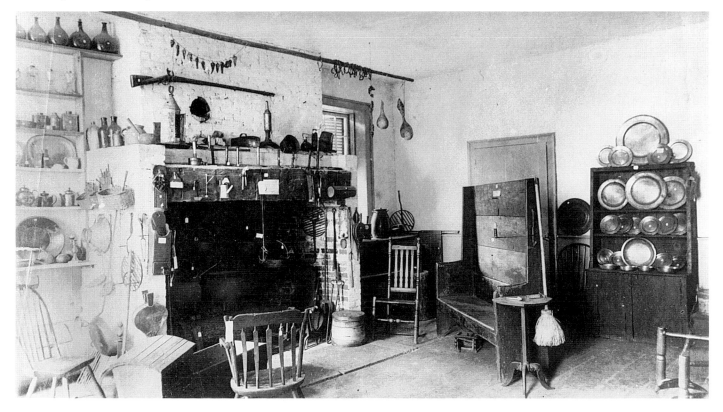

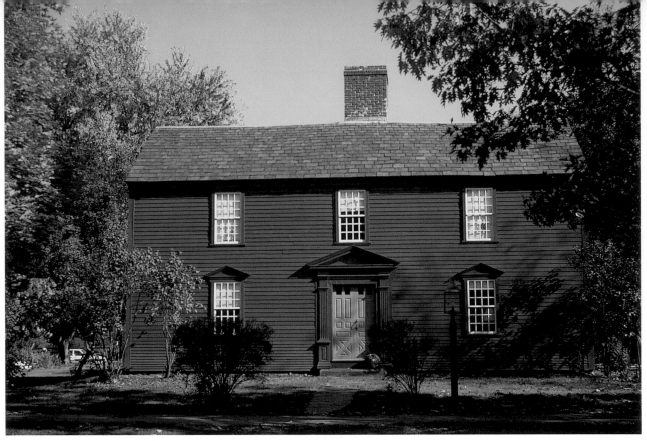

The red saltbox from Conway.

Wilson Printing Office.

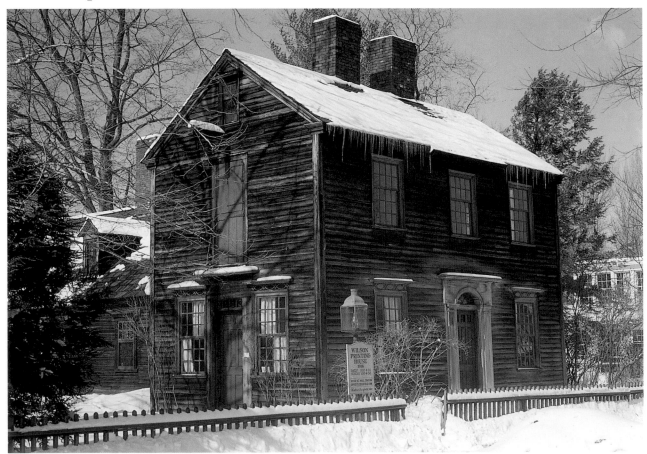

all the years they worked together, he was at odds with Gass over the latter's charges and the time it took him to do the agreed-upon work, as well as other matters from time to time. "Can't you give me some assurance that you personally are watching this job, for I cannot believe, from my own eyes and reports from people...that you are really paying much attention.... I cannot quite see how we can proceed to spend money like drunken sailors the way we have on the Allen House much longer," he wrote to Gass on July 2, 1946. Responding to similar complaints a few years later, Gass says, "My profit has decreased instead of increased. All prices have gone up and my margin has not. To do Deerfield the way I think it should be done it takes all my time. You want to stop and think that for one [man] to draw, detail, [do] shop work, supervise, etc.—I don't have much time to take on other work.... After seeing (Williamstown) and all these bosses, supers, fore men, checkers and double checkers I feel I get more out of my men than they do."[46]

Frank Boyden had the same response to Bill Gass that Henry Flynt did. "Whatever we individually may feel with regard to his costs," Boyden wrote, "I think there can be no doubt but that he more than any one person really understands the Deerfield atmosphere and is a very ingenious and interesting designer."[47] While they never failed to complain about his costs, both Boyden and Flynt respected Bill Gass's work.

Although Henry Flynt, particularly, wanted his restorations to be accurate, he wasn't so critical of Gass's architectural inaccuracies as later students have been. In fact the Flynts certainly approved, and perhaps specifically asked for, these aspects of the work. More recent students have frequently objected to the liberties Gass and/or the Flynts took with early building plans and practices, however. Among examples are the exterior of Dwight House, which lacks the entire back section of the original Springfield house. Bill Gass brought only the front section to Deerfield, leaving out sections of the rear that could have been included. He also gave Dwight House a nineteenth-century chimney and a slate roof rather than an eighteenth-century shingle roof. When Architectural Conservator Bill Flynt asked Bill Gass why he put slate roofs on eighteenth-century buildings, Gass replied that they last longer and they look nice. Another example of Gass's incorrect restoration is the big kitchen of Dwight House, with a brick floor, huge fireplace, and exposed ceiling beams—all inaccurate for a mid-eighteenth-century New England kitchen. The fireplace in the barroom of Hall Tavern is a further example. Its substantial brick, rather than wood-paneled, chimney breast and hearth cause Peter Spang to consider it "one of the greatest triumphs of the true taste of Bill Gass."[48]

Bill Gass's ideas of colonial architecture and traditions developed in the field, so to speak. He never had any formal training in architectural styles, but learned from his own observation of old houses in and around Deerfield while on the job for the family firm. Having grown up in Deerfield, Gass would have been familiar with the period rooms, particularly the kitchen, in Memorial Hall—a display decidedly more romantic than realistic. The "old-time kitchen" with a massive brick fireplace as its focal point had been a compelling symbol of the colonial past at least since the Sanitary Fairs of the Civil War period. Early writers on American antiques stressed the romantic appeal of such rooms: "It is almost impossible to picture the domestic life of the American colonists in the seventeenth and eighteenth centuries without calling up a vision of the huge kitchen fireplace, with its pewter-laden mantel, the old flintlock hung above, strings of peppers and onions overhead and the family of our forebears gathered about it in the ruddy glow of hickory and birch," wrote Walter Dyer in 1910.[49]

Gass's familiarity with the Memorial Hall period rooms, whose authenticity or correctness he would have had no cause to question (in fact, quite the opposite), must account to some extent for his conception of the colonial kitchen. Another influence on him must have been old houses in Deerfield, such as the Frary House and perhaps his friend Miss Whiting's house, which were furnished in the same eclectic and romantic manner as the Memorial Hall rooms. These, as much as anything else, may have shaped Gass's idea of "colonial" interiors, with their focus on the brick fireplace, exposed beams, unpainted paneling, and dim atmosphere.

Later research has shown that early American kitchens were serious workrooms, set up to facilitate the performance of a variety of demanding household tasks. The fireplace was undeniably important as a source of heat and light, but it was encased in wood planks or paneling rather than brickwork. Fireplace equipment and cooking vessels and implements were present in more modest numbers than many restorations would lead us to believe, as were pewter and ceramics. A bed frequently occupied one corner of the kitchen.

Nor did Helen and Henry Flynt have any background in colonial American architecture. Their ideas, too, were shaped by exhibits such as those at Memorial Hall and by the domestic environments of friends and acquaintances. Until William Sumner Appleton took an architectural survey in Deerfield in 1917, the old houses had not been scrutinized by anyone knowledgeable in the field. The emphasis on the part of Deerfield residents such as C. Alice Baker, the Allen sisters, Jennie M. A. Sheldon, and their contemporaries had been on what they considered the feeling and atmosphere of the colonial, and not on accurate colonial details.

Whether they were aware of it or not, both Gass and the Flynts were undoubtedly also influenced by the more

general sentimental ideas of colonial America that pervaded the late nineteenth and early twentieth centuries. Cozy knotty-pine paneled rooms with open fireplaces and braided rugs symbolized the tranquil past to Americans brought up on magazine and newspaper articles on colonial domestic life. Department-store, antiques-shop, and historical-society period rooms and Norman Rockwell's nostalgic *Saturday Evening Post* covers also contributed to their impressions. Exposure to more scholarly arrangements such as those of the Metropolitan Museum's American Wing, which the Flynts visited in 1947, didn't necessarily erase the earlier, more romantic ideas.

Bill Gass's restoration methods involved studying the building for evidence that would indicate the existence of early paneling and moldings and the placement of walls, doorways, stairs, and other original features. "When you've been in this [business] as long as I have," he told Architectural Conservator Bill Flynt, "moldings tell you a lot of history—what period, when changes were made." Other clues to original appearance included evidence of paint, fragments of plaster and wallpaper, old nail and pegging holes, and oxidized wood (oxidation indicates that wood has gone for a long period without paint). Gass recalled, for example, that the marks on the clapboards of Dwight House had indicated that the house had had a gambrel roof. "So I took the pitch and made it exactly as it originally was in Springfield," he said.[50]

When he could find no evidence of original work—and sometimes even when he could—Gass designed moldings, paneling, doorways, and other features that were based more on his experience with old houses and his own taste than on actual eighteenth-century precedents. A number of the decorative pedimented doorways that ornament Deerfield houses are Gass's own freely adapted versions of traditional Connecticut Valley doorways, called by some residents "Bill Gass originals." It is clear from the following statement that he felt perfectly free to embellish an early house if he thought his addition would improve the design: "See what I did just to make a change [in the design of Dwight House]? I made dormers of different sizes—see, those two dormers are shorter just for interest, no other reason."[51]

Another occasion on which his own taste took precedence over eighteenth-century reality was when the Flynts bought an early saltbox in Conway, Massachusetts, and had Gass move it to a lot on the main street in Deerfield. According to Peter Spang, "a modest example of an A. J. Downing–type house" had formerly stood on the site. This was undoubtedly one of the houses Henry Flynt had described as "unfortunately not in the best Deerfield tradition" that he hoped to tear down because they didn't look colonial.[52] (The Flynts and many others of their generation were interested *only* in colonial and early Federal houses; they drew the line at 1820 or 1830 and refused to recognize the merits of anything later.)

Henry Flynt wrote Gass in reference to the job of moving the saltbox from Conway to Deerfield, "I hope that you will have time to give some of your personal attention to this, especially because of the removal of any good floor boards and panelling in a way which will not destroy them the way I fear some panelling was destroyed when the Parson Ashley House was moved." Whether Gass heeded Flynt's words we don't know, but Peter Spang says, "Inside, [the saltbox is] very much a modern house with early framing. I don't think there's any [early] trim surviving at all."[53]

Outside, Spang feels "this probably comes closest to a 'Bill Gass original' in a house, even though the frame is early." Archival photographs of the house as it looked in Conway reveal that it had five windows across the second floor and, because it had been converted into a store, display windows on either side of the door on the first floor. After Gass brought the house to Deerfield, however, it had only three windows above and one on either side of the front door. It is possible that the Flynts asked Gass to alter the saltbox's façade to make it look like their friend Joseph Downs's saltbox in Guilford, Connecticut. With the exception of Gass's architectural embellishment on first-floor windows and the front door, the red saltbox in Deerfield is a dead ringer for Downs's farmhouse.[54] This is not one of the museum houses—it has been used by Historic Deerfield staff for some years—but its cheerful red exterior makes it popular with visitors.

Gass's men took care of all aspects of the Flynts' restorations, including plastering and brickwork. They usually tore out all materials they judged to be later than eighteenth century, stripped original woodwork of paint, and made up necessary paneling, moldings, and other elements from old wood. "That's what's made Deerfield," said Gass, "the old materials...because you can't make new material look old unless you paint it."[55] One of the hallmarks of Gass's work, amply evident throughout the museum houses, is his preference for unpainted wood paneling and trim. While Gass's designs weren't always authentically colonial, everyone agrees that the quality of his workmanship is very high. He set up his own cabinet workshop to ensure that jobs were completed by hand exactly to his specifications.

When the Flynts decided to return a much traveled building to its original site and restore it to its 1816 appearance as John Wilson's printing office, Bill Gass took to the project with enthusiasm. Once the building itself was restored, it remained only to furnish it with a printing press. An early example was not available, so Gass and his carpenter Francis Olszewski went to the American Antiquarian Society in Worcester, Massachusetts, to study the press of the celebrated colonial printer Isaiah Thomas.

They made sketches of all the individual parts of the press so that Olszewski could copy it accurately. "I studied it enough so that I knew what every part was named," Gass said.[56] When the printing office was completed, Gass planted a buttonball tree on the property, for he was interested in exterior environments as well as architecture. For a number of years the Flynts had a printer actually working in the building and explaining its history and the art of printing to visitors. That practice eventually proved too expensive for an organization the size of Historic Deerfield, and was discontinued.

Despite his limitations and because he had a real ability to produce houses that had an early look, Bill Gass was widely sought after. Architectural Conservator Flynt said that Gass "was a very knowledgeable person as far as the history of architecture in the area. He did a lot more than just the houses along The Street. He was quite influential in restoration as early as the 1930s until almost the present day in most of New England and throughout Connecticut." Peter Spang adds that he and Henry Flynt used to agree that at the time the Flynts were restoring Deerfield houses, no other builder in the area knew as much about them as Bill Gass.[57]

In the end, Gass remembered the good times with the Flynts rather than the disagreements. "I've always said if it wasn't for Mr. and Mrs. Flynt, Deerfield would look pretty sick today," he said in 1982. "Because people that lived here didn't have the money to [renovate the houses]—damn lucky if they could paint.... Mr. Flynt, instead of yachts, he did houses, which is a great thing.... Him and I got along until he died—twenty-eight years—not doin' too bad."[58]

꒰ℎ ꒰ℎ ꒰ℎ

When Helen and Henry Flynt decided to furnish some of their old Deerfield houses with antiques and to open them to the public as museums, they plunged into the world of collecting just as Henry had feared they would when he swore Helen to their noncollecting pact. What made it all right was his conviction that *this* collecting was in an excellent cause. In buying and furnishing the houses, Flynt felt that he and Helen were expressing "a real sense

Stone Hedges, the Flynts' Greenwich home.

31

of gratitude for our own ancestors and children and family. We wanted to do something to show that sense of appreciation—call it building a monument to them...."[59]

The Flynts' only previous furnishing project before they started in Deerfield had been that of equipping the "stockbroker's Tudor-style" house they built in Greenwich, Connecticut, in 1929. "We had many family things about which we had sentiment," wrote Henry in explaining how they furnished that house. They bought conventional pieces to supplement the family things, but didn't focus particularly on antiques. They did like antique styles, however, and Henry told of their discovering a source for such pieces:

> One day in New York we saw a desk we were charmed with— an English flat-top one with attractive carving. It was on Madison Avenue but was so expensive we just had to pass it up. A few weeks later we were in a little cabinet-maker's shop over on Second Avenue, and saw one just like it being made. We discussed it and bought it for a quarter of the price asked on Madison Avenue, and learned that the other one had been made, worm holes and all, in the little shop.[60]

Finding sources of genuine American antiques, learning about them, and buying them for the Deerfield houses became a whole new project. The Flynts listened to old Deerfield residents such as Miss Whiting, Margaret Harris Allen, Mrs. Mary Fuller, and her daughter Elizabeth, who told them about important local family pieces, and they made a real effort to buy as many such objects as they could. One splendid opportunity was the 1946 auction of the estate of Miss Susan Hawks, descendant of early Deerfield families, granddaughter of the historian George Sheldon, and long-time antiques dealer. At the auction Henry was so intent on keeping "many of the [Sheldon and Hawks] things in Deerfield" that afterward he apologized to a woman he felt he'd slighted, saying he was sorry "everything was so hectic."[61]

Among Flynt's purchases was a maple chest of drawers that brought such a high price for that time and place ($575) that the auctioneer included the story in his reminiscences. Because Miss Hawks had been an antiques dealer and her stock was included in the auction, the antiques sold were by no means all Hawks or Sheldon family pieces (the maple chest wasn't), but the old family names added luster to all the items offered. Peter Spang speculates that at the time of the Hawks auction the Flynts "hadn't become quite the connoisseurs that they became later, and many of the pieces they bought they later looked upon as mistakes."[62]

Within a few years, another venerable Deerfield lady died and left an estate rich in Deerfield heirlooms. Miss Louisa Billings had retired from teaching in 1924 and moved to her family's home in Deerfield. "She resented the school [Deerfield Academy] and the historic group

Maple chest of drawers from the Hawks sale.

[PVMA, in which the Flynts were very active] taking over the town. She wanted the town to still be its people," said Stephen G. Maniatty, a local artist and longtime Deerfield resident. He continued:

> Whenever any of the natives sold to Mr. Flynt, [Miss Billings] said they were selling their birthrights. She called Deerfield by a wonderful descriptive term—she would call it "richocratic" Old Deerfield. The people that lived in Old Deerfield had a kind of aloofness...they did feel that they were better than everyone else in the valley.... They had been the ones who had settled it. They had fought the Indians. They had dug the soil. They had built the community.[63]

Miss Billings's family furnishings descended to her from the Billings and Williams families of Hatfield and Deerfield, and Peter Spang characterizes her house at the time of her death as "one of the two or three greatest treasure houses of fine furnishings in Deerfield if not in the Connecticut Valley." Miss Billings had told her neice, Ruth French, who lived with her, that when she died absolutely none of her inherited furnishings were to go to Flynt. She associated him with the Academy and the PVMA, of which she disapproved, and she wanted Deerfield heirlooms to remain in the old families. Miss French was in such a state about fulfilling her aunt's wishes that before the will was probated she sold many of Miss Billings's best pieces to Harry Arons, the renowned

picker from Ansonia, Connecticut, who appeared on the scene very shortly after Miss Billings's death.

Steve Maniatty lived across the street from the Billings house, and when he saw Arons piling antiques onto his truck, he called Headmaster Frank Boyden. Boyden immediately got in touch with Henry Flynt in Greenwich, and Flynt got into his car and started for Deerfield, meeting Arons on the road. He continued on to Deerfield and went straight to Miss French, whom he found in tears. She'd been hoodwinked, she said, and Arons now had all her aunt's best pieces. Flynt decided that despite the fact that selling a deceased's effects before her will was probated was highly illegal, the situation would become unduly complicated if legal action were taken. So he set off for Ansonia to rescue the furniture. "I remember [Flynt's] saying that he got the furniture back from [Arons] and brought it back to Deerfield and had to pay double its value," recalled Maniatty. Among the fine local furniture Mr. Flynt retrieved from Arons were the very rare "sunflower" chest now in the Ashley study, an unusual casepiece which Philip Zea now attributes to Hatfield cabinetmaker Cotton White, and a tall-case clock made in Northampton. There was an auction later on to sell the rest of Miss Billings's effects.

As he and Helen worked on each of the houses, Henry made a sincere effort to track down furniture that had

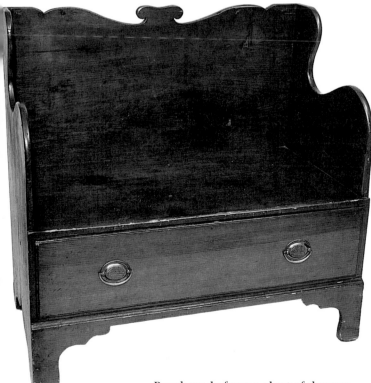

Bench made from a chest of drawers.

been in the family or families who had built or owned that house during the period to which it was being restored. He wrote in 1946, for example, "We have been able to locate and have purchased and placed in the Allen House quite a number of pieces of furniture that have been there at various times." Amelia Fuller Miller later described the approach the Flynts employed in furnishing the Ashley House, their first Deerfield museum house:

> Concentrating always on the Parson's entire life rather than on any specific year, furnishings in the house fall into several categories of ever broadening degrees of association with the Reverend Jonathan Ashley. Beginning with the very personal, there are some pieces which actually belonged to the Parson and some which were once owned by his close relatives. Slightly removed, other pieces have come from neighboring Deerfield homes. Still another group is allied geographically, having a history which relates to Connecticut Valley families similar in background and social position to Jonathan Ashley. Finally, some furniture was collected because of stylistic similarity to known family pieces.[64]

The Flynts continued to implement this approach in all the houses they subsequently furnished, and their focus on Deerfield history and connections enables Historic Deerfield's staff to interpret the past in terms of the actual people, events, and objects of the region. In 1950, Henry pursued leads to furniture made by cabinetmaker Daniel Clay of nearby Greenfield, writing to several people he'd been told owned Clay pieces. (It seems likely that he was aided in this project by Miss Julia D. Sophronia Snow, a Greenfield antiques dealer with whom he and Helen were friendly. Miss Snow had made a specialty of local antiques and had written about Daniel Clay for *The Magazine Antiques* in the 1930s.) In at least one case, Henry's campaign to track down Clay furniture paid off, and he was able to secure a clock with a case by Clay by agreeing to trade the owner one like it by another maker. In 1956, he wrote a Sheldon descendant, "Thank you ever so much for your help and understanding in connection with our desire to have as many of the Sheldon things as possible back in the [Sheldon-Hawks] house for our opening on Sunday." On this occasion Flynt bought a Sheldon family corner chair, vaseback chair, banister-back chair, and clock, and borrowed a "little Pembroke table which means so much to us, as I feel quite sure it may well be the one which was in an old account book which Betty Boyden ran down in connection with the inventories."[65]

When he knew of something he'd like to use in a restored house that belonged to one of Deerfield's redoubtable women such as Miss Billings, who objected to selling family heirlooms to someone she considered an outsider, Flynt was not above subterfuge. He "had to go and find somebody who would represent him.... Mary [Danielski], his assistant, and especially Terry Vanderplas

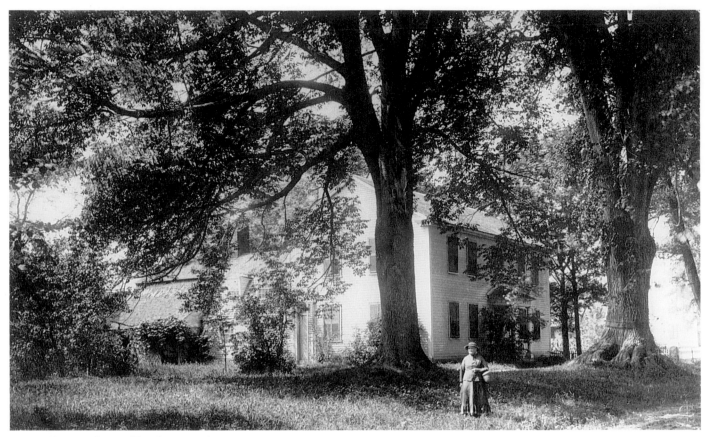
Miss Billings in front of her house, 1906.

[one of the silversmiths], were unknowns and would go to some of these places and would buy things."[66]

🙜 🙜 🙜

The Flynts' active involvement in historic preservation and in the early arts and crafts of Deerfield led naturally to their association with the PVMA. Mrs. Flynt was appointed to the board first, and then in 1948 Flynt was elected to the office of president, which he held until he died. He felt that his selection was "at the suggestion of Miss Whiting, one of the great ladies, who, with Miss Baker, Mrs. Fuller and a couple of others, had done so much at the turn of the century to sustain a cultural influence in the Village." Amelia Miller said that the low point of the Association came in 1948, just before Henry Flynt took office.[67]

With his zeal for new projects and his commitment to Old Deerfield, Flynt brought vitality to the PVMA. Its Memorial Hall Museum, in dire need of cleaning, repair, and rearrangement, was refurbished in 1949 and 1950. In a letter requesting financial support for these operations, Flynt said,

Memorial Hall has never had heat. This makes the treasures inaccessible to students or visitors for most of the year and has had a bad effect on many of the items located there. One of the first things in spreading the gospel of courage and the spirit of enterprise and of use in overcoming the rampant Communistic or Socialistic ideas is to hold forth this shield or banner of Deerfield courage throughout the year.[68]

Private donors failed to respond to Flynt's stirring appeal, so he arranged for the PVMA (of which he was president) to sell a house and lot adjacent to Deerfield Academy to that institution (of whose board he was president) for about what it would cost to make basic repairs. When Memorial Hall reopened, it had been thoroughly cleaned and painted, the contents rearranged, the foundations repaired, and it had received a new slate roof. It also offered many new activities and exhibits.

In a sense, the PVMA was just what Henry Flynt needed—a platform for programs and events related to Deerfield architecture and antiques, subjects in which he had become vitally interested. One of the first and most spectacular events was an eleven-day exhibition of colonial silver held in the fall of 1950. It drew visitors from "all the surrounding towns as well as many other states, including Wisconsin, Minnesota, Oregon and California."[69] In connection with the exhibition, which included communion pieces lent by the First Church of Deerfield

as well as objects from leading museums, dealers, and private lenders such as the Flynts, there were lectures by Kathryn Buhler of Boston's Museum of Fine Arts and John Marshall Phillips of the Yale University Art Gallery.

Other exhibitions dealt with subjects such as needlework and firearms, and Flynt continued the practice of importing experts to speak. This was a new—and to some oldtimers an unwelcome—departure, for it had been traditional at PVMA meetings for members to read papers on subjects of immediate local interest. Flynt also revived the custom, suspended during the war years, of holding an annual dinner on the anniversary of the 1704 French and Indian attack, which provided the occasion for "many interesting and varied programs. Members were active in giving talks, musical evenings and staged performances complete with costume." In 1952, says Mrs. Miller, Miss Mary (Mollie) Wells became curator, and Memorial Hall "began to show signs of loving care such as it had not known in a long time. Spiced tea and cookies in the music room and flowers everywhere will keep us ever mindful of Mollie Wells."[70]

One of the PVMA's most illustrious early members was Miss C. Alice Baker, George Sheldon's cousin and an early preservationist. She left her Deerfield home, Frary House, to the PVMA with the stipulation that her companion, Emma Lewis Coleman, and after her some cousins from Maine, were to have life tenancy. Thereafter, the PVMA was to have the house and to maintain it in "the true spirit of the colonial times," as Miss Baker put it in her will. Since Miss Baker had died in 1909, Frary House was in need of drastic repairs by 1950, and the Flynts offered to undertake the cost "provided many of the ambiguities of [Miss Baker's] Will were clarified." They were particularly bothered by the phrase "true spirit of the colonial times," which, Flynt wrote, "certainly didn't mean Victorian furniture should be retained, or a round plaster model of a Della Robbia plaque should remain over the mantel of the beautiful ballroom."[71] He and Helen felt, too, that the south rooms under the ballroom (in what is now called Barnard Tavern) should not be the caretaker's apartment, but should be restored to their original use as tavern rooms.

Approaching these problems energetically, as always, Henry Flynt asked Amelia Miller to do research on the house and procured an affidavit from distinguished curator Joseph Downs reinforcing Flynt's view that Miss Baker's late nineteenth-century touches were inconsistent with a colonial atmosphere. The affidavit was presented to the probate judge of Franklin County and Flynt reported that as a result the PVMA obtained a decree "which gave us broad powers to make changes." Flynt wrote that they then made extensive repairs and modifications, "checking every move with the three trustees [of Frary House], Mrs. Frank Boyden, Mrs. Carlos Allen, Ernest Coffin, and [with] the Curator, Miss Harriet Childs." Changes included replacing those of Miss Baker's furnishings they considered inimical to the true spirit of colonial times, tearing out the diamond-paned windows Miss Baker had installed in the kitchen and bedroom above, painting and wallpapering in colors they considered suitably colonial, and installing modern plumbing, heating, and electricity.

From the Flynts' point of view, all their structural alterations and decorative modifications were perfectly justified, for the period rooms, books, and magazines of the era indicated that their approach was authentic. From today's point of view the difficulty with such wholesale changes is that in making them the Flynts simply substituted their personal vision of colonial times for Miss Baker's, and theirs was no more accurate than hers, as is discussed in the chapter on Frary House. In looking back on attitudes toward the period room in the 1940s, 1950s, and 1960s, Alice Winchester says, "I would love to know how it is fifty years from now. I do approach the subject with a certain amount of skepticism because we all thought we knew it all [in those days]."[72]

When Frary House was shipshape, according to Henry Flynt, they held a special opening with music in the ballroom. Many guests came in costume, as they had to Miss Baker's famous fancy-dress ball of fifty-eight years earlier. Just as Miss Baker's ball had ushered in a new epoch in the history of Frary House, so did this mid-century costume party.

<p style="text-align:center">ᔥ ᔥ ᔥ</p>

By the late 1940s, Henry Flynt, an "outsider," was wearing three different hats in Deerfield. He had become president of the Deerfield Academy board of trustees in 1943, he was now president of the PVMA board, and he was clearly masterminding the program to preserve Deerfield's old houses. So it isn't surprising to find that occasionally there were indications of discontent on the parts of both the "Academy crowd" and townspeople who felt that Deerfield should be run by members of the old families.

The Flynts' program to buy and preserve the old houses on Deerfield's main street aroused a certain amount of resentment among some townspeople. When the Flynts restored the Academy's Delano House to a colonial appearance (rather than to its previous Greek Revival look, which everyone was used to), some residents objected. Among those who took exception to the Flynts' buying and altering houses was the formidable Miss Billings. According to her neighbor Stephen Maniatty:

> She was a typical New England Yankee who lived by the philosophy of not being beholden to anybody. That's why she never wanted her house to fall into the hands of Deerfield Academy or Mr. Flynt's Historic Society [PVMA].... She didn't approve of these outside institutions coming into the

Miss Baker's bedroom in Frary House.

Tea at Memorial Hall; Helen Flynt's back is
to the camera, c. 1960.

The Flynts and the Boydens host an opening reception at the newly restored Frary House, 1950.

town.... She wasn't particularly happy about the town becoming a museum.... She wanted the town to still be its people—to keep its natives.[73]

Another recalcitrant lady was "Hen" (Gertrude L. Cochrane) Smith, so-called because of her ill-fated attempt to raise chickens in her backyard. Mrs. Smith had been a good friend of Miss Whiting and upon the latter's death had become custodian of the Blue and White Society's records and inventory. Helen Flynt characterized her as "contrary" as a result of her tendency to change her mind about participating in PVMA meetings. On one occasion Mrs. Smith had told the Flynts she couldn't attend a PVMA meeting because of heart trouble. Helen, concerned to hear of Mrs. Smith's condition, said to Henry, "Don't tease her to come," upon which Hen immediately reversed herself and declared that she would be at the meeting. Hen Smith, too, was determined that her house would not go to the Flynts and left it to the Bement School (a school for young children that occupies several houses on Deerfield's street). Eventually, after some complicated dealings, the Flynts did get the house, which is now occupied by Historic Deerfield's director and his family.

Stephen Maniatty speculated that with the Deerfield independent schools' need for classroom and dormitory space, "Everybody [was] competing to try to get land to build their schools bigger and bigger.... I think the resentment among some of the old timers was the fact that they were taking over the properties and the town was losing its identity."[74]

In the late 1940s, when the Flynts were buying up houses along Deerfield's main street, Maniatty suggested to his bedridden neighbor, Ruth French, that they start a story and see what would happen. The story was that Henry Flynt had bought one of the last remaining active farms along the street. "It didn't take a week for [the farm's owner] to come up and say that he heard Mr. Flynt had bought his farm.... Any little gem of that kind could go the rounds quick, when Flynt was buying up property in the community."[75] Because they were aware of resentment that they were buying up houses and therefore depriving Deerfielders of living space, and because they were trying to increase student and faculty living space for the Academy, the Flynts always included an apartment to the back of houses they restored as museums.

Problems also occasionally arose in the Flynt-Boyden relationship. From the beginning of his participation on the Academy board, it had disturbed Henry that Frank Boyden brooked no interference—from trustees or anyone else—in the way he ran "his" school. "Everything and everybody was completely dependent on Mr. Boyden," wrote Flynt. "He had a superb sense of public relations and a complete lack of business sense." Flynt suggested a business manager, drew up charts indicating

income and expenditures, and in general worried about the "disregard of many good business practices" at the Academy. Boyden simply refused to listen.[76]

"Finally," wrote Flynt, "came a day when the auditors' report showed a deficit. Helen Boyden stopped me on the Albany Road just before a meeting and asked whether I thought the Board would dismiss Frank. She and he really thought we would. Of course, we didn't." Even that scare didn't move Boyden to agree to a business manager for his school.[77]

Aside from his position on stricter financial accountability, Flynt sometimes disageed with Boyden on other Academy matters. On the question of where the new infirmary should be placed, Flynt wrote Boyden: "I appreciate I may have been too much of an impatient soul and striven to get forward in such a way that my motives or interfering have been misjudged. I'll endeavor to slow myself down and be less of a nuisance in the future." Flynt went on to say that if the Boydens would tell him and Helen "when to stop, look and listen," they would comply.[78]

As they became more and more interested in the museum aspect of the houses—their proper preservation and their furnishing with genuine antiques—the Flynts were also beginning to diverge from the Boydens in their thinking on that issue. The Boydens' focus was always unwaveringly on the Academy, and their main goal in preserving old houses was to maintain them externally to retain the "old-time atmosphere" Frank had mentioned to William Sumner Appleton in 1924, as well as to provide more living space for students and faculty. Even so, the two couples were still basically in sympathy with one another. Frank Boyden wrote in August of 1950,

I thought your last visit one of the finest we have ever had because as I watched you showing your guests around I realized more than ever before how much has been accomplished and how well the whole program is beginning to tie together. When such a big undertaking is involved there are bound to be many misunderstandings and many frustrations, but as we look at the picture as a whole a great historical venture has exceeded far beyond what most people had thought would be possible. I just hope we can both go forward to complete both the P.V.M.A. and Academy project.[79]

Divisive issues continued to pop up now and then, however, and by June of 1952 there had been enough disagreements over various matters that Henry Flynt wrote Frank and Helen Boyden:

We (as you both know) have been heart sick over the last months because of the various indications which prompted us to feel that possibly we were not wanted in Deerfield anymore.

Although technically I am Chairman of the Board of Trustees of the Academy and on the Building Committee I can

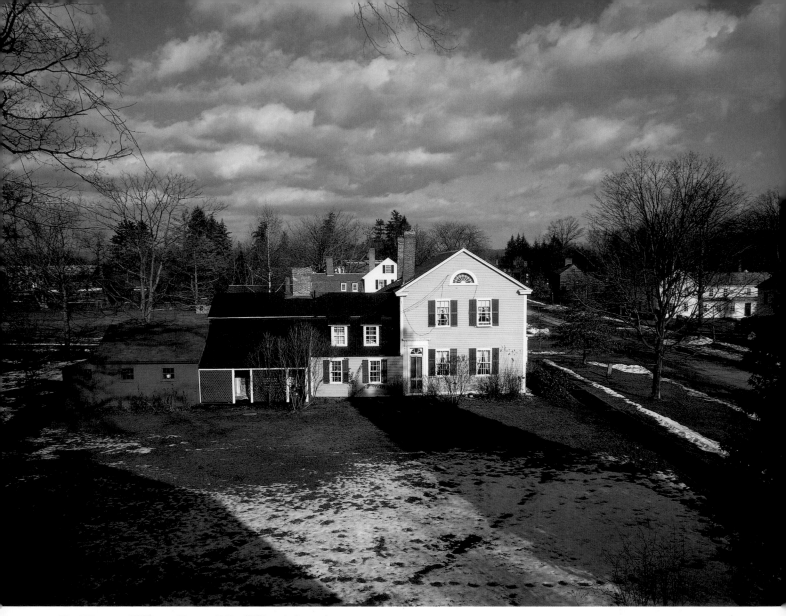

Dr. Thomas Williams House (Miss Billings's home).

not function effectively if we are not wanted or our advice is not welcome or the impression is abroad that we are more interested in the historical side of the Town than the Academy, its welfare and its future.[80]

Flynt then reviews all the houses he and Helen have bought either to preserve Deerfield's old street or to provide more Academy housing, or both. He recalls their discussions about finding a sponsor such as John D. Rockefeller, Jr., to preserve the town, their consultations with Bela Norton of Colonial Williamsburg, and asserts that he and Helen "gave of our heart and soul and substance and dedicated our lives to make those dreams come true, to plan the preservation of the Town and the fulfillment of your ideals for the Academy, working, as we believed hand in hand with you."

Returning to his review, Flynt mentions Helen's gift of the squash courts with another couple whom Flynt interested, their joint gift of the school store and equipment, and Helen's contribution to the tennis-court fund. He reminds the Boydens that besides all this, he and Helen have given substantial cash gifts over the years. Flynt admits that he has not given cash in the last few years, and says that there are several reasons, "among them perhaps because of the feeling that has been sort of growing up in our minds, right or wrong though it may be, that perhaps we had done enough and that some felt our part should be a less important one. This feeling too in no small degree colored our thinking re the establishment of a foundation to hold title to our various properties...."[81]

The Flynts then went forward with their idea of creating a foundation, which was chartered in November

of 1952. Before taking this step they had consulted their children, whose inheritances would be decreased by the foundation, and the children encouraged them to go ahead. The purposes of the Heritage Foundation (now Historic Deerfield, Inc.) were to educate the public in the American—particularly the New England—colonial heritage; to acquire and preserve houses and other buildings and all sorts of material culture relating to the early colonies; to support and promote the principles and standards of the colonists; and to receive money and other gifts to be used in this work. Although Frank Boyden was one of the trustees, to some extent at least the Heritage Foundation must have seemed like competition to him and his wife. The president of their own board of trustees, instead of focusing all his energy on the school, was establishing another institution. Although the Academy and the Foundation could work together, their basic aims were necessarily different.

For his part, Henry Flynt was undoubtedly glad to have his own organization, which he could run according to his own ideas of good business practice. His letters to his family indicate that he continued to be worried by Frank Boyden's administrative foibles during all the years he was on the Academy board. Finally, an issue arose that aggravated already existing divisions between the Flynts and the Boydens.

This was the question of a liquor license for the Deerfield Inn. This caused a period of great difficulty between the Flynts and the Boydens because Frank Boyden didn't want to have a bar. He was a teetotaler and was no doubt concerned about what impact selling alcohol would have on the boys at the Academy. On the other hand, the Flynts felt that serving cocktails would offer guests more flexibility in entertaining and dining and would improve the Inn's profits. When Baxter Webb arrived in 1964 to take on the position of innkeeper, he felt strongly that the Inn should have a liquor license. He managed to secure one for the winter months at that time, and the Inn has since been issued a year-round license. While the liquor license was a very real point of disagreement, the matter produced such strong feelings on both sides because of the backlog of differences that had built up between the Flynts and the Boydens.

It couldn't have helped that Frank Boyden was by this time well into his eighties, and whereas most people thought it was time for him to retire, he didn't share their opinion. As head of the board of trustees, Flynt had to orchestrate Boyden's retirement and the selection of his successor. Flynt told about it:

> Discussions were rife for several years about the wisdom of securing the resignation and retirement of Frank Boyden as Headmaster. The reasons usually advanced were his age, his health, his lack of ability to really control the boys, lax habits

that had developed, our uneasiness about finances, and his complete unwillingness to accept advice and his failure to cooperate on fund raising with constant objection on his part to methods of others engaged in that vital work.[82]

From Boyden's point of view the school was so much a part of him, and he of it, that retiring must have seemed like cutting out a part of himself. His achievement in building Deerfield Academy from a practically defunct country school to an internationally recognized institution was monumental. To retire was to cease to be who he was.

The discussion went on and on, with Boyden always agreeing that he'd retire after this project or that building was finished. Finally, the board secured his promise to *think* about retiring and they worked from there to Boyden's reluctant resignation in 1968. This period again put a serious strain on Flynt-Boyden relations.

At the same time that he was coping with Academy and other problems, Henry Flynt was continuing to move forward with his various Deerfield projects. His energy for the work was holding up splendidly. "There are many amazingly interesting facets to the Heritage Foundation program," he wrote. "Education of 'Fellows,' staff training, collecting, inventory control, cataloguing, publication, building a library, preservation of houses, trees, grounds and collections, acquiring properties, entertaining many friends and distinguished guests, raising endowments, etc. There is never a dull moment."[83]

Among the undertakings he and Helen engaged in during the three decades they were involved in Deerfield were some designed to preserve the "look" of the main street. In the late 1940s they built the town firehouse on property between the Stebbins House and the Hall Tavern. They enlarged and remodeled the post office

The Flynts greet the Boydens in Frank's golf cart, 1967.

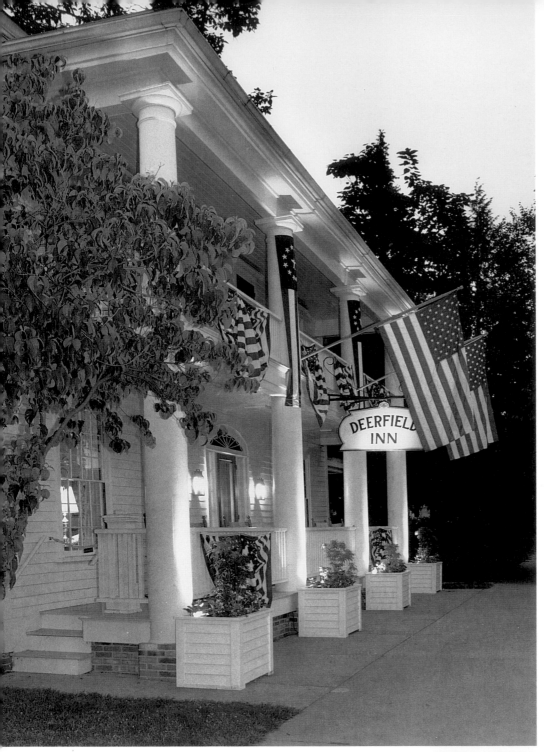

Deerfield Inn on the Fourth of July.

Helen Flynt and Helen Boyden at an Allen House party, 1968.

across the street from the firehouse in 1953 to resemble Deerfield's third meetinghouse, erected in 1696. The design was taken from a drawing made of the building in 1728 by visiting Harvard College student Dudley Woodbridge. In 1957, they also bought the White Church, the former Orthodox Congregational Church (the Congregational and Unitarian churches having merged), which is across the street from the Wells-Thorn House. They remodeled it extensively and opened it as the town's community center in 1958. The Flynts worked for a period of several years to have the utility wires along Deerfield's old street put underground, and were finally successful in 1967. In 1968, they moved the one-room schoolhouse (given by Paul Hawks) from the nearby settlement of Wapping to a site just behind the Wright House. Their goal was to preserve this vanishing architectural form for future generations, and to provide space "for use by various [community] groups for a variety of purposes." They invited "only teachers and pupils who had taught or studied in the school" to the inaugural party, held in the fall of 1968.[84]

As head of the Academy's buildings and grounds committee, Henry Flynt was also able to influence the appearance of five large dormitories built in the 1950s. Three were placed directly across the street from the Academy's main building facing the town common, and two were built on the Albany Road, which bisects the Academy campus. Originally designed to coordinate with the formal institutional brick style of architect Charles Platt's main building, the dormitory façades were altered by Bill Gass under Flynt's direction to harmonize with the less pretentious wooden architecture so much more characteristic of Deerfield. According to Peter Spang, some architects have been annoyed because the buildings "are based on houses in town—they're close copies but such buildings never would have existed in the eighteenth century." They do help to retain the colonial character of the old street, though, says Spang. Ironically, more visitors to Deerfield now take pictures of these Colonial Revival buildings than they do of the actual colonial houses on the main street.[85]

Because of the Flynts' community-mindedness and despite their occasional differences with the Boydens and townspeople, there were still many points of intersection. Residents emphasized this positive aspect of the relationship in October of 1967, when they gave Helen and Henry Flynt a party in recognition of their twenty-five years of achievement in Deerfield. Working with Peter Spang, whom they enlisted because of his close ties to both the Flynts and many townspeople, they organized a gala celebration. Over two hundred people gathered for a ceremony that included the presentation to the Flynts of a painting of their Deerfield home, Allen House, and of a crewelwork "map" that a group of artistic Deerfielders

had worked to illustrate the twenty-six buildings the Flynts had repaired or restored along the street. The gesture moved the couple to tears.

꿔 꿔 꿔

Since they were filling several rooms of each restored house with antiques, the Flynts soon found that local Deerfield sources alone were not adequate to supply their needs. They had to branch out, and one of the first people they approached was Henry Flynt's fraternity brother John Kenneth Byard. Byard (1885–1959), graduated from Williams College in 1908, eight years before Henry Flynt. He also preceded Flynt to Columbia University Law School, and practiced law in New York City from 1911. For his fiftieth reunion at Williams, held in 1958, Byard wrote:

> My career has been primarily the Law, with a liberal admixture of Banking and Real Estate, pursued without particular enthusiasm or distinction. From the beginning my avocation has been American Antiques of the 17th and 18th Centuries and American Folk Art. For several years past dealing in antiques has been and still is my full time vocation and a very pleasant one.

According to Electra and Watson Webb, Edith and Ellerton Jette, and Helen and Henry Flynt, customers and friends of Byard who wrote a "Note of Appreciation" for the catalogue to the auction held after his death in 1959, Byard's "love of old things started as a small boy in upper New York State, when he received the then munificent sum of twenty-five cents a day to drive his father's horse and buggy around the countryside, while an elderly lady collector purchased items from even older inhabitants of that area."[86]

Byard moved from New York City to Silvermine, Connecticut, in 1920, and began collecting antiques to furnish his pre-Revolutionary farmhouse. When he retired from the practice of law in 1942, he established an antiques business at Silvermine, dealing in American and English furniture and accessories. He was also the proprietor of the Silvermine Tavern, a country inn he furnished with early American pieces. Since the Flynts' home in Greenwich was within easy reach of Silvermine (which is part of Norwalk, Connecticut), and since Byard and Flynt had many things in common as Williams alumni, fraternity brothers, and New York lawyers, it was natural that they should form a close relationship.

In December of 1946, Flynt wrote that "Byard has been a friend of mine of long standing and is really an authority on antiques and has helped me in the acquisition of many things which are now in the Allen House and other places." Flynt's correspondence indicates that he was in touch with Byard frequently, that he visited him at Silvermine often, and that he bought many antiques from

Deerfield Post Office.

The White Church.

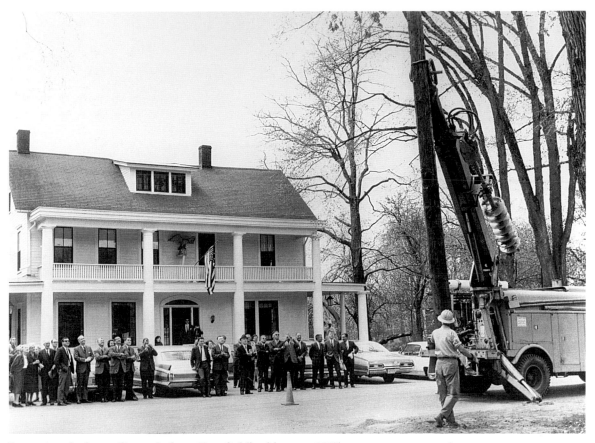

Removing the last utility pole from Deerfield's old street, 1967.

him. It was not unusual for Byard to send Flynt a list of ten or more objects, ranging from major pieces of furniture to delftwares, paintings, and brass candlesticks. "Mike" Byard, as the Flynts called him, knew the Deerfield houses and would sometimes mention in a letter that a particular piece he was offering would fit into a specific room or house. In 1957 Byard wrote, "We go to Deerfield…to do a little work with [Henry Flynt] in connection with the houses—this is always fun for we quarrel about things with great good humor and I cannot say that I always win out." Byard also went to Deerfield to give slide talks "to the staff and curators" in the 1950s.[87]

That Byard and his wife, Dorothy ("D"), influenced the Flynts considerably in the early years of their collecting seems indisputable. And that the Flynts were grateful for their help and advice seems also undeniable. Henry Flynt's letter of January, 1953, expresses "appreciation for all the help you have given us in connection with our Deerfield project":

You and Dee have been tireless in your efforts to help us. Your more extensive background and knowledge was shared with us when we were real novices and your repeated trips, visits and telephone conversations have been not only a source of pleasure but have taught us worlds. Your advice, although not

always followed to be sure, has been sincere and our differences have only been as to personal tastes or our financial restrictions.[88]

In the 1950s, when the Flynts were involved in the furnishing and upkeep of Frary House on behalf of the PVMA, the Byards offered to "fix up" two of the plainly furnished tavern rooms. Henry Flynt announced the gift of furnishings for one of the rooms in a special edition of *The PVMA Newsletter:*

One of the most unusually fine gifts your Association has received in a long time came this summer from two knowledgeable members, Mr. and Mrs. John K. Byard, of Silvermine, Connecticut. Mr. and Mrs. Byard, realizing that some of the rooms in the Frary House have architectural charm but lack both the tasteful touch and the ring of the spirit of the Colonial Days which Miss Baker (who gave the house to us) spoke of in her will, decided to furnish the room on the south side between the old tap room and the dining room. This decision was fulfilled with splendid results for which we are truly grateful.[89]

Flynt's description of what the Byards had given turned out to be very apt—in referring to "the tasteful touch and

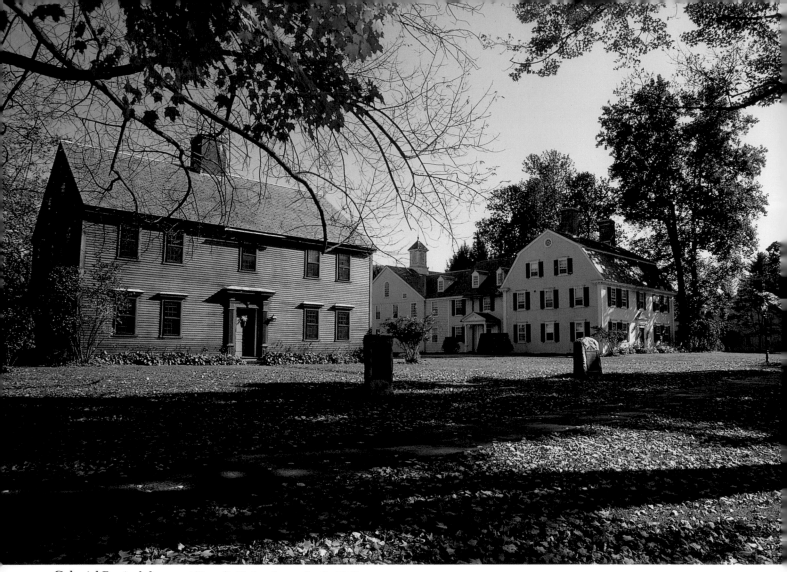

Colonial Revival dorms at Deerfield Academy, built 1950s.

the ring of the spirit of the Colonial Days," it focused on atmosphere rather than accuracy. The room was indeed brightened by the Byards' contributions, but most of the contents were later discovered to be either of inferior quality or downright fakes, or to be from regions outside New England. Nearly all the Byards' gifts were eventually removed from the rooms and deaccessioned.

Although many of the pieces the Flynts bought from Byard have proved to be perfectly all right—there were, in fact, wonderful pieces as well as complete fakes, according to Philip Zea—Helen Flynt was distressed to be told after her husband's death that some of the Byard pieces were in doubt. "He tried always to buy everything in good condition," she said. "He was a good friend. If anyone tells you the things he sold were not right, I won't believe it, and I hope you won't believe it, [either]."[90]

Lest Byard be made to bear the brunt of the blame for placing fake or otherwise questionable material at Deerfield, it seems only fair to say that such objects came

into the collection from a number of other sources, as well. Philip Zea feels that the current generation of furniture experts looks at objects both more critically and with more technological aids than past experts. It is extremely difficult to judge at this distance when dealers sold fake or worked-on pieces with intent to deceive and when they themselves had been duped. Although there is no question that American furniture has been consciously faked for more than one hundred years, it is also true that what we consider overrestoration today was often judged less harshly by earlier generations.

The Flynts remained good friends with the Byards until Mike Byard's death. Upon her husband's death, Dorothy Byard gave his working antiques library of 172 volumes to the Flynts in his memory for curatorial use at Deerfield.

Another antiques dealer the Flynts patronized at least as early as 1947 was Ginsburg & Levy, purveyors of English and American furnishings on Madison Avenue in New York. Mrs. Flynt's father and stepmother had bought

Deerfielders celebrate the anniversary of the Flynts'
twenty-fifth year in town, 1967.

John Kenneth Byard.

Tavern room at Frary House furnished by the Byards, 1950s.

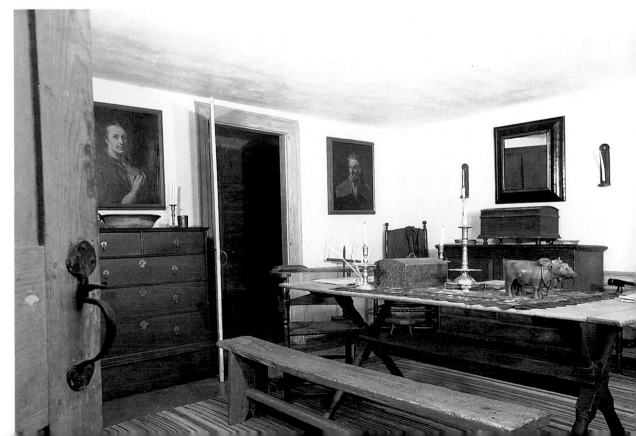

English antiques from the firm for their house in Cincinnati, so it must have seemed natural to the Flynts to turn to them for Deerfield furnishings. Bernard Levy (son of one of the founders) recalls that when he first met the Flynts, "they were having fun furnishing a group of houses without any great concern for authenticity. They wanted to buy items that pleased them—not that were right for a museum. That came later, with their friendships with men like Joseph Downs and Vincent Andrus."[91]

The first time the Flynts went shopping at Ginsburg & Levy, they looked at a number of pieces and Henry tried to put together a package deal. "How much would it be if I took these two and that one? Or those two and this one?" And so on, until Bernard Levy said, "Let's forget about everything except these two pieces you're really interested in"—a fine Connecticut high chest and an important Chippendale desk and bookcase made for the Reverend John Marsh of Wethersfield, Connecticut, and later owned by Richard Henry Dana, author of *Two Years Before the Mast* (see fig. 17). After a good deal of discussion, they arrived at a price of so many thousands plus fifty dollars. "I'll just leave off the $50 and write the check for a round number," said Flynt, as he opened his checkbook. Levy said, "No," and even though Flynt persisted, he remained adamant. Finally Helen Flynt said, "Henry, if you don't pay that $50, I will!" That settled the matter, and Flynt wrote out the check in the full amount.[92]

When business matters were concluded, Bernard Levy took a handsome courting mirror worth about $850 in those days and offered it to Helen. "Mrs. Flynt, you admired this," he said, "and I would like you to accept it as a gift." Henry was dumbfounded: "You wouldn't take $50 off my bill, but you'll *give* my wife an expensive mirror?" "Yes," said Levy. "The point is that these are *my* things, and I can price them as I like."

Bernard Levy recalls, as do many others who knew Henry Flynt, that Flynt regularly had a hard time bringing himself to pay the asking price. "Maybe he enjoyed negotiating as much as [he wanted] the item," says Levy.[93] Whatever the reason, Flynt's frugality was not confined to transactions with Ginsburg & Levy. He often replied to a dealer's offer of an antique that it was "too rich for my blood." Several times he told Israel Sack, dealer in American antiques on 57th Street in New York, that his prices were too high, although he did on occasion purchase a piece from Sack.

In February of 1950, in describing a remarkable New England Queen Anne piece, Sack wrote Flynt: "You might think we are asking an unreasonable price [$7,500], but what is the value of something that is so rare and unusual as a Queen Anne spinet that was made in Boston in 1760? And besides being almost two hundred years old, it is so beautiful. It is one of those things which turns up perhaps once in a lifetime." Flynt replies simply that he is not interested in the spinet for many reasons, "especially when it gets into the realm of 57th Street prices." A few years later, in offering Flynt a Plymouth table of about 1650, Sack asserts that "if you appointed me an assistant curator to the Deerfield Village Museum, I certainly would recommend that this table be in one of your old houses." Flynt thanks him for the offer, writing, "Indeed I think your table is a very good one, but I can't quite stand the price that you are asking for it."[94]

As might be expected, Flynt carried his frugality into other areas of his life. He once chastised one of the guides in Ashley House for buying a new bottle of ink so that visitors could sign the guest book. He and Helen also kept old clothes at Allen House that they wore in Deerfield year in and year out. Helen, too, had her thrifty side, and Robert C. Vose, Jr., of Boston's Vose Galleries, remembers that:

Mrs. Flynt was usually my stumbling block. I remember offering them a 50 x 40 Joseph Badger full-length of a young man in a red coat. The original coat went with the portrait, and the canvas was in its original carved frame. The price was $5,000 but Mrs. Flynt felt that was too much. Hirschl & Adler bought the painting and sold it to Ima Hogg for a reported $10,000, where it is featured at Bayou Bend today.[95]

It is possible that it was easier for Henry Flynt to pass up objects other than silver, which was his great love, and for Helen to pass up things other than textiles, where she specialized. The story of their purchase of ninety-two pieces of American silver from the English dealer Victor Watson in 1954 (related in the chapter on the silver collection) indicates that the Flynts did sometimes extend themselves financially in a very special case. The tale of the turret-top tea table (see fig. 82) conveys the same message.

Helen Flynt wanted such a tea table, a rare form with turretlike projections around the top, of which only six examples are known. One came up for sale at the auction of the estate of the well-known collector Reginald Lewis, and Helen hoped to get it. Unfortunately, she was the underbidder and the table went to Wilmington dealer David Stockwell. Distressed to find that Helen was "frightfully disappointed," Henry determined to get the table for her. For several years he tried to buy it from Stockwell, but never succeeded. "Finally," he said, "we agreed on a price on condition he had it placed in our garage after dark on March 18th, [Helen's] birthday." Stockwell kept his bargain and the family gathered for the birthday party. When Helen went upstairs to get something for one of her grandchildren, Flynt had the table brought into the living room, where it replaced another table. When Helen returned, she was at first caught up in conversation but finally turned, saw the

table, and asked where it had come from. "We all said 'Happy Birthday' and told her the story," said Flynt. "I think she's enjoyed it ever since."[96]

Bernard Levy's story of Henry Flynt's continued reluctance to buy the candlesticks of his collateral ancestor Tutor Henry Flynt of Harvard, made by renowned Boston silversmith John Coney in 1716, gives further proof of Flynt's great resistance to what he considered high prices even in the case of important objects he clearly wanted very much (see fig. 84). Levy discovered the candlesticks, which had come down in a Boston family, and notified Flynt that they were for sale for $7,500. Flynt went up to Boston to look at the sticks, but as he couldn't get their owner to lower her price, he decided against them. Not too long afterward, Levy stopped by to see Connecticut dealer Harry Arons (the man who'd snapped up Miss Billings's family furniture). Arons produced the Tutor Flynt candlesticks and announced that they were for sale for $8,500. Levy excused himself and immediately called Henry Flynt, saying it was too bad the sticks had gone up in price, but that they were still available. Flynt turned them down again and Arons sold the candlesticks to a Connecticut collector.

Shopping for a present for Henry for a very special occasion a few years later, Helen Flynt and her brother Frederick Geier stopped in at Ginsburg & Levy and asked whether the Coney candlesticks might still be for sale. Upon inquiry, Bernard Levy found that the Connecticut collector would sell them, but the price would be $14,000. Helen said, "I don't want Henry to be mad at me, and I'll have to get his O.K. to spend that much." But again Henry said "No." Two or three years later, the Flynts finally bought the Tutor Flynt candlesticks—but naturally the price had escalated yet again. Bernard Levy speculates that when Flynt was stubborn about price, it may have been part of a game he played in buying things.[97] It is also likely that his memories of his parents' financial difficulties throughout his boyhood help to explain his frugality.

ৡ৸ ৡ৸ ৡ৸

At the same time that they were getting to know the dealers, the Flynts began to meet curators and other collectors. Besides Joseph Downs and Vincent Andrus, they had come to know Charles Montgomery, a knowledgeable pewter dealer who later became a distinguished museum man. They knew John Marshall Phillips, curator of the renowned Garvan Collection of American antiques at Yale University. Phillips, a highly regarded silver expert, was a definite influence on the Flynts in the area of American silver. Also among their acquaintances were Kathryn Buhler, silver specialist at Boston's Museum of Fine Arts, and Nina Fletcher Little, an expert on many early New England arts.

The first Antiques Forum at Colonial Williamsburg, held in 1949, was an ideal place to meet others engaged in collecting and preserving American art and architecture. In those early days, the Antiques Forum was more like a private-club meeting than an institutional event, because although the Forum was open to everyone, it was small, and participants shared an interest in the subject. It was the first annual event that brought collectors, curators, dealers, scholars, and others in the field of American

Helen and Henry Flynt in the silver vault, 1967.

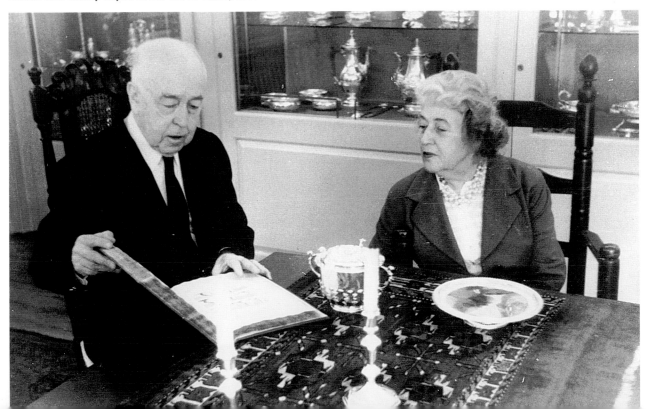

antiques together in an environment where they could exchange ideas and become acquainted. The Flynts met many people with whom they later became good friends, and the lectures and exposure to the Colonial Williamsburg collections must have helped to shape their taste. Bernard Levy feels that the Flynts were definitely influenced by Williamsburg curator John Graham in the areas of textiles and English ceramics.

Among the other collectors who attended the first Forum were Electra Havemeyer Webb, Katharine Prentis Murphy, and Miss Ima Hogg, an imposing triumvirate who began friendships with one another and perhaps with the Flynts on this occasion. Alice Winchester, editor of *The Magazine Antiques* and co-organizer of the Antiques Forum, was in attendance along with Helen Comstock, a much respected scholar who was also on the *Antiques* staff.

Another regular at the Forums from the first was J. A. Lloyd Hyde, an urbane dealer in and student of Chinese Export porcelains, eighteenth-century lighting fixtures, silks, and other elegant and decorative antiques. It was Lloyd Hyde, according to Alice Winchester, who organized a number of active collectors into an informal group. It was Hyde's perception that these collectors "needed one another for further knowledge and stimulus and to share ideas on how to run things." He invited the group to his house in Connecticut, and may have suggested that others follow his lead in arranging gatherings. Among those invited were the Garbisches (early and active folk-art collectors), Electra Webb (who established the Shelburne Museum in Vermont), Maxim Karolik (donor of major collections of American art to Boston's Museum of Fine Arts), the Ralph Carpenters (early collectors of Rhode Island furniture), John Graham of Colonial Williamsburg, Katharine Murphy (who had a dramatically furnished farmhouse in Connecticut), and Ima Hogg (who collected for her home, Bayou Bend, in Houston).[98]

"There were a few years there," says Miss Winchester, "when each of these promoters was being very active in his own project, and they enjoyed getting together at no special time but maybe two or three times a season. People like the Flynts and Electra and Miss Ima were the ones with a preservation project and they would get the whole gang to come for a whole weekend or a couple of nights." The late 1940s and early 1950s were the years when there was "a great stirring of interest in American antiques and old houses...new things began to happen in the field." The National Trust for Historic Preservation was organized and museums began to open one after another—in Sturbridge and Deerfield, Massachusetts; Cooperstown, New York; Wilmington, Delaware; and Shelburne, Vermont. The founders of these museums, says Miss Winchester, "did influence each other in what they bought and how they used their collections. They

had fun *and* felt they were contributing something useful to society."[99]

Because several members of this group had New York apartments as well as country homes, parties and get-togethers could be held either in the city or at various places in the country. Katharine Murphy has remained in many people's memories as one of the circle's most gifted party givers:

The Murphy apartment was often the scene of brilliant parties—usually of from eight to twelve people. Helped by her devoted retainers, Julia and Samuel, Mrs. Murphy set a sumptuous table with early eighteenth-century silver, Dr. Wall Worcester, and old ruby glasses. Delicious crab and lobster hors d'oeuvres were followed by a great thick steak or a roast—carved by the hostess herself—served in a romantic candlelit atmosphere. Samuel circulated, pouring his famous whiskey sours from pewter pitchers....[100]

Parties given *for* Katharine Murphy were brilliant too. Ralph Carpenter recalls that for seventeen years beginning in 1950 he and his wife gave a party every year on Katharine's birthday at their Scarsdale home. On her seventy-fifth birthday everyone went in costume—Katharine's being a dress and hat copied from a portrait of

The Flynts at the Williamsburg Forum, 1960.

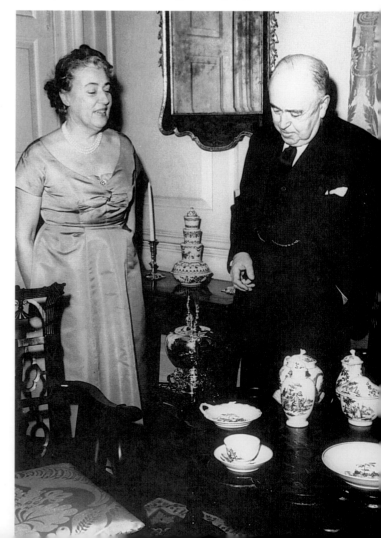

New Hampshire Governor Wentworth's wife. She took the portrait along and hung it on the wall for the duration of the party. The long table, decorated with a sunken garden, was lit by seventy-five candles. At her eightieth birthday celebration, held in the Versailles suite at New York's St. Regis Hotel, Katharine presided over the head table with nine of her favorite men as her companions. A former student at Deerfield Academy remembers seeing Mrs. Murphy arrive in Deerfield to visit the Flynts sitting in the back of "the longest limousine in history" wearing one of the huge black hats that were her signature.[101]

During that same visit, Peter Spang recalls, he and the Flynts escorted Mrs. Murphy to the Wells-Thorn House, which had recently been opened as a museum. The keeping room, as it was called then, was furnished with antiques of Mrs. Murphy's favorite periods—the seventeenth and early eighteenth centuries—and the Flynts asked if it met with her approval. She recommended some changes which were duly made and then turned to her chauffeur/butler, Samuel, for his advice. He made further suggestions which Mrs. Murphy immediately endorsed and by the time they left, the room was completely rearranged. Spang recalls, however, that Mrs. Murphy and Samuel could not have been more than a mile or two out of town before the Flynts enlisted his help in putting everything back exactly as it had been before their visit.

When the Flynts entertained the group of antiques enthusiasts at Deerfield, guests were put up at the Inn and, as Alice Winchester remembers it, "Henry would get out the team [of oxen] and drive us up and down the street and give us a talk about each building and what was going on in the way of preservation and so on. We'd go inside, too—it was all informal and apparently unorganized. Henry Flynt would be, as usual, the life of the party. He and Frank Boyden from the school were a great team and they picked up each other's stories. We had a big dinner in the evening after all this touring—we'd take over the whole dining room of the Inn and have a delicious dinner."[102]

Many of the crowd were invited to Houston in 1956 for that city's first Fine Arts Forum, no doubt at the behest of Miss Ima Hogg, who was perhaps the first person in Texas to collect fine American antiques. Henry Flynt and Ralph Carpenter were lecturers, while Henry Francis du Pont received the Texas Heritage Scroll. A couple of years later, Miss Ima wrote the Flynts:

I have dwelt many hours upon the wonderful group which it was my good fortune to meet during the last few years. I think not only of the members of the "Zipper Club," but also the other "Antiquees" who have so greatly enriched my life. This is one reason why I want the new room at Bayou Bend to be homage to Katharine Murphy. She symbolizes to me what all of you have accomplished.[103]

It was in the early 1950s that the Flynts' newly established friendships in the American collecting world led to Henry's being asked to join the Walpole Society. Formed in 1910 to acquaint American antiques enthusiasts with one another, this select group of men included scholars, museum curators, and collectors. It was—and still is—a peripatetic society, with meetings held in different locations each fall and spring. Members take turns organizing meetings in their vicinities, so that the burden of making arrangements is shared.

Henry was elected in 1951 and hosted the Society at Deerfield on a May weekend of that same year. Members gathered at the Deerfield Inn for cocktails and dinner, repairing to the Hall Tavern afterward for "a short musicale with the spinet and flute" before the business meeting. During the weekend they visited the Ashley and Asa Stebbins Houses, The Manse (which the Flynts had helped to furnish, but which belonged to Deerfield Academy), Frary House, the Wilson Printing Shop, and Memorial Hall. They had cocktails with the Flynts at Allen House and all other meals at the Inn. A local newspaper quoted one man as characterizing the Society: "They're an extremely interesting group. Some are millionaires, of course, but some of us haven't got a cent." Another member, when asked if there were any women in the group, exclaimed "Heavens no!"—and this despite the fact that women were among the major collectors and dealers of the era. Helen Flynt is said to have resented the fact that the Walpole Society hadn't taken her in, too.[104]

In fact, in spite of Henry's consistently going out of his way to praise Helen for her work at Deerfield, she always felt that he got all the credit for their activities there. It is certainly true that it was Henry's zeal and enthusiasm that sustained and broadened the Flynts' activities in Deerfield. It became his major interest in life and this was never as true for Helen, whose love of tennis, squash, and bridge, and whose commitment to spending the summer at their seaside home in Bay Head, New Jersey, necessarily diluted the strength of her commitment to Deerfield. Her sensitivity on the matter is clearly evident in the exchange she had with the editor of the Deerfield Academy newspaper, *The Deerfield Scroll*.

A front-page article in the *Scroll* for October 26, 1963, reported that the Wells-Thorn House was being preserved "through the generosity and tireless efforts of Mr. Henry Flynt, president of the Heritage Foundation." Mrs. Flynt announced in a letter to the *Scroll*'s editor that the article had gotten her dander up, and she continued, "Mrs. Thorn was only willing to sell her house to me, not to Henry Flynt. It is my house. I purchased it and am paying for the restoration which is the most expensive one as yet. The plans and decisions are mine."[105] It seems only fair to point out that Helen Flynt was extremely generous in giving monetary gifts to both Deerfield Academy and the Heritage Foundation. While it may have been Henry's

fervor that sustained the Deerfield project, it was Helen's active emotional and financial support that made much of it possible.

‰ ‰ ‰

As a result of their new circle of friends and acquaintances the Flynts entered a new phase of collecting. By the mid-1950s they were furnishing houses much more elaborately than they had in the 1940s and early 1950s. The parlor of the Dwight House (called the Dwight-Barnard House when it opened in 1954) is an example, with elegant furniture from the Boston area, lavishly valanced draperies by the fashionable Ernest LoNano of New York and Williamsburg, and a handsome flamestitch rug. Woodwork was painted a warm green found when the walls were scraped down to an early paint layer, and seats were upholstered in yellow and green damask (see fig. 63).

It was in this period, too, that the hooked rugs and simple furnishings of Allen House gave way to more elegant Queen Anne and Chippendale pieces, opulent textiles, and oriental carpets. The dining room table received such a magnificent display of pewter vessels and dishes that the thought of eating a meal on it seemed ludicrous (see fig. 5).[106] This was also the decade in which the Sheldon-Hawks House opened. Besides being the repository of Boston and Connecticut Valley furniture, it was a veritable showcase of English eighteenth-century ceramics—many from the Flynts' own collection, but quite a number given by Westport, Connecticut, collector John B. Morris (see fig. 75). When it opened, the Sheldon-Hawks House also contained a sewing room for the display of textiles and early clothing from the Flynts' impressive collection.

It is clear from the foregoing descriptions that the Flynts had indeed caught the collecting disease Henry Flynt believed ran in his family. While they collected systematically for each of the twelve buildings they restored and furnished, they also began to specialize in certain categories. Henry Flynt's affinity for silver is discussed in the chapter on that collection. Both he and Helen were attracted to ceramics, and they formed major collections of English and Chinese Export wares, which are considered in the chapter on Wright House in particular and in chapters on most of the other houses as well. Both were also interested in the early clothing and other fabrics addressed in the chapter on the Helen Geier Flynt Fabric Hall, although Helen Flynt has traditionally been given credit for forming that collection.

Despite the Flynts' unwillingness to pay what they considered to be high prices for certain things, wonderful though they might be, and despite the fact that they bought a certain percentage of fakes and other unworthy objects, as did the other major collectors of their day, overall the Deerfield collections are of the highest quality.

The silver collection, which represents the work of colonial and Federal silversmiths, is internationally recognized as an important one. The textile and clothing collections are similarly broadly based, with many European examples, and the textile display is one of the few in America where visitors can see a variety of eighteenth-century clothing all year round. The ceramics collection is a decidedly interesting and important one, according to ceramics expert John Austin, who surveyed the collection in the 1970s. In the realm of furniture, there are notable collections of both formal and vernacular New England pieces, with special strength in the Connecticut Valley region. Gifts from the Cluett family, descendants of collector George Alfred Cluett, have greatly increased Historic Deerfield's strength in urban furniture of the Chippendale and Federal periods. These high-style pieces serve as a foil to the more provincial Connecticut Valley material.

By 1956, when *The Magazine Antiques* devoted a special issue to the Flynts' restored houses and collections in Deerfield, Henry Flynt was obviously somewhat defensive about the richness of some of the furnishings he and Helen had installed in their rural New England town. He wrote Alice Winchester,

> Some people may say that 18th century Deerfield people never saw, much less had, such beautiful crewel work. This can easily be contradicted by seeing some of the magnificent things in Memorial Hall....
>
> The same can be said about furniture, and, of course, the Chinese Export Porcelain in Memorial Hall is wonderful as far as type and style are concerned, even though most of the pieces are broken. Still it demonstrates the point that Deerfield people had good taste and the means to satisfy it.[107]

Despite their gravitation toward elegant antiques abundantly displayed, the Flynts retained a sense of the importance of local connections. For example, Henry Flynt wrote to ceramics collector John B. Morris:

> We have thought of and talked about you often recently, especially since we have been working on the Sheldon-Hawks House in Deerfield, which has just been opened to the public on the 1st of July. We have put in there many of the wonderful pieces which you have given us from time to time. For instance, you remember the Castleford tea set, which you said you secured sometime ago from Susan Hawks, well that is now in the parlor of her old house.[108]

Another reason for the Flynts' continuing focus on Deerfield history and connections, according to Historic Deerfield's Grace Friary, is that they continued to be very much influenced by such old Deerfielders as Mary Williams Fuller and her daughter Elizabeth. "That's not right for Deerfield," they would say, and the Flynts would listen. If it hadn't been for the Fullers and others like them, Ms. Friary feels, "you wouldn't see the great continuum of

The Flynts, Cynthia Carpenter, and Alice Winchester at the
Carpenters' birthday party for Katharine Murphy, 1950s.

Vincent Andrus and Henry Flynt at the Carpenters' party.

Helen Flynt working with the textile and clothing collection.

Forum goers touring the old street in ox-drawn carts.

Peter Spang and Helen Flynt, Allen House dining room, 1972.

history in Deerfield. People like the Rockefellers [patrons of Colonial Williamsburg], Ima Hogg, and du Pont would have had much more influence."[109]

It may also be that Henry Flynt's fellow Walpole Society members influenced him in giving priority to local traditions and objects. Many members were conservative New Englanders who understood the value of the local history and material culture of New England and knew a great deal about it. Association with such men would have reinforced Flynt's own strong feeling of attachment to the New England, and specifically the Deerfield, past.

<center>ॐ ॐ ॐ</center>

In the 1950s, Henry Flynt also began to implement his ideas about Deerfield as a stimulating and educational environment for American youth. He agreed with Frank and Helen Boyden that the town provided an inspiring background for the Academy, but he was anxious to reach out to young people in other ways. In explaining "the phase of education which this Foundation endeavors to develop," Flynt wrote,

> If the youth of today are impressed with the struggles our country has been through, we feel that they as citizens will be better able to withstand the shallow arguments advanced to tear down our private enterprise system.[110]

As a result of this line of thought, Flynt organized educational conferences to which he invited representatives of a small group of New England colleges. His purpose was to encourage college history and art departments to use Deerfield as "a kind of laboratory for their students." In another effort to engage young people directly with Old Deerfield, its history, and its settlers' courage, Flynt instituted a summer fellowship program for undergraduate men (women have since achieved suffrage in the program). This was inspired by the Deerfield Forum lecture of Francis Henry Taylor, director of the Metropolitan Museum of Art, in about 1955. Taylor got up to give his talk, but in a dramatic last-minute gesture he threw away his prepared speech and announced that he would talk about the importance of educating young people in museum and historical studies. Mrs. John Mayer was in the audience during Taylor's speech and she offered to support a program of the kind he envisioned at Deerfield. Her backing has been an important element of the program ever since.

In 1956, one student spent the summer in Deerfield doing research and working with visitors. Flynt wrote that his hope was that the student would be inspired "to make a career in museum work and/or the field of American study."[111] Funds were sufficient for only one fellow that year, but the next year Mrs. Mayer and another sponsor made it possible for six young men to enter the program.

Deerfield's summer fellowship program offered free board and room, a $300 stipend, and expenses-paid trips to other museums such as Old Sturbridge Village, the Metropolitan Museum, Winterthur, and Colonial Williamsburg. Other trips focused on the architecture of towns like Newport, Boston, and Philadelphia, and on similar historic sites. The program lasted for eight weeks, at the end of which each fellow presented a paper or other individual project. Fellows divided their days between research for the project and guiding in one of the museum houses under the supervision of a trained guide. Today the program "accepts up to ten fellows, is staffed by a Head Tutor and an Assistant Tutor and relies heavily on the collections and staff of the Memorial Libraries, and the expertise of Historic Deerfield's curators."[112]

A third educational enterprise the Flynts undertook in the 1950s was a Forum for "invited guests," held each spring and fall. Henry Flynt maintained that these events were inspired by his 1954 attendance at the Attingham course on English country houses. He used to tell Peter Spang that he had fallen asleep during one of the long Attingham lectures and had a dream that they should have something of this kind in Deerfield. The Williamsburg Forums, too, must have helped to form Flynt's ideas. The first Deerfield Forum lasted a week, and was much too long, Flynt felt; it included day trips to Williamstown, Amherst, and Springfield, Massachusetts. Thereafter, each Forum lasted for only three days—a weekend—and was much more narrowly focused. Riding in ox-drawn carts, the group visited all the houses with Henry Flynt as their guide. Collectors, museum people, and other experts

Peter Spang leads the American Studies Group at the Academy, c. 1964.

were invited to speak, and there were social gatherings in various museum houses. In describing the Forums, Henry Flynt wrote, "These groups are limited to between thirty-five and forty, because of our desire to have a chance to get to know the people and have them see the collections intimately, ask questions and not be in too much of a crowd; also, so they will have a chance to visit and talk with the speakers who go around with the group discussing various items in the collections."[113]

The unhurried, informal nature of the Deerfield Forums set them apart from other such gatherings. The Flynts' very personal attention to details and to their roles as host and hostess made their Forums resemble friendly houseparties. Everyone stayed either at the Inn or at The Manse (borrowed from the Academy for the occasion), coming together for meals, tours, lectures, and other events. Cocktails might be served in the silver vault at lunchtime and at Hall Tavern in the evening, and there were always cocktails at the Flynts' own Allen House on at least one occasion. After the evening lecture, guests might be invited to tour the Asa Stebbins House by candlelight.

The flavor of both the Forums and the smaller house-parties the Flynts gave for their antiquing friends was much the same, and Alice Winchester described it in a talk to Deerfield's 1977 summer fellows:

The Flynts were beautiful hosts and entertained with both elegance and informality, and they gave us a wonderful time. I believe they enjoyed these parties as much as their guests

did, for they loved their friends and they loved Deerfield and they loved to have their friends love Deerfield. Henry was always an expert guide, full of information and of accounts of their collecting experiences. He was a born storyteller and I only wish I could remember some of his tall tales—but the effect was in the telling, and I lack his gift as a raconteur. One evening he and Dr. Boyden had a sort of contest in telling Yankee stories, each one capping the other's. It was a memorable evening.[114]

Along with the Flynt-Boyden repartee, guests could visit with old friends and make new ones and participate in games and quizzes based on people and subjects at the Forum. One year a questionnaire tested guests' powers of observation and memory with questions such as "Who was Jacob Hurd?" and "What kind of rug is in the North Bedroom of Dwight-Barnard House?" Another diversion was the "name game," in which the answers to the riddles were the names of various guests.

♫ ♫ ♫

By the middle of the 1950s, when the Flynts had bought and restored numerous buildings and had six museum houses open to the public, they began to consider seriously the need for curatorial help. In 1956, Henry Flynt wrote that he and his wife "are turning over in our minds that some time soon we must get around to thinking of a director or a curator at Deerfield."[115] Up until this time they had run their project with the help of the innkeeper,

who served as their Deerfield administrator, and two maintenance people. Frank Boyden often helped out by attending to local details and lending Academy personnel, and faculty wives served as (paid) guides. For the most part the Flynts thought out the furnishing and decorating of the houses themselves, although in the 1940s they had had the help of a Miss Ashton in selecting old fabrics and having them made up into curtains and other items. Both of them stressed that Helen's specialty was in the area of decorating: "I'm interested in color, proportions, and making a place look lived in," she said.[116]

But with the number of museum houses and objects growing all the time and with more projects in the planning stages, the Flynts conceded that they needed help. It is impossible to know how they found the perfect person for the job, but find him they did. Joseph Peter Spang, III, a recent Harvard graduate who had spent the previous year studying architecture and decorative arts in England, was interviewed in May and came to work in Deerfield in September of 1959 after attending the first Seminar for Historical Administrators at Colonial Williamsburg that summer. His qualifications included not only an excellent grounding and real interest in subjects crucial to the Flynts' work but also acknowledgment of the Flynts' desire to remain at the center of the project, a willingness to turn his hand to anything that needed to be done, a friendly nature, and an affinity for village life.

"I started at 3:30 in the afternoon on September 29," said Spang. "I remember because [the Flynts] drove in from the south as I drove in from the north and we both pulled up in front of the Inn at the same time. My apartment was in the back of Sheldon-Hawks House and my office was in my head." Henry Flynt had written Spang earlier in the month reviewing his duties as Assistant Curator (the Flynts being the Curators). They included keeping up inventory and photographic records, research into the history and architecture of the houses, considerable responsibility for the semiannual Forums and the summer fellows, and guide training. Spang became a one-man band, carrying out the Flynts' policies and instructions, greeting and entertaining important visitors in their absence, and linking the Foundation and the community. As Flynt himself pointed out, he and his wife were not getting any younger, so Spang's duties also included seeing to their comfort and needs when they were in Deerfield.

Spang's influence on the Heritage Foundation in these years was to make it a resident, rather than an out-of-town, operation. He was there for townspeople to express opinions and ideas to, and he provided consistency and stability. He established a direct connection between the Heritage Foundation and Deerfield Academy by conducting an American Studies group for interested students. He also influenced the Flynts in the direction of more professional standards and policies. He had an impact particularly with respect to accuracy in the Foundation's architectural restorations. His most consistent theme, in fact, was substituting accurate procedures and displays for those based on personal preference.

One of the ways in which Peter Spang is proudest of having influenced Helen and Henry Flynt is with respect to a professional library for the Foundation. When he arrived in Deerfield, the single shelf containing the organization's library was in the visitors' center in Hall Tavern. It contained Wallace Nutting's *Furniture Treasury*, Sheldon's *History of Deerfield*, and four or five other volumes. "Eleven years later," says Spang, "we had a library building of four stories. I've always been as interested in facilities for educating the staff as in museums, and I impressed upon the Flynts the need for a library."

The Flynts restored and opened four more museum buildings in the 1960s, but perhaps their most important work during this decade was their steadfast effort to provide the enormous and costly repairs needed at Memorial Hall and their fundraising for, planning of, and supervision of the construction of the Memorial Libraries. As they concentrated their efforts more and more on fundraising for these two projects, they spent correspondingly less time and money on the collections.

In the winter of 1968 it was discovered that part of Memorial Hall—a wing that had been added to the back in 1810—was in such a state of deterioration as to be hazardous. "Specifically," the *Heritage Foundation Quarterly* reported, "the west exterior walls are buckling, the foundation is sliding into the cellar, while the roof timbers are rotting and splitting and the main supporting timbers for the floors are pulling away from the walls."[117] The wing was emptied and closed. Soon workers began to dismantle it, saving everything possible, including interior elements such as mantelpieces, door and window frames, and cornices. Bricks and other exterior elements were also salvaged so that the wing could be restored as closely as possible to its original appearance.

The plan was to rebuild the north wing of Memorial Hall and to add another wing to contain the combined libraries of the PVMA and the Heritage Foundation. The PVMA library was at that time housed in a fireproof wing of Memorial Hall. The Foundation library had migrated to a converted basement garage—not a location favorable to the preservation of valuable books and manuscripts and certainly not conducive to sustained research. The solitary shelf of books that comprised the Foundation's library in 1959 had now grown to many shelves. John Kenneth Byard's books on the decorative arts had enriched the library after his death in 1959. Then came the

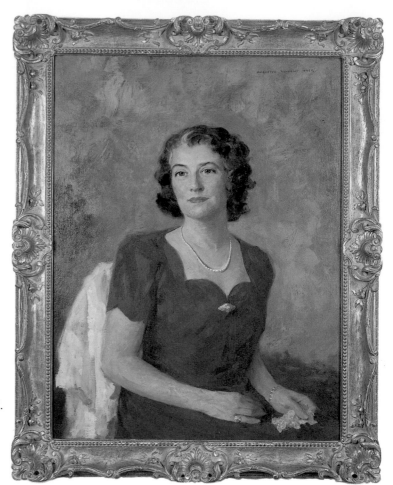

Helen Geier Flynt (1895–1986),
by Augustus Vincent Tack, 1947.

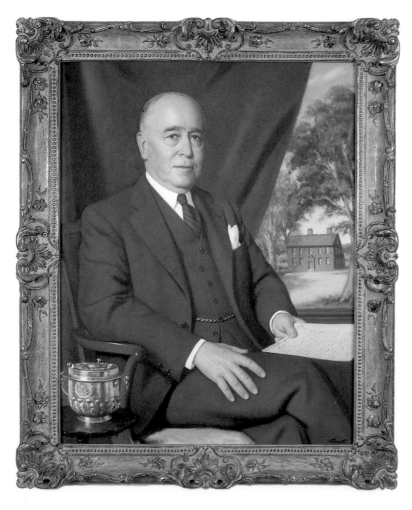

Henry Needham Flynt (1893–1970),
by David Shanks Ewart, 1954.

Lucius D. Potter Memorial of 142 volumes and many catalogues and periodicals on the subject of American art. This was followed by the memorial of Mr. and Mrs. Louis W. Dommerich, 244 volumes devoted to local and New England history. Each of these gifts filled in where the others were lacking, so that by the time the new library building opened the Heritage Foundation had a solid foundation in the fields of fine and decorative American art and New England and local history.

The PVMA library was rich in documents and other material that made possible the chronicling of life in the Deerfield area over a period of nearly three hundred years. Although Henry Flynt always claimed that the restoration work he and Helen did in Deerfield was heavily influenced by material in the PVMA library, those papers, diaries, and other documents had never been properly organized and catalogued. Amelia Miller, who worked among the dusty boxes of papers for years before the new library building went up, says that she and a fellow researcher, David Robb, "turned Henry Flynt off bricks and mortar and onto paper." They wrote a treatise, she says, that convinced Flynt of the need for a properly catalogued library. Their appeal, combined with Peter Spang's continued insistence on the need for a Heritage Foundation library building, clearly made an impression.[118]

The Flynts had raised about $200,000 toward the Heritage Foundation library by the time the desperate situation of Memorial Hall became known. The funds required were now more than twice that amount, creating one of the biggest challenges Henry Flynt had faced in all his years in Deerfield. As always, his energy and enthusiasm were equal to the job. In an effort to raise funds toward the needed work, the PVMA (under Flynt's leadership) again arranged to sell property. This time it was Miss Baker's Frary House, which was sold to Flynt's Heritage Foundation in 1969 for $50,000.

On May 22, 1970, the centennial of the PVMA, the new library building was dedicated and Memorial Hall was rededicated. The opening ceremonies and keynote address were followed by a basket lunch on the Memorial Hall lawn and tours of the renovated museum and the new library building. The library turned Henry Flynt's dream of Deerfield as an elite educational center into reality.

Summer fellows now had a practical facility in which to research their papers and projects, students at nearby colleges and universities could look into subjects related not just to Deerfield but to all of Franklin County, and serious scholars of all ages could work in comfort the year round.

As their final major Deerfield projects were nearing completion, the Flynts received an important award honoring their achievements. In the fall of 1969, at a meeting in Denver, Colorado, the National Trust for Historic Preservation presented them with the Louise du Pont Crowninshield Award, the most significant tribute in the field of American historic preservation. The National Trust cited the Flynts' "enthusiastic and intelligent devotion to the historic preservation of the buildings and land of Old Deerfield, Massachusetts...." Naturally, they were extremely pleased and proud of the award, as they had been to receive the degree of Doctor of Humane Letters from Williams College ten years earlier. That tribute, too, had been for their work in Deerfield, as well as that in Williamstown. In recalling the latter honor, Henry Flynt wrote of what "a thrill it was to be standing there with [Helen], the gay marching music of the band, the High Sheriff of Berkshire County with his mace and tall hat, cutaway brass-buttoned coat and striped trousers.... I'm sure I was alternately all smiles or in tears, the emotions of all the years welled up before me."[119]

Henry Flynt died in August of 1970, just a couple of months after the library dedication. His vision—of ensuring that Deerfield endured as a place where it was possible to experience "the thrill of seeing the houses aglow in the evening dusk bespeaking a living vibrating community which is proud of its past, living in the present for the future"—had been realized, and he left the Heritage Foundation to carry on the work. Helen Flynt led the Foundation with the help of Peter Spang and Robert Parsons, the new board president. She told the guides in an informal talk that she tried "to do everything doubly because Henry isn't here." In 1974, she was incapacitated by a stroke and was no longer able to travel to Deerfield. The story of the next two decades, in which the organization reshaped itself to exist independently, is told in the next chapter.[120]

From Private Vision to Public Trust

Libraries and museums owe their existence and development to a very few people. In the beginning there must be a collector, then comes a curator who puts what has been collected in order, and, finally, the scholar who makes use of what has been collected and properly housed.[1]

Collectors who came of age in the first half of this century were still in the early stages of collecting American antiques. They had relatively few reliable reference books and scholarly museum exhibits to learn from, but they had the thrill of discovering the objects that have become our icons and of arranging them in the appealing and evocative room settings that are the hallmarks of their generation. The Winterthur Museum near Wilmington, Delaware; the Shelburne Museum in Shelburne, Vermont; Old Sturbridge Village in Sturbridge, Massachusetts; and Bayou Bend in Houston, Texas, are among those that share with Historic Deerfield the noteworthy characteristic of having been founded either by one person or by a couple. Each reflects the foibles and whimseys, the tastes and prejudices, and the follies of its creator.

It wasn't just a love of history or of the objects themselves that drew these collectors on. It was also the feeling of being special—of opening up a whole new field. They lived for their antiques and their antiquing friends. They loved to entertain one another in the dramatic settings they created to show off their antiques, to share their newest treasures, and to compare notes. The Flynts' friend Katharine Prentis Murphy used to say that when she died she hoped to wake up among Henry du Pont's splendid William and Mary furnishings in the Wentworth Room at Winterthur.[2]

Although Henry Flynt was not a scholar, he was concerned about accuracy and historical precedent. He wrote as early as 1950, "I am very anxious to only show the things which are authentically correct. Perhaps I'm getting to be too much of a purist but I'm approaching the matter from an educational angle...."[3] Nevertheless, it has remained for those who have succeeded him to put his collections in order and to make scholarly use of them. The transition from a collection arranged according to its creator's fancy to one cared for and administered according to modern professional standards is often lengthy and painful. But it is a transition that has occurred at Deerfield and that has or must occur at all other museums founded on personal collections.

At Deerfield, the passage from private collection to professional museum began in the 1960s when the Flynts began to spend less on objects and to plan for a library and an endowment. Members of the board of trustees reflected these forward-looking interests rather than simply being supportive old friends, as had been the case in earlier years. After Henry Flynt's death in 1970, Helen's instinct was to leave everything as it was. It had always been hard for her to change a room setting or a display once it was thought out and in place, but now her conservatism extended to personnel, programs, and new acquisitions. Although she had never been involved in administrative and maintenance tasks as Henry had been, she continued to be active in Deerfield. She served as chairman of the board of trustees until she was confined to her home in Greenwich by a stroke in September of 1974.

The 1970s became a time during which president Robert W. Parsons led the board in addressing the task of creating financial and governing systems that would allow Historic Deerfield, Inc. (as the Heritage Foundation became in 1971) to function independently on a day-to-day basis. Peter Spang, who had become Curator in 1969,

David Proper (left) and Peter Spang (right) instruct a group in the library, 1977.

carried on the curatorial work. David Proper had come in 1970 to head the new libraries and he was busy cataloguing and organizing them and, with the aid of a dedicated group of volunteers, making them accessible to the public. In the fall of 1971 Spang and Proper were joined by Donald Friary, who had been Head Tutor to the summer fellows since 1965 and had accepted a new permanent position as Director of Education. "With the arrival of Donald Friary as full time Education Director," wrote Peter Spang, "I was able to transfer to him a great deal of important responsibility for trying to further our goals in the education field, especially in regard to interesting the various colleges in the area of Historic Deerfield."[4]

Friary's ideas for reaching out to new audiences and for involving students of all ages with the Deerfield collections were in accord with Henry Flynt's goals. From the beginning, Flynt's most frequently articulated aims were to preserve Deerfield's old houses for their educational and inspirational impact. As early as the 1940s he had referred to the old town's "quiet subconscious effect and influence on the young boys at school."[5] Friary's programs included students from schools and colleges outside as well as within Deerfield.

The summer fellowship program remained Deerfield's major educational endeavor, but the Education Department also offered special tours to school and adult groups throughout the year. With Robert Dalzell from Williams College, Donald Friary, who has a doctoral degree in American Civilization, offered a short course in local history to Williams College students during their January reading period. Friary also offered a seminar on the interpretation of objects as historical or cultural documents at Deerfield Academy.

The education agenda continued to include the three-day Forums that had been such a popular feature of the Flynts' program, and began to incorporate one-day, single-subject Forums as well. Until Mrs. Flynt's stroke she carried on as hostess at the Forums, while Peter Spang took over Henry Flynt's roles as guide and master of ceremonies. These events maintained the Flynts' tradition of warm personal staff involvement, pleasant and convivial meals at the Inn, and opportunity for participants to talk with speakers.

While the Flynts were in charge, they did their own fundraising and themselves contributed heavily to Deerfield programs and projects, but this was no longer the case. By 1975, Donald Friary had succeeded John Banta as Executive Director of Historic Deerfield, and he began to solicit funds from government agencies and other sources for such activities as cataloguing manuscripts and diaries, hiring interns to undertake a variety of interpretive tasks, and generally sorting and organizing the collections. Friary also broadened the base of the Friends of Historic Deerfield, adding less costly

Philip Zea and Iona Lincoln at the fall Forum, 1990.

categories of membership than the original $100 and steadily increasing the number of members. He feels that this organization has developed a constituency for the museum—a group of loyal supporters who feel they're involved in an important and interesting enterprise. Membership has increased from a couple of hundred in the 1970s to more than 1,500 in the early 1990s.[6]

The arrival of David Proper and Donald Friary had freed Peter Spang from a number of duties, but still left him in charge of the houses and collections, interpretation and guides, publications, and many other aspects of museum work. During their tenure, the Flynts had done all the buying themselves, sometimes acceding to Spang's urging to buy a particular object, sometimes not. As a result, Spang had not always been able to fill holes he perceived in the collections, particularly in the area of local material. After Henry Flynt's death, Helen was persuaded to set aside $1,000 per year for curatorial acquisitions, giving Spang a modicum of responsibility but not allowing him to affect seriously the shape of the collections.

At first, therefore, he concentrated on conservation of

Grace and Donald Friary (left) with Forum guests, 1990.

Peter Spang and guides visit Sunnyside in Irvington, N.Y., 1965.

existing collections, and this became a major thrust of his work in the 1970s. There was much to be done in all categories of objects, and Donald Friary helped by securing grants for some of the work. Buildings, paintings and prints, ceramics, and metalwares were among the objects conserved. Lexan, a clear plastic that filters damaging ultraviolet rays, was installed in the windows of some houses as a preventive measure.

A major step forward for the curatorial department was the establishment in late 1976 of the Mr. and Mrs. Hugh B. Vanderbilt Fund for Curatorial Acquisitions. Mr. and Mrs. Vanderbilt, friends of the Flynts' from Greenwich, credit the Flynts. with inspiring them to collect American antiques. The Vanderbilt Fund finally enabled Spang to acquire objects relevant to the Deerfield collections when they came on the market. His focus was mainly on local material and in the first year he acquired furniture from the Stebbins, Sheldon, Allen, and Starr families of Deerfield as well as other objects made in the area. Although Helen Flynt was conserving her funds to help with running the organization, she made important yearly gifts of material from her own collection, as did other friends of the museum.

Another major area of curatorial responsibility was that of interpretation and guiding. Henry Flynt had founded the guides program in the 1940s by arranging for wives of the faculty members who lived in the apartments created in back of each museum house to conduct visitors through the museum rooms. Public access to the houses was limited at first, for although the Ashley House was open by appointment, the Hall Tavern was the only building consistently on view throughout the winter. Visitors to the Tavern could see the pewter display, inspect and place orders for wallpaper reproduced from local patterns, and take a tour of the museum rooms. Flynt recruited guides for Hall Tavern in an informal manner exemplified by a story former guide Lee Boyden tells. The wife of Deerfield Academy faculty member Bartlett Boyden, she was hanging out her wash in the yard one day in the 1940s. Henry Flynt drove by in his station wagon, spotted her, and leaned out his window. "How would you like to work for me?" he called. "I'd love to," replied Mrs. Boyden, and that was that.[7]

Guide training in those days was equally informal. Henry Flynt would put down what he knew about each object—often whatever information he had acquired from the seller—on a card. Mrs. Boyden would look up similar pieces in *The Magazine Antiques* and add what information she could to the card, along with details gleaned from knowledgeable visitors. "I shudder to think of all the misinformation we gave out in those days," she says.

Later on, when the Flynts had acquired and opened more houses and needed more guides, Henry Flynt asked

Greenfielder Winifred Curtis to gather some Franklin County women who were interested in antiques and old houses. Jennie Danielski, who is among Historic Deerfield's most senior guides in terms of knowledge, service, and age, remembers that the group of six women met with Henry Flynt and Peter Spang. They were to be trained by the handful of women who were already guiding under Spang's direction and with occasional sessions with Henry Flynt. "In those days you had on-the-job training," says Mrs. Danielski, "and I still think that's an awfully good way to learn." When the training period was over, she says, "I discovered I was going to be paid! I never in my life at that time had done something that was worth a little money."[8]

From the beginning the Flynts encouraged the guides to attend Forum lectures and arranged occasional study trips to other museums. If such an outing took the group close to the Flynts' Greenwich home, they would entertain the guides for lunch or tea. Trips to other museums to view the collections and compare notes with guides continue to be a part of Historic Deerfield guides' training.

By the 1970s, a more formally organized Guides Training Program was established. A notice in local newspapers announced the dates of the wintertime course, whose

Guide Barbara Hoadley (left) shows Forum guests toys from the Potter collection, 1978.

Museum of Architectural Fragments.

"aim is to give the new people a sound background in the history of Deerfield and in the decorative arts before they begin to learn specifically the Deerfield collections." Under Peter Spang's direction, the course consisted of lectures by himself and senior guides; at the course's conclusion new guides were chosen and began to train to guide in individual houses. By the 1980s Historic Deerfield had a winter training program "for guides to increase their knowledge of life in early New England, in general, and Deerfield in particular...."[9]

Although during the Flynts' occupancy Allen House wasn't open to visitors except by personal invitation, Henry Flynt used to tell a story about the day he gave an impromptu tour. Having settled down in the living room to take a little nap after lunch, he awoke with a start to find two ladies in the room with him. He politely inquired whether he could help them. No, they replied, they just wanted to look around the house. Flynt obligingly took them through, telling them about the architecture and interesting and important antiques. At the conclusion of his tour the ladies offered him a tip, which he refused. His subsequent comment was that he should have accepted it in order to find out how much the tour was worth.[10]

Another major curatorial task was that of the display of the collections. In 1972, Peter Spang organized architectural fragments "rescued from demolished buildings of the Connecticut Valley ranging in date from 1690 to 1910" in a nineteenth-century barn behind the Dwight House. Spang's goal in developing this unusual new museum was "to create a greater awareness toward

historic preservation in Franklin County."[11] Also in 1972, Historic Deerfield received Frank Boyden's carriage and sleigh collection as a gift from his family. These vehicles were placed on view in the barn behind the E. H. Williams House, and remain a reminder of the days when one of Deerfield's most cheering sights was that of Frank Boyden driving down the old street in his horse and buggy.

Toward the end of the decade, Spang and Friary undertook some reinstallation projects. The small room on the south side of the Asa Stebbins House that had been furnished as a pantry was redone as an office, which research had determined was its original use. "Local furniture, Stebbins family memorabilia, early 19th century office equipment, and a green painted canvas floor cloth made by the Historic Deerfield maintenance crew" transformed the room. Parson Ashley's study received a group of prints based on eighteenth-century probate lists for Deerfield Tories that expressed the Parson's own strong Tory sentiments.[12]

Other more scholarly approaches were reflected in the employment of a professional archeologist to dig on the site of the Dr. Thomas Williams house, owned by Historic Deerfield but not a museum house. The discovery of shards from a Rhenish stoneware mug on the property prompted the staff to engage an archeologist for a month in the summer of 1976. He unearthed more than 1,900 artifacts from the period 1740–1760, adding "substantially to our knowledge of personal and domestic behavior, food consumption, and life style in mid-18th century Deerfield." (More recent archeological projects have built solidly on this early effort.) Microscopic analysis of successive layers of paint on some of the houses disclosed their original colors, and after they were repainted, "for the first time Historic Deerfield guides and staff could show visitors what early New England houses actually looked like."[13]

Publications about the houses and collections had always been high on Henry Flynt's list. When they were buying and restoring the houses, he and Helen often produced a little booklet telling what they knew of a building's history, which they sent to friends at Christmastime. Amelia F. Miller's book, *The Reverend Jonathan Ashley House*, published by the Heritage Foundation in 1962, set a standard of scholarly treatment that Flynt hoped to follow for other houses, although that plan was never carried out. Henry Flynt's and Samuel Chamberlain's *Frontier of Freedom*, first issued in 1952 and revised many times, was until the present publication the only overview of Deerfield architecture and furnishings. In 1968, Henry Flynt's last major publishing effort appeared. Entitled *The Heritage Foundation Collection of Silver, With Biographical Sketches of New England Silversmiths, 1625–1825*, the book was a collaborative

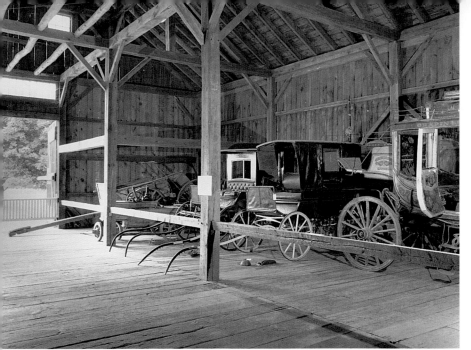

Boyden Carriage Collection.

Henry Flynt's right-hand man, Ed Gritz, repairing the E. H. Williams House fanlight, 1974.

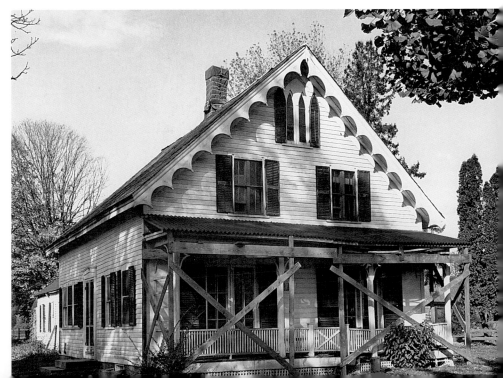

Moors House, 1848, Historic Deerfield's next restoration-in-progress.

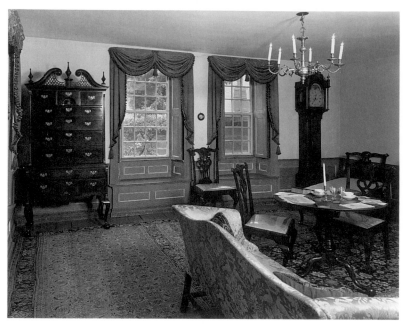

Wells-Thorn House north parlor in the Flynts' day.

Wells-Thorn north parlor today.

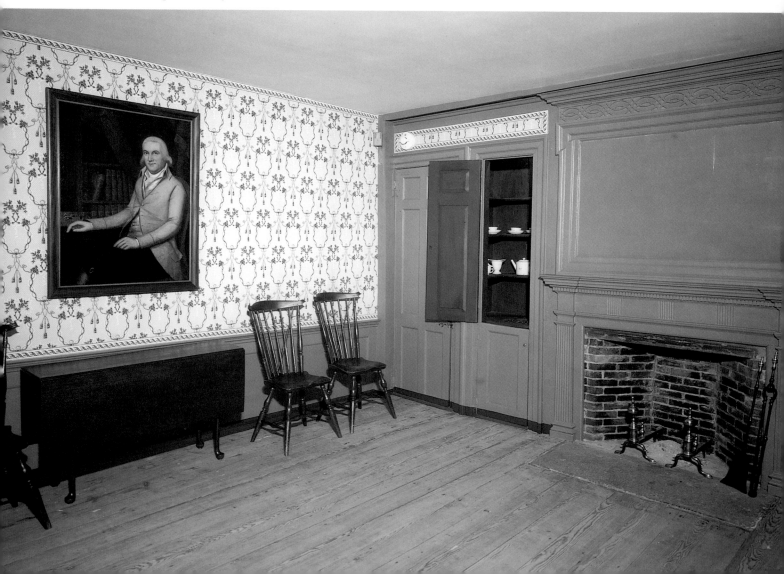

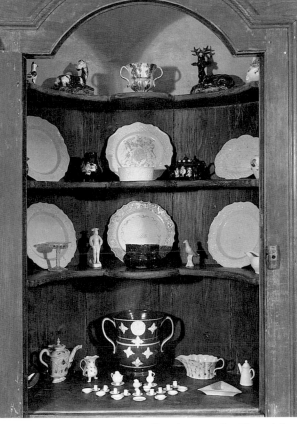

Corner cupboard at Wells-Thorn in the Flynts' day.

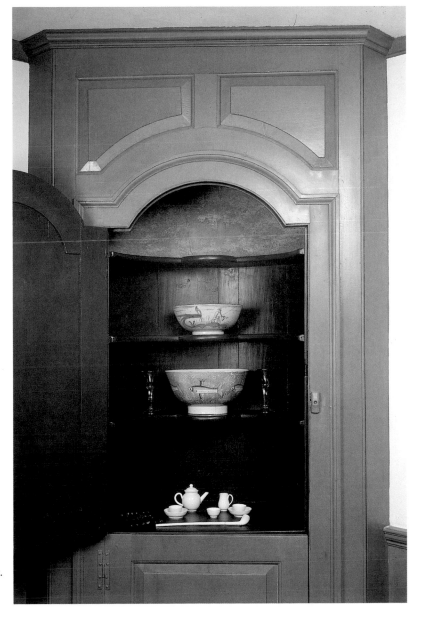

Wells-Thorn cupboard today.

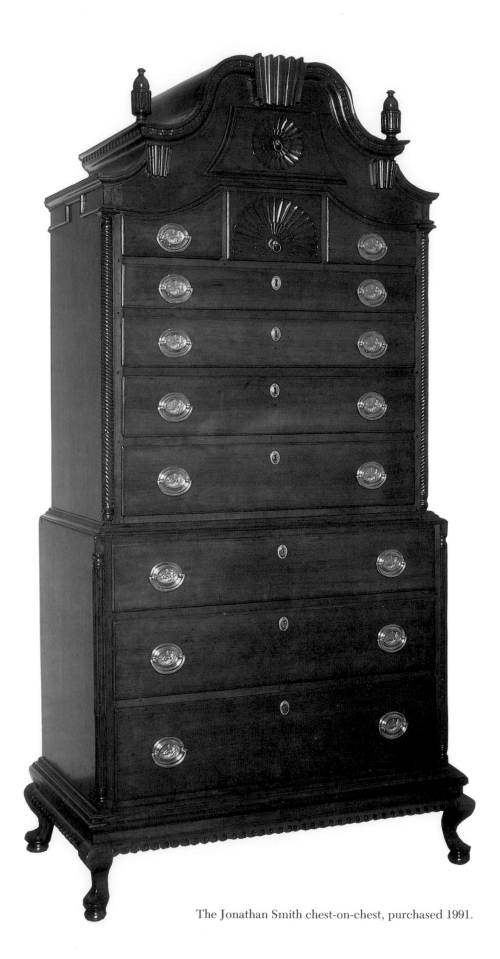

The Jonathan Smith chest-on-chest, purchased 1991.

effort with silver expert Martha Gandy Fales. Flynt described it in his introduction as "a time-consuming, strenuous, enjoyable, exciting and rewarding undertaking."[14] In 1976 *The Furniture of Historic Deerfield*, by Dean A. Fales, Jr., appeared. In it, Mr. Fales referred to the Deerfield furniture collection as "one of the biggest and best assemblages of early New England furniture in the country today."[15]

In the early years, care of buildings and grounds had been in the hands of Henry Flynt and two Deerfield men, Edward Gritz and Charles Dodge. The Flynts relied on Ed Gritz, particularly, for help with maintenance of both architecture and furnishings. He was "Mr. Flynt's right-hand man," says Lee Boyden. "He could do anything Mr. Flynt wanted in his houses or find someone who could."[16] By the late 1970s, it was clear that repairs and maintenance were no longer a one- or two-man job. The maintenance staff was expanded, and the Flynts' grandson William A. Flynt was asked to come to work as Architectural Conservator. "He had recently completed a graduate program in architectural restoration at the University of Vermont and has specialized in the preservation of wooden buildings," noted the *Annual Report* for 1979.

Flynt, working with Julian Goralski of the maintenance staff, began to study the conservation of Historic Deerfield's houses. He researched original paint colors and began to plan for the preservation of Historic Deerfield's unpainted buildings. Since very little was then known about preserving unpainted exterior wooden surfaces, work in this area was necessarily experimental. In 1982, it was decided to renovate the E. H. Williams House as a period house, and Bill Flynt became the project manager. The house was to be a "restoration-in-progress," showing the public five successive stages in the restoration process: structural stabilization, interior restoration, research on furnishings, collecting the furnishings, and interpretation.[17]

The difference between this approach and that of the restorations completed earlier was immense. Documentation of earlier houses was "sketchy at best," according to Bill Flynt, who reports that E. H. Williams documentation consists of black-and-white and color photographs (suggested by William S. Appleton as early as 1924), paint and paper fragments, and sources for all evidence. A binocular microscope revealed original paint colors and such fine points as the rag content of wallpaper fragments. Throughout the project, says Flynt, "research continued and alterations were made. Much unexpected evidence turned up."[18]

When it is completed, the E. H. Williams House will have taken ten years to research, renovate, and furnish—compared to the six to eight months it took to move the Hall Tavern from Charlemont to Deerfield, renovate and furnish it, and open it to the public. The differences

between attitudes and expectations at mid-century and in the last decades of the twentieth century are obvious. The Flynts wouldn't have thought of exhibiting the *process* of restoration; their goal was to educate, but to educate in the realm of colonial taste and values, which they did by creating "tasteful" and atmospheric interiors. Today's goal is to educate in the actual approaches to and techniques of restoration work—to discuss why and how things are being done and with what products and tools. It is an approach that fascinates visitors; one common suggestion throughout the years the restoration-in-progress has been on tour, says Bill Flynt, has been, "Stop where you are—let the house alone."

Historic Deerfield's recent acquisition of the Moors House, an 1848 Gothic cottage on Deerfield's old street, indicates a new direction—that of renovating and furnishing a house in an interesting nineteenth-century revival style. It also provides another opportunity for a restoration-in-progress. Its extremely dilapidated condition makes it "a real handyman special," says Bill Flynt, and its renovation can begin "as soon as we get the first floor out of the cellar."[19]

A study committee formed in the early 1980s addressed itself to the task of the "redefinition, reinstallation, and reinterpretation of all the museum buildings and collections," and produced a ten-year plan adopted in 1985 to work toward those ends. Among the organization's priorities from the early 1970s on—and one reaffirmed by the new plan—was the conservation of the textile collection. Peter Spang and Iona Lincoln, Curatorial Assistant (now Associate) for Textiles, put special energy into bringing this collection into line with current conservation practices. Once they had provided for proper storage of textiles, clothing, and accessories, Mrs. Lincoln was able to turn her attention to rotating reproduction and genuinely old textiles so that the latter could have periods of "rest." She could also begin to focus on reupholstering pieces of furniture in a "noninvasive" way—a new field in the last few years. Working with furniture conservator John Payson, Mrs. Lincoln has embarked on a period of combining what she learns at seminars and from other textile conservators with what she and Payson determine about noninvasive procedures through trial and error. "As long as you're not pounding a nail into that piece of furniture, you figure you've got it made," she says. Using the new techniques, Mrs. Lincoln and Mr. Payson have reupholstered more than fifty pieces in the Historic Deerfield collection.

The arrival in 1981 of Assistant Curator Philip Zea, a Deerfield fellow and a graduate of the Winterthur Program in Early American Culture who specializes in Connecticut Valley furniture, has enabled the curatorial department to move toward its part of those goals more quickly. As in architectural restoration, ideas about

interpreting the decorative arts were changing radically in the 1970s and 1980s. "I and others do not wish merely to *appreciate* early objects," wrote Winterthur Museum Furniture Curator Robert F. Trent in explaining the new approach. "We want to use them as artistic and cultural evidence in broader historical arguments."[20]

Applied specifically in Deerfield, this approach resulted in the reinterpretation and reinstallation of the Wells-Thorn House. The basis for the new procedure, says Philip Zea, who became Curator upon Peter Spang's retirement in 1986, was a study of probate inventories taken in Deerfield and other Connecticut Valley towns from the late seventeenth to the mid-nineteenth century. "Meticulous scholarship, imaginative interpretation, and the wealth of material in the Historic Deerfield collections have made it a model of historic house furnishing and reinterpretation," stated the 1988 *Annual Report*. The Wells-Thorn House differs markedly from earlier Deerfield period houses in reflecting an objective, rather than the Flynts' very subjective, method. "The new approach involves much greater scrutiny, using less hunch and more facts," said a *New York Times* article in 1988. "It looks at archeological finds and contemporaneous written documentation, along with historical and social events of the time. And it investigates all manner of artifacts, from architectural details to chamber pots, from wall treatments to bed hangings. The result is interiors that offer a more accurate picture of how people actually lived."[21]

The curatorial approach to furnishing the E. H. Williams House is similar to that employed at Wells-Thorn. Amelia Miller's recent study of E. H. Williams's life provides the curators with the basis for "conclusions about life style, domestic economy, consumerism and beliefs of Williams and his peers." Among other issues to be examined are the Williams family's sources of household items—did they shop in Deerfield, Greenfield, Boston, and/or Hartford?—and the intellectual life of Williams and his Connecticut Valley contemporaries. Deciding what sorts of things were considered too trivial to be included in Williams's 1838 probate inventory is another thorny problem. Other objects, of course, have been obtained because of their *inclusion* in the inventory.[22]

Having spent the 1970s solidifying its systems of governance and financial operation, Historic Deerfield was able to expand its staff, its collections, and its programs in the 1980s. In addition to Zea, Flynt, and Lincoln, the staff has increased to bring broader experience and more diverse points of view to the organization. Anne Digan, a Cooperstown graduate, filled the new position of Assistant Curator for Interpretation in 1986. Kevin Sweeney, a Yale Ph.D. in history, brought a specialization in American material culture to the new post of Director of Academic Programs in 1986, and was succeeded in 1990 by Kenneth Hafertepe, a University of Texas Ph.D. in American Civilization with a specialty in architectural history. Janine Skerry, a Winterthur graduate, became Assistant Curator in 1987, with responsibility for silver and ceramics. Bruce Moseley was appointed Registrar in 1986 and has brought new vigor and heightened professional standards to Historic Deerfield's records management.

The 1990s promise to be as exciting for the current staff as the 1940s and 1950s were for the Flynts. The new approaches to house restoration and furnishing lead to constant discoveries, surprises, and even setbacks, just as collecting and furnishing did in "the good old days," when the Flynts first got involved with the world of American antiques. But now the thrill of the chase and the capture that used to be reserved for the collector/founders of museums like Historic Deerfield is the domain of the curator, as Philip Zea's most exciting recent acquisition demonstrates.

The whereabouts of this stunning seven-foot-tall chest-on-chest made in 1803 by Jonathan Smith, Jr., of nearby Conway, Massachusetts, had been unknown since 1935, when a newspaper article announced its existence. Curators and collectors tried to track it down with no success, and Zea's intensive efforts to locate the chest for a major exhibition of early Connecticut Valley material in 1985 were no more fruitful. Then earlier this year a friend apprised Zea of a chest-on-chest that was coming up for auction at Sotheby's in New York. When he examined it, Zea found that here at last was the long-lost chest, the first documented work by cabinetmaker Smith to appear. The highly embellished scroll-top chest was "the one thing I wanted to get my mitts on," said Zea upon his triumphant return from the auction. In filling a "gaping hole in the museum's collection of Connecticut Valley furniture," the chest-on-chest ensures Historic Deerfield's supremacy in that category.[23] It stands also as a symbol of the Flynts' and the current staff's commitment to Deerfield and the Connecticut Valley and to the continued exploration of the early life and material culture of this region, which Henry Flynt designated a "frontier of freedom" forty years ago.

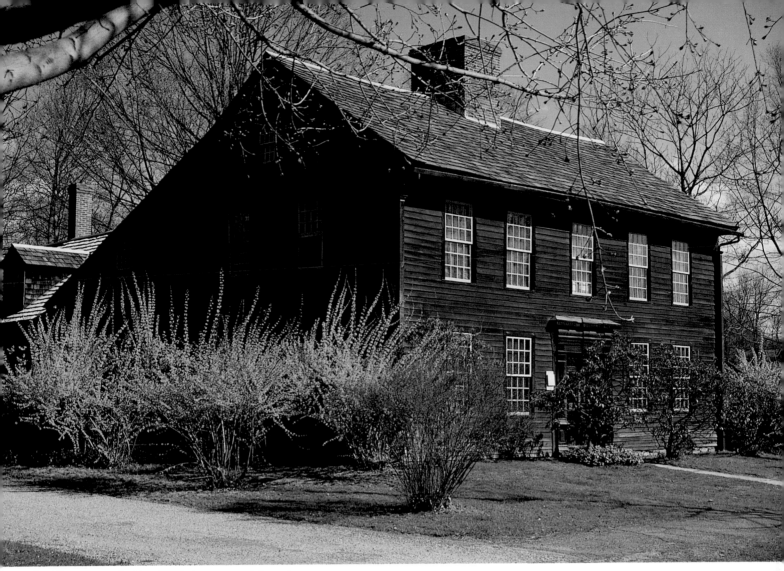

1. Allen House, built c. 1720, in a present-day view.

The Allen House

In 1945, the year they bought the Deerfield Inn and the Jonathan Ashley House, Helen and Henry Flynt also acquired the Allen House with the thought of making it their Deerfield home. By this time the Flynts had been involved with the Academy and the town of Deerfield for nearly ten years. They usually stayed with Headmaster and Mrs. Boyden when they visited, but the prospect of having their own home in Deerfield must have seemed attractive.

Henry Flynt recalled many years later that the house was in "deplorable condition" when they bought it, but he and his wife were attracted by "the splendid proportions and charm of its early lines," he said.[1] Bill Gass, the local restoration contractor, took on the job of restoring Allen House at the same time he was working on the Ashley House and the Rossiter ("Pink") House.

The first house on the property, which was "believed to

be fortified with palisades,"[2] was burned in the 1704 attack. Indians captured its owners, Simon and Hannah Beaman, and took them to Canada. Until recently it was thought that upon the Beamans' return to Deerfield in 1705 they hastily put up another house, but new studies indicate that the earliest part of the present house was built about 1720.[3] Hannah Beaman conducted the first school in Deerfield on this site or nearby. Thomas Bardwell, saddler and farmer, bought the property from Hannah in 1722, adding a leanto to the main house and a shop on the northwest corner of the lot about 1725. The Bardwell family retained ownership until 1842, when the property passed into the Allen family through the marriage of Catherine Elizabeth Bardwell and Caleb Allen.

Wholesale remodeling in the nineteenth century completely obscured the eighteenth-century plan of the

house. In the second quarter of the century, Catherine Elizabeth Bardwell, later Mrs. Caleb Allen, wrote a friend, "Our old house has become entirely new since you left, not one spot as it used to be…you would hardly know it…."[4] The old central-chimney house had been transformed by a center hall and stairway into a two-family house. Its doorway was replaced, the interior plan was dramatically altered, and more space was enclosed behind the leanto. In its new, up-to-date state, the house passed down through the Allen family for about a hundred years. In 1896, Caleb's nieces Frances and Mary Allen and their mother came into possession of the house and took up residence there. The Allen sisters were photographers with a strong interest in the history and traditions of Old Deerfield, and their pictures of idyllic and evocative Deerfield scenes and pastimes span the years from 1898 to 1929. "The Misses Allen," stated their catalogue of available photographs for the year 1917, "have made a special study of New England landscapes and country life, and also of unconventional portraiture."[5] The sisters used the north front room, now the bedroom, as a shop for their photographs, which were very popular.

Upon the sisters' deaths in 1941, the house passed to their nephew Francis E. Allen, who sold it to Henry Flynt in 1945. As always when they bought a house on the old street, the Flynts planned to create space in the wing to house Deerfield Academy personnel. In August of 1945 Flynt wrote to inform Headmaster Frank Boyden that the house was now in his possession and should be cleaned out quickly so that the Academy could use it to lodge one of the masters and "some of the boys this year." In December of 1946 Flynt advised Boyden that "the house is available for five boys and a Master, and, in addition, we have equipped the Master's room with furniture."[6] Flynt and Boyden then agreed upon a reasonable rent and the Academy was slightly relieved of its chronic housing shortage.

Because they were focused entirely on the eighteenth-century aspects of Deerfield, the Flynts decided to tear out the nineteenth-century features and return Allen House to its earlier appearance. In order to learn as much as possible about the house and its former inhabitants, the Flynts enlisted the help of their friend Elizabeth Fuller and of Jean Campbell, both of Deerfield. Although research uncovered many facts, it remained true that the later changes and additions had altered the appearance of the house so totally that it was impossible to know exactly how it had looked in colonial days. It was in situations like this, which occurred frequently during these early days of the Flynts' restoration work, that contractor Bill Gass's familiarity with early local houses was very helpful. "I figured God gave me hands that could draw and a brain that just knew old things and studied," said Gass of his affinity for early houses.[7] Even so, Gass acquired his knowledge on the job rather than through thorough study of eighteenth-century building practices. When evidence of original architectural features was lacking, he filled in with designs based on his experience and on his own taste.

In order to return Allen House to an eighteenth-century appearance, Gass and the Flynts decided to gut it—to strip the walls of all existing woodwork, paneling, and plaster except for what was clearly of the eighteenth century. Decisions about Allen House, Gass explained, were made by him and the Flynts as work progressed. "I might make a drawing," he said; "they'd look at it and if they liked it they'd tell me—if they didn't they'd tell me!" Since both he and the Flynts were often just guessing anyway, Gass said, "I never had to change much."[8]

When they began their restoration work, Helen and Henry Flynt subscribed to the mellow unpainted look for paneling and other woodwork. Gass used old wood—it was easy to get in those days, he said—and made up the necessary paneling and other details in his shop. He used wide boards that had been used as wainscoting in the eighteenth century, and these were excellent for restoration work. "You can't find lumber like this today," said Gass in an interview in the early 1980s. "You can't buy feather-edge [sheathing for interior walls] and you can't buy wide boards."[9]

As renovation progressed and the Flynts inspected each stage of work, Gass recalled, "They'd ask me why did I do this, why did I do that. Well, I had to have my answers. And they usually ended up going along…." Not always, though. Said Gass, "[Helen Flynt] was a pretty stubborn woman." But he went along with her and tried to please her because, he said fair-mindedly, "It was their money."[10]

The result is that much of the interior of Allen House is not authentically colonial, for there was limited evidence of its earliest architectural features to go on. It is, instead, a colonial-revival interior designed by the Flynts and Bill Gass and reflecting their tastes and prejudices. Walls and floors are covered with wide boards with a warm brown unpainted finish. Both living and dining rooms have the large brick fireplaces and hearths that have been a favorite feature of colonial-revival rooms for the last century. Nostalgic Americans envisioned colonial interiors that combined what they thought of as the best of the eighteenth century with the comfort of the twentieth. So the Flynts assembled well-aged wood and brick to create a background, but supplied modern conveniences as unobtrusively as possible. Up-to-date heating, plumbing, and electrical systems were installed and concealed, ensuring comfortable living in a "colonial" setting (see figs. 5, 7, and 8).

Allen House furnishings in the 1940s and early 1950s also embodied the Flynts' taste for simple, even rustic, features. Much of the furniture they first bought was of early utilitarian forms made of native woods such as oak,

2. Side view, Allen House, showing the eighteenth-century leanto and the long ell the house received during the nineteenth century. The Flynts built a modern kitchen, bathrooms, and bedrooms in the ell.

3. Contractor Bill Gass's crew preparing to install a flat-top Connecticut Valley doorway in the front of Allen House, 1946. The design is Gass's own, freely adapted from traditional local doorways.

maple, and pine, often with an unpainted finish.[11] Colorful ceramics and textiles, pewter, brass, and hooked rugs contributed to the cozy, cheerful effect the Flynts sought. Henry Flynt's friend and Williams College fraternity brother John Kenneth ("Mike") Byard, a Wall Street lawyer turned antiques dealer, was a major influence and source of furnishings for Allen House. "Byard has been a friend of mine of long standing," Flynt wrote in 1946, "and is really an authority on antiques and has helped me in the acquisition of many things which are now in the Allen House and other places."[12] Later on, when Helen and Henry Flynt became acquainted with major collectors of American antiques, their tastes shifted and they replaced many of their early unpretentious pieces with more formal things of walnut, mahogany, and cherry. Lathe-turned legs, stretchers, and uprights gave way to the sinuous S-curves of cabriole legs, vase-shape splats, and scrolled pediments. Hooked rugs disappeared and rich orientals took their places. Although Allen House was their Deerfield home rather than a museum like the other houses they were restoring and furnishing, the Flynts eventually placed some of their greatest treasures there.

Downstairs in the parlor (which the Flynts called the living room), for example, are two matching side chairs made in 1775 by the well-known cabinetmaker Eliphalet Chapin for Erastus Grant of East Windsor, Connecticut, Chapin's home town; three other side chairs are attributed to Chapin. Two splendid casepieces, a high chest and a chest-on-chest, were made about 1781 for Julius and Dorothy Deming of Colchester, Connecticut (see fig. 8). The dining room contains a rare twelve-sided drop-leaf table and a set of six Queen Anne chairs with needlework seats made near Boston by Jane Brown about 1760. The parlor and dining room also contain notable collections of ceramics and pewter (see figs. 5 and 10).

The bed in the Allen House guest bedroom was hung with a set of crewel-embroidered hangings worked about 1750 by Esther Meacham Strong of Coventry, Connecticut, granddaughter of the Reverend John Williams of Deerfield. The Flynts first saw the coverlet at Colonial Williamsburg, when Curator John Graham proudly displayed it as a new acquisition. The Deerfield connection naturally fascinated them and Henry Flynt immediately asked if he could buy the coverlet for Deerfield. Graham replied that if Flynt could produce another American example of comparable quality and date, he would let the Deerfield one go. Flynt explored every avenue, but couldn't come up with a similar spread. It wasn't until he and Helen happened upon four additional pieces, part of the same set, that Graham relented and let Flynt buy the crewelwork coverlet for Deerfield. In telling the story many years later Flynt added, "I had no such luck in getting away from John a brown ceramic tig with the words, 'Henry Flynt—1704,' of which I was the under-bidder at an auction at Christie's in London a couple of years after the crewel work episode."[13]

The Flynts were very sociable and were always delighted to share their house and collections with visitors. They entertained often and were pleased to have an event at Deerfield Academy, at the local historical society, or at their own Heritage Foundation as an excuse for entertaining (see fig. 4). They also loved to have an annual house party at the time of the Williams-Amherst football game. They gave tours of Allen House on these occasions—Henry's were more factual and informative, while his wife's were vague, focused on atmosphere rather than authenticity. They both loved to tell stories connected with the history or acquisition of a piece, and sometimes it was the history that decided them to make a purchase.

Entertaining often involved drinks at Allen House before dinner at the Deerfield Inn. Henry would serve drinks and hover in front of the fire keeping watch over his guests, then perch on the splendid eastern Massachusetts joint stool in front of the fireplace. Helen would sit on one of the loveseats near the fireplace and invite favored guests to "come sit next to me."[14] Very rarely they stayed at Allen House rather than going to the Inn for dinner, and on these occasions the plates and drinking vessels were all antique. "There was nothing modern," recalls one former guest.[15]

Peter Spang remembers that as the party went along, the Flynts would tell their guests, "Now Peter will take you upstairs and show you around." Spang would dash up to the dark second floor and hurriedly turn on lights as the guests dutifully made their way up. When they returned to the living room Helen would ask if Peter had shown the unusual brick stairs to the attic, while Henry would inquire if he'd told the story of the crewel bedhangings. On one occasion, Headmaster Frank Boyden, who didn't drink and whose experience of cocktail parties was minimal but who did like to get around and talk to people, picked up a dish of potpourri and passed it in the belief that it was edible.[16]

After such a gathering, or after suggesting that guests go for a walk at dusk to watch the lights come on along the street, Henry Flynt reflected on the experience of living in Deerfield. "As we turn back to the glowing hearth, light a pipe and perhaps have a friendly warming bit of cheer from generous flip glasses, we wonder whether there is another such unspoiled community? It all seems unique. Is it we ourselves who are here or are we just a shadow of the past?"[17]

This engaging picture conveys Flynt's very personal, romantic vision of life in eighteenth-century Deerfield. Like many of his fellow collectors, Flynt imbued the past with characteristics he found lacking in the present. The fireplace becomes a "glowing hearth," a cocktail becomes

"a friendly bit of warming cheer" served not in utilitarian tumblers but in "generous flip glasses." Although Flynt and others of his era genuinely believed in the serene and civilized world conjured up by such descriptions, it's almost as if they realized at some hidden level that it was a world too good to be true. Are we really experiencing these things, Flynt asks, "or are we just a shadow of the past?" Although Allen House has a long and interesting history, it was almost certainly never the haven of comfort and civility it became during the Flynts' occupancy from the 1940s to 1974.

After Henry Flynt's death and Helen's confinement to her Greenwich home because of ill health, she gave Allen House to Historic Deerfield in 1975 to be opened as a museum. It was decided to "freeze" the contents and their arrangement—that is, to leave them exactly as they were when the Flynts lived in the house. So visitors see "an eclectic collectors' collection," according to senior Allen House guide Barbara Hoadley, and not an authentic recreation of an eighteenth-century house. Rooms are chock-full of furniture and other objects, reproductions are occasionally mixed in with authentic antiques, and a few of the Flynts' personal belongings are still in evidence.

A squash racquet—testimony to Mrs. Flynt's enthusiasm for the game—rests in a butter churn near the front door. A few pieces of clothing remain in the bedroom. And plastic flowers and a modern bridge lamp strike jarring—but authentic—twentieth-century notes, for this was the Flynts' home and it reflects their needs and tastes.

It also reflects the influence of their collector friends, particularly of Henry du Pont, whose antiques-filled period rooms at Winterthur inspired two or three generations of collectors. The Allen House parlor (see fig. 8), for example, is arranged as "a miniature up-country version of Winterthur's Port Royal parlor, though it's one-tenth the size and sheathed in pine," according to Philip Zea. The Port Royal room (see fig. 9) celebrates great Philadelphia craftsmanship, while the Allen House parlor focuses on outstanding Connecticut workmanship, but the rooms are similarly arranged and decorated in yellow silk damask.

Other du Pont influences are visible in the use of iron-and-brass standing candlestands and in the carrying out of themes within a room, as in the Hogarth room at Allen House (see fig. 7).[18] The Hogarth room, so called "because there are five colored prints of Hogarth's political scenes, and as in most of his pictures, there is a profusion of people and things which depict a tremendous amount of activity," according to Henry Flynt, recalls the taste and decorating style of another well-known collector, Katharine Prentis Murphy. The combination of William and Mary furniture with its turned elements and Spanish feet, most of it "exceptionally good" said Henry Flynt; oriental rugs; numerous accessories of brass and ceramics; and oil portraits evoke Mrs. Murphy's vivid and attractive rooms.[19] Rooms like these expressed their creators' taste and provided an atmospheric background for a gregarious social life.

4. A party in full swing in the dining room of Allen House in 1948, probably to celebrate the opening of Ashley House.

5. Dining room, filled with fine furniture, early textiles, pewter, and oriental carpets, probably in the 1960s. The abundant display of pewter suggests the range of the Flynts' collection of that ware. The two easy chairs are upholstered in eighteenth-century fabrics, a practice followed by many collectors of the Flynts' era but one much out of favor today because of the fragile nature of old textiles. The Flynts had "table-itis," Senior Guide Barbara Hoadley quotes Henry Flynt as saying, and the dining room contains tables from five different regions ranging from New Hampshire to the Delaware Valley.

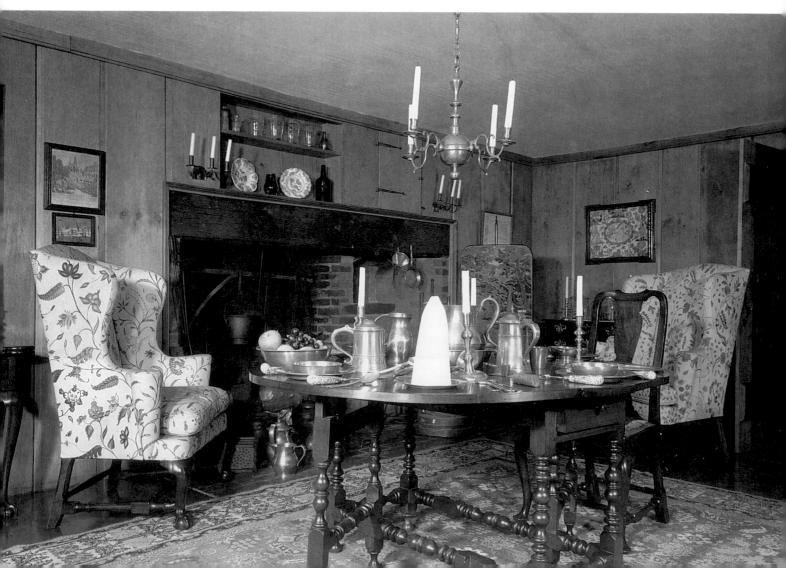

6. A corner of the dining room showing a fine Boston reverse-serpentine chest holding an assortment of the Flynts' collection of English glassware. Above is an English needlework picture of the Stuart period from the Flynts' significant collection of early needlework.

7. The Hogarth room, so called because it contains a group of colored engravings of political scenes by eighteenth-century English painter and satirical engraver William Hogarth and is filled with a profusion of objects, as Hogarth's prints are. Influences from the Flynts' friends and fellow collectors Katharine Prentis Murphy and Henry Francis du Pont are evident in the furnishing and decoration of this room. Mrs. Murphy's fondness for combining early turned furniture, oriental rugs, and oil paintings is apparent here, as is du Pont's partiality for themes—here Hogarth, card playing (a pastime depicted in some of Hogarth's prints and much enjoyed by Helen Flynt), and furniture with Spanish feet. The portraits by John Singleton Copley, c. 1756, are of the Reverend Arthur Browne and his wife, Mary Cox Browne.

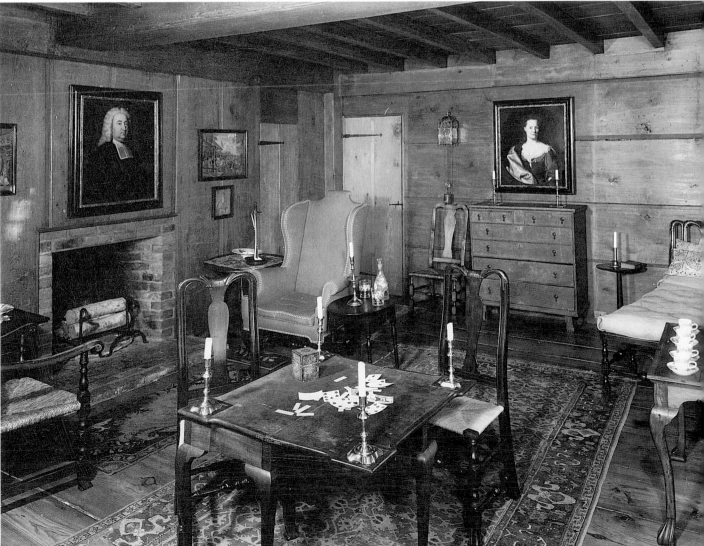

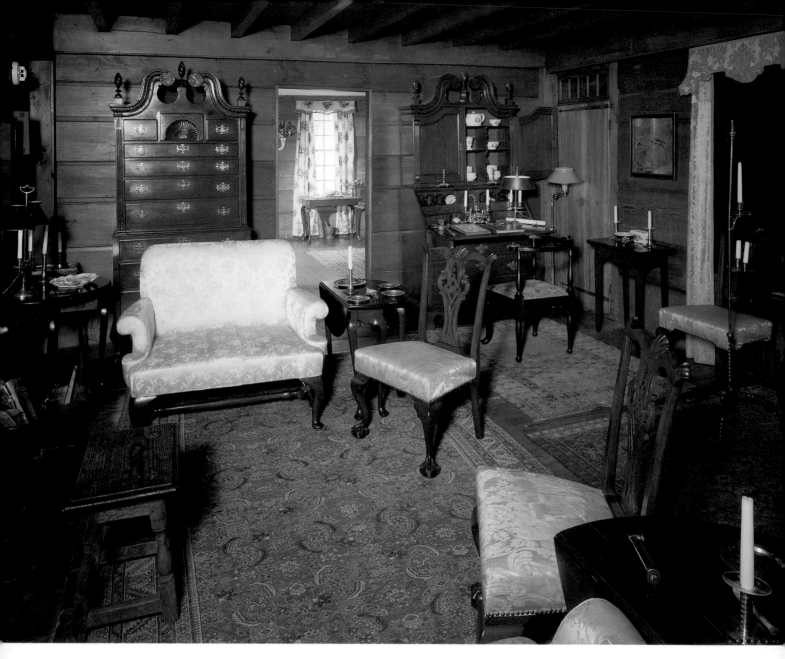

8. On either side of the door from the living room into the dining room is a striking casepiece: a mahogany desk and bookcase and a cherry chest-on-chest, both made in Colchester, Connecticut, for Julius and Dorothy Deming, c. 1781. The room is crowded with other fine pieces, including two Newport tables the Flynts were particularly proud of (one is visible to the right of the desk and bookcase). As she stood beside her Marlboro-leg Newport table in the parlor one day, Mrs. Flynt noticed another table exactly like it, but smaller, on top of an antiques-dealer's station wagon parked across the street. She immediately alerted her husband, and they bought the smaller example forthwith. As Philip Zea points out, the pairing of two splendid casepieces, settees flanking the fireplace, and the use of brilliant yellow silk damask for curtains and upholstery make this reminiscent of the Port Royal Parlor at Winterthur.

9. The Port Royal Parlor at H. F. du Pont's Winterthur Museum may well have inspired the Flynts' "upcountry version" in Allen House.

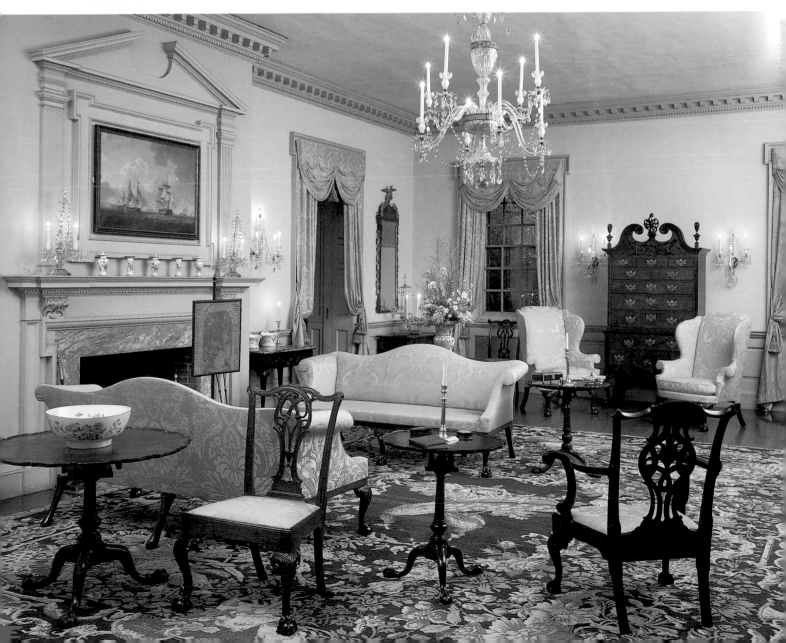

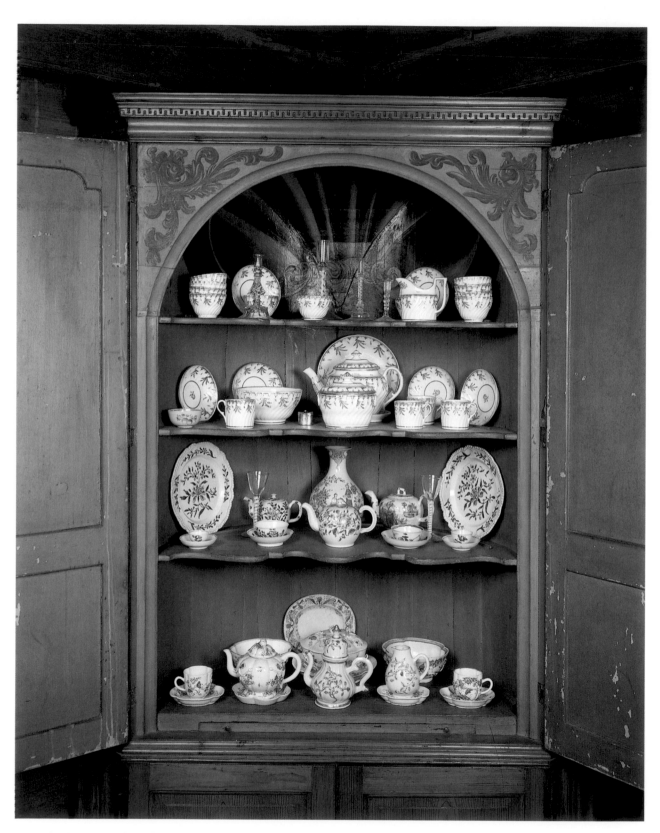

10. Corner cupboard, parlor. In a letter to his wife in the late 1960s, Henry Flynt recalled buying this "pine corner cupboard with green-painted interior" from Greenwich dealers Frederick Denson & Son. Flynt notes that it is "obviously English," and remarks to Helen that her collection of ceramics in the cupboard "adds luster to your taste." The cupboard remains as she arranged it.

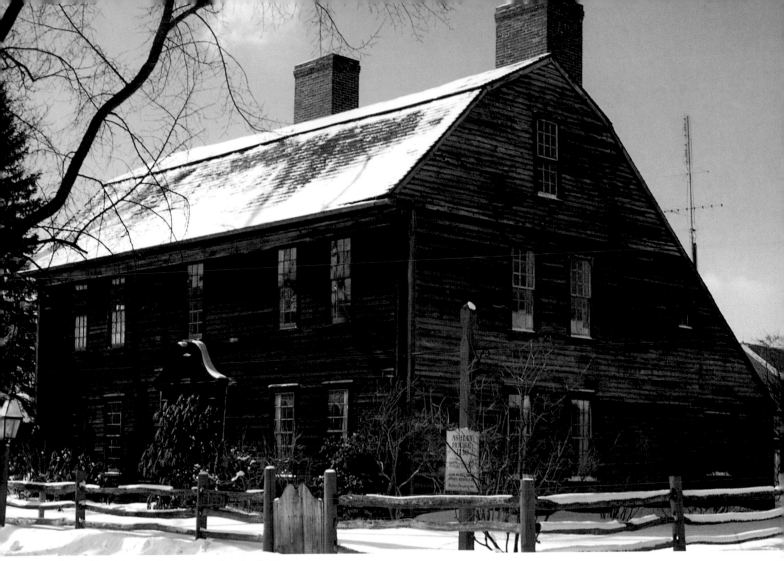

11. The Ashley House after restoration in 1948.

The Reverend Jonathan Ashley House

Ashley House was the first of Deerfield's colonial dwellings to become a museum under Helen and Henry Flynt's guidance. The lot had been in the Wells family from the seventeenth century until 1733, when the Reverend Jonathan Ashley acquired it. Ashley had been ordained minister of the Deerfield church in 1732, when he was nineteen years old, and he bought his house and land with funds he had received from the church. The house then on his lot is believed to have been built between 1726 and 1733.[1]

Although his origins were modest, Jonathan Ashley rose, through his calling and through his marriage to a Williams, to membership in an elite class of Connecticut Valley residents dubbed River Gods, a group of citizens who "were notable for the degree to which they controlled...civil, military, and even clerical offices"[2] in western Massachusetts. Although most of these men were more affluent than their neighbors, many of them were of relatively modest means in comparison to their counterparts in port cities such as Boston. Nevertheless, about mid-century, their desire to emphasize their status as community leaders led them to build or remodel their houses in the newly fashionable early Georgian style.

There are structural indications that Ashley's house began life with a center chimney and a steep pitched roof. In the 1750s, however, the parson replaced the pitched roof with a more commodious gambrel type and replaced the central chimney with a center hall and stairway, adding a chimney on either side and a pilastered chimney-breast wall to the north parlor. He may also have added an elaborate pilastered and pedimented front doorway, although clear evidence of the eighteenth-century

doorway no longer existed when the Flynts acquired the house.

Parson Ashley's house now resembled those of his fellow River Gods and bespoke his aristocratic ambitions. Although the present doorway is contractor William Gass's own design of the 1940s, based on but not an exact copy of a typical Connecticut Valley doorway, it conveys the formality and dignity of the originals (see fig. 13). These lively ornamental entrances were the work of a small number of joiners who created them from mid-century to 1800 for upwardly mobile patrons in the Connecticut Valley.[3]

Because most eighteenth-century Deerfield houses were unpainted and had weathered to a dark brown, a painted house was immensely fashionable. There is documentary evidence that in his later years Parson Ashley painted his house blue, though there is no indication of the exact shade. Even though Ashley was seemingly always in need of money, his choice of blue paint has been described as of "particular extravagance." It has further been said that when painting a house, "whether an expensive blue or even an inexpensive red or Spanish brown...the desired effect was to suggest the solidity of a freestone or brick masonry structure and to give the house a 'well-finished' appearance."[4]

Having gone to such trouble over the exterior of his house, Ashley would naturally have felt bound to maintain sufficiently affluent standards of hospitality within. Records indicate that he ordered rum and wine in quantity and often bought luxury items such as sugar, pepper, rice, salt, tea, soap, and chocolate.[5] When entertaining a minister from nearby Northfield, the Ashleys produced a feast of a "fat roast pig." On other occasions they served such local delicacies as "salmon, veal, custard, baked bear, Indian pudding, and raccoon."[6]

When Parson Ashley died in 1780, his son Elihu moved into the house and lived there with his family until his death in 1817. His son Thomas Williams Ashley then inherited the homestead and so it went, passing down through the family until the Flynts acquired the property.

Ashley's descendants had decided by 1869 that, as a residence, the house was hopelessly old-fashioned. They had moved it to the back of the property and put up a more modern home in its place. Languishing in a field, the parson's house lost its eighteenth-century doorway, nearly all of its interior paneling, and its paint (see fig. 12). Windows were boarded up, walls and floors were torn out, and its dim interiors were used for storing crops and perhaps for sorting tobacco. In 1945, Deerfield Academy and the Flynts collaborated on buying the property with the understanding that the 1869 house would be moved down the street to the Academy to provide much needed lodgings for faculty and students. The Flynts would then return the derelict eighteenth-century building to its original site on the street and restore it.

William E. Gass took on the job of repairing and renovating the old house. He wrote Henry Flynt in August of 1945, "I have looked over the Parson Ashley House and this house really talks. There is not any house in the Connecticut Valley that can begin to equal [it] for proportions and detail."[7]

Gass's enthusiasm for the Ashley House was fortunate—perhaps even necessary—because the task of restoring it was formidable. Original exterior doorways, clapboards, and chimneys were long since gone. The roof and the surviving later clapboards were rotting. What happened inside Ashley House during its sojourn in the field is unclear. One man from a neighboring town told of buying a paneled wall from the house in 1921 for use in his summer home; when he asked if he could buy additional paneling, he "was told that it would be too much trouble to remove it."[8] Henry Flynt believed that much paneling was destroyed in 1945 when the house was moved from the field back to its initial site, for he wrote Bill Gass, "I recall definitely that there were some large sections of panelling in this house which were still good but which are now in pieces, with many of the panels split and others sawed off and others exposed to the weather and others broken."[9] Whether the movers, earlier farm workers, or the elements had ruined these paneled sections is not known, but the only original interior paneling now in the house is that which serves as the north wall of the front hall and the south wall of the parlor, and the wainscoting on the two outside walls of the study.

Luckily, when the moldering clapboards were removed from exterior walls, the sturdy vertical-plank siding beneath bore markings that revealed many original features. Among them were the placement of windows and doors, the basic shape and size of the front doorway, and the existence of a leanto in Parson Ashley's day.

Similar evidence on the interior disclosed the original placement of walls and staircase, the shapes of moldings, and the location of fireplaces. The paneling that had survived in the front hall provided a pattern for reproduction paneling for other walls. Bill Gass and his crew studied nail and mortise holes, outlines on beams and plaster, and other clues, trying to create as accurate a picture of Parson Ashley's house as possible. In places where there were no indications of original work, Gass seems to have relied equally on his knowledge of other local houses with similar features and on his imagination for guidance. He later claimed that he copied the front hall stairway from one in a house in nearby Hatfield, and was inspired to design the pedimented front doorway by the doorway of a house in neighboring Hadley.[10]

Bill Gass's own workshop produced all the woodwork

needed to restore the house, from cupboards to paneling to baseboards and moldings. He used old material, so that the finished house would look properly aged. As became their standard practice, the Flynts also assigned Gass to install plumbing and other modern facilities, and to create an apartment behind the dwelling to house Deerfield Academy faculty.[11] When work was completed, three years after it was begun, the Flynts invited all of Deerfield to a series of opening receptions. They had, they wrote, "endeavored to catch the spirit of the 18th Century" within the walls of Ashley House. Visitors found their efforts notably successful. They came from near and far and loved the house, which has been widely published and copied. In fact, says Architectural Conservator Bill Flynt, "There are Ashley Houses all over the country."[12]

Its popularity has several probable sources. Although it represents the home of one of Deerfield's elite eighteenth-century families, the Ashley House isn't intimidating to the ordinary viewer. Its proportions, while dignified, are not stately; its rooms, while ample, are not overwhelming; and its pedimented entrance, while ornamental, is of a familiar local type. Its surrounding property, populated with barns and other out-buildings, indicates the family's participation in seasonal agricultural endeavors. The Ashleys may have been "of the better sort," but they engaged in ordinary daily activities like everybody else and visitors can therefore relate to them.

When the Ashley House opened to the public on May 4, 1948 (admission fifty cents plus ten cents tax), Americans were struggling to achieve equilibrium after the upheaval and uncertainty of the war years. As soldiers returned to civilian life, they wished to concentrate on home and family, to turn away from the outside world and its problems. Communities like Deerfield and dwellings like the Ashley House offered a setting that suggested to many the stability and harmony of an idealized American past. Even if they lived in the standard interior spaces of Levittown, these nostalgic Americans were inspired by Deerfield's dignified old houses and furnishings to personalize their own dwellings. The Ashley House symbolized not only the serenity and harmony postwar Americans craved, but also the simplicity, dignity, and virtue they believed were characteristic of America and the American way of life, in contrast to the unspeakable conditions of wartime Europe and the Pacific.

As early as 1939, Bela Norton of Colonial Williamsburg had stressed to Henry Flynt the importance of doing as much research as possible before beginning a restoration

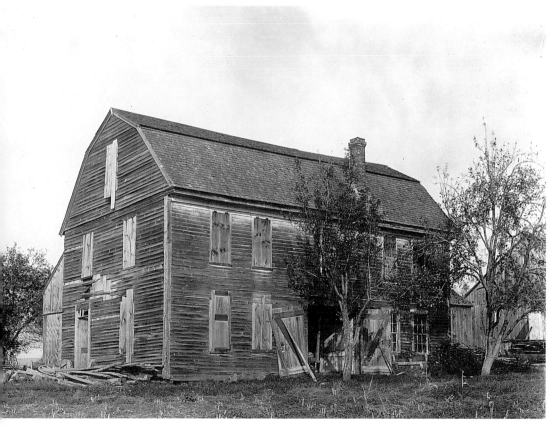

12. The Ashley House as it looked after it was relegated to a field behind the house lot in 1869. The Flynts rescued it in 1945, restored it, and opened it as a museum in 1948.

project.[13] Therefore, Flynt hired Miss Jean Campbell to do research and enlisted Deerfield friends and Ashley family members in an effort to find out everything possible about the house. As the site was being prepared to receive its original building, Flynt sent a telegram to Headmaster Frank Boyden saying: "Cannot emphasize enough importance of archaeological work on new Ashley House cellar / Suggest Sheehan West or some other young master might take this on at my expense if necessary / Saving all fragments china wood pottery or other items."[14]

Although this attempt to understand the material culture of Deerfield in the Reverend Ashley's day was by no means so sophisticated as such a project would be today, it indicates Henry Flynt's serious interest in documentation and his willingness to pay for it. Research unearthed much information about the Reverend Ashley, which the Flynts used to procure furnishings and decorations that would "depict the entire span of the Parson's life in the house—1733 to 1780." They acquired Ashley family and other suitable local pieces by both loan and purchase whenever they could and, says Philip Zea, "they even reproduced the Ashley family dressing table, which family members were to retain."[15] They supplemented family and local pieces with objects from the greater Connecticut Valley and from New England as a whole.

Simple inexpensive and old-fashioned pieces furnished working spaces such as the kitchen and the parson's study, where daily routines took place (see figs. 18, 23, and 24). Fashionable objects such as a mahogany desk and bookcase, Chippendale chairs, and a tea table set with imported china were reserved for the best parlor, used only on special occasions (see figs. 15 and 17). The Reverend Mr. Ashley, as the town's minister and one of its most prominent citizens, was expected to entertain and provide lodging for important visitors to Deerfield. The Ashleys accommodated guests in the best chamber (probably also the master's chamber), which thus contained such luxury items as a set of English crewelwork bedhangings, a high chest of drawers, and an imported looking glass.

Since the Ashley House first opened, scholars have added considerably to our knowledge of the architecture, life styles, and material culture of the Connecticut Valley in the colonial and Revolutionary periods.[16] While the Flynts, like all other collectors of the 1940s–1960s, erred on the side of furnishing Ashley House more fully, more lavishly, and more according to modern notions of comfort than is now believed to have been the case in eighteenth-century Deerfield, they succeeded in setting an engaging scene in which to discuss the Ashley family's daily life.

The kitchen contains a variety of utensils, gadgets, pots, and pans that illustrate colonial cooking methods. Tables and cupboards hold pewter, horn, wood, and ceramic tablewares that exemplify the materials and forms available to families of the Ashleys' station. The parson's study is furnished with a mixture of relatively recent and earlier styles, demonstrating that while a minister might have fashionable objects in his best rooms, his means did not necessarily permit such extravagance throughout the house. The books in the study, the Flynts wrote, "are on history and ecclesiastical subjects, also sermons, several by Parson Ashley himself, some even in his own handwriting...," to give the viewer a sense of the Reverend Ashley's pursuits and interests.[17]

Because of his concern with history, Henry Flynt also made much of the fact that the Reverend Mr. Ashley was a Tory in a largely Whig environment. "The Parson," stated a newspaper article describing the opening of Ashley House, "was a fearless defender of his opinions in religion, education, and politics, although they were often on the side of the minority and caused bitter criticism."[18] The Reverend Ashley refused to read Thanksgiving proclamations ordered by the Continental Congress, held a tea party in defiance of the nonconsumption [of tea] act, and is thought to have encouraged his son to participate in chopping down the liberty pole erected by the Whigs to signify their desire for independence from England. Telling visitors about all of this not only shed revealing light on a fascinating eighteenth-century political situation, but it also made for good stories. Stories and anecdotes were important to the Flynts in making Deerfield and their houses come alive for guests.

Today, the staff has made some furnishing changes and interprets Ashley House differently. Instead of presenting it as an accurate representation of the Reverend Ashley's home, guides now use it as a sympathetic setting in which to discuss the ideas and society the minister's family embodied. "The numbers of objects are incorrect," says Philip Zea, "but the types of things are correct." Zea adds that the curatorial staff is always on the lookout for objects known to have been owned in the Deerfield area during the Reverend Ashley's lifetime. A recent example in this category is a wonderful famille rose bowl that Historic Deerfield has acquired and that the curatorial staff intends for display in the Ashley House parlor.

This revised interpretation does not conflict with the Flynts' essential goals, however. Although some currently acceptable historic-house furnishing practices would almost certainly surprise them, the emphasis remains on the important constants—on the Reverend Ashley, on his house, and on his family's life within.

13. The Ashley doorway, with broken scroll pediment and pilasters, a "Bill Gass original" of the 1940s inspired by traditional Connecticut Valley doorways of the second half of the eighteenth century.

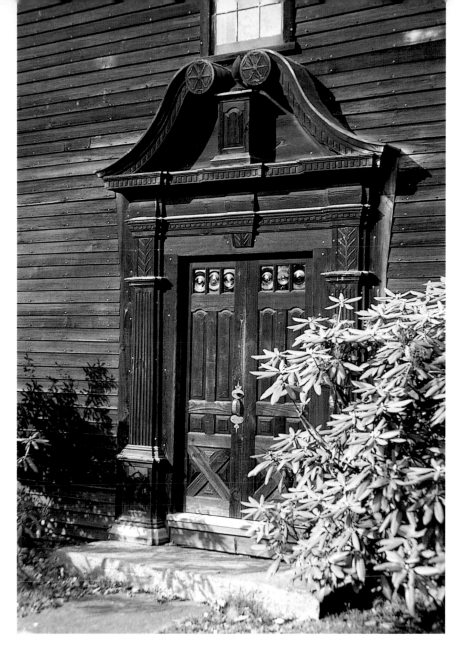

14. Helen and Henry Flynt at the opening of Ashley House in 1945. With them are (*left to right*) the painters "Brownie" and "Pete" Chevalier and contractor Bill Gass.

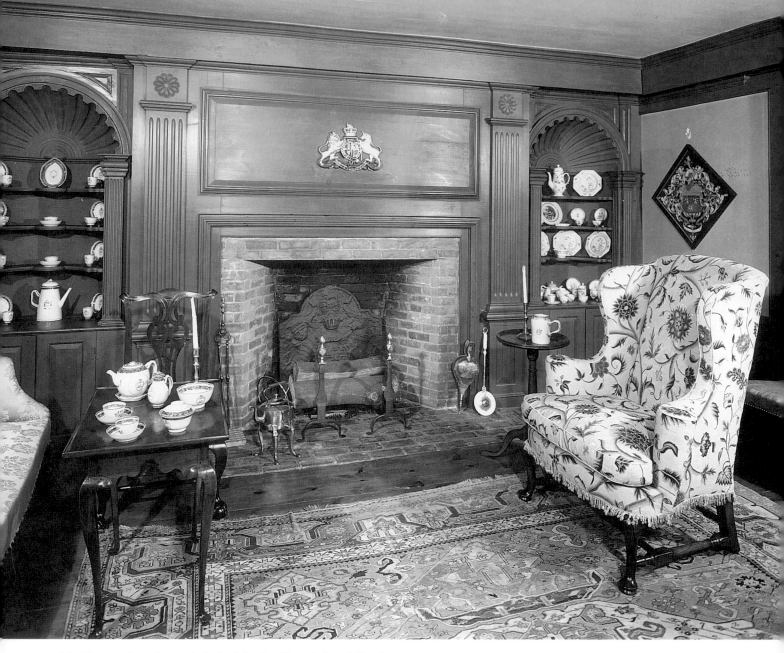

15. The north parlor as it looked in the Flynts' day. Like the Ashley exterior, the parlor was much published and influenced house-museum restorations across America. Popular—although not necessarily authentic by today's standards—features included the ceramics-filled cupboards, the crewel-covered easy chair pulled up to the fireplace, the laden tea table in front of the sofa, and the splendid oriental rug.

16. Entrance hall showing original paneling on the north wall. ▶ The portrait is believed to be of the Reverend John Williams of Deerfield, Parson Ashley's predecessor and a member of elite Connecticut Valley "River God" society. The Queen Anne chairs, made in Boston, belong to a small group of chairs made in the eighteenth century and decorated in the early nineteenth. Such chairs had great appeal to collectors of the Flynts' generation, who thought they had been sent to the Far East for japanned decoration.

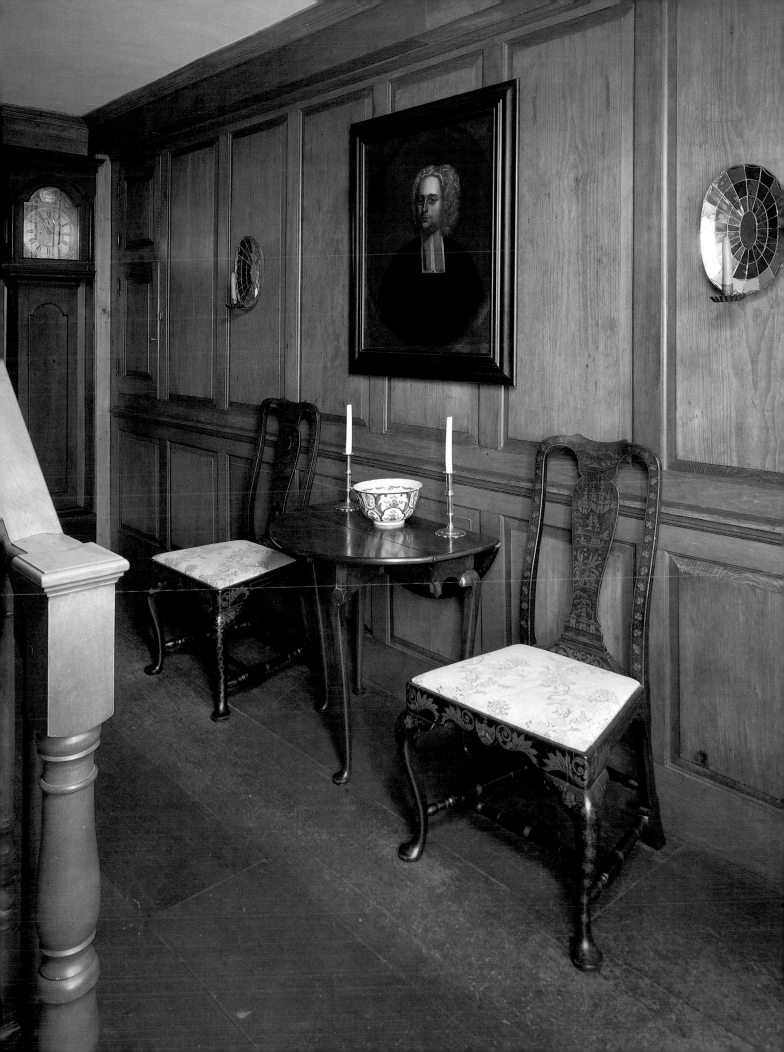

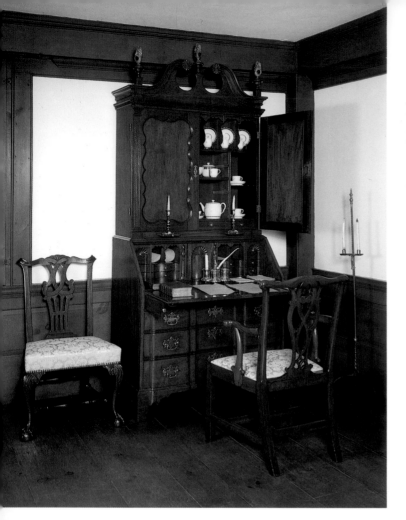

17. Parlor, northeast corner. The Flynts were very proud of this splendid Boston desk and bookcase, replete with a blocked base and pierced, gilded finials, and a history of having been owned by a minister in the Connecticut Valley in the eighteenth century (the Reverend John Marsh of Wethersfield). It is the kind of fashionable status-giving piece the Reverend Ashley might well have owned—or wished to own. Its upper section contains English ceramics, a very decorative treatment and one that has long been popular with collectors, but one that was not employed in eighteenth-century New England, where books would have filled the shelves. The Portsmouth, New Hampshire, armchair pulled up to the desk was Henry Flynt's favorite—he sits in it in his formal portrait, with the Onckelbag silver cup at his elbow.

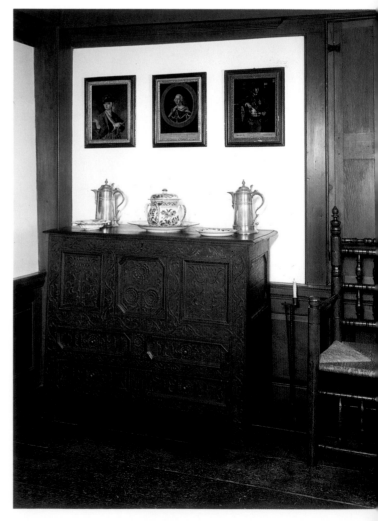

18. Study, southeast corner. This group, containing a Connecticut Valley chest, delft and pewter wares, English mezzotints splendidly colored and in original frames, and a turned great chair, represents the Flynt aesthetic, says Philip Zea. "Every collector," Zea maintains, "had to have a 'Brewster' chair, even if it was heavily restored, as this one is." It was the juxtaposition of aged wood with the colors and textures of early ceramics and pewter, and the romantic appeal of eighteenth-century mezzotint portraits that captivated the Flynts and their collecting friends—and that continues to attract many of us today. The Wethersfield chest, a particularly well-made example of its type, descended locally in the Billings family.

19. Slipware plate, English, seventeenth century, shown on a table in the study. This striking example of English slipware—a rare and coveted form today—illustrates the range and quality of the Flynts' ceramics collection.

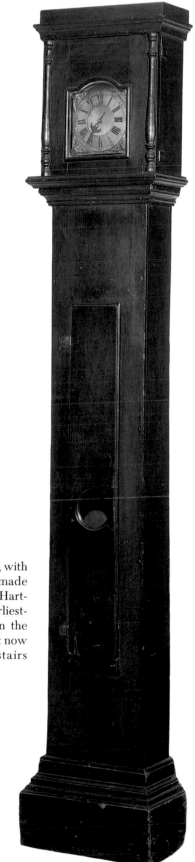

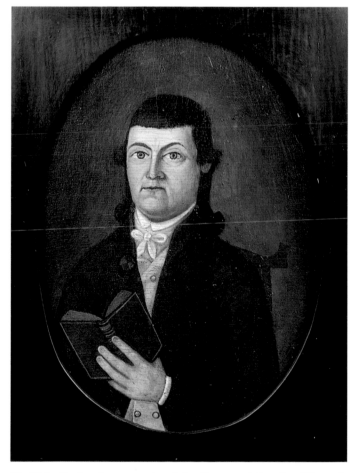

21. Tall clock, c. 1740, with brass and steel works made by Seth Youngs of Hartford; this is the earliest-known clock made in the Connecticut Valley. It now stands in the upstairs hallway.

20. This diminutive portrait, of the Reverend Stephen West of Stockbridge, Massachusetts, was painted by Joseph Steward of Hartford. Fittingly, it occupies the best chamber, as West himself would have done had he visited the Ashleys. Dr. Stephen West Williams of Deerfield was Dr. West's namesake.

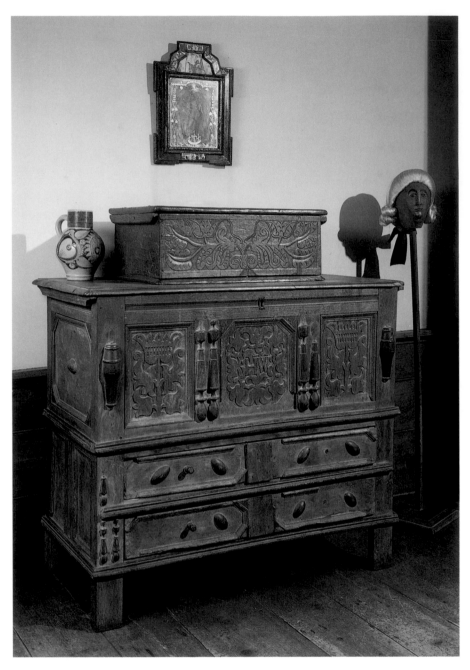

22. This group in the south chamber "sums up the major shop traditions in late seventeenth-century Connecticut Valley joined furniture," says Philip Zea. The two-drawer chest, of the Wethersfield type, is a splendid example of a characteristic form, with much of its old color and in unrestored condition. It supports a box decorated with incised carving of the type called "Hadley," which ornaments another group of Connecticut Valley casepieces. The engaging wig stand beside them, which was probably made in Deerfield, bears the inscription, "For Elijah Williams, Esq." Williams was a prominent Deerfield merchant.

23. The open-shelved cupboard in the ▶ kitchen contains a stunning display of English and Dutch delftwares, including on the second shelf from the top a set of the famed—and much coveted by collectors—Merry Man plates. Contractor Bill Gass probably added the frilly wooden scallops to this Salem cupboard.

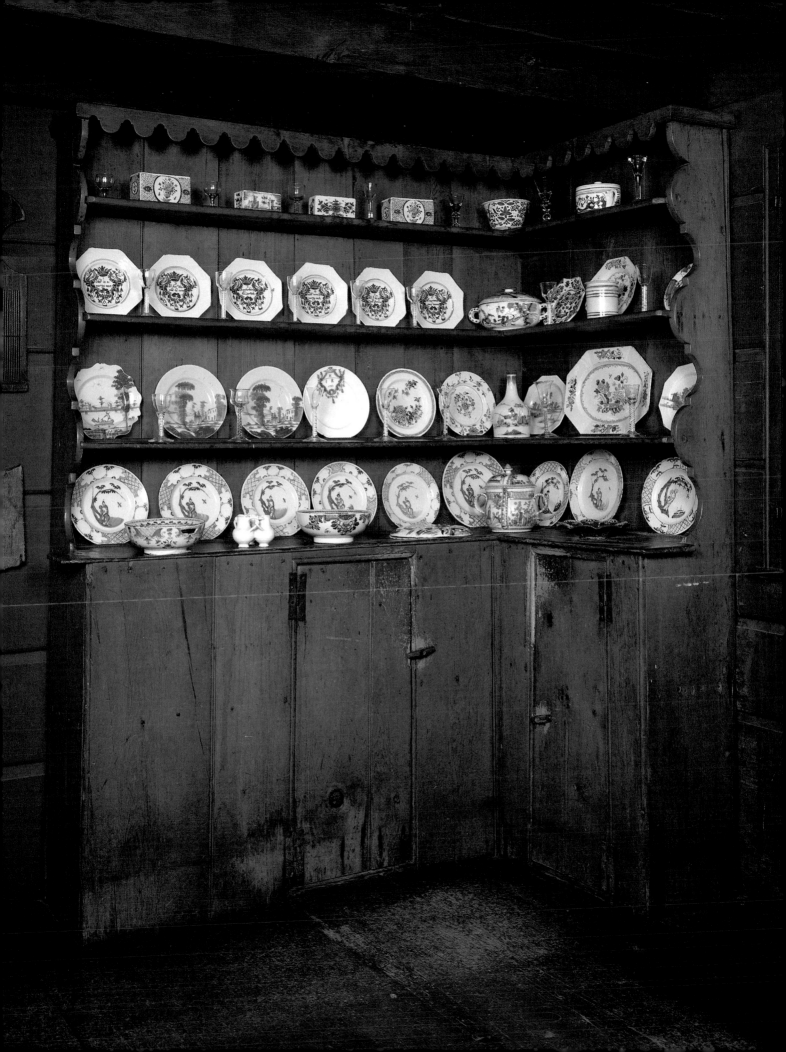

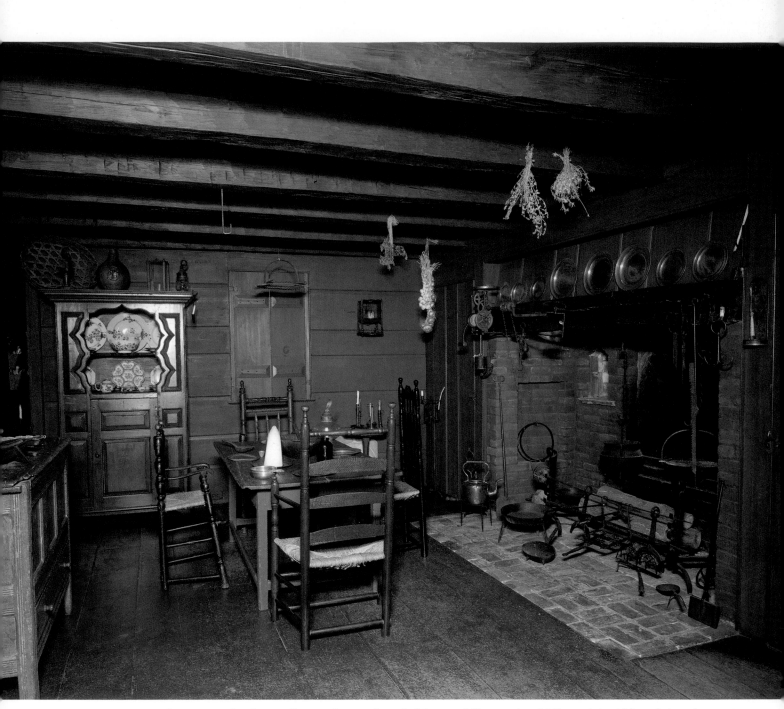

24. On the opposite kitchen wall is another cupboard, this one of Connecticut Valley origin. Although it and most of the other pieces visible in this view were originally painted, the Flynts and contractor Gass liked the effect of interiors filled with mellow unpainted wood surfaces, and the Ashley kitchen reflects that bias. Delft, pewter, copper, and brass wares add highlights.

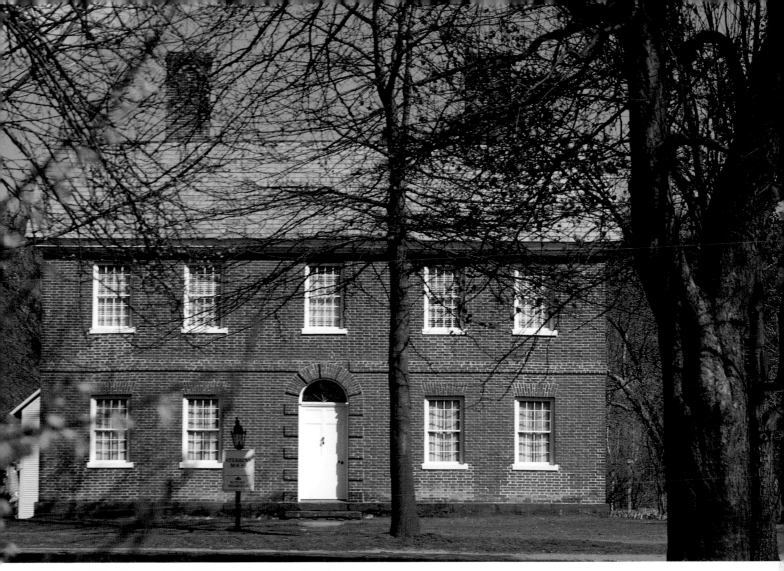

25. Asa Stebbins House, built 1799, as restored by the Flynts.

The Asa Stebbins House

Unlike the Allen and Ashley Houses, which represent a provincial colonial style characteristic of the Connecticut Valley, the Stebbins House exemplifies a new departure. Its brick construction sets it very decidedly apart from earlier houses of wooden clapboards. Brick was rare in Deerfield until the very end of the eighteenth century, when Asa Stebbins was the first to build his residence of that material.

Asa Stebbins was born in Deerfield in 1767. His father and older brother, both named Joseph, were successful farmers and tradesmen and were active in town affairs. Asa's brother Joseph was in the company of Minute Men who marched on Lexington and, according to Deerfield historian George Sheldon, "He came to the front as a patriot leader at the outbreak of the Revolution...." Asa, too, eventually became a colonel in the militia, though he never achieved such prominence as his brother.[1]

Asa did follow his father and brother in becoming a successful farmer and entrepreneur. "Like their father," said a local newspaper article of the brothers Joseph and Asa, "they took advantage of every demand of the public by creating the supply. Their father had been a tanner, cordwainer, currier and shoemaker...." With his brother Joseph, Asa built "the famous Meadow Mills," south of Old Deerfield, around which a number of active industries grew up. Asa also participated in the raising of "stall-fed oxen," choice beef cattle bred for sale in Boston and New York in the late eighteenth and early nineteenth centuries. Deerfield farmers vied with one another in raising the fattest ox, and Asa is said to have produced one so ponderous that he had to be hauled to market on a sled instead of walking with the rest of the herd.[2]

Success in business led to involvement in town government. Asa Stebbins served for many years in a number of

capacities, including those of selectman, state representative, assessor, and justice of the peace. He also served the community by lending money to fellow townsmen on occasion. He was an equally committed father, furnishing both his married sons with fine houses, and sending both his deaf-mute children to the special school for those afflictions in Hartford. He left this house to his son Asa, who was to maintain it as the home of the two deaf-mute children.

Stebbins was on the building committee for the new building of Deerfield Academy, and was no doubt influenced in choosing brick by the fact that the Academy building (now the Pocumtuck Valley Memorial Association's Memorial Hall) was constructed of that substance in 1798, the year before Stebbins and his family moved into this house. Designed by the rising young builder/architect Asher Benjamin of nearby Greenfield, the Academy embodied the lines and proportions of the newly fashionable Federal style. Gone were the bold scrolled doorways and window pediments of the mid-eighteenth century; in their place were flat, two-dimensional façades and simple linear ornament. The only decorations Asa Stebbins chose for his new house were a rusticated surround (raised trim arranged to suggest stonelike blocks) framing the front door and a slightly raised belt course between the first and second floors—embellishments that were already old-fashioned in urban centers (see figs. 25 and 27).

The similarity of appearance between the Academy building and the Stebbins House suggests that they may have been built by the same person. Since Asher Benjamin is known to have relied on Calvin Hale, a Greenfield joiner, to assist him in supervising the building of Deerfield Academy, it may be that Hale was involved in building Stebbins's house as well.

Although the building materials and decorative elements were new, the plan of Stebbins House is traditional, with two rooms flanking a center hallway upstairs and down. The decoration of these spaces does reflect fashionable Federal ideas, however. The staircase is of a self-supporting circular plan, curving gracefully up and around to the second floor. This was a very new feature in America at this time, and its use in Stebbins's house must have caused quite a stir among his traditionally minded Deerfield neighbors. Like Jonathan Ashley and other members of previous generations, Asa Stebbins expressed his prosperity and elevated social status by building a house in a very new and forward-looking style.

Having taken in the simple linear elegance of the brick exterior, visitors stepped into Stebbins's front hall to encounter these further expressions of the new Federal style: simple, strictly symmetrical moldings around the two doors that lead from the hall to the parlors (see fig. 28), and cornice and ceiling decorations inside the south parlor that have serene swags, compass curves, and geometri-

cally regular lines (see fig. 29). Once he had decided to use this kind of decoration in his own house, Stebbins could either have bought suitable moldings in Boston or asked a local craftsman to copy them from a design book. Asher Benjamin, for example, author of the first architectural design books written and published in America, had brought out *The Country Builder's Assistant* in nearby Greenfield in 1797. In it he illustrated classical orders and ornaments which, he said, "will be particularly useful to Country Workmen...."[3]

Besides the two parlors and the front hall, the rooms on view in Stebbins House include a dining room—Stebbins seems to have had the first separate dining room in Deerfield—and an office (pantry in the Flynts' day) on the first floor and two bedchambers above (see figs. 30, 33, and 34).[4] Both the dining room and the office beside it are in the ell that extends behind the front, formal, part of the house, and their walls are gaily decorated with freehand designs. These carry out in the relatively inexpensive medium of paint the delicate regularity of the more expensive plaster ornament of the hall and parlors.

During Asa Stebbins's lifetime, his house "was considered one of the show places of the village."[5] Upon his death in 1844, the house passed down through the family, some member of which added a wooden ell to the rear. In 1889, the Lambs of Greenfield bought the house, and the next year the Greenfield *Gazette and Courier* reported that "the brick house, known as the Luke Wright place, has been bought by E. A. Lamb of Greenfield, and is undergoing repairs that will make it very attractive. A piazza on the west and south will make a great change."[6] The piazzas were duly added, the house was painted yellow, and the Lambs lived there comfortably for a time (see fig. 26). By the early 1900s, however, their fortunes had turned and they were obliged to take in boarders, one of whom was Frank Boyden, who lived there during his early years as headmaster of the Academy.

Helen Flynt recalled that when she and Henry acquired the Stebbins House from the Lamb family in 1945, Mrs. Lamb announced that there was some wall painting in the house, "but she wouldn't tell...where." At first when she looked around the house, all Mrs. Flynt could see was dust, for the plasterers were at work. Finally she noticed that "there was some painting on the wall in the dining room." She wetted the wall to bring out the pattern and it became clear that there was indeed faded wall painting in both the dining room and the small room next door, which is now called the office.[7]

The Flynts called upon Nina Fletcher Little, a distinguished collector and much respected student of early New England furnishings and decoration, to advise them on the wall paintings. Mrs. Little's studies had led to her identification of an itinerant artist named Jared Jessup, whose work she felt the Stebbins wall paintings

were. Jessup had offered his services in the Deerfield area in the early nineteenth century.[8] Local artist Stephen G. Maniatty restored the designs, leaving patches of the original wall in both dining room and office so that visitors can still see how the walls looked before their renewal.

The walls of the lower and upper hallways are covered with a vivid pictorial wallpaper that came originally from the Ruel Williams house in Augusta, Maine. The Flynts knew that such papers had been used in Deerfield during the Federal period—in fact, another French scenic paper remains on the walls of the parlor of the E. H. Williams House (see fig. 127)—and they felt it would be appropriate in the home of one of Deerfield's wealthiest citizens. The Stebbins House paper, made in France between 1804 and 1806 by Joseph Dufour, is entitled *Les Voyages du Capitaine Cook*, and is the earliest of the great scenic papers produced by the Dufour firm (see fig. 32). In advertising the Captain Cook paper, Dufour claimed that besides being extremely decorative and introducing buyers to exotic native regions, scenic wallpapers served a didactic purpose in teaching children history, geography, and botany.[9]

Each of the two bedchambers off the upstairs hall is also decorated with a vivid French wallpaper. The south chamber is hung with a paper imitating elaborate drapery of "heavy green-striped white silk fabric with gold fringes and ornamentation," which was block printed in France about 1815 (see fig. 33). A fashion for such *trompe l'oeil* draped-silk designs had sprung up in France in the early nineteenth century, and a number of astonishingly realistic patterns were produced, of which this is an excellent example. It is known that such papers were familiar to well-to-do residents of the Deerfield area because swag-patterned wallpapers were advertised in Greenfield newspapers from 1792 into the 1800s, and other examples survive in Deerfield. This paper also came from the Ruel Williams house.[10]

The Flynts' goal was to restore the exterior to its early nineteenth-century appearance, so they removed the porches and the yellow paint and the late nineteenth-century windows. The unpainted brick house now looks much more as it did in Asa Stebbins's day.

An inventory made upon Asa Sr.'s death in 1844 survives and the Flynts referred to it in furnishing the house. However, collectors of the Flynts' generation often refused to recognize the value and interest of objects made after about 1830, so the Asa Stebbins House was furnished with antiques of the early Federal style, made between 1790 and 1810. In recent years, curators have refurnished the office, but for the most part other rooms in the house contain furnishings the Flynts selected. Although there are some locally made pieces among them, such as a chest of drawers and a tall-clock case by Greenfield cabinetmaker Daniel Clay, many of these are sophisticated and expensive urban things that represent the Flynts' collecting interests rather than necessarily the tastes and interests of the Asa Stebbinses. In the south parlor, for example, are tables and a desk made in eastern Massachusetts and Rhode Island and shield-back Rhode Island chairs—sophisticated high-style pieces that the Flynts combined with elegant English ceramics and luxurious upholstery and curtain fabrics. The charming and appealing room embodies the taste of mid-century American collectors for fashionable and expensive urban furniture, and also the twentieth-century ability to bring rich and sumptuous objects together easily from many different places.

The walls of the south parlor are a pleasing pink color achieved, the story goes, through the mixing of some substance of that color into the plaster as the room was being finished in 1799. Mr. and Mrs. Flynt always enjoyed entertaining guests by engaging in public disagreements and Peter Spang remembers that they invariably argued about the identity of the pink additive. "It was brick dust," Flynt would say. "Why, Henry, you *know* it was sumac juice," Mrs. Flynt would counter.[11] Whatever the source of the color, it made for a charming room and one that remains much as the Flynts arranged it, with fringed-silk and Indian mull curtains, elegant high-style Federal furniture, and handsome pink Sunderland china. It is a room that embodies the tastes and interests of Helen and Henry Flynt and their collecting friends. Rather than focusing on either mid-twentieth-century collecting trends or the life and times of Asa Stebbins, however, the current staff interprets Stebbins House in terms of neo-classical design and taste.

26. View of Stebbins House as it looked in the early twentieth century when the Lamb family owned it. The brick was painted yellow, porches are evident, and the house has a Victorian air.

27. Front doorway, Asa Stebbins House, showing rusticated trim and curved interior stairway.

28 (opposite, above). Front hall, showing curved staircase, *Capitaine Cook* wallpaper, and a portrait of Greenfield (later Boston) architect Asher Benjamin discovered in an antiques shop by Peter Spang in 1981. Painted c. 1830, the portrait is attributed to Chester Harding (1792–1866), who was born in Conway, Massachusetts, and worked in Springfield and Boston. This portrait is particularly appropriate to Stebbins House, which was much influenced by Benjamin's designs. The view through the doorway is of the elegant south parlor.

29 (opposite, below). South parlor showing restrained neoclassical plasterwork trim on ceiling and at cornice level. This is the only such plaster decoration in Deerfield and is, in fact, among the few surviving examples in the entire Connecticut Valley. The delicate pink wall color is said to have been achieved by mixing some substance of that hue into the plaster when it was being applied in 1799. The secretary was made in Boston, as was the pair of chairs in front of the windows. The set of six side chairs and the card tables are from Rhode Island.

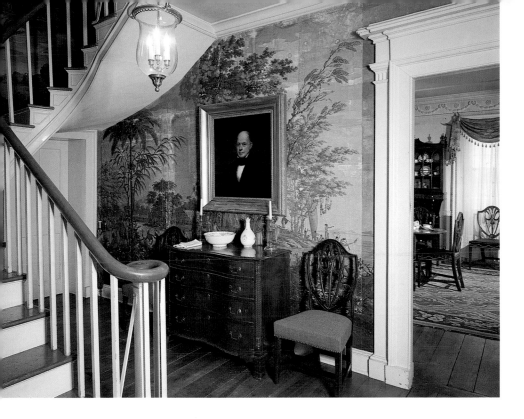

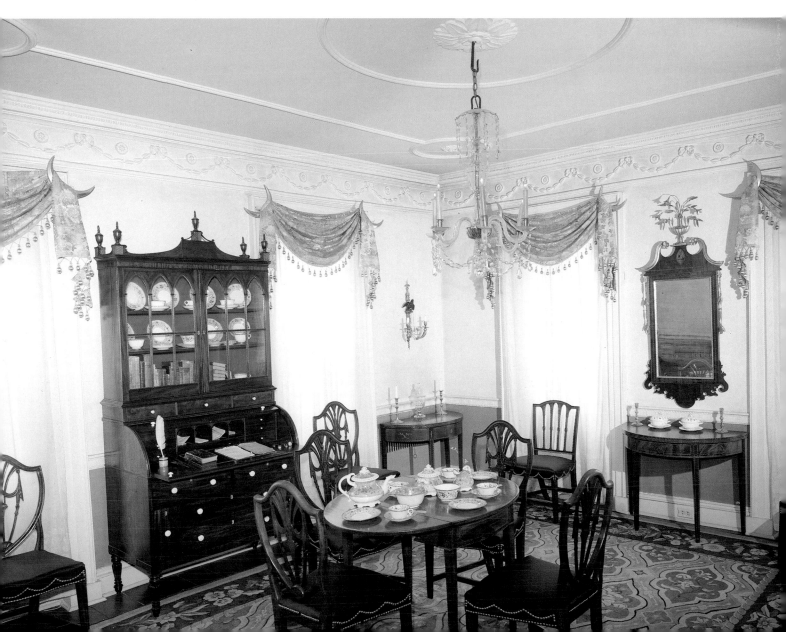

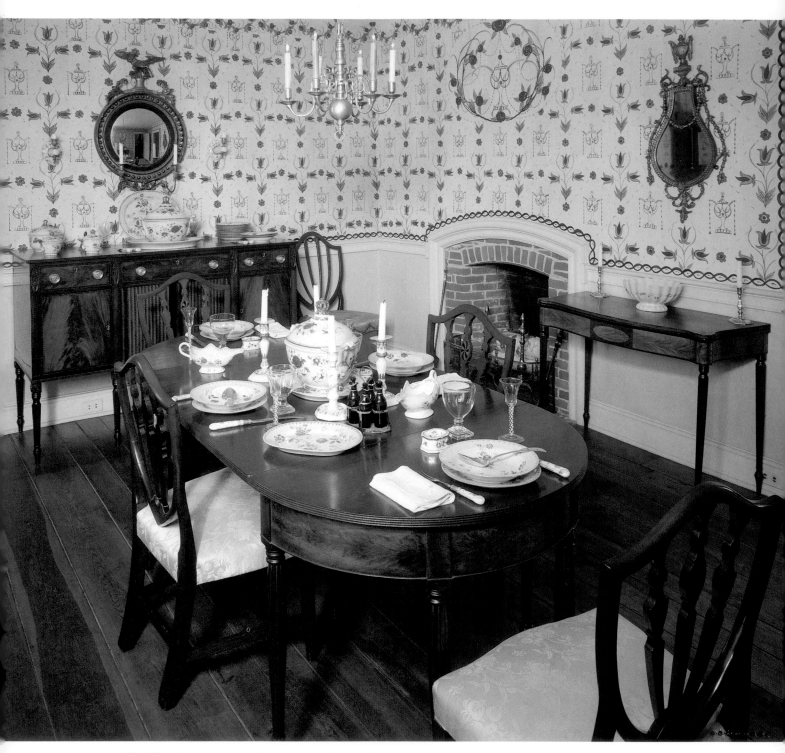

30. The dining-room walls are painted in freehand designs that were probably done by the itinerant artist Jared Jessup c. 1813–1814; the painting was renewed in the late 1940s by local artist Stephen G. Maniatty. Outstanding among the Federal furniture is the sideboard, which was probably made in the shop of John and Thomas Seymour of Boston. Connecticut chairs with inlaid splats surround the extension table from Brookfield, Massachusetts, which is set with Chinese Export porcelain from the Flynts' extensive collection of that ware.

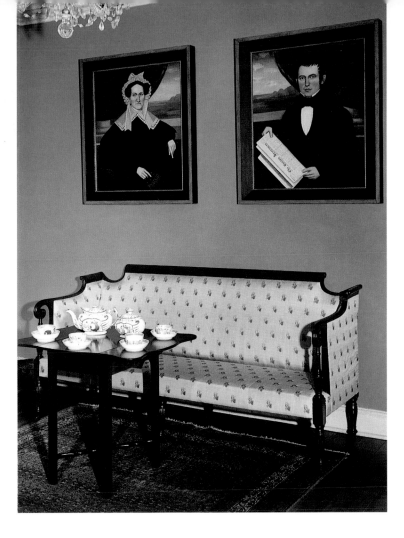

31. North parlor showing two of Historic Deerfield's seven paintings by Erastus Salisbury Field. This well-known folk painter, a native and lifelong inhabitant of the Deerfield area, was not represented in the collections until this purchase of 1989; the portraits came down in the sitters' family, from whom Historic Deerfield acquired them. The sitters are Betsey Dole Hubbard and Ashley Hubbard, painted about 1837. The date of the *Boston Statesman* Ashley Hubbard holds is March 4, 1837; it is also the date of Martin Van Buren's inauguration as president of the United States, and is "perhaps an allusion to the political role of the Hubbard Tavern, where the artist lived and worked" (*Acquisitions 1989*). The portraits are newly conserved and their colors show up particularly well against the vivid green walls, whose color the Flynts said "faithfully follow[ed] remnants of the original color, discovered after removing several layers of Victorian wallpaper" (*Historic Deerfield*, 1979).

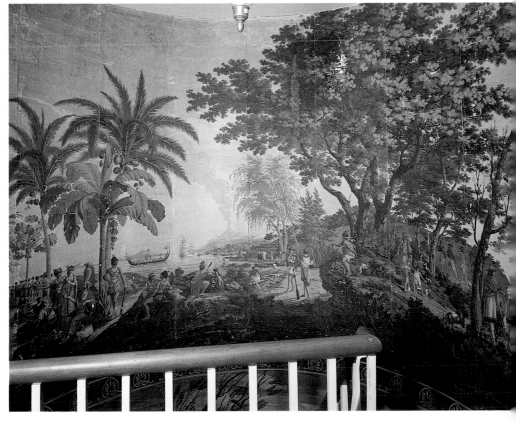

32. Stair landing, showing a portion of the wallpaper called *Les Voyages du Capitaine Cook*, made in France by Joseph Dufour between 1804 and 1806. This is the earliest of Dufour's magnificent scenic papers; it was originally in the Ruel Williams House in Augusta, Maine, which was demolished to make way for highway construction in the 1950s.

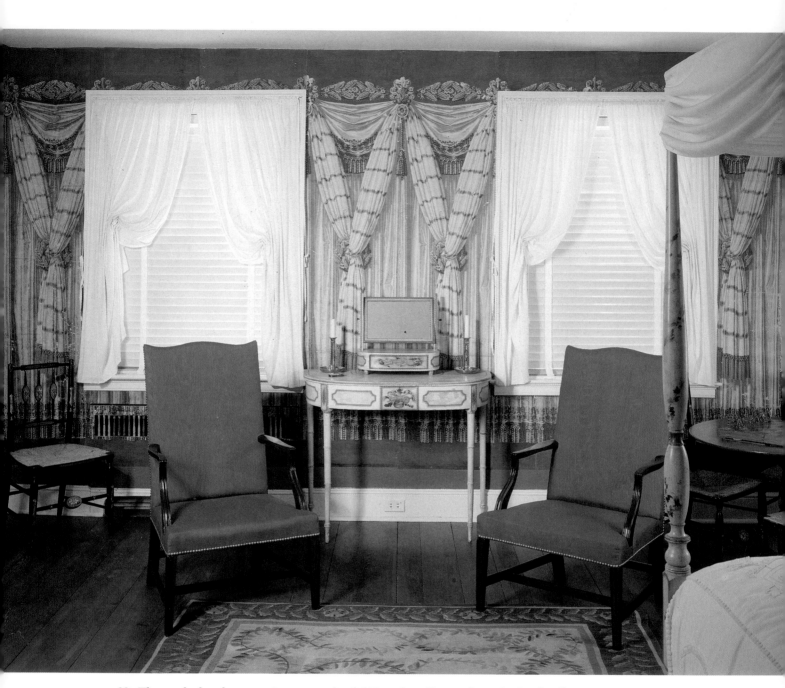

33. The south chamber contains more splendid French wallpaper from the Ruel Williams House in Maine— a rich *trompe l'oeil* drapery design. Painted furniture picks up both the colors and the light, decorative feeling of the wallpaper. The dressing table from Middletown, Connecticut, on loan from the Hascoe Foundation, is particularly fine, with its diminutive box and looking glass mortised into the top of the table. The pair of lolling chairs is from eastern Massachusetts.

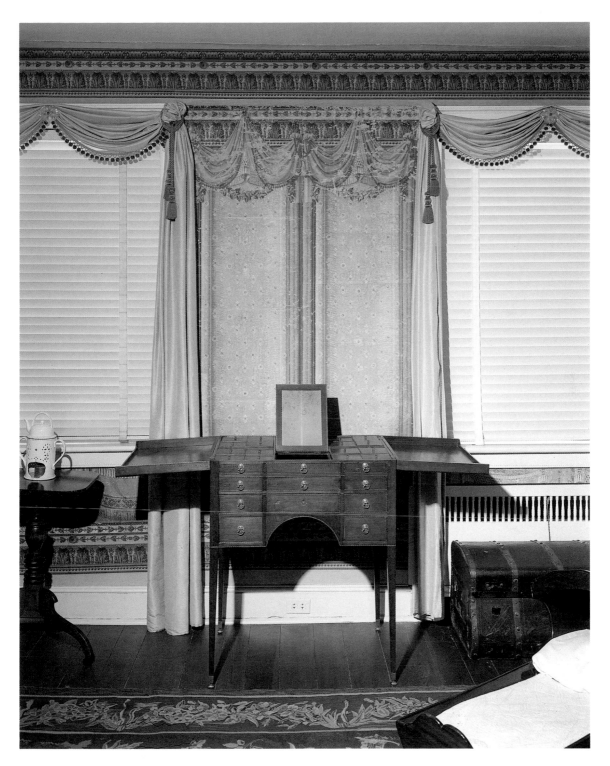

34. Yet another French wallpaper graces the north chamber; here the pattern is composed of drapery and architectural motifs. Mrs. Flynt designed the curtains to match the wallpaper. The "beau brummel," or fitted dressing table, between the windows is one of a very small number of American examples. Of cherry with an old mahoganized finish, it was probably made in Connecticut.

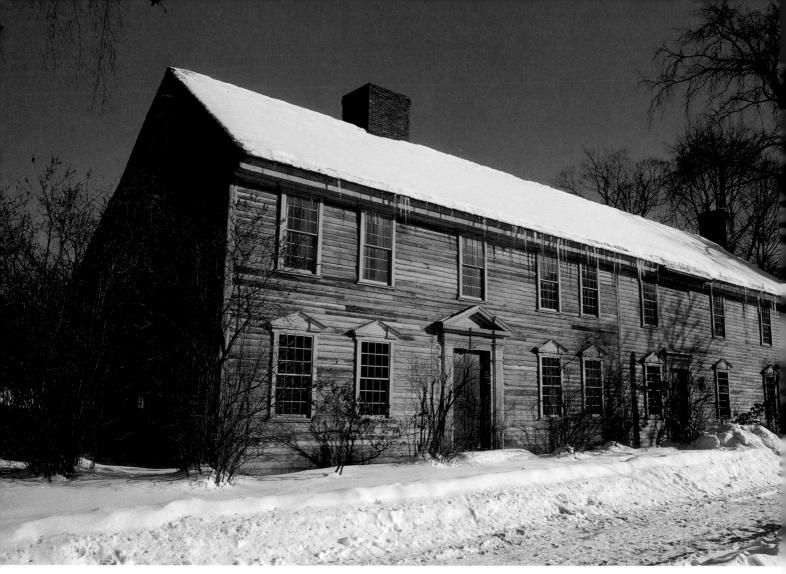

35. Hall Tavern, brought to Deerfield from East Charlemont, Massachusetts, in 1949, and opened to the public in 1950.

The Hall Tavern

The story of Hall Tavern involves a happy conjunction of lovers of history. Descendants of the Hall family of East Charlemont, Massachusetts, loved both the old tavern and the stories and memories of their ancestors Joel and Lucretia Hall, who had raised their large family and entertained in the tavern in the early days of the Republic. When Henry Flynt, who loved all kinds of history but was particularly partial to that of New England, found that Hall family descendants were distressed that the old homestead was sinking into disrepair, he was delighted to accept the Hall Tavern and to add it to the old buildings he was restoring on the street in Deerfield.

The tavern is unusual in having been moved to Old Deerfield from another town. While a number of houses along the venerable street have been moved, most have ended up only a few hundred feet or so from where they

started, and only a handful have been brought in from outside.

The building now known as the Hall Tavern began life in East Charlemont, Massachusetts, about 1765, and is thought to have become a tavern sometime after 1781. The Hall family acquired the building in 1807, and by 1812 Joel Hall, Jr., was living there with his family and keeping a tavern. Joel's wife, Lucretia, was a famous housekeeper, cook, and gardener. "Grandmother's garden was the glory of the whole town," wrote Madelene Taylor Nichols in 1911. "Everyone who came that way stopped to look at it.... Mary's earliest remembrance is of looking out the west door in the kitchen down the long walk through the garden with beautiful borders on each side."[1]

The Joel Halls expanded their house as their family

increased, at one point adding "a long low shed below and a ballroom with a vaulted ceiling above." The tavern was "the real center of Village activity both for the traveler and local people. It is said the lawyers always looked forward to their stay at the Tavern for days at a time, because they so enjoyed Mrs. Hall's fine dinners. It was the meeting place for local gossip and the looked-for spot on the trip westward and a haven for the farmers taking their stock to market."[2]

The Halls continued to run the tavern into the 1840s, although they apparently tore the bar out in the 1830s as the Temperance Movement gained strength. In 1857, the tavern passed out of the Hall family, but nostalgic members bought it back again in 1905 to occupy during the summer months. The building underwent many alterations during its stint as a summer home, and by the time the Flynts received it in 1949, it looked very different from the way it had been in Joel and Lucretia's heyday.

Flynt's interest in both distant and recent history was evident in his arrangements for a groundbreaking ceremony at the new tavern site in Deerfield. He asked local members of families who had lived in the Hall Tavern to participate, thoughtfully linking the building's past with its future.

In the fall of 1949, the tavern was taken down in East Charlemont and transported over the Mohawk Trail to Deerfield. As they had with other old-house renovations, the Flynts brought restoration contractor William Gass into the project. Gass made drawings of the building on its original site, drew up plans for its reconstruction in Deerfield, and oversaw the work. At the end of April 1950, Helen and Henry Flynt invited townspeople to an opening reception at the re-erected tavern across the street from the Deerfield Inn.

Although its function has changed over the years, in 1950 the Hall Tavern was the center of activity of what is now Historic Deerfield. It was—and still is—the information center, with guides and brochures available for consultation. But then it contained a shop that sold reproductions of wallpapers found in the Deerfield area, and a reproduction pewterer's shop complete with the tools and touchmark of Greenfield pewterer Samuel Pierce. There were also rooms furnished to convey an idea of early American tavern life, as well as the town's only grocery store, established in its own quarters in the south wing of the building. There was modern living space sandwiched in here and there, too, arranged not so much for the convenience of the tenants as for that of the restorers. Like the other modern living quarters the Flynts almost always provided in the houses they restored, these were highly unorthodox, requiring tenants to go into the museum section to get from one part of the apartment to another. And when the Flynts finally conceded that their Deerfield project required the services of a full-time curator, the first curatorial office was established in a cubicle just outside the ladies' restroom in the Hall Tavern. At that point the organization's meager library was also housed on a shelf in the information center.

Visitors arriving at the Hall Tavern entered a dim wood-paneled room lit by antique fixtures and filled with an intriguing jumble of potentially helpful but, in fact, confusing services and exhibits. The guides on duty presided over a long table placed in the middle of the room. There postcards, slides, and printed information about Historic Deerfield (then called the Heritage Foundation) were displayed on wooden stands "all done up to order in old wood."[3] Other objects displayed for sale might include willow baskets by Franklin Thorn and painted trays by Mrs. Arms, two of the last of the artisans who had been part of the flourishing craft industries established in Deerfield in the late nineteenth and early twentieth centuries. Helen and Henry Flynt were eager to support the craft tradition, but this once thriving aspect of Deerfield culture was dying out by mid-century.

Behind the guides' table was the wallpaper cupboard, where visitors could see samples of papers found in Deerfield houses and on hatboxes found in and around Deerfield that were being reproduced and could be ordered. There was also the pewterer's display, complete with a plaster figure of Greenfield pewterer Samuel Pierce, created as a surprise for Mr. and Mrs. Flynt on opening night (see fig. 37). An exhibition of old pewter, some by Pierce and some by other early craftsmen, included examples of many different types and styles of pewter objects. Ledlie Laughlin, the great pewter collector and expert, had acquired Samuel Pierce's tools, molds, and touchmark from Greenfield antiques dealer Julia Snow, and he gave this important collection to the Flynts for their display.

Not only is it rare to find surviving tools and molds of a well-known American craftsman, but no other American pewterer's touchmark is known to have survived. Here it all was, laid out for visitors to inspect and handle with nary a thought for breakage or thievery. And, to indicate how times have changed, nothing *was* broken or stolen in those early days. Deerfield was then, says Peter Spang, "one of the centers for old pewter," where interested collectors could see a wide variety of forms.

There were also pieces of pewter that were actually for sale, supplied to the Hall Tavern by pewter dealer Carl Jacobs. Which was on display and which was for sale, people wondered. But as Spang points out, things moved more slowly in those days and the guides had time to explain the different displays to bewildered visitors.

Before long the grocery store went out of business, much to the distress of Deerfield residents. The museum shop moved into that space, which was opened up so that it was accessible from the visitors' center. Eventually, the

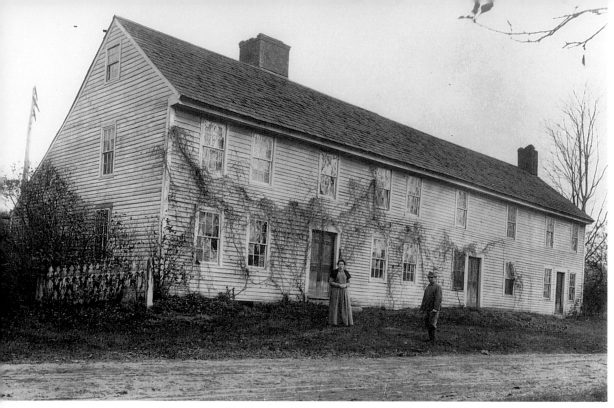

36. Hall Tavern *in situ* in East Charlemont, Massachusetts, c. 1873.

37. Pewterer's shop in Hall Tavern, c. 1950, complete with a lifesize "Samuel Pierce," the Greenfield pewterer. Pierce's tools, molds, and touchmark, seen here on display, were a gift from pewter collector and expert Ledlie Laughlin. Laughlin had bought them some years before from Greenfield antiques dealer Julia D. Sophronia Snow, who was interested in Samuel Pierce and other local craftsmen.

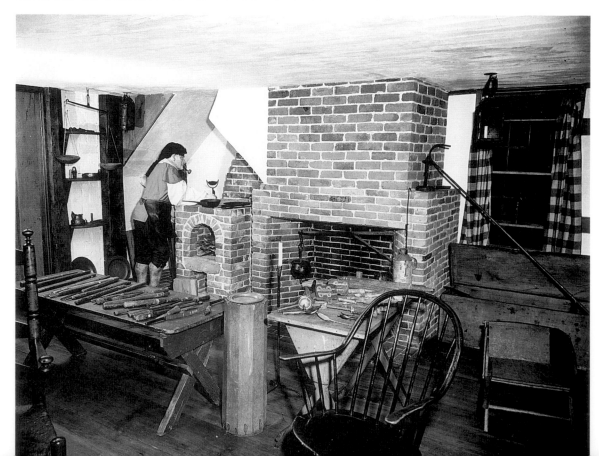

pewter and wallpaper displays were also moved, and today the visitors' center is set up in a more straightforward way. The former grocery store has now been made into an audio-visual center where visitors can see presentations relating to various aspects of the museum. And the museum shop has moved across the street to more spacious quarters in the former Pratt store.

Once they were oriented, visitors might choose to begin with a tour of the Hall Tavern. This meant moving out of the public space into the restored taproom, which opened off the visitors' center (see fig. 38). Although architectural evidence has since suggested that the bar was in a separate room behind and never actually *in* the taproom, the Flynts and Bill Gass found markings on the floor that they interpreted as indicating the presence of the bar within the room.[4] They created an atmospheric bar at one end of the taproom, complete with antique ceramics and glass drinking vessels and a barred gate to pull down at closing time.[5] Other aspects of the room that reflect Colonial Revival thinking rather than serious research include the chimney breast, which would not have been of exposed brick originally, the use of a fine set of Hogarth prints on the walls (out of place in a rural tavern), and the furniture, which included some pieces of dubious ancestry (no longer on view).

But the Flynts were delighted to have a tavern to furnish, where they could escape the domestic constraints that fettered them in the Ashley and Stebbins Houses. In the tavern they could play with ideas about drinking and eating, public entertainment, and playing games. "Mind your Ps and Qs," they would call to guests to advise them to refill their pints and quarts before the bar closed.[6] They enjoyed showing off unfamiliar objects like the tobacco box they brought back from England. After quizzing visitors about its use, they pronounced it an "honesty box," because it was necessary to put a penny in before the box would open to allow the smoker to fill his pipe with tobacco. They loved telling the story, supplying guests with old-fashioned English pennies to try the box, and providing props like the broken clay pipe to lend verisimilitude.

Another favorite was the smoke oven, which, when it was rediscovered early in this century, still contained the corn cobs that had perfumed the hams Lucretia Hall served at her renowned dinners over a century earlier. Gadgets such as the "cow's colic cure," an implement with a screw in the end for piercing and extracting an apple from a cow's throat, the corn-kernel remover, and the apple parer made for amusing stories and good times. As Peter Spang observes, "There was no Disney World in those days, and people enjoyed collecting odd and unusual things" to create their own colonial fantasies.[7]

Other collectors of the Flynts' generation who relished such intriguing survivals of an earlier day include the Wells brothers, whose immense collection of tools, gadgets, and implements is now part of Old Sturbridge Village; Electra Havemeyer Webb, whose equally vast collection of folk art and early New England everyday objects now furnishes the Shelburne Museum; and Katharine Prentis Murphy, whose Candlelight Farm in rural Connecticut, although it never went public, was the scene of many convivial antiquarian gatherings.

These collectors, although they were sincere about understanding the American past, had a more naïve and romantic attitude toward it than we have today. For one thing, much less basic research had been done and much less was known about life in colonial and Federal America. Henry Flynt could write of the taproom, for example, "Old bottles and glasses from Deerfield and other Colonial Villages, the massive exposed chimney, the beautiful old red paint and early furnishings, make it easy to visualize this room as a happy meeting place for the community to hear the latest news brought over the hills by stagecoach, discuss town affairs or just gossip, play checkers, smoke and drink."[8] He and the other collectors of his day focused on the atmosphere—the ambiance—of the rooms they created. And they assumed a past in which the inhabitants of their period rooms were all of a certain social level and degree of refinement—people not unlike themselves.

Today's curators, building on the research into inventories and other basic documents that has flourished over the last fifteen or twenty years, are able to concentrate much more specifically on how rooms were furnished, arranged, and used than was possible in earlier eras of collecting. Today's interpretation might center on what kinds of people are likely to have been present in the taproom of a rural New England tavern, what women's roles might have been, what sorts of food and drink were served and in what kinds of containers—we know about such things more specifically, so we can be more precise. The picture that emerges is often quite different from what we're used to, and suggests customs and assumptions that are unfamiliar and that traditionalists sometimes resent. Some of the new discoveries would certainly surprise the Flynts and their friends.

For example, in the research that Historic Deerfield has conducted into early cooking methods and recipes in recent years it has been learned that our assumptions about a traditional Thanksgiving meal are faulty. Susan McGowan, who conducts sessions on hearth cooking in the Hall Tavern kitchen, says there is "little evidence that turkey, cranberry sauce or pumpkin pie were more significant on Thanksgiving than on any other day."[9] What *might* have been served, Ms. McGowan suggests, is pease porridge (pea soup), egg-and-bacon pie, and Indian pudding.

From the taproom the tour continues into the parlor

where, in the early days of the restoration, there were many furnishings that have since been banished as being either Canadian or not entirely genuine. Peter Spang observes that there was so much furniture that was later identified as Canadian that Historic Deerfield now has quite a good collection of such pieces, which are brought out for exhibition from time to time. Some "worked-on" or "married" pieces—things that have been changed or added to in major ways—remain on view to illustrate both naïve and nefarious restoration practices. An example is the "poor man's court cupboard," as these simple painted two-story cupboards were called in the 1940s and 1950s when they appeared on every serious collector's "want list." There is a small group of American cupboards of this kind that are very important in our furniture history, but the one the Flynts acquired has turned out not to be among them. Still, it serves to remind collectors and students of the tactics and techniques of the furniture forger and makes a fascinating study. "Historic Deerfield has a select but strong collection of study objects of this sort in all areas of the decorative arts," says Philip Zea. He feels that there is as much to be learned from fake and overrestored pieces as from genuine objects.

Early photographs show the parlor filled with simple furnishings of a variety of periods. Combined with them are an oriental carpet and flowered draperies made of antique fabric, both hallmarks of the mid-twentieth-century Colonial Revival interior. The Flynts also hung their collection of "courting mirrors" in this room, creating a kind of additional theme for the room, as Henry du Pont and other collectors of the period loved to do. Although furnished with some of the same pieces today, the parlor has simpler curtains, a bare floor, and more the look of a simple country sitting room.

In the dining room (the original kitchen), the Flynts created their own version of the pine kitchen that remained vividly in the mind of anyone who had ever visited Harry Sleeper's colorful, eccentric, and unforgettable summer home, Beauport, in Gloucester, Massachusetts.[10] Using a mixture of old and new elements, Sleeper, a Boston decorator, created a maze of rooms whose walls, ceilings, floors, and furnishings either were or *seemed* antique. Many of the rooms had themes based on a color such as sea green, or on a material such as tiger maple, or on a famous personage such as Lord Byron. Sleeper's Beauport rooms influenced early collectors in creating settings whose purpose was to charm and to delight. When this approach got mixed up with a more serious effort to create period rooms that embodied the styles and customs of a particular time and place, as the rooms at Deerfield were meant to do, some confusion resulted. This occurred not just in rooms the Flynts put together in

Deerfield, but in nearly all period rooms devised in the first two-thirds of this century.

In the Flynts' pine kitchen (see fig. 39), which they called the Hall family dining room, a large brick fireplace, pine paneling, a long wooden table set with "treen," or woodenware, and horn spoons and cups created the desired "colonial" atmosphere. All these elements could certainly have been part of an actual colonial kitchen, but not in such profusion nor so artistically arranged. An imposing press cupboard topped with early bottles and delftware plates stood at one end of the room. A setting like this lent itself to the kind of event the Flynts and their friends loved to stage: cocktail or dinner parties for a select group of fellow collectors before the opening of a new house or collection. Spirits were high, food and drink were lavish, and nothing could be more enjoyable than to partake of them seated in colonial chairs at a colonial table lit by a colonial fixture and hand-dipped candles.

To the left at the top of the stairs is the north chamber, which, unfortunately, retains almost none of its original paneling. Across the hall, between the north chamber and the ballroom, is what the Flynts called the "supper room," which, they hypothesized, "served as a game room or sitting room for the older people who did not participate in the strenuous square dances and as an extra bedroom...."[11] More recent thinking holds that this room was a Hall family bedroom and a cloakroom for ladies during a ball.

The ballroom itself is reconstructed to correspond to Gass's drawings made in East Charlemont. According to Peter Spang, "one section of the [ballroom] wall was brought to Deerfield and the other walls were based on that. There is no evidence for the scene over the fireplace, as that area was so blackened by smoke that there was no trace of the original decoration, but New England wall-painting expert Nina Fletcher Little suggested this design."[12] The stenciled designs themselves, based on the originals, were executed by local artists Elizabeth Fuller and Steve Maniatty. The ballroom's arched ceiling was made of beams cut and bent on the Halls' property in East Charlemont.

During the Deerfield Antiques Forums the Flynts instituted, guests would come over to the Hall Tavern from the Inn after dinner. Cordials were offered in the supper room and guides were available to show the tavern informally. Then a lecture or other program would take place in the ballroom, for which guests would be seated on antique Windsor and fancy chairs. "After the talk," recalls Peter Spang, "guests would saunter downstairs and go over to see Stebbins House by candlelight. It was all wonderful and people loved the Flynts and loved Deerfield for [events] like that."[13]

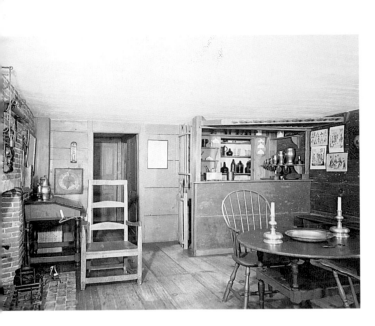

38. Hall Tavern taproom with the bar at one end, c. 1950. Peter Spang calls this room "one of the greatest triumphs of the true taste of [restoration contractor] Bill Gass, and not very accurate." Spang mentions particularly the brick fireplace, noting that the fireplace wall would have been paneled rather than being made of exposed brick. The room pleased the Flynts, however, and they loved to serve drinks in old glasses or pewter mugs, test their friends' knowledge of oddities like the "honesty box," and play early games.

39. Kitchen, c. 1950. Many of the elements of the "pine kitchen" beloved of collectors of earlier eras are present here. Among them are pine-sheathed walls; a long trestle table surrounded by an assortment of "Pilgrim-century" chairs and benches and set with copious amounts of wooden, pewter, and horn vessels; a variety of monumental brass candlesticks and other lighting equipment; and—most important of all—an enormous brick fireplace hung about with cooking, smoking, and firelighting equipment. The press cupboard on the far wall, while "rejuvenated earlier in this century," according to furniture expert Dean A. Fales, Jr., is still a "noble late-seventeenth-century eastern Massachusetts cupboard." Splendid examples of delft and glass wares adorn its top. This room provided a perfect setting for the special dinners the Flynts loved to create for fellow antiquarians.

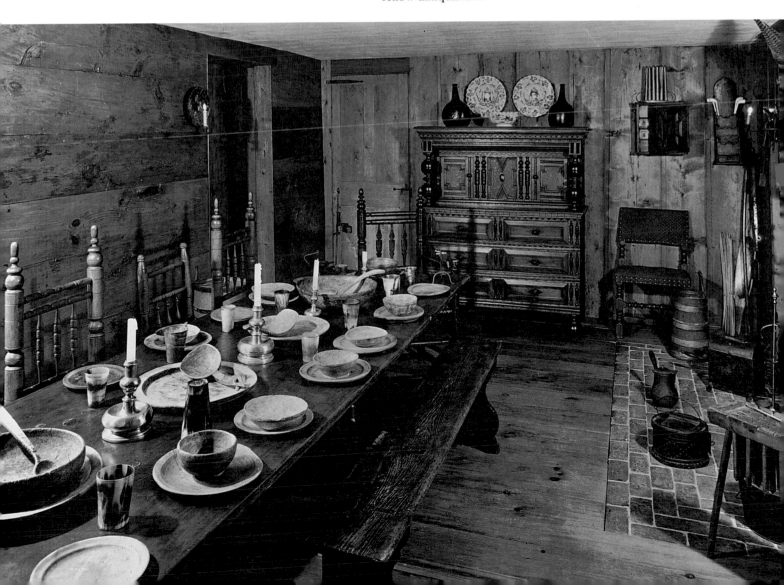

40. A demonstration of historic cookery in the Hall Tavern kitchen as it looks in the early 1990s gives visitors an idea of kitchen technology in Lucretia Hall's day.

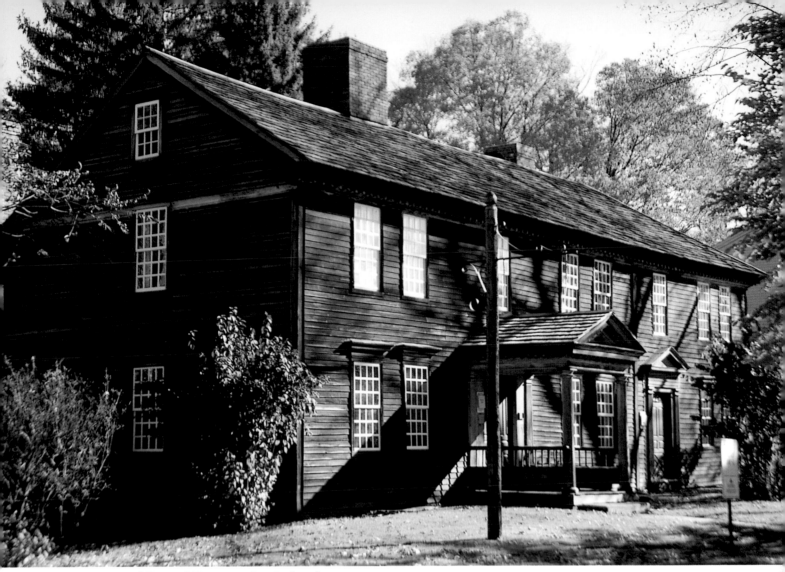

41. Frary House and Barnard Tavern as they look today.

The Frary House and Barnard Tavern

One day in the first quarter of the 19th century, a little girl rode with her kitten on top of the stage coach during the all-day trip from Springfield to Deerfield. She came to visit her grandparents who lived in the south part of Frary house.

This timid little girl was to become famous as an educator of girls, for her literary activities, for her historical research, and for preserving one of the historic landmarks of Franklin County. She was C. Alice Baker....[1]

Nearly a lifetime later, in 1890, when the little girl had long been a woman, she returned to the house as its owner. She recorded in her personal notebook that she had paid $1,150 to her cousin George Sheldon, who apparently acted as her agent in purchasing the house. She spent almost another $5,000 to restore it, for when she acquired the building, it "was almost a ruin. There was a hole in the roof; the lean-to leaned over-much; there were no windows in the parlor, which was then used for sorting tobacco and was the resort of idle children; a hen had made her nest in the little entry."[2]

C. Alice Baker's ancestor Samson Frary was one of Deerfield's earliest settlers. His name first appears in records for 1670, in connection with the lot the Deerfield Inn now occupies. Samson, his wife, and two of their children died in the French and Indian attack of 1704, and although Miss Baker believed that the oldest part of Frary House was built by Samson, the house is now thought to have been built in the mid-eighteenth century. Samson's son Nathaniel, who survived the attack, sold the original lot and bought the lot Frary House now stands upon. In 1752 Nathaniel's heirs sold the property to Joseph Barnard, and a Frary descendant never again owned it until Miss Baker's day.

In the 1760s, Salah Barnard bought the property and

altered the house substantially both in that decade and the next. Salah's additions included paneling the fireplace wall, boxing the summer beam, and creating a built-in cupboard in the parlor. In the mid-1790s, Salah added a tavern onto the south end of Frary House. The tavern wing "included a ballroom with such Federal details as a vaulted ceiling, arched alcoves, and benches along the walls."[3] This addition, with its numerous public and sleeping rooms, meant that the family could live privately in the earlier part of the building. One student points out that the addition of the Barnard Tavern greatly increased the length of the building along the street. "This elongated façade," he says, "was as much a mark of a commercial establishment in the eighteenth century as the asphalt parking lot is today. Its multiple windows and doors are intended to be inviting."[4]

When Salah Barnard died in 1795, "he left the north part or Frary house, of which he had acquired ownership, and the south part, the Barnard house, to different heirs and they were maintained as separate units until 1858.... The house had passed through the hands of too many owners to mention, several of whom held it for less than a year... [see fig. 42]." Eventually farmers lived in the Barnard Tavern and used part of Frary House for crop storage. By the time Miss Baker bought the building in 1890, "a tree was growing through the roof and it had been used as a hen house and a tobacco barn."[5]

C. (for Charlotte) Alice Baker had been born in Springfield, Massachusetts, in 1833. Her father died a few years later, leaving Alice and her mother in financial straits, and as a result Alice had a rather difficult childhood. She was sent off to study at schools in Greenfield and Boston, as well as to Deerfield Academy. During the 1849–1850 school year she served as a teacher's assistant at the Academy to pay for her tuition. That same year she met Susan Minot Lane, a Bostonian who became her life companion. Miss Baker and Miss Lane founded schools in Chicago and Boston, eventually settling permanently in the Boston area.

Miss Baker was known as a brilliant teacher with a gift for making history come alive for her audience. "She can make a cobblestone live," said one of her students. As a descendant of one of Deerfield's first settlers, she became fascinated with Deerfield and New England history and wrote an account of the citizens who were taken to Canada after the attack of 1704. Entitled *True Stories of New England Captives*, it was published in 1897. No less an authority than Francis Parkman said of *True Stories*, "It is an excellent piece of original research and a real contribution to New England history...."[6]

An offshoot of her interest in history was Miss Baker's fascination with old houses and antique furnishings. She amassed a sizable collection, which at first furnished her room in her mother's house in Cambridge, and later over-

flowed into the garret. Besides furniture and architectural fragments, which she collected to furnish and decorate her homes, Miss Baker amassed notable collections of pewter and early English enamels. Margery Burnham Howe, in her charming picture of life in Deerfield about 1890, wrote:

Miss C. Alice Baker, who was just beginning to rescue the fine old Frary House, arranged with the tin peddlers in the area to stop whenever they were near and she bought old tankards and chargers for a few cents more than the junkmen offered, thus beginning her fine collection of early American pewter.[7]

In her will Miss Baker specified that her pewter "always [be] kept together in my dining room...properly catalogued and described and carefully guarded."[8]

Just before she purchased Frary House, Alice Baker had received a letter from her cousin, historian George Sheldon. "If you ever intend to buy the old house," he wrote, "you must do it now, for there's a hole in the roof and it's fast going to destruction."[9] Miss Baker took heed of Sheldon's warning and went to work on purchasing Frary House. Afterward, when someone asked why she had bought it, she gave three reasons: "To rescue it; To dance in it; To make a summer home for my mother." She also intended to share the house with Miss Lane and Emma Lewis Coleman, a younger woman who had become their companion. Miss Lane was an artist and photographer and Miss Coleman was a photographer and writer to whom we are indebted for her memories of Miss Baker and Frary House. In addition, Miss Coleman seems to have helped a good deal with furnishing the interior of Frary House, as Miss Baker's main interests with regard to the restoration were apparently in collecting and architecture.

Although many of her friends thought Miss Baker was crazy to take on such a derelict house, Emma Coleman praised her "courage and vision" in making the purchase. "As we went through it," Miss Coleman wrote of their first inspection trip to Frary House, "we literally went through a floor-board which broke beneath our feet...but that first day Miss Baker's mind saw it restored almost as it stands today."[10]

To rescue Frary House, Miss Baker called upon the Boston architectural firm of Shepley, Rutan, and Coolidge and on Clarence P. Hoyt, a Boston architect who was born and grew up in Deerfield and who had experience in "colonial" architecture. Miss Coleman wrote of the restoration:

Miss Baker was very fortunate in having the aid of Mr. [George] Sheldon, Mr. Horatio Hoyt and his son Clarence, all of whom took the greatest interest in this restoration. I remember that one night we were called from our supper to admire Mr. Hoyt's cart, piled high with treasures he had

rescued from the woodpile of an owner who didn't like "old wooden closets and partitions"—which were indeed treasures for the dining room.[11]

The restoration team immediately set about repairing Frary House and its attached Barnard Tavern, and altering them to Miss Baker's specifications. Outside they made a number of changes, including adding old doors and a copy of an eighteenth-century portico to the main entrance. Among interior changes were the rebuilding and adding of chimneys, the making of extensive repairs to structural elements, and the adding of an extension that provided more space and light in the dining room and in Miss Baker's bedroom above. When Miss Baker decided to restore the building she also decreed that there should be no modern facilities like electricity and plumbing. Since the house and tavern were only her summer home, the hardships were far fewer than if she had lived there year round.

For many years C. Alice Baker had been collecting fragments of old buildings, and she incorporated many of these into Frary House. Oliver Wendell Holmes's house was next door to her in Cambridge, and when that was demolished she secured architectural fragments. Miss Coleman reported that Miss Baker brought panels and drawers from the room in the Holmes house "in which the

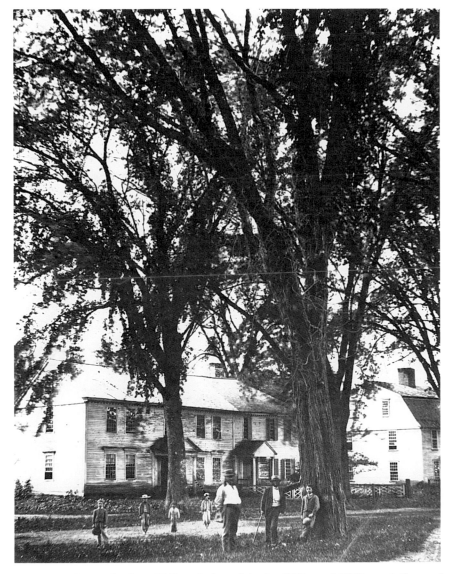

42. Frary House, built c. 1740 and altered in the 1760s and 1770s, and Barnard Tavern, added to Frary's south side c. 1795; photograph made in the 1860s.

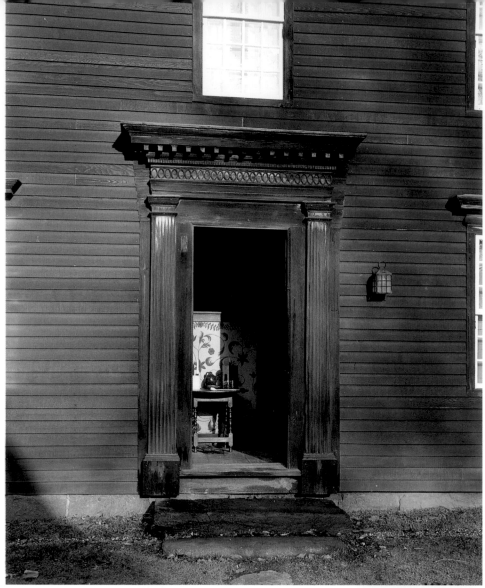

43. South door of Barnard Tavern, built mid-1790s, exhibits elegant Federal pilasters and cornice.

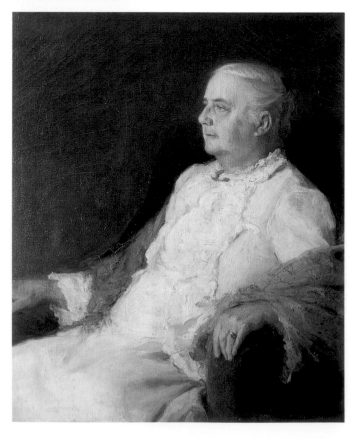

44. *C. Alice Baker* (1833–1909), 1900, by Augustus Vincent Tack (1870–1949).

American generals planned the battle of Bunker Hill...."[12] It also seems likely that Miss Baker knew of renowned newspaperman Ben: Perley Poore's country estate, Indian Hill, near Newburyport, not far from Boston. Poore was one of the earliest collectors of old-building fragments, beginning just after the middle of the nineteenth century. He built many of his fragments into his house, as Miss Baker did, and furnished it with an eclectic assortment of antiques, as Miss Baker also did. Among other influences on Miss Baker was the local historical society, the Pocumtuck Valley Memorial Association (PVMA), which was crammed with antique artifacts, including architectural fragments, many collected by her cousin George Sheldon. She was a life councilor of the PVMA, whose period rooms (a kitchen, a bedroom, and a parlor opened in 1880) no doubt also inspired her in her collecting and in furnishing Frary House.

Miss Baker was on the job supervising workmen nearly all the time the remodeling was going on. She didn't hesitate to get involved with the real work of restoration, either. According to one researcher, "It was not uncommon to [see] her stripping paint, cleaning bricks, or searching the countryside for old windows and doors to replace those that were missing." When one of the chimneys was being rebuilt, she handed bricks to the workman one by one. Miss Coleman explained Miss Baker's reasoning: "To make sure that the big old bricks, blackened by two hundred years of smoke, were not rejected by the masons, Miss Baker overlooked the work and actually handled the bricks of her choice; causing an old Irishman to say 'I've worked in brick for many a year, but I niver had a lady tinder before.'"[13]

The remodeled house contained a parlor (see fig. 50); an office that Miss Baker called the Canada Room because of the pictures hung there; a "colonial" kitchen with a huge fireplace hung about with pots, pans, and gadgets (see figs. 47 and 48); and the Pewter Room, where Miss Baker's precious pewter collection was displayed (see fig. 46); a store or barroom and a parlor on the Barnard side; and the ballroom that Miss Coleman recalled as "beautiful in its proportions" above (see fig. 53). Upstairs were numerous bedrooms (see figs. 49, 51, and 52).

When the house was finished, complete with a suite of rooms for her mother, Miss Baker gave a fancy-dress ball in the impressive ballroom, thus accomplishing her second and third goals—to provide a summer home for her mother and to dance in the house. The dance was a gala affair to which guests wore colonial costume and danced to colonial music (see figs. 45a and 45b). Miss Coleman described it:

There could never have been a more beautiful ball in the old house than the house-warming given by Miss Baker in 1892, to which she asked the people of the village and her other friends to come in eighteenth century costume. The guests were received in the parlor, announced by our kind gardener masquerading in powdered wig and silk stockings! Being English, he dropped his aitches, to our delight.

Musicians played, a few lamps and many candles glowed, "and the gayly clad players added much to the picture. Miss Baker,—blue-eyed and blue-dressed, with a lace petticoat, blue feathers in her hair and a miniature of Washington at her throat" welcomed guests. In the ballroom John Putnam, a fiddler from Greenfield, "called off" the dances, which he had come down to teach them earlier.[14]

Thereafter, many entertaining and cultural events took place in Frary House and its attached tavern. These included readings in literature and history, musical programs, and such milestones as a "braiding bee." The whole town was often invited to enjoy these improving presentations. "Wednesday mornings" were held every week, but only for invited guests, who engaged in crafts projects while being entertained by readings "to make the work go faster." The local Red Cross was organized in the ballroom and, Miss Coleman reported, "we had much good singing and many merry dances." In 1908, the year before Miss Baker died, she and her companions held a "Bizarre Bazaar," an event that included colonial games, a children's orchestra, and singing in the ballroom, as well as a variety of booths and activities outdoors on the lawn and in the barn. Miss Coleman reported sending the proceeds of the bazaar—$1,000, a handsome sum in 1908—to the Franklin County Hospital. And, she added, "there were at least ten, possibly twelve, automobiles in Old Deerfield Street!"[15]

Upon Miss Baker's death in 1909, the building went to the PVMA with the stipulation that Miss Coleman and, after her, four of Miss Baker's cousins, should have life tenancy provided the house was cared for, fully insured, and had its taxes paid. Miss Coleman gave it up in 1932 to conserve energy and money, she said, and one of Miss Baker's Maine cousins came to live in Deerfield. By 1940, "with leaking roof over her head and unpaid taxes on her back," this cousin turned the property over to the PVMA. It was opened to the public briefly, then closed during World War II.

In the late 1940s Helen and Henry Flynt, who were by then active members of the PVMA, offered to restore and furnish the house for the Association. Thinking they were adhering to the spirit of Miss Baker's wish, stated in her will, that the premises be kept "intact and unaltered with the furnishings as typical of the colonial period,"[16] the Flynts, working with a PVMA committee and restoration contractor Bill Gass, tore out most of the changes Miss

Baker had made in order to recreate their own vision of the colonial past. Theirs was no more accurate than hers, however; it was simply conceived in a later phase of the Colonial Revival. Among the Flynts' changes were the removal of the diamond-paned windows in the dining room (the old kitchen) and in Miss Baker's bedroom, creating dark interiors where there had been light. The Flynts also added the modern plumbing and other conveniences Miss Baker had shunned, and created an apartment in the north ell. In 1969, the PVMA sold the property to the Flynts' Heritage Foundation for $50,000, which the Association desperately needed to reinforce its crumbling building.

How much C. Alice Baker's example inspired others to establish summer homes in Deerfield is not known, but it is clear that in the late nineteenth and early twentieth centuries Deerfield was a cultural and artistic center—at least in the summer. Miss Baker and her friends were as much committed to preserving the history and traditions of Deerfield as they were to their own professional pursuits as craftspeople, artists, and writers. They embraced the Arts and Crafts ideals of honesty in materials and workmanship, as well as the elitist ideas of the Colonial Revival.

The Colonial Revival, connected to and in many ways an outgrowth of the Arts and Crafts Movement, looked back at the colonial period as one of superior morals, as well as of superior architecture and decorative arts. Colonial (an elastic adjective that spanned the years from 1620 to about 1840, when the Industrial Revolution began to take hold) artifacts and buildings merited special recognition and respect, for they were not only "honestly" made by hand but they were also thought to convey the hardworking, forthright, and courageous spirit of the colonial period.[17]

It was under the influence of such ideas, and no doubt also of her historian-and-collector cousin George Sheldon, that Miss Baker decided to restore Frary House to what she believed was its original, colonial, appearance. And it must have been these same influences that inspired her to begin collecting old architectural fragments and antique furnishings even before she bought Frary House.

When it was completed, Frary House expressed both Arts and Crafts and Colonial Revival aesthetics. Some colonial features were authentically of the eighteenth century, like the paneling in the parlor, and some were modern adaptations, like the Georgian portico over the main entrance. Like most other Colonial Revivalists, C. Alice Baker seems not to have minded combining genuine and reproduction. It was the look and the atmosphere she was after, not a genuinely colonial whole. Inside, while many of the furnishings were actually colonial, there were also Empire things and recent Arts and Crafts objects like locally made baskets and needlework.

Very personal expressions of Colonial Revival taste such as Miss Baker's Frary House seemed eclectic and unfocused to collectors of the 1940s. They had been impressed by the period rooms of the American Wing of the Metropolitan Museum of Art in New York and of Henry Francis du Pont's home at Winterthur, Delaware (shortly to be opened as the Winterthur Museum), where the architecture and all the furnishings conformed to the same date and style. These museum rooms were much "purer" than the interiors of Frary House, and the Flynts considered Miss Baker's rooms incorrect, rather than an expression of a different era and viewpoint. They felt they were making a more correct statement by getting rid of the nineteenth-century changes.

Today it seems unfortunate that we have lost much of Miss Baker's Frary House, although many of her antiques are still there. Current curators have made some changes, but for the most part, the house remains as it was in the Flynts' day. Now, with the Flynts' changes and additions overlaid on what is left of Miss Baker's era, we get a kind of double exposure showing two phases of the Colonial Revival—that of the late nineteenth/early twentieth century and that of the 1940s. Present plans are to return the house to its appearance in Miss Baker's day. "We do want to clarify it as Baker's house," says Philip Zea, "right down to the house plants, if we can!"

45a and 45b. Miss Baker's ball, a housewarming for Frary House, 1892.

46. The Pewter Room to the right of the front door of Frary House, in a view taken before the Flynts' restoration. Miss Baker's notable pewter collection is displayed on most of the visible surfaces.

47. Frary House kitchen, probably 1890s. This view shows vessels of pewter, iron, and ceramics, as well as panels, drawers, and cupboards rescued from other old houses. Miss Baker found many early architectural fragments herself, but builder Horatio Hoyt also contributed some.

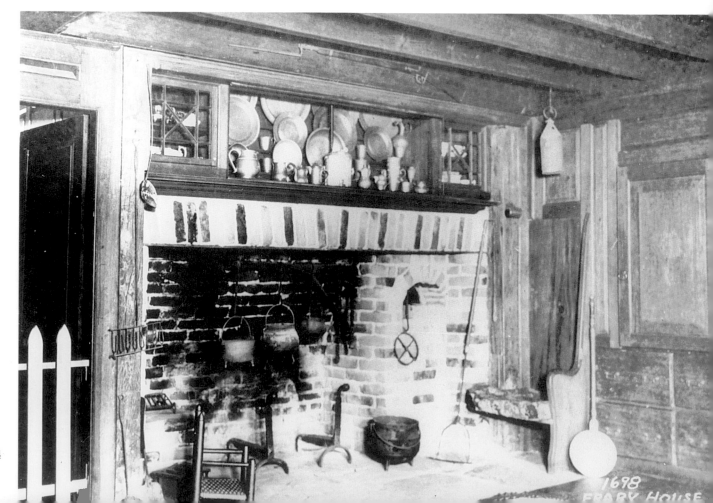

48. *Frary House Kitchen*, attributed to Augustus Vincent Tack (1870–1949), early twentieth century. This small scene shows the fireplace wall "at Miss Baker's time," according to an old label on the back of the painting.

49. North chamber of Frary House, west wall, showing an outstanding Connecticut Valley scallop-topped dressing table of the 1770s, probably made in Northampton. The curtains represent the revival of weaving and fringe-making in late-nineteenth-century Deerfield; they were made by Margaret Allen in the 1950s or 1960s.

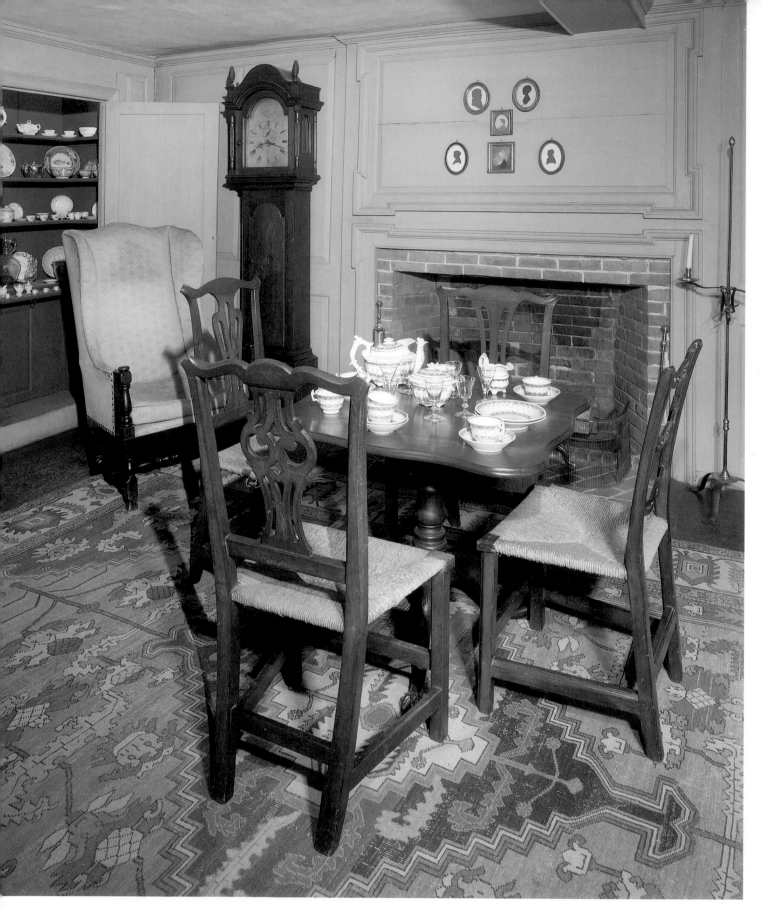

50. Parlor, furnished with objects from both the Baker and Flynt eras, except for a recently acquired tall clock made by Elijah Yeomans of nearby Hadley about 1775. Note the Colonial Revival easy chair beside the clock and Miss Baker's eclectic assortment of old china in the built-in cupboard.

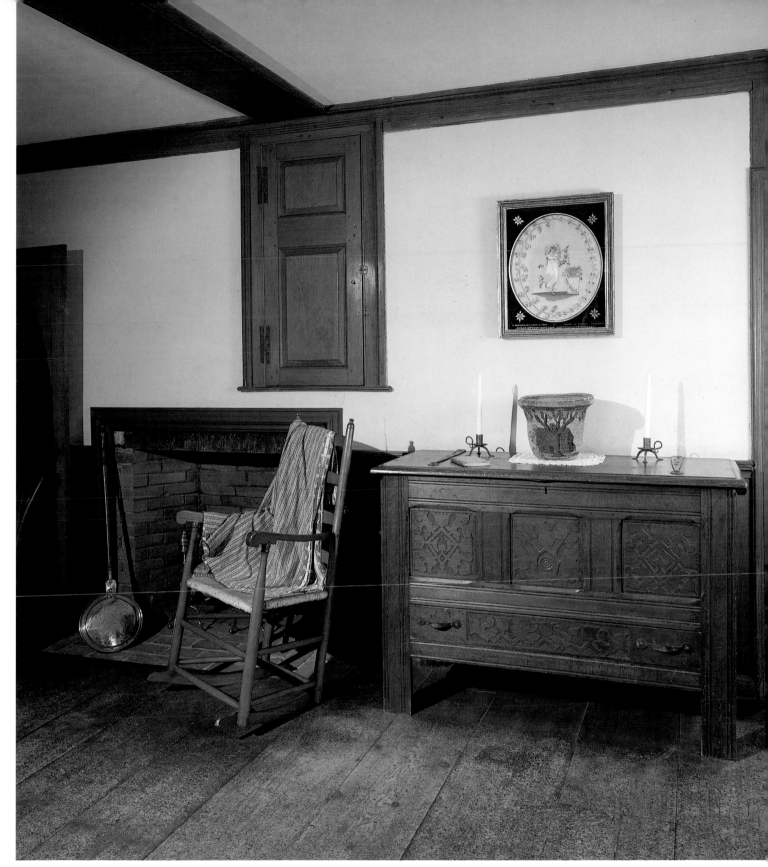

51. Grouped in the north chamber of Frary House are a number of products of Deerfield's flourishing late-nineteenth and early-twentieth-century Arts and Crafts movement—a chest of the Hadley type by Dr. Edwin Thorn and Caleb Allen, wrought-iron straps for the chest and candlesticks by blacksmith Cornelius Kelly, and a basket with a decorative picture of the Old Indian House woven into it sitting on a handmade doily possibly by Rachel Hawks. Above the chest hangs a needlework picture that states, "Wrought by Elizabeth A. Swan at Rowson and Haswells Academy." The picture, probably dating from c. 1807, is very important in the study of American needlework because it is identified with a specific school—Rowson and Haswell's Academy for young ladies, founded in Boston in 1797 by Mrs. Rowson.

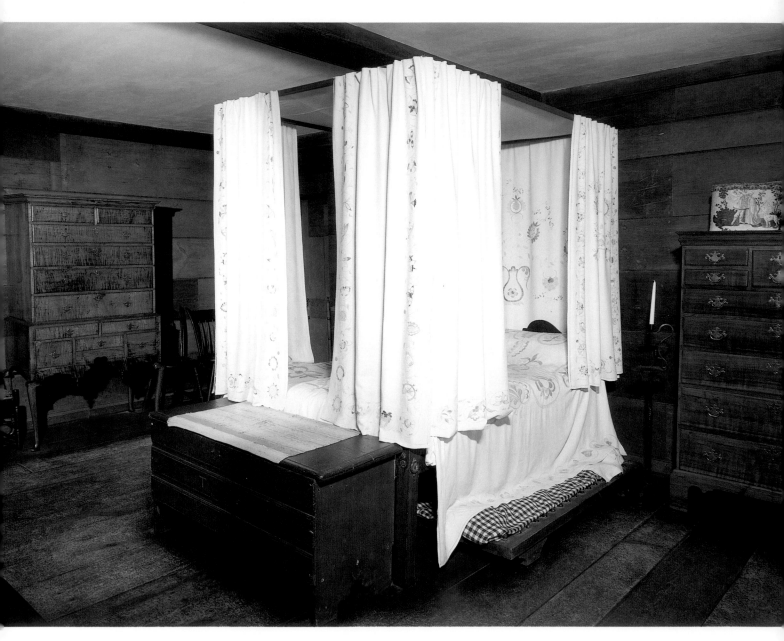

52. In the south chamber stands a bed hung with splendid blue-and-white embroideries. Such work was done by the women of Deerfield's Blue and White Society, founded in 1898 to preserve the tradition of fine New England needlework. This particular design was adapted from a bed rugg designed by Olive Curtiss of Granville, Massachusetts, in 1798. "This stitchery," writes Margery Howe, "is some of the finest ever produced by the Deerfield workers." The high chest to the left, probably from New Hampshire, belonged to Miss Baker.

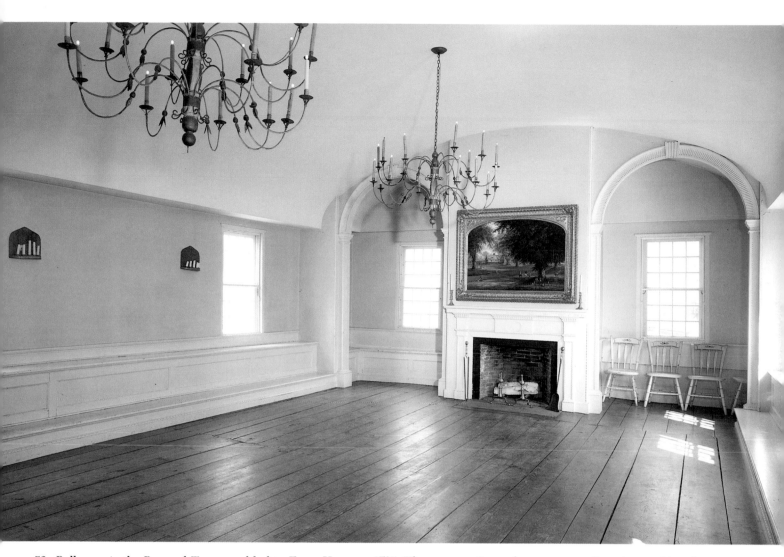

53. Ballroom in the Barnard Tavern, added to Frary House c. 1795. Three generations of owners contributed to making the ballroom look as it does today. The mantel, arched ceiling, and alcoves on either side of the fireplace are original to the room, as are the built-in benches. Miss Baker commissioned Tiffany and Co. to make the wall sconces, and the Flynts purchased the chandeliers, which are said to be from a meetinghouse in Vermont. The large painting of the 1840s over the fireplace, by Robert Havell (1793–1878), depicts the Deerfield common with the Old Indian House prominent at the far end. Considered "a Colonial icon even as early as 1840," says Peter Spang, "its demolition in 1848 came after the first organized historic preservation effort took place." During the course of the struggle to preserve the Old Indian House, which was the scene of some of the fiercest fighting during the French and Indian attack of 1704, a document was printed "in the name of historic preservation." Although the preservationists were unsuccessful, the episode raised New Englanders' consciousness about the importance of protecting historic landmarks.

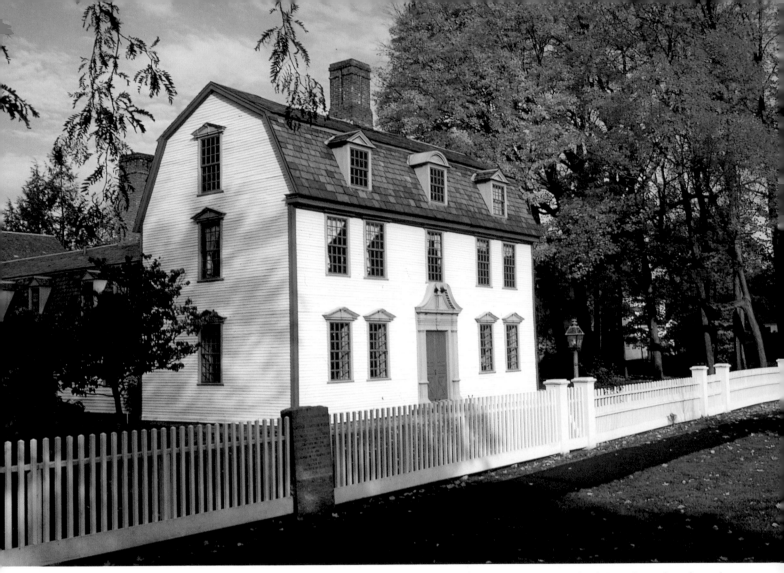

54. Dwight House, built in Springfield, Massachusetts, by David Ingersoll between 1722 and 1733, enlarged and made fashionable with window, door, and dormer pediments and a lively paint scheme in the 1750s by Josiah Dwight. Here its front portion is seen on Deerfield's old street, to which it was moved in the 1950s. It opened to the public in 1954.

The Dwight House

In 1950, *The Springfield Union* reported that "another Springfield landmark," the Dwight House, formerly one of the most fashionable residences in the Connecticut Valley, was being taken down and would be reassembled in Old Deerfield. The house had been reduced to doing "duty as a rooming house. Some time ago it became too rundown and shabby for even this purpose, and was sold to a wrecker."[1]

William Gass of South Deerfield, the Flynts' restoration contractor, got a call from the Chicopee Building Wreckers, who knew he was always interested in material from old houses. Gass recalled, "The wrecker called me up and said he had a house on Howard Street [in Springfield] he'd like me to look at. I went down and looked at it and it looked so darn good to me I called Mr. Flynt right up and

he came up the next day and we bought it."[2] Peter Spang remembers the Flynts' telling him that when they went to Springfield, "they felt so sorry for the house, which was the oldest one in Springfield, that they rescued it and brought it up to Deerfield...."[3] Although it was in sorry shape and was missing its original scrolled doorway, the house did retain many impressive features (see fig. 56). Its sturdy frame was held together by mortise-and-tenon joints, and its clapboards, which were "a source of admiration to the wreckers," were not sawed as twentieth-century clapboards are but had been split with an axelike hand tool called an adze, "and they are marvels of the workmanship of 200 years ago." Hundreds of hand-wrought nails were salvaged and reused when the house was re-erected in Deerfield.[4]

The Flynts had no site available in Deerfield for the Dwight House, so they stored it while they took down an Italianate villa that Josiah Fogg had built on the street in 1868 (see fig. 57). Peter Spang says, "To my mind, one of the greatest losses in Deerfield was to have [this Italianate house] removed...to make room for this colonial edifice...."[5] Representing a fashionable nineteenth-century style, the Fogg house embodied a taste considered today to be as legitimate and historically interesting as that for eighteenth-century styles. It was not a taste that the Flynts and others of their generation could understand or even condone, however, and they saw nothing wrong with ejecting the later house to make way for an eighteenth-century example that they considered superior in every way.

The Dwight House, according to Peter Spang, "was one of the most elaborate and monumental works that the Flynts ever did...it reflects...their taste at the height of their powers, with modest documentation and consequently, while [the house is] very beautiful...[it] is perhaps the least authentic along the street."[6] Among the reasons for this claim of inauthenticity are the facts that the house is not indigenous to Deerfield and that only the front part of the original was brought from Springfield, so that the rooms at the back and in the ell were all built by Gass in the early 1950s. The roof is slate—a nineteenth-rather than an eighteenth-century roofing material, and the chimney is Victorian rather than colonial in style. Within the house, too, the Flynts and Gass took many liberties with actual colonial building practices.

Interestingly, the result is a house that many visitors loved when it opened in 1954 and that many continue to love today, though it is no longer described as being in "authentic 18th Century style," as it was in an article a day or two after it opened. Visitors are attracted by its dressy pedimented windows and scroll doorway, its big brick-floored kitchen, its elaborately furnished parlor, and its doctor's office filled with medical equipment and other objects from three generations of doctors in Deerfield's Williams family.

Old beliefs and prejudices die hard, and this is nowhere more apparent than in historic houses and period rooms. Americans raised in the belief that huge exposed beams, unpainted wooden walls, brick floors, dim lights, and faded colors are hallmarks of "early American" and "colonial" interiors find it hard to give these ideas up, even in the face of evidence to the contrary. The fact, for instance, that there is no evidence of a brick floor in the Dwight—or in any other Connecticut Valley—kitchen, or for a massive fireplace with set-in kettle and monumental rough-beam lintel doesn't diminish visitors' delight in this room.

Peter Spang says, "We used to ask the Flynts why the kitchen was done so inaccurately, and they said Bill Gass said that his parents-in-laws' house had these features." Years later, when Spang and others from Deerfield went to visit that house, they found very few of the features Gass had attributed to it. "The whole thing," says Spang, "was just an interesting concoction as a setting for colonial furniture." But because this inaccurate, though very romantic, setting is an excellent representation of the views and prejudices of its creators, the current curators have chosen to leave it much as it was during the Flynts' time (see fig. 59). As Spang points out, "generations from now people will be studying the 1950s," and this kitchen and much of the rest of the house will be a perfect example of the taste of that era. Philip Zea calls Dwight House Deerfield's answer to the elaborate Chippendale rooms at Winterthur, and says that eventually he hopes to get the Connecticut Valley material out and add more damasks and other rich materials to point up the Flynts' taste for high-style objects.

Bill Gass, when interviewed many years later, maintained that there were New England precedents for the brick floor and that "the Flynts wanted a brick floor." Gass continued, "A lot of people like the kitchen. I think more people write and ask me if they can get dimensions...because they want one like it." But in the end, while both Gass and the Flynts consciously strove for as much accuracy as possible, they also strove for a fairly quick restoration job, eschewing unduly time-consuming research. They were by no means alone in that attitude, which they shared with nearly all their collecting friends and contemporaries.

When the Dwight House opened to the public in 1954, it was interpreted as the home of a wealthy and influential doctor's family. A writer for the Greenfield newspaper described his experience at the time: "One enters [the kitchen] facing a fireplace so interesting that for the moment the rest of the room is forgotten."[7] He describes the massive fireplace and hearth, the set kettle, and the wooden crane for drying blankets, among other objects. He then takes the reader around the room with him, pointing out furniture, lighting devices, ceramics, and some of the doctor's personal possessions. The tour continues through the doctor's office and the parlor and on upstairs, focusing on interesting and unusual objects and telling stories related to them.

Dwight House was built originally between 1722 and 1733 on Main Street in Springfield, Massachusetts, just thirty miles downriver from Deerfield. It had two stories with two rooms on each floor, a central chimney, and a garret; the builder, David Ingersoll, later added a leanto. Josiah Dwight purchased the house in 1743, and between 1755 and 1759 he added a gambrel roof, elaborately pedimented dormers, a highly fashionable broken-scroll doorway, ornamental window pediments, and the stylish polychrome paint scheme. The house remained fashionable through the middle of the nineteenth century, but then the neighborhood began to go downhill and the once proud dwelling became a rooming house. In about 1884,

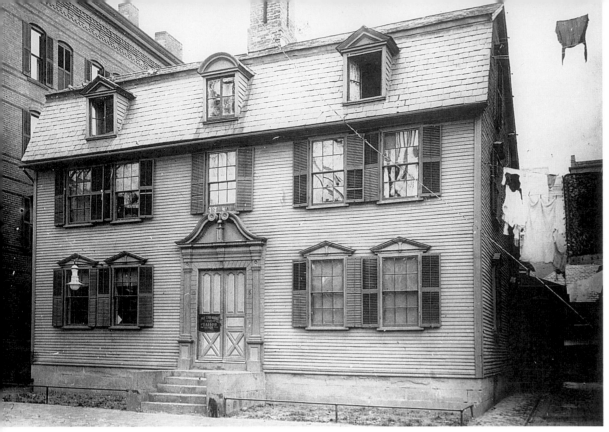

55. This photograph of the 1920s or earlier shows the original pedimented door of 1755–1759 in place before Henry du Pont bought it for his Southampton, Long Island, summer house.

56. Contractor Bill Gass's photograph of Dwight House being taken down in Springfield in the early 1950s.

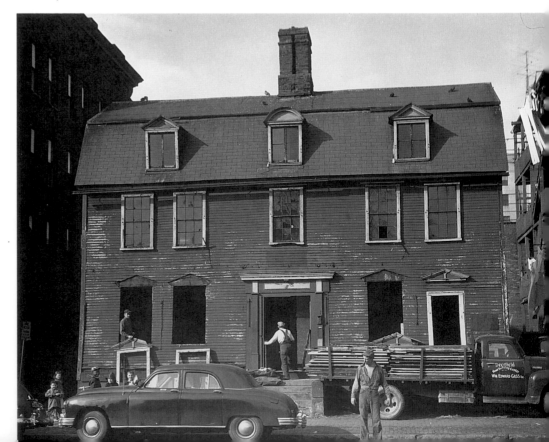

57. Fogg House, the Italianate structure that occupied this site until the Flynts razed it in order to make room for Dwight House.

58. Helen and Henry Flynt inspect the cellar hole before Dwight House is moved onto the site in Deerfield.

it was moved from its site on Main Street around the corner onto Howard Street, where it was when the Flynts bought it.

Photographs taken when the house was moved from Springfield to Deerfield in 1950 show that the window pediments survived until that date, but the scrolled doorway did not (see fig. 56). It had been sold to a collector whose identity was unknown to the Flynts until some time later, when they learned that Henry Francis du Pont had acquired it for his summer home in Southampton, New York. (He later moved it to his home at Winterthur, Delaware.) The present doorway was designed by Bill Gass, working from a 1905 photograph that showed the house with its original scrolled doorway intact.

Very little original woodwork remained unchanged on the first floor of the house. Upstairs was a different story. One of the most interesting and decorative wall treatments in all of Deerfield remains on the fireplace wall of the south chamber on the second floor. It is the original grained paneling that was added to the room in the mid-1750s (see fig. 65), and it is a remarkable survival in a house that underwent so much hard use during half of both the nineteenth and twentieth centuries. Bill Gass said that the surviving paneling on the second floor was "pretty fancy," which meant that first-floor paneling had been even more ornate, and this influenced him in restoring rooms on the lower floor.[8]

In the doctor's office, arranged in the north front room, are many furnishings and other objects from Deerfield's distinguished Williams family (see fig. 62). Miss Elizabeth Fuller, a Williams descendant, took an early and immediate interest in the Flynts' efforts to preserve, furnish, and exhibit Deerfield houses. As a result of her enthusiasm and her substantial help during the Flynts' early years in Deerfield, she was asked to join the board of what was then the Heritage Foundation. She and her sister, Katharine Arms, at first gave and lent and later gave and sold many Williams pieces in memory of their mother, Mary Williams Fuller. According to Peter Spang, who knew Miss Fuller and Mrs. Arms well, their inheritance included many objects made in Deerfield, as well as in Connecticut and Boston.[9]

The two ladies and the Flynts were particularly interested in gathering things that had belonged to the three generations of doctors in the Williams family. Dr. Thomas Williams (1718–1775) was a prominent doctor and major office-holder in Deerfield, and served as an army surgeon during the French and Indian War. His son Dr. William Stoddard Williams (1762–1829) studied medicine in Stockbridge, Massachusetts, and returned to Deerfield to practice; he, too, was active in community affairs. His son Dr. Stephen West Williams (1790-1855) studied medicine with his father and remained in Deerfield to practice; he was well known throughout New England both as a physician and as the author of books on his family and on medical biography.

Among Williams family furniture in the doctor's office (not all objects mentioned can be seen in this view) are the desk and bookcase labeled *twice* by Daniel Clay of nearby Greenfield; a cardtable with gadrooned trim, also by Clay, signed on the bottom of a drawer; some Windsor chairs; a scalloped-top chest-on-frame perhaps given to Mary Hoyt of Deerfield upon her marriage to William Stoddard Williams in 1786; and a desk-on-frame that belonged to Dr. Thomas Williams. Other Williams heirlooms include some of the apothecary jars and other ceramics, many books, and other miscellaneous items.

As both Philip Zea and Peter Spang point out, this room sums up much about the Flynts' approach to Deerfield. Zea notes that the doctor's office is proof of the Flynts' interest in Deerfield history—it features a significant group of material from the Williamses, one of the town's leading eighteenth-century families, and also locally made furnishings that exemplify the refined rural craftsmanship of the Connecticut Valley. The Flynts' historical consciousness shows, too, in their focusing on objects related to eighteenth- and early nineteenth-century medical practices. Such articles as the glass medicine jars and mortar and pestle; the drug, or apothecary, jars; crutches; bed warmer; and apothecary scales exemplify the paraphernalia of the Doctors Williams.

Another extremely interesting local heirloom is the pair of portraits of Dr. and Mrs. William Stoddard Williams by William Jennys, an artist who worked in the Connecticut Valley after 1800. Painted in 1801, the portraits are a remarkably documented addition to the collection of Williams family material. An account-book entry for the portraits survives, and informs us that Dr. Williams paid Jennys $24 for the paintings, Daniel Clay $2 for the frames, and Jacob Wicker $1.50 for painting and gilding the frames.

Although the fireplace wall is a reproduction by Bill Gass, the woodwork on the surrounding walls is original to the house. The blue paint was chosen by Mrs. Flynt; the draperies and valances she also installed were found to be too elaborate for a Deerfield doctor's office in the late eighteenth and early nineteenth centuries, and the current staff has removed them.

The south parlor, the other first-floor room to survive from the original house, is filled with Chippendale furniture of the highest New England style (see fig. 63). Since this house was made fashionable in the mid-eighteenth century by a wealthy and influential Springfield family and is furnished with many heirlooms from a similarly distinguished Deerfield family, it is fitting that the best parlor be richly furnished. Curator Zea notes that this room serves as a sympathetic setting for the rich urban furniture the Flynts bought in the 1950s.

Bezaleel Howard, whose family owned the house in Springfield after the Dwights, owned a desk and bookcase with a bombé, or kettle-shaped, base, made in Boston in the most fashionable style. It is similar to the one displayed in this room, but not shown in this view. Although it seems reasonable to wonder whether even if a well-to-do Connecticut Valley family had such a fine piece, they would *also* have a bombé chest of drawers and an imported looking glass whose bottom frame echoes the chest's bulging lines, this grouping of fashionable bombé forms reflects the collecting enthusiasms of the Flynts in the period the house was furnished.

The side chairs in the parlor are also from eastern Massachusetts rather than from the Connecticut Valley; their splats display the "owl-eye" pattern popular throughout New England in the Chippendale period. The chairs form what is known as an "assembled set": each has the same outline and splat pattern but variations occur from chair to chair in carving, crestrail, and leg treatment. The cherry tea table made in eastern Massachusetts descended locally in the Williams and Billings families. The spirited scalloping of its skirt relates to the scalloped-top chests and dressing tables characteristic of the upper Connecticut Valley (see fig. 49).

In the Flynts' day this room seemed less stark and formal because the furniture was arranged in conversational groupings familiar to twentieth-century viewers. There were more small objects scattered about to pique visitors' interest and there was a lively flamestitch carpet on the floor. Intense research into room arrangement and use have informed us in the last few years that in the eighteenth century the best parlor was a strictly formal room,

however. It was arranged with most of its furniture lined up around the walls when not in use, the exception being the tea table, which was kept set up as a symbol of the wealth and status of its owners. Even families of means did not necessarily have carpets, and many kept inexpensive slipcovers on chairs and sofas to protect their costly upholstery.

Upstairs, the two front rooms, the north and south chambers, are from the original Springfield house. Because it had been so changed during its period of service as a rooming house, it is extraordinary that the original grained paneling survives in the south chamber (see fig. 65). Such painted *trompe l'oeil* decoration was meant to suggest the elaborately grained woods used to panel rooms in the great houses of England. The dressing table shown to the right of the fireplace is described by Philip Zea as "the best one in the collection." Besides having a splendid gilded shell and drops, its front façade and top are covered with walnut veneer and its sides are inlaid with geometrical stars indicative of the best Massachusetts work. The Queen Anne side chair with sculptural shells in its crestrail and on its knees descended in the Williams family.

Like most other Historic Deerfield houses, Dwight House continues the tradition of housing Academy faculty, and an ell behind the restored museum rooms contains an apartment. "Mr. and Mrs. Flynt...felt good if they had somebody living here from the Academy," said Bill Gass, reminding us that in the beginning the Flynts bought houses in Deerfield to provide faculty housing and to preserve the colonial atmosphere—not really to create a museum.

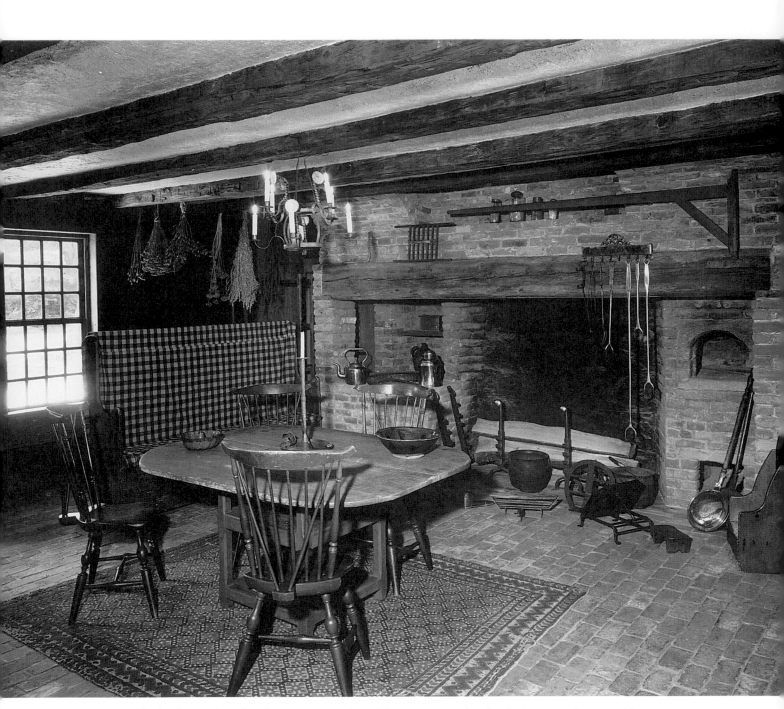

59. The kitchen, whose fireplace one writer found "so interesting that for the moment the rest of the room is forgotten." Although it is more Colonial Revival in spirit than Colonial, this room has always appealed tremendously to visitors. They love the brick fireplace and floor, the many pots and utensils, the low ceilings and exposed beams—in short, they love the ambiance. This photograph from the Flynts' day shows the kitchen table sitting upon a fine imported carpet—a hallmark of mid-fifties decorating with antiques.

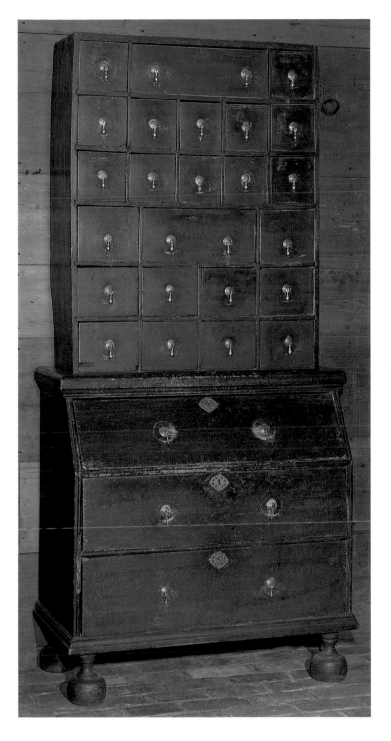

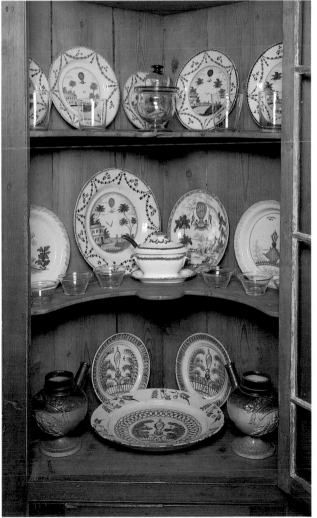

60. Apothecary chest shown against the unpainted pine-sheathed walls of the kitchen. Made c. 1725 and painted a greenish blue (which has been partially restored), this double chest of drawers descended in the Perkins family (possibly from Dr. Matthew Perkins) of Ipswich and Newburyport, Massachusetts. It is the kind of interesting, conversation-generating piece the Flynts were particularly fond of.

61. Corner cupboard filled with one of Mrs. Flynt's special collections—old plates whose theme is a balloon ascension. Objects decorated with balloons were inspired by the French Montgolfier brothers' 1783 demonstration of the first practical balloon.

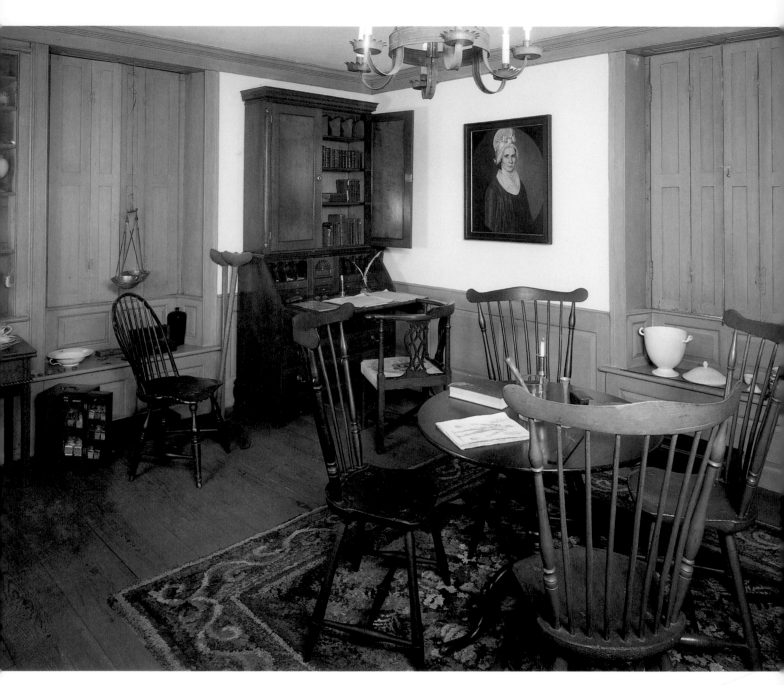

62. In tribute to the three Doctors Williams who practiced medicine in Deerfield, the north parlor has been arranged as a doctor's office. A large number of Williams family objects furnish this room, many courtesy of Elizabeth Fuller and Katharine Arms in memory of their mother, Mary Williams Fuller. Among Williams family heirlooms are the flat-topped desk and bookcase labeled twice by Daniel Clay of nearby Greenfield (given by Captain Edgar M. Williams); a card table (partial view at extreme left) also labeled by Clay; ceramics; books; and many other objects. The portrait of Mary Hoyt Williams was painted by William Jennys in 1801; a record of the prices charged for this and the portrait of her husband, Dr. William Stoddard Williams, and for the frames and the gilding survives—total: $27.50. The Flynts enjoyed gathering the paraphernalia of eighteenth- and nineteenth-century doctors, says Peter Spang, and they were particularly pleased with the pair of crutches and the wooden leg. They liked, as well, to point out the leech jar marked by Wedgwood (on the windowseat), apothecary jars, and rare important documents on the desk.

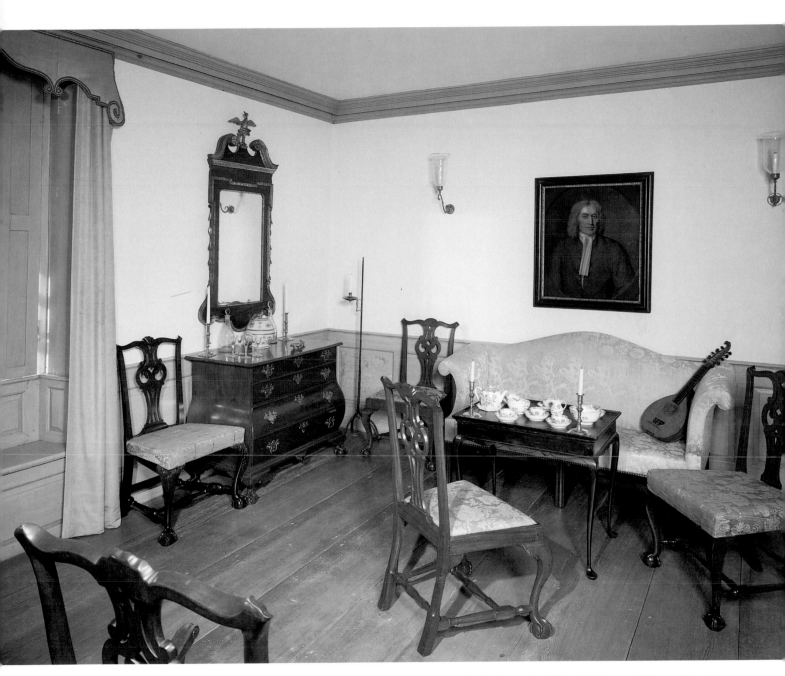

63. The south parlor presents a definite contrast to the informal atmosphere of the doctor's office. Helen and Henry Flynt's interest in the fashionable formal furniture many of their friends collected is apparent in this room. Chairs, bombé chest, camelback sofa, and tea table are all from the shops of eastern Massachusetts cabinetmakers who catered to a wealthy and sophisticated clientele. Opulent silk damasks and elaborately valanced curtains by the fashionable upholsterer Ernest LoNano of New York add another layer of richness. The painting of Deacon John Barnard is by Peter Pelham.

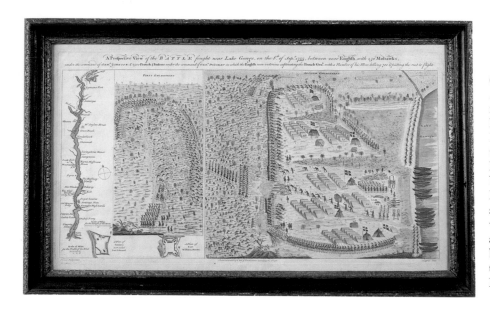

64. *A Perspective View of the Battle Fought Near Lake George, on the 8th of Sept. 1755*, reads the beginning of the title of this rare and historic engraving. Originally published by Blodgett of Boston, this is an English copy of the American version. Major Ephraim Williams, leader of a scouting party before the battle and brother of Dr. Thomas Williams of Deerfield, died in an earlier engagement shown also in this print. Dr. Thomas Williams, whose desk-on-frame is in the doctor's office across the hall, was the surgeon of his brother's regiment. He dressed the wounds of the defeated French commander, Baron Dieskau.

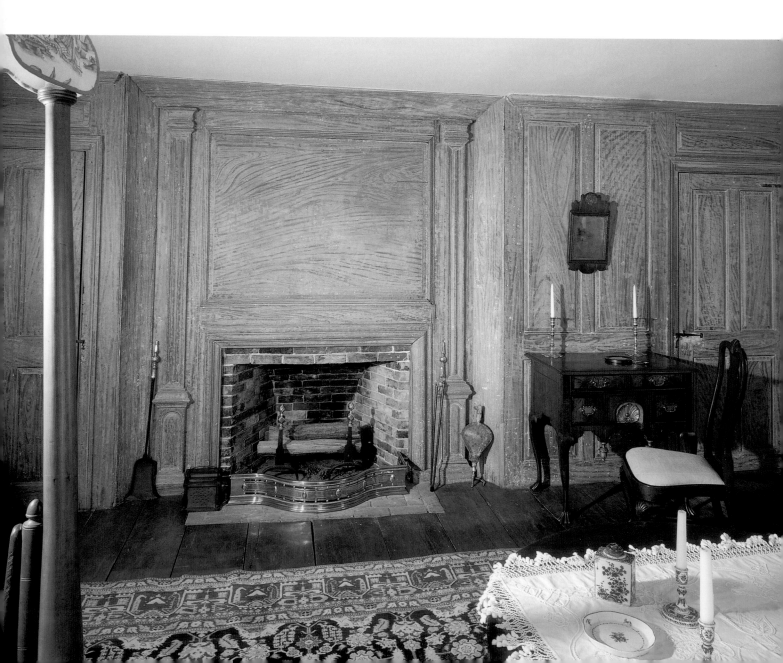

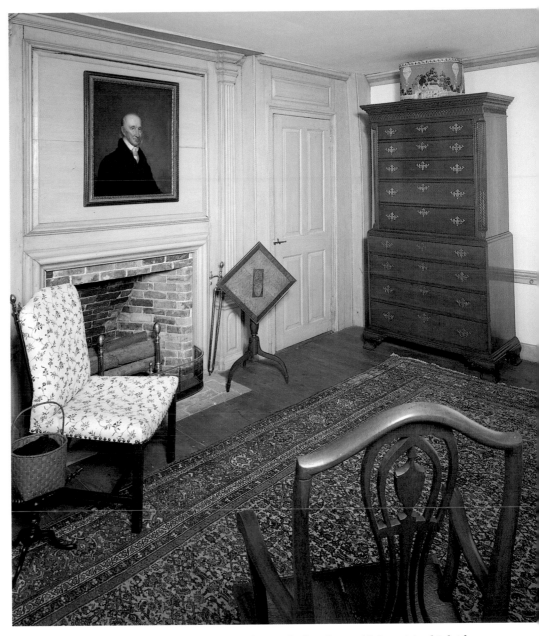

65. The original graining on the fireplace wall of the south chamber is an amazing survival, having endured through many years of hard use when the Dwight house served as a tenement. The splendid dressing table shown against the wall is "the best in the collection," according to Philip Zea. The walnut veneers and herringbone inlays of its front and sides are further enriched by a gilded shell and drops and, on the top and sides, inlaid compasslike stars. Made in eastern Massachusetts, it was owned by the Elder and Hoyt families of Boston. The Queen Anne side chair drawn up to the dressing table descended in the Williams family of Deerfield.

66. The imposing cherry chest-on-chest in the north chamber, with its spirited inlaid and carved ornament, was made by Cotton White of nearby Hatfield about 1795. It descended in the Billings family of Hatfield and Deerfield. The hatbox atop the chest, decorated with printed wallpaper probably made in America, depicts the 350-mile balloon flight of Richard Clayton from Cincinnati, Ohio—Helen Flynt's hometown—to Munroe County, Virginia, in April 1835. Against the nicely paneled fireplace wall, whose pilasters are very much like those seen on typical Connecticut Valley doorways, is a tilt-top table inlaid with a variety of lively woods.

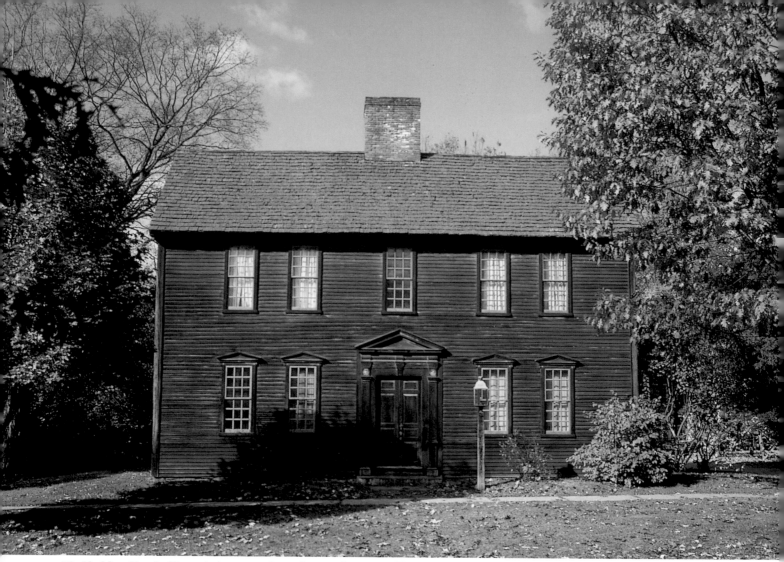

67. Sheldon-Hawks House in its restored condition. The original house was built by 1743; the gambrel-roofed ell was added between 1799 and 1802.

The Sheldon-Hawks House

Although several houses on Deerfield's main street remained in the same family through an astonishing number of generations, only the Sheldon-Hawks House stayed in the same family continuously from the mid-eighteenth century to the mid-twentieth. No records exist to tell us exactly when John Sheldon built his house on the property, but circumstances suggest that he had done so by 1743.[1]

The earliest house was made up of the two front rooms on the first and second floors and a leanto kitchen. Sheldon-Hawks's front façade is the least changed of any of Historic Deerfield's eighteenth-century houses, for it retains most of its original beaded clapboards, hand-wrought nails, and hardware, as well as its pedimented doorway—an unusual and important survival (see fig. 69).

Between 1799 and 1802, when John and Persis Sheldon

found themselves and their several children cramped in their five-room house, they added a gambrel-roofed ell containing five more rooms. Tragically, five family members succumbed to tuberculosis before 1807, radically reducing the need for the enlarged space. The added rooms were used by successive family members for a variety of purposes throughout the house's history.[2]

The John Sheldon who built the house was the grandson of Ensign John Sheldon, builder of Deerfield's revered Old Indian House and hero of the 1704 attack. He was also the great-grandfather of George Sheldon, author of the much esteemed *History of Deerfield*, and one of the town's most venerated citizens.[3] George inherited the house and farm upon his father's death in 1860.

From the beginning, the Sheldons were farmers. George, too, though he worked for a time in Chicopee, Massa-

chusetts, eventually returned to the family homestead and took over the farm. His affinity for politics and history set him apart, however, and he took what time he could to pursue those interests. In "Recollections of George Sheldon," Margaret Whiting remembered that he had told her that "his interest in Deerfield was at first no more than a strong feeling for his inherited place, in its settlement and in the family holdings that had descended to him."[4]

In 1871, George's daughter, Susan Arabella, and her husband, Edward A. Hawks, moved in with her family and Edward took over the farm, freeing George for political commitments and the historical research he loved. His fascination with his own family's history eventually extended to all Deerfield families and resulted, Miss Whiting said, in three important accomplishments: in his writing the renowned *History*; in his founding and presiding over the PVMA, Deerfield's historical society; and in his establishing in Deerfield's citizens a reverence for their history.

Miss Whiting remembered meeting George Sheldon in 1876, when he was already a venerated local figure (see fig. 70). Describing her first visit to the Sheldon-Hawks House, she said of George, "There he sat at his littered desk, a handsome, tall and large man, with brilliant eyes deep set under bushy brows, a hawk nose, and a noticeably long dark beard just beginning to be streaked with white." Sheldon received his visitors in a room so jammed with objects that Miss Whiting could hardly find room to step over the threshold. She describes the jumble as containing objects that ranged in period from the earliest days of Indian settlement to the Civil War: "Tin and iron, wood and china that was broken or cracked or well-kept, furniture of every sort, farmer's tools, kettles and pots, pictures, framed certificates, and deeds, fire irons, toasting forks and frying pans..." ad infinitum. Most of these things went to Memorial Hall, the PVMA's museum, when it opened in 1880.

In 1897, George, whose first wife had died in 1881, married again. His second wife was Jennie Maria Arms, much younger than he and a person of education and means. He went to live with Jennie in another of Deerfield's fine houses, the Colonel Joseph Stebbins house just north of the Deerfield Inn, which was built by Asa Stebbins's brother Joseph about 1772. George's daughter, Susan Arabella, had died, but her husband, Edward Hawks, and their two children, Edward and Susan, continued to live in the Sheldon family homestead.

Edward Hawks died in 1925, leaving the house in the possession of his daughter, Susan Belle Hawks. Susan had been educated at the New England School of Music in Boston, and a sign found in the Sheldon-Hawks attic reads "Miss Hawks / N. E. C. of Music / Piano–Harmony." Although she is reputed to have given both voice and piano lessons, by the time she died no one in the

neighborhood could remember her having done so.[5] Later in life, no doubt inspired by the years spent surrounded by her grandfather Sheldon's collections, Susan Hawks decided to follow in his illustrious footsteps. She turned to studying and selling antiques from her home, calling her business The Old Homestead Antiques Shop (see fig. 71).

Mr. and Mrs. George Signor, who lived in Miss Hawks's north second-floor rooms from 1941 to 1944, remembered that the "two [downstairs] front rooms were filled with antiques, where customers came to make purchases." Mr. Signor recalled that it was he who found "the 1699 I S blanket chest" that Miss Hawks later enthusiastically wrote up. She described the chest as "a simple pine chest, of the sort fundamentally and variably useful in an active household."[6] It had, she said, "rested unnoticed for at least half a century," in the attic of the Sheldon-Hawks House, where Mr. Signor eventually came upon it. He recalled that "...Miss Hawks cried for days...she was so elated at [the] discovery."

What moved Miss Hawks to tears was her belief, stated in the article, that her ancestor Ensign John Sheldon (I S) had ordered the chest from her ancestor John Hawks, the joiner. Reciting the "vicissitudes through which [the chest] passed" during its sojourn in Ensign Sheldon's Old Indian House, Miss Hawks tells of her intention to bequeath it to Deerfield's historical society "as the earliest dated piece of furniture from that historic village."[7]

Many local residents shared Miss Hawks's sense of the importance of her family furniture, and one of the momentous town events of 1946 was the auction held at the house after her death. Auctioneer George Bean told of conducting the auction in his book, *Yankee Auctioneer*:

> In the fall of 1946 I conducted a sale in Old Deerfield to settle the estate of Miss Susan B. Hawkes. The sale was a natural, with everything in its favor from the start.
>
> Just the name "Old Deerfield" conjures up in the mind of antiquers thoughts of colonial homes and rare collector's items.... Every foot of ground has a historic past. And the house from which the sale was held was no exception....
>
> Another thing which added interest was the fact that Miss Hawkes had been an outstanding dealer and collector of choice antiques. I believe she was as well and favorably known from coast to coast and border to border as any collector in the country. Many homes in all parts of the United States have fine pieces which passed through her hands. Hers was a shop where the real choosy buyers went to secure extra-quality items.[8]

The Flynts were just beginning to buy old Deerfield houses and townspeople encouraged Henry Flynt to buy as much of the Sheldon and Hawks estate as he could. As it turned out, some things were significant, but others were less so. Peter Spang says, "It was in the very beginning of

133

the Flynts' activities in the 1940s, and they said they made many mistakes. Some of the pieces they acquired [at Susan Hawks's auction are not of museum quality.] But they got other important pieces for Deerfield. They were told to buy these by local people to preserve them for the town."[9]

Susan Hawks's profession naturally brought her into contact with other antiques dealers. One with whom she formed a close relationship was Frederick P. L. Mills, who had been educated as an architect at M.I.T. Susan suggested to Mills that he buy land she owned just south of

her house and come to live in Deerfield. Mills agreed, and built a small house that he designed himself.

Miss Hawks and Mr. Mills lived peacefully side by side for some time, but eventually they had a falling out that left both of them very bitter. They stopped speaking to each other, and Mills took his revenge by buying a pig and naming it Susan. On hot summer days when Miss Hawks's and all his other neighbors' windows were open, Mr. Mills would step outside and call "Here, Susan. Here, Susan." The pig would come running up, oinking loudly.[10]

In November of 1946 the Flynts bought the Sheldon

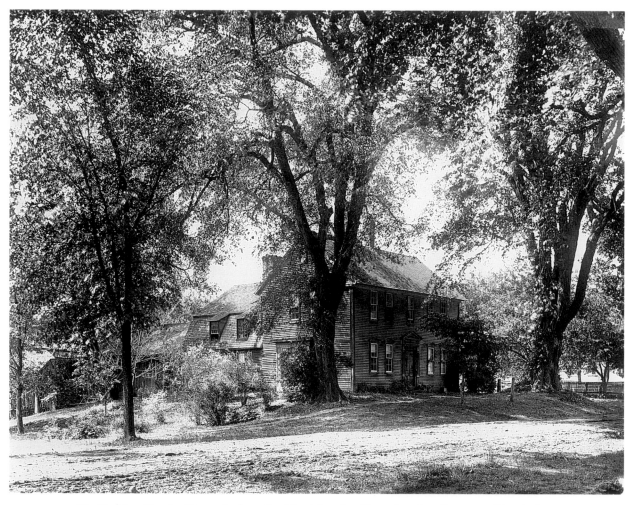

68. Sheldon-Hawks House before the Flynts' restoration, showing the magnificent elms long before they succumbed to the Dutch elm disease.

homestead from Miss Hawks's estate. They did necessary repairs, replaced large-paned nineteenth-century windows with smaller ones in the eighteenth-century style, and rented the house to Deerfield Academy. They maintained this situation for nearly a decade, and then decided to renovate the house and open it as a museum.

According to Peter Spang, the Flynts' experience with Bill Gass's work on the Dwight House, where he had taken so many costly liberties with probable and even actual architectural facts, had discouraged them and they stopped calling on him for a period. Spang feels that the Flynts "had felt the pressure of criticism from scholars on the work they had done, especially at the Dwight House." So although they finally relented and hired Gass again, they asked architectural historian Abbott Lowell Cummings to advise them on the restoration of the Sheldon-Hawks House. As a result of Cummings's suggestions, "I would say that the Sheldon-Hawks restoration was really a conservative one," says Spang, "while the Dwight House... was too liberal."

Although the Sheldon-Hawks House would probably have been painted by the late eighteenth century, there is no evidence that it was painted after about the middle of the nineteenth. Spang points out that "by the time of the early Colonial Revival [1880s], people liked the dark color and thought it was correct, so it was kept. And now, of course, it's the Deerfield look, so it's unlikely that this house will ever get painted again." Its deep brown hue is partly the result of weathering and partly the result of the creosote Susan Hawks put on it in the 1930s.

Like the exterior, the interior had undergone remarkably little alteration, perhaps because of the antiquarian tendencies of George Sheldon. The interior woodwork is original, as are the stairs. The central chimney was replaced in the nineteenth century and the present one is a reproduction of an eighteenth-century example. The Flynts pursued their usual pattern of installing modern plumbing and electricity, as well as radiant heat in the ceilings, and creating an apartment in back. Peter Spang, who lived in the Sheldon-Hawks apartment for twenty-three years, described its organization as haphazard and eccentric, as was often the case with the living quarters the Flynts provided in the museum houses. He found the living room beautiful but cold and the upstairs suffocating under the eaves. "In winter," says Spang, "it was about 95 upstairs and 45 downstairs!" Sometimes it was so cold the pipes froze. The most consistently comfortable spot was the kitchen, where Spang consequently spent most of his time.

In preparation for the opening in June of 1956, the Flynts concentrated on finding and acquiring furnishings from the Sheldon and Hawks families. Henry Flynt wrote to a Sheldon descendant of "our desire to have as many of the Sheldon things as possible back in the house for our opening on Sunday." He added that her family was cordially invited to the opening, saying, "You will add luster and personal family connection to the whole occasion.[11] Flynt's respect for his own ancestors made him especially sensitive to the importance of the participation of Deerfield descendants in the preservation work he and Mrs. Flynt were doing.

The *Greenfield Recorder-Gazette* for Monday, July 2, 1956, reported that visitors to the newly opened house museum "expressed appreciation for the home-like atmosphere, artistic coloring and arrangement of the furnishings almost entirely due to efforts and long study of Mrs. Helen Flynt...." Mrs. Flynt was described as having shopped in France and England for textiles, pictures, and furnishings "like those often brought to this country by early sea captains for use by well-to-do New England colonists." Like her friend Katharine Prentis Murphy and many others of their generation, Mrs. Flynt chose to think of the eighteenth-century occupants of the Sheldon-Hawks House as people of refinement, culture, and means. In fact, of course, the Sheldons and Hawkses were farmers throughout most of the history of the house, and the volume of sophisticated imported goods that furnished their home could not have been as high as Mrs. Flynt liked to think. Philip Zea hopes eventually to have this house represent the life style of a successful farmer's family in eighteenth-century Deerfield. This will mean the relocation of much of the expensive mahogany furniture, as well as the rich textiles and ceramics.

When the Flynts were planning the museum section of the Sheldon-Hawks House, they decided to include a sewing room as a setting for an exhibition of the clothing and textiles Mrs. Flynt was collecting. According to Peter Spang, they got the idea when they visited a French museum that had a sewing room populated by mannequins dressed in early clothing. Upon their return to Deerfield, the Flynts found that there had been "sempstresses" at work there in the eighteenth century, and decided to use that fact as a basis for creating a room devoted to textiles and needlework. In preparation for their exhibit, the Flynts went looking for mannequins in nearby Greenfield, and although the examples they were able to buy from a department store "had 1930s high heels and brightly painted 1930s faces," they felt the mannequins would do fine if viewers didn't inspect them too closely. When the figures arrived, the maintenance crew was requested to take them outside and wash the travel and storage dust off them. Townspeople who passed Sheldon-Hawks that afternoon were amused to see the men at work in the yard washing off a group of nude ladies.[12]

As the sewing room was finally arranged, a table placed in the center held sewing implements, needles, thread, and crewel wools. Another table was set up to show the

sempstresses at work making garments that customers might have ordered. Clothing, in both adult and children's sizes, was displayed on mannequins and on wall pegs, and other textiles such as quilts and coverlets were also on exhibit.

Another special focus of the display in Sheldon-Hawks was the English ceramics the Flynts had been collecting. A large and colorful variety of eighteenth-century wares fills shelves and cupboards and decorates tables throughout the house. Among them are blue-and-white tea and dinner wares that occupy the several tables in the south parlor (see fig. 73); a cupboard full of English creamware in that same room; and a variety of forms in Whieldon-type wares that fill a cupboard in the north parlor (see fig. 75). Upstairs in the north chamber a glossy black Jackfield tea set furnishes the tea table (see fig. 77). Containing one particularly rare plate, the tea set has survived with nearly all its original gilt intact. This is so unusual that Philip Zea calls it "outrageous." The Jackfield set was a gift to Deerfield from Mrs. Harold G. Duckworth, a distinguished collector of ceramics who, Zea says, "has been a strong supporter of Historic Deerfield's ceramics collection over the years."[13]

About four years after the Sheldon-Hawks House opened to the public, Helen and Henry Flynt were astonished when a front-page story in the Greenfield newspaper was brought to their attention. The article announced that a wealthy and well-connected Greenfield woman, Rowena Russell Potter, had died and left all her household furnishings to the Heritage Foundation (now Historic Deerfield). Her husband had died some years earlier and she had no children, so Mrs. Potter willed her furnishings to the Heritage Foundation, to be used in the Sheldon-Hawks House. Descended from the Sheldons and Russells of Deerfield, Mrs. Potter thought of the Sheldon-Hawks House as her ancestral home (the doorway of her Colonial Revival home in Greenfield was adapted from that of the Sheldon-Hawks House).

This windfall both delighted the Flynts and caused them some consternation. They had to rethink the furnishing of the house entirely, move a good deal of furniture out to make room for the Potter pieces, and create appropriate room settings with the new arrivals (see figs. 74 and 76). Peter Spang benefited because "there were so many pieces that we put a lot [of the Potter furnishings] in my apartment," he said. Among them were a blockfront desk, a handsome gateleg table, an English sofa, two easy chairs, and fine rugs. The apartment took on a very distinguished air.[14]

A couple of years after receipt of the Potter bequest, Henry Flynt set down an account of the circumstances surrounding it, which appeared in *The Heritage Foundation Quarterly* for January 1963. "Although Mr. and Mrs. Potter had collected many things together," he wrote, "after Mr. Potter's death Mrs. Potter continued and expanded this interest, furnishing both her house in Greenfield and her Nantucket home with fine things. Generally speaking, she acquired very high quality pieces, including blockfront furniture for her Greenfield house, and earlier and country things for the Nantucket residence."[15] Furniture in the Queen Anne and Chippendale styles fit into the Sheldon-Hawks rooms beautifully, as did the Potters' notable collections of seventeenth- and eighteenth-century brass candlesticks and other metal objects. But "because Mrs. Potter had many fine collections which were either too large or not suitable to the 18th Century character of the house, it was decided to convert a room in the small shed on the property into a display space in the same manner that Mrs. Potter had changed her three car garage into a room to show more of her collection [at her Greenfield house]."[16]

The Flynts had paneling from a house in Northfield, Massachusetts, that was put up in the shed as a backdrop for the additional display. Hooked and braided rugs from the Potter collection went on the floor and seating furniture provided a welcome resting place for visitors. Along with furniture there were tin and iron toys, glass paperweights, Nantucket baskets, children's books and furniture, and a doll's tea set of pewter.

Today the house still reflects the themes established during the Flynts' era: it is a showcase for many Potter furnishings; it contains numerous displays of English ceramics collected by the Flynts and given by friends; and, through its Sheldon and Hawks backgrounds, it serves as a starting point for a discussion of Deerfield families and local history.

69. Sheldon-Hawks doorway, one of Deerfield's two surviving examples of the triangular pediment form. It was added about 1760.

70. George Sheldon working at his desk in the Sheldon-Hawks House. This famous photograph, showing Sheldon wearing a food screen to keep flies off his head, was taken by Sheldon's neighbors the Allen sisters.

71. One of the front rooms of Sheldon-Hawks House when it contained merchandise for Susan Hawks's Old Homestead Antiques Shop. Here, according to a tenant of Miss Hawks, "customers came to make purchases."

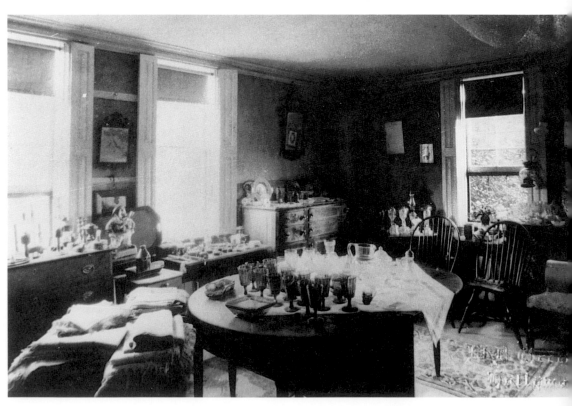

72. In the Flynts' day mannequins in the south parlor showed off eighteenth-century dresses from their noteworthy collection. Other mannequins were presented as "sempstresses" in the sewing room.

73. Chairs and tables of a variety of styles furnish the south parlor; every surface in the room holds examples of blue-and-white ceramics from the Flynts' large collection. In the Flynts' day, as figure 72 reveals, mannequins were arranged at a tea table with the hostess standing to pour and the guest, dressed in a blue-and-white fabric whose design resembled that of the ceramics, seated across from her. The secretary against the west wall is "an outlandish, outdated, glorious example of rural cabinetmaking," according to Dean A. Fales, Jr., in *The Furniture of Historic Deerfield* (fig. 476). Of cherry with maple inlays, it is attributed to Israel Guild of nearby Conway, Massachusetts. It was made for Nancy Stoddard of Northampton, probably around the time of her marriage to John Williams of Conway in 1799. The portrait, painted by Ralph Earl in 1796, is of Sally Buel of Litchfield, Connecticut.

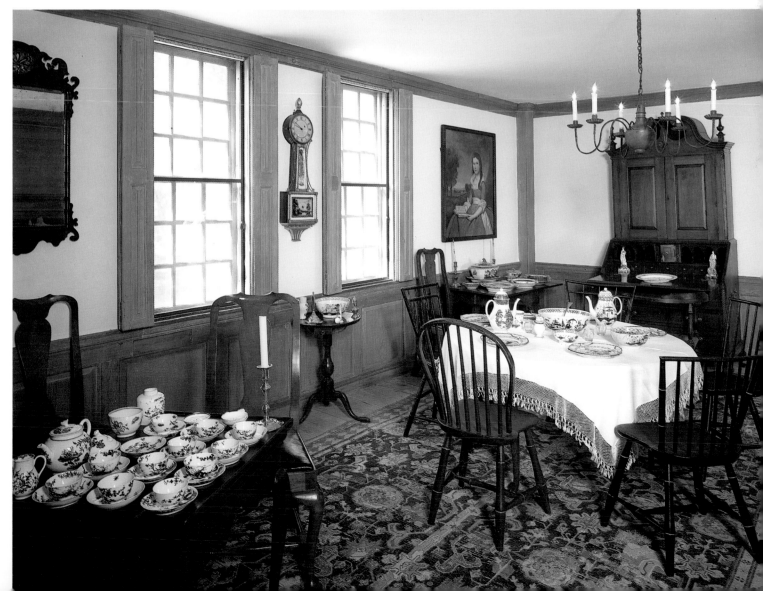

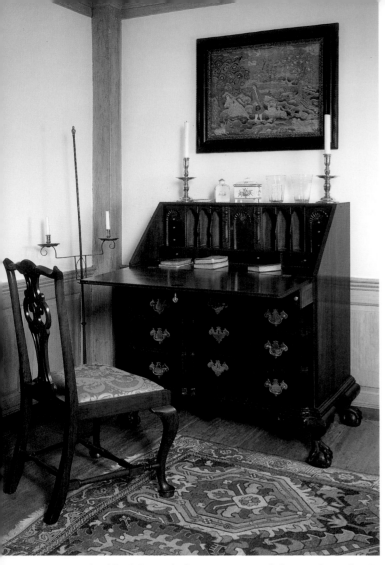

74. The blockfront desk in a corner of the north parlor is from Rowena Russell Potter's notable collection of blockfront pieces. The picture of the shepherd and reclining shepherdess above is part of Mrs. Flynt's large collection of important needlework.

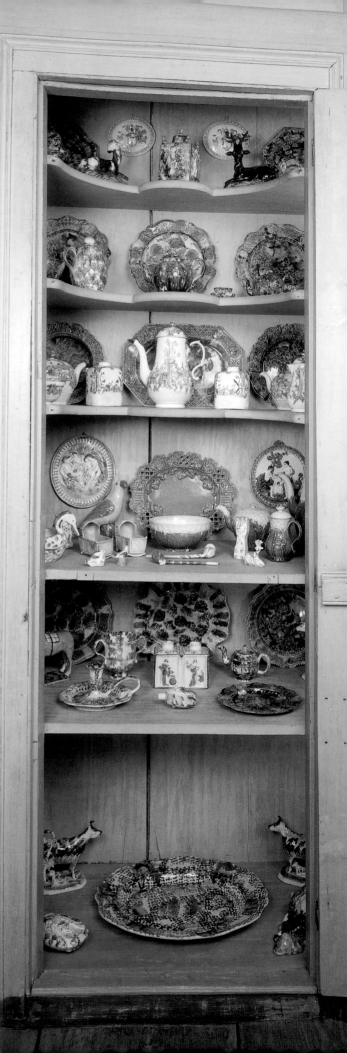

75. This built-in cupboard in the north parlor contains a splendid collection of mottled Whieldon-type wares, many contributed by collector John Morris of Westport, Connecticut, a friend of the Flynts.

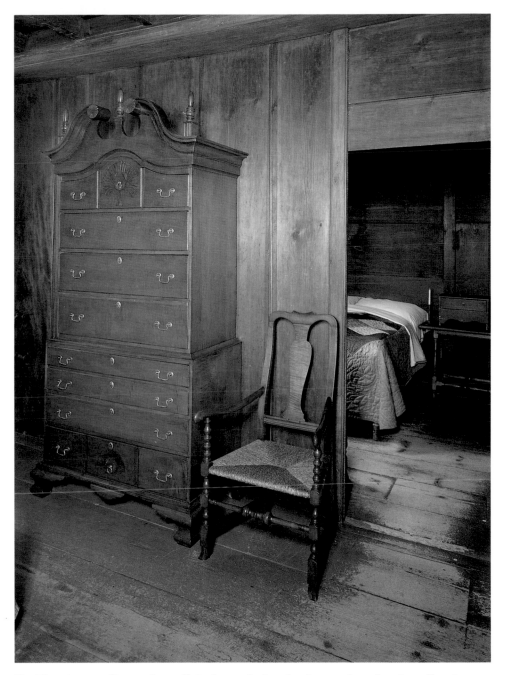

76. The pine paneling on the walls in the south chamber has aged to a lovely mellow brown. The maple chest-on-chest, from the Potter collection, was made in New Hampshire about 1800, possibly by Moses Hazen of Weare. Through the doorway a very handsome American calamanco coverlet, also from the Potter collection and made 1820–1850, may be seen covering the low-post bed.

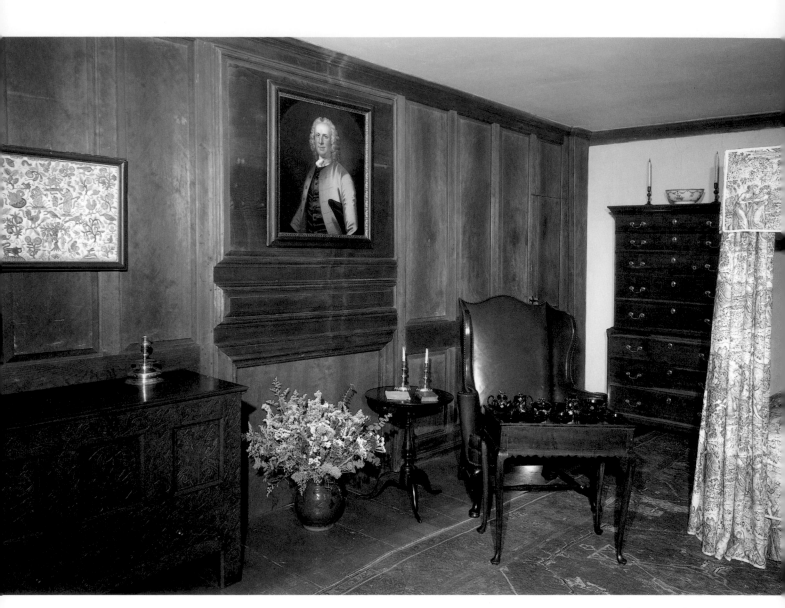

77. The north chamber, which is much more formally decorated than the south chamber, retains its original unpainted paneling, a feature that Philip Zea describes as remarkable. The portrait by John Wollaston above the fireplace is of Stephen Greenleaf, the last Colonial sheriff of Massachusetts. On the tea table is a Jackfield tea set that, amazingly, retains its original oil-gilded decoration; it was a gift from Mrs. Harold G. Duckworth, who has made significant additions to Deerfield's ceramics collection over the years.

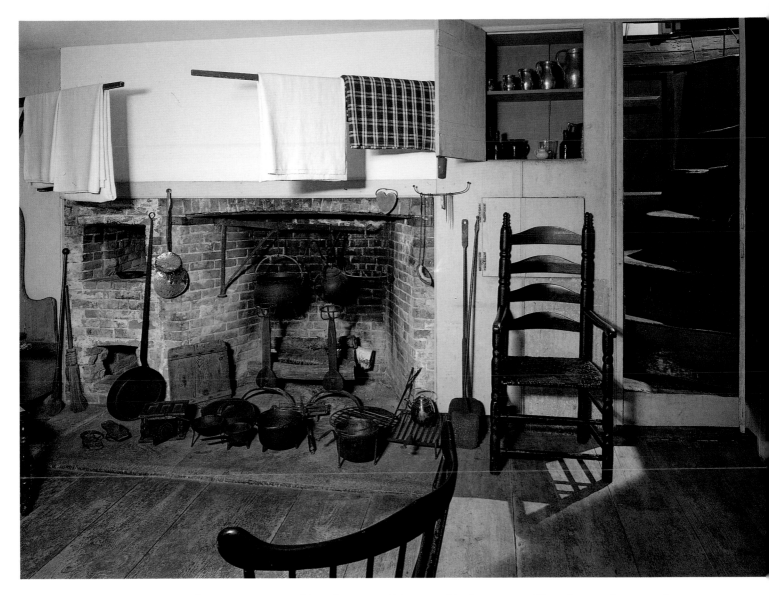

78. The kitchen at Sheldon-Hawks retains its original hearthstone, and is unusual in that respect. Note the wooden arms above the fireplace for drying or airing linens and blankets. Philip Zea says the original twisting staircase at right "underscores the kind of quaintness people associate with places like [Historic Deerfield]." Below the built-in cupboard is a door that opens to reveal the back of a beehive oven. The kitchen is furnished to remind visitors that the purpose of this family was farming—a fact that is easily forgotten amidst the fine furnishings of the parlors and chambers.

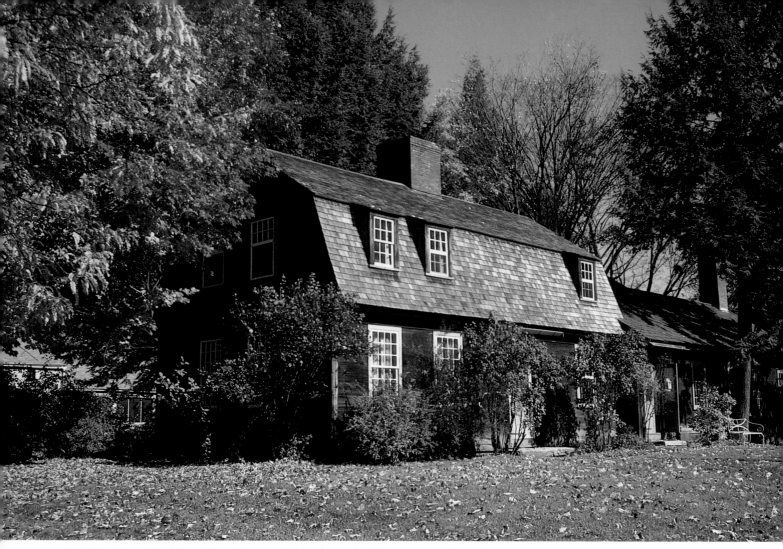

79. The Henry Needham Flynt Silver and Metalware Collection, opened to the public in October, 1961. The gambrel-roofed section of the building, built in 1814 by Joseph Clesson, houses the pewter collection and the silversmith's workshop. A modern addition to the rear contains the Flynts' notable collection of silver.

The Henry Needham Flynt
Silver and Metalware Collection

The building that houses the silver and other metals collection is a combination of old and new. The front part, which faces the street, is the parlor of the Clesson House, built by Joseph Clesson on this site in 1814. The rear extension, which contains Historic Deerfield's notable collection of American silver, is a specially built vault added in 1961. Between the two, in what was the kitchen of the old Clesson House, the Flynts re-created a silversmith's shop, where they planned to have a working silversmith demonstrate his craft to visitors. They had decided to present the building as the home, workshop, and sales room of Isaac Parker, a silversmith who moved to Deerfield in 1774 and took on John Russell as an apprentice (thus the original name of this building, The

Parker and Russell Silver Shop). Although Parker's shop was actually on the Albany Road and not on Deerfield's main street, the fact that he'd practiced his craft in town provided a hook for the Flynts to use in their re-creation.

Joseph Clesson inherited lot 38 on the Deerfield street from his father, and he apparently intended this two-story gambrel-roofed building to be the ell of a larger house that he expected to build in the future. He died two years after putting up the ell, however, and his plan was never carried out. In 1872, his house was moved around the corner and a little to the east, where it served as a tenant house on the Cowles property. An uninspired Victorian house took its place on lot 38, remaining there until the Flynts bought it in 1960. By that time, it had "fallen into

disrepair and its unremarkable, rather plain Victorian exterior presented a shabby appearance though covered with ivy and shielded by tall blue spruces."[1]

It was the Flynts' dream, says Peter Spang, to take down the Victorian house and return the Clesson House to its original site. They undertook the project in 1960, having photographed both houses extensively in order to preserve records of them in their locations at that time. In August of that year, contractor Bill Gass moved the house from its position near Route 5 back to its original lot on Deerfield's old street.

The Clesson House had been clapboarded in the 1930s, and when Gass removed the clapboards he discovered early wide-board sheathing underneath. The weathered boards were left exposed and Gass, whose partiality to unpainted wood, aged or not, is visible throughout Deerfield, commented to Architectural Conservator Bill Flynt many years later, "I like that [weathered-board surface]. It gives relief." Others obviously agreed, for Peter Spang recalls that "many people thought it was the nicest building the Flynts ever did as far as its charm on the outside is concerned."[2]

Inside, most of the woodwork of the original parlor and kitchen survived. The parlor was replastered, its wood was scraped of paint, and it was furnished modestly with turned furniture the Flynts considered appropriate to the home of an eighteenth-century artisan. A portrait of silversmith Benjamin E. Cook of nearby Northampton hung over the fireplace to carry out the theme of the building.

In what had been the Clessons' kitchen the Flynts set up a silversmith's workshop complete with early tools and molds, a forge copied from the one silversmith Benjamin Cook had used in the early nineteenth century, and a workbench. Clocks and other objects were placed about the room to indicate that despite his name, a silversmith in a rural New England town was a clockmaker, locksmith, optician, and dentist, as well as a worker in precious metals. There was also a cage containing a stuffed parrot, which Spang describes as "typical of the Flynts' giving a human aspect to a room."[3]

It was Henry Flynt's plan to have craftsmen at work in the silver shop as well as in the printing shop down the street. The first smith was a former Deerfield summer fellow, and he lived above the shop in the apartment that the Flynts had provided. Spang recalls that Flynt went to a great deal of trouble to train the first silversmith, sending him down to Colonial Williamsburg to work in their silver workshop and then to England to study the craft. When he left, another former summer fellow followed, and the tradition was continued into the early 1970s (see fig. 81). At that time, says Spang, when Henry Flynt had died and Helen Flynt was no longer active in the organization, it was decided to drop the idea of having a working

silversmith. Supporting craftspeople in a restoration the size of Historic Deerfield seemed uneconomical and besides, says Spang, the silversmiths were bored creating colonial reproductions for sale in the shop and were always anxious to get on to their own modern work.

The final and most important room on display was the exhibition room where the Flynts' silver collection was kept. This was constructed to be very secure as well as to provide an appropriate setting for the collection. Although this room was modern, its exterior was covered with old boards so that it wouldn't look incongruous. It was designed with a bow window flanked by smaller windows in the center of the long south wall, an arrangement that Peter Spang thinks was inspired by an English print of a silversmith's shop that is on view in the workshop. Though the window itself was new, contractor Bill Gass glazed it with old glass. "We was lucky to get the glass," he said, adding that he and his men "got it out of sheds and henhouses and traded it for new. We'd take the old glass out and put new glass in."[4]

Looking for old paneling to put in the exhibition room, the Flynts found a fireplace wall from the home of clockmaker Preserved Clapp of nearby Amherst languishing in storage.[5] They instructed Gass to install it on the east wall, opposite the entrance to the room, where it supplied atmosphere and its two cupboards provided extra display space (see fig. 82). Woodwork for the rest of the room was based on that of the fireplace wall, whose old green paint also furnished the color scheme. Modern display cabinets were encased in green paneling, early chandeliers were hung, oriental carpets were put down, and eighteenth-century furniture was installed.

Since it was Henry Flynt's plan to arrange the exhibition room to simulate a shop, he and his wife set the cases up in a way he thought would have been convenient for potential purchasers. All the tea equipment was in one case, all the mugs in another, the tankards in another, and so on, so that the "customer" could shop in the sections in which he or she was interested.

Helen Flynt, who was in charge of colors and fabrics, chose cool blue acetate for the curtains and case linings. She sewed the material together herself, often taking her work with her to the Deerfield Inn, where "people were always intrigued [with her project]," says Spang.

The silver collection was Henry's special pride, as the textiles and clothing were Helen's. His longtime interest in American history, manifested in the collection of American historical documents and letters he began early in his career, led him to silver as well. Unlike most other American antiques, silver can usually be accurately dated, and its maker, geographical origins, and often, its owner, can be correctly identified. It was the only one of the American crafts besides pewter in which a maker's mark was standard, and since silver objects were often

145

commissioned to commemorate a special occasion or event, they were frequently engraved with initials and inscriptions. Colonial silver is therefore not just beautiful, it is also important as a record of actual historical events and personages, and the latter aspect must have appealed to Henry Flynt immensely.

Despite the fact that silver was Henry Flynt's particular interest, it was Helen who purchased their first truly important piece. As a gift for her husband on their twenty-fifth wedding anniversary, she presented him with an elaborate covered cup by New York silversmith Gerrit Onckelbag (see fig. 84). This is a rare and unusual form in American silver, a piece to excite any dedicated collector. The question in this case, however, is why did it interest Helen Flynt—who was *not* a dedicated collector in 1945—enough to buy it? This was very early in the Flynts' involvement with Deerfield houses and furnishings and it is surprising to find Helen buying an expensive and somewhat esoteric piece of American silver at this early date.

The answer may lie in a newspaper article that appeared in the *New York Sun* for October 19, 1940. It shows a photograph of the Onckelbag cup and describes it as "one of the rarest pieces of American silver yet discovered." It goes on to tell of Onckelbag's career and notes that this is only the "sixth known piece" by the New York maker. The photograph was credited to Stephen Ensko, the highly regarded New York silver dealer.[6]

Whether Helen or Henry clipped the article we don't know, but it is likely that one of them did, for it has remained in the file they kept on the covered cup from the time of its purchase. Did Henry hint that he'd love to have the cup? Did Helen take the hint or did she simply see the newspaper article and buy the cup—either in 1940 or over a period of years—in anticipation of their twenty-fifth anniversary in 1945? Or did the cup have another owner between the time the article was published in 1940 and Helen Flynt's gift of it in 1945? We may never know just exactly how or why the purchase occurred, but we do know that Henry Flynt was immensely proud of the cup and of Helen for buying it. In speaking of the cup, he paid tribute to Helen's "appreciation of fine silver, [and to her] courage and decision." When his portrait was painted, he had the Onckelbag cup at his elbow (see p. 56).

It is explained in the catalogue to the silver collection, published in 1968, that "it had been through their

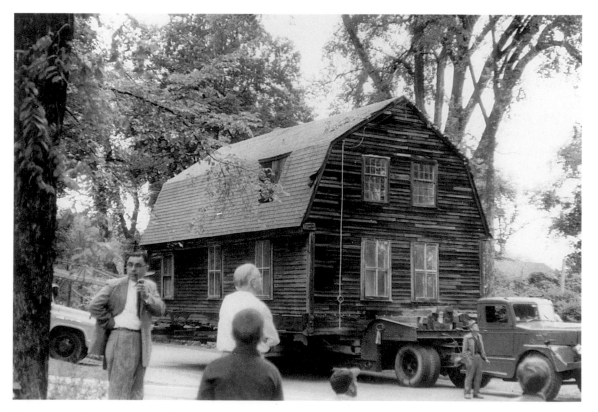

80. August, 1960. Contractor Bill Gass's men move the Joseph Clesson House back to its original lot on the old Deerfield street from the site near Route 5 that it occupied for eighty-eight years.

collecting of English silver...that the Flynts first became introduced to collecting American silver."[7] Additional reasons for their focus on American silver are the historical importance of many examples, mentioned above; their growing interest in American antiques of all kinds as they sought furnishings for the houses they were restoring in Deerfield; and their friendship with John Marshall Phillips, curator of the outstanding Garvan collection of American silver at the Yale University Art Gallery. Henry Flynt described Phillips as a "fascinating, authoritative expert" who was "generous with his knowledge. We learned a great deal from him in many fields...."[8]

One of their earliest contacts with John Phillips came about as a result of an exhibition Henry Flynt organized as president of the PVMA, Deerfield's venerable historical society. Described as "the most outstanding collection exhibited in western Massachusetts," the exhibition contained loans from America's most prominent silver collections. Besides pieces from New York's Metropolitan Museum and Boston's Museum of Fine Arts, there were many distinguished examples from private collections, including the Flynts'. Local silver from Deerfield's First Church, Sunderland's Congregational Church, and Greenfield's St. James's Church made up another impressive group within the exhibition. A newspaper article reported that "more than 500 visitors took advantage of the unusual opportunity of seeing so large a collection of silver in a local museum."[9]

It was in connection with this event that John Marshall Phillips lectured in Deerfield, as did another leading authority on American silver, Kathryn Buhler of the Museum of Fine Arts, Boston. Mrs. Buhler, like Phillips, was to become a friend and advisor to the Flynts.

A few years later, in 1954, the Flynts went to England to participate in one of the earliest of the Attingham courses, offered to acquaint interested students with the architecture and furnishings of England's great country houses. A friend had arranged for Henry to have lunch at Goldsmith's Hall in London with members of that distinguished society of silver- and goldsmiths. When he mentioned that he was always on the lookout for American silver, he received the name of an English dealer who had a collection of such wares. Begun just after World War I by Lionel A. Crichton and continued by his son-in-law and partner, Victor A. Watson, this was a choice collection of American silver, much of which had been exhibited at London's renowned Victoria and Albert Museum.

Henry Flynt often told the story of his and Helen's meeting with Victor Watson. They had only two days in London before the Attingham course was to begin, so they arranged an appointment with Watson immediately. He received them courteously but coldly. He did have some American silver, he said, but it was not for sale nor could they view it. In desperation, Helen Flynt mentioned how much they missed their good friend John Phillips, who had died only the year before. At the mention of Phillips's name, Watson's reserve faded and he produced a book of photographs of the silver collection, which was stored in a bank vault. The Flynts pored over the photographs, expressing interest in a number of pieces. Watson "flatly refused...to consider an offer on any individual piece," wrote Flynt. "He finally named a figure for the entire lot. We borrowed the book in order to do some homework with arithmetic. The theater that evening held no real interest for I continually thought of a Hurd teapot, Myer Myers salvers, a Burt can, or a Revere spout cup."[10]

The result of Flynt's cogitation and figuring throughout the play (whose name he could never afterward remember) was his decision "that a deal might be possible. After discussing it with Helen before retiring, we practically decided we'd make an offer in the morning if, after sleeping on it, we felt in the same mood and could examine the items."[11] Watson agreed to retrieve the silver from the vault so that they could view it, and despite its severely tarnished condition (Flynt later told Peter Spang he'd never seen such a "huge collection of dark stuff"),[12] they could tell there were many wonderful pieces. They agreed to buy the collection on the condition that Watson polish it, arrange for its export to the United States, and crate and deliver it to their stateroom aboard the *Queen Mary* several weeks hence.

Throughout the rest of their trip the Flynts avidly studied the photographs of their new acquisitions, wondered whether they'd made a mistake in buying them, and chafed at not being able to possess them immediately. The crates were duly delivered to their stateroom but they dared not open them before clearing customs and getting them safely home. Finally the time came to open the crates. "All went well," reported Flynt, "excitement mounted as we opened the cases and arranged on our pool table the beautifully shined pieces. The joys of the hunt, the capture, and the transport home were all heightened when the opinion of people more knowledgeable than ourselves confirmed our judgment and friends agreed with our taste and congratulated us on our good fortune."[13] Alice Winchester, former editor of *The Magazine Antiques*, remembers that when they heard about the Flynts' acquisition of the Crichton-Watson collection, other collectors felt that Henry Flynt had been very daring and shrewd to get it.

The acquisition of ninety-two pieces of American silver in one fell swoop greatly expanded the Flynts' silver collection. They continued their search for American silver in foreign collections and found Mrs. G. E. P. How, who, with her husband, had been "friends and searchers

with John Phillips for extraordinary items," particularly helpful. From Mrs. How they acquired some early American spoons and a tankard by Bartholomew Schaats of New York. They also obtained pieces from two American collections—that of Edward E. Minor, noted collector of exceptional American silver, and of Dr. George B. Cutten, former president of Colgate University and noted American spoon collector and silver scholar. "If the objects in the Minor Collection represented the most unusual or earliest objects by the best makers," wrote Flynt and Fales, "the silver which the Flynts acquired... from the collection of the late George B. Cutten created a happy balance with spoons, the most common item of silver...."[14]

To augment their acquisitions from notable private collections the Flynts bought silver from leading dealers, including Stephen Ensko of New York, from whom Helen had bought the Onckelbag cup in 1945, and J. Herbert Gebelein of Boston. Their collection continued to grow in breadth and depth until it illustrated the craft of the silversmith in early America. It came to represent all major forms made in America, all important American silversmiths, and geographical regions "from Maine to South Carolina, and even to New Orleans." It contained, as well, many items with "interesting family histories, and objects which belonged to people associated with the early history of our country."[15] The current staff continues to supplement the silver collection when appropriate pieces come on the market.

Peter Spang recalls that when he arrived in Deerfield to work for the Flynts in 1959, the silver didn't stand out as an important facet of the collections because there was no special silver exhibit. He remembers that "the small art gallery at Deerfield Academy had three cases of silver in it, along with minor works of art. There were no alarms, no special locks, no guards on the windows. You could look through one of the windows right into a case."[16] One case contained the very important silver belonging to Deerfield's First Church, including pieces by Paul Revere and other notable makers, and the other two held silver on loan from the Flynts (they kept a good deal of the collection at their home in Greenwich until the present building was constructed). Although Henry Flynt professed to be concerned about the lack of security at the Academy art gallery, he left his silver on view there until the present exhibition room was built. When the silver was

finally transferred to its new, highly secure, home, Spang breathed a sigh of relief. The church silver remained at the Academy for some years, however, before being placed in a bank vault. A few years ago it was placed on loan in Historic Deerfield's vault.

The opening of the new Silver Shop was timed, according to *The New York Times*, to take advantage of "the early October foliage season, when Old Deerfield and the Connecticut Valley are luminous with autumn color and are visited by more tourists than at any other time of the year."[17] Although the exhibition room had been supplied with fluorescent lights concealed in a cove molding at cornice level, only the display cases and the candle bulbs of the chandeliers were lit for the opening reception. Peter Spang recalls that the ambience of the dimly lit room was magical.

Today the silversmith's workroom remains much as it was in the Flynts' day, but the parlor and exhibition room are quite different. When the Hall Tavern was reorganized a few years ago, the pewter collection, together with examples of other base metals such as brass and iron, was transferred to the parlor of the Clesson House, where it makes a nice foil for the silver. It is arranged to illustrate differences among English, Continental, and American pewterwares, and one cabinet exhibits objects made in the Connecticut Valley, where pewtermaking was an important craft. The parlor also contains the desk and bookcase from Henry Flynt's study in Greenwich, which he believed had belonged to Josiah Bartlett. Flynt was particularly attached to it because of his interest in American history, for Josiah Bartlett of New Hampshire was a signer of the Declaration of Independence. More recent research, however, has revealed that this is one of "about five desks and bookcases Josiah Bartlett was supposed to have owned," says Philip Zea, adding that the piece probably postdates the signer.

A few years ago, Peter Spang and intern John Bacon rearranged the silver into groups that show chronological and geographical development. Also in recent years the oriental rugs have disappeared and the modest turned furniture has been replaced by an intriguing display of tea tables from a number of different geographical regions. Each table displays silver and ceramic tea equipment. The Flynts' spirit remains, however, in the basic design and decoration of the room and in the taste evident in the objects displayed.

81. A working silversmith explained the craft to visitors during the 1960s and into the 1970s. Here, silversmith Gordon Wainwright is at work.

82. A rare turret-top tea table holds eighteenth-century silver by leading Boston and New York makers and Chinese Export tea equipment in the *encre de chine* pattern popular in the mid-eighteenth century. The paneling on the fireplace wall in the background was rescued from Amherst clockmaker Preserved Clapp's house, which was largely demolished in the hurricane of 1938.

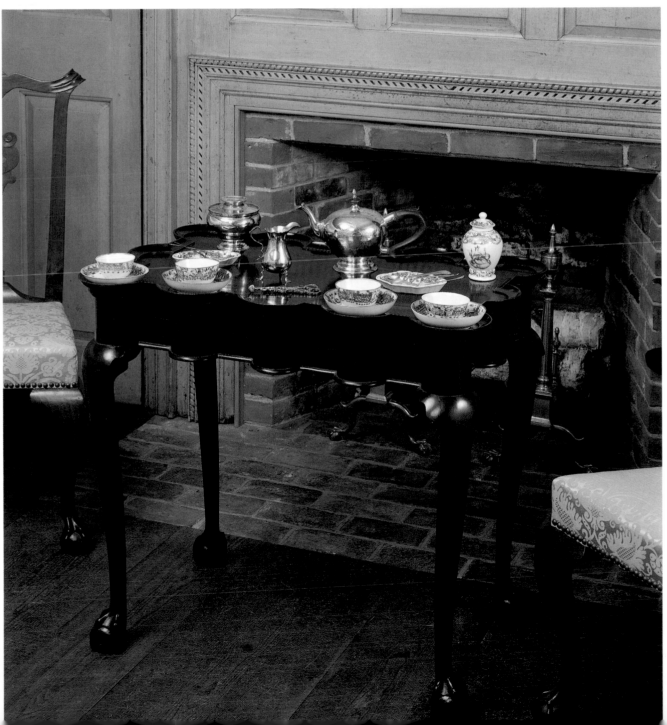

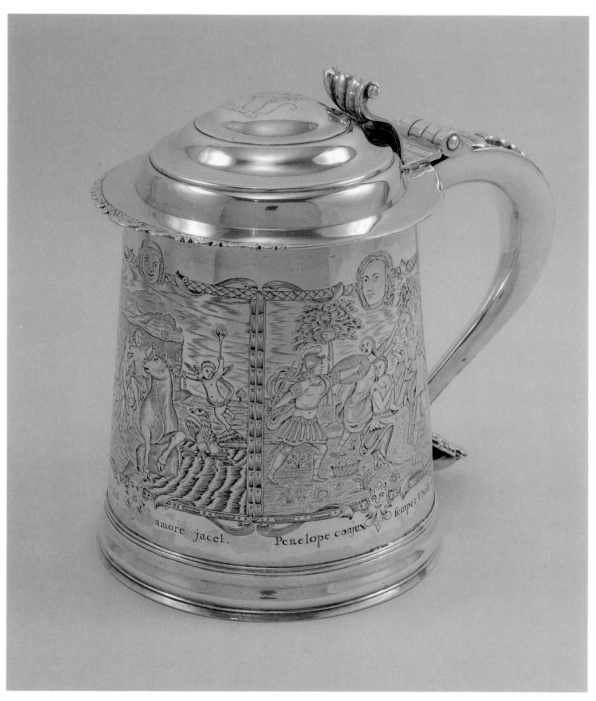

83. Tankard, by William Vilant, Philadelphia, c. 1725; engraved by Joseph Leddel of New York in 1750. Three elaborately engraved scenes from Ovid make this one of the most ornate pieces of American silver known. Above each scene is a portrait head; the one visible in this view is of Philip, Earl of Chesterfield, probably taken from a published portrait of him by William Hoare. *Ex coll.* Crichton-Watson.

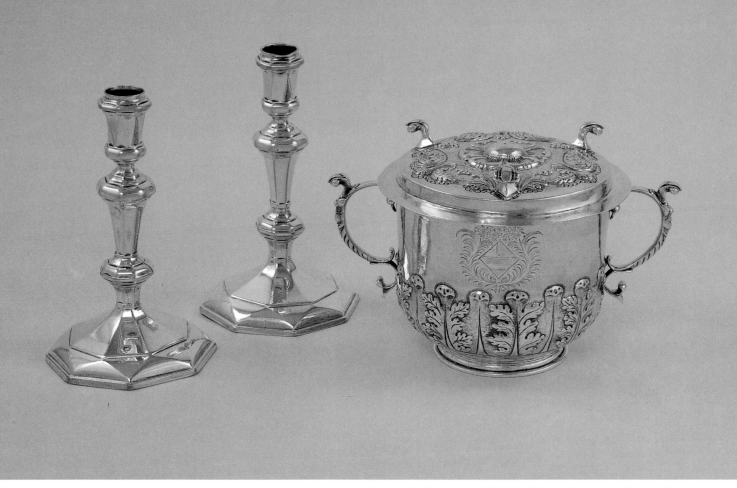

84. Pair of candlesticks, by John Coney (1656–1722), Boston, 1716; made for Henry Flynt's collateral ancestor Harvard tutor Henry Flynt as a gift from his students; inscribed *Ex dono Pupillorum 1716*. Flynt acquired these splendid sticks after years of alternately coveting them and refusing to pay what he felt was a stiff asking price. Finally, in 1962, he took the plunge and bought them at several times the figure originally asked.

Covered cup, by Gerrit Onckelbag (1670–1732), New York, 1695–1700. This rare and elaborate form is known in America only in the work of New York silversmiths and is one of the treasures of the Flynts' silver collection. Helen Flynt presented it to her husband in 1945 on their twenty-fifth wedding anniversary.

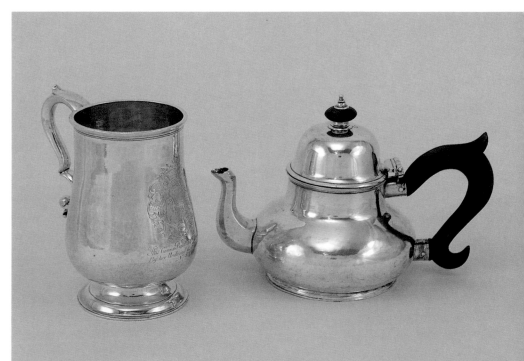

85. Cann, by Samuel Edwards (1705–1762), Boston, c. 1754. Made for Colonel Ebenezer Hinsdale, this elegant vessel descended in the Williams family of Deerfield. Although it came into the collection in 1983, this cann combines satisfying artistic qualities and local associations in a way that never failed to appeal to Henry Flynt.

Teapot, by Jacob Hurd (1702/3–1758), Boston, c. 1730. This diminutive pear-shaped pot is one of a very small group of Boston pots of this form. It is a splendid recent addition to the group of Hurd objects already in the collection.

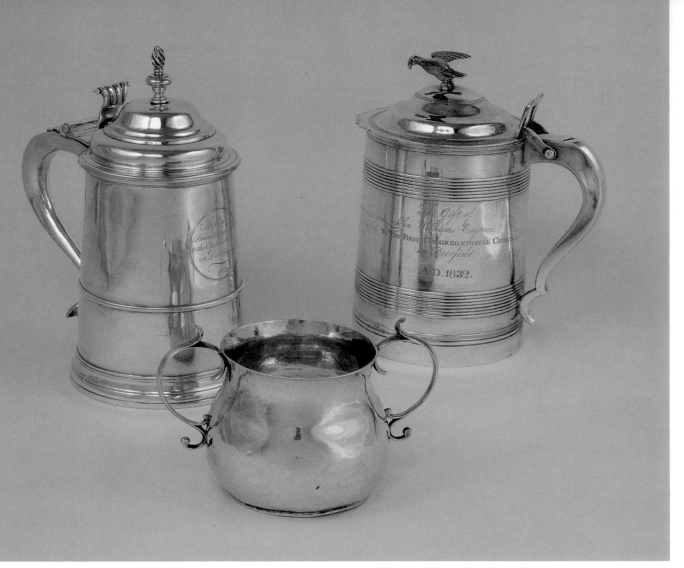

86. On loan from the First Church of Deerfield: tankard (*left*) by Paul Revere (1735–1818), Boston, 1763, inscribed "The gift of Samuel Barnard, Esq. to the Church of Christ in Deerfield 1763."

Tankard (*right*) by Samuel Williamson (1772–1843), Philadelphia, c. 1801. John Williams of Deerfield received this from the "Directors of the Banks of the United States, North America and Pennsylvania" in appreciation for his help in apprehending three counterfeiters. It went to the church after the death of Williams's widow in 1832.

Caudle cup, by William Pollard (1690–c. 1745), Boston, c. 1720, made for Hannah Beaman, Deerfield's first schoolmistress and an early owner of the Flynts' own Allen House.

87. Teapot, Sheffield plate, England, 1800–1810. Made in the French Empire style, this pot has a history of ownership in Deerfield. It is the kind of locally or regionally owned imported item the present curatorial staff considers important as evidence of what was actually owned and used in some post-Revolutionary Connecticut Valley homes.

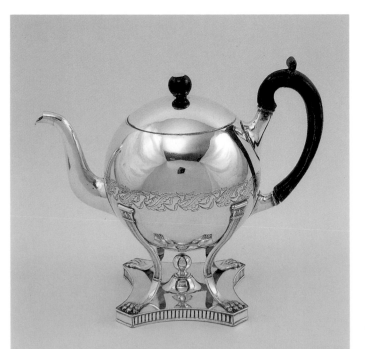

88. A cupboard in the Clesson House parlor holds pewter made in the Connecticut Valley by such masters as the Boardmans of Hartford and Samuel Pierce of nearby Greenfield.

89. The touchmark of pewterer Samuel Pierce (1767–1840) of Greenfield, Massachusetts, a unique survivor in the field of American pewter, rests on a plate that Pierce stamped with this touchmark. *Ex coll.* Ledlie Laughlin.

90. Soapstone mold shown with a pewter beaker bottom by Samuel Pierce that was made in this mold. It is a tribute to Henry Flynt's understanding of the importance of documenting early American craft techniques that he bought this practical and unglamorous mold. The dealer from whom he purchased it was Charles Montgomery, an early and avid pewter dealer and, later on, a legendary museum man.

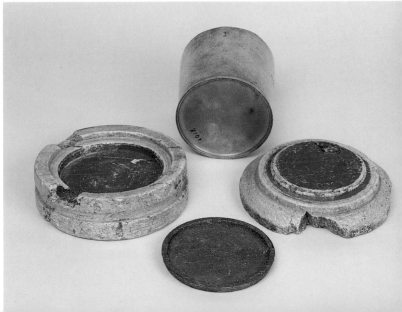

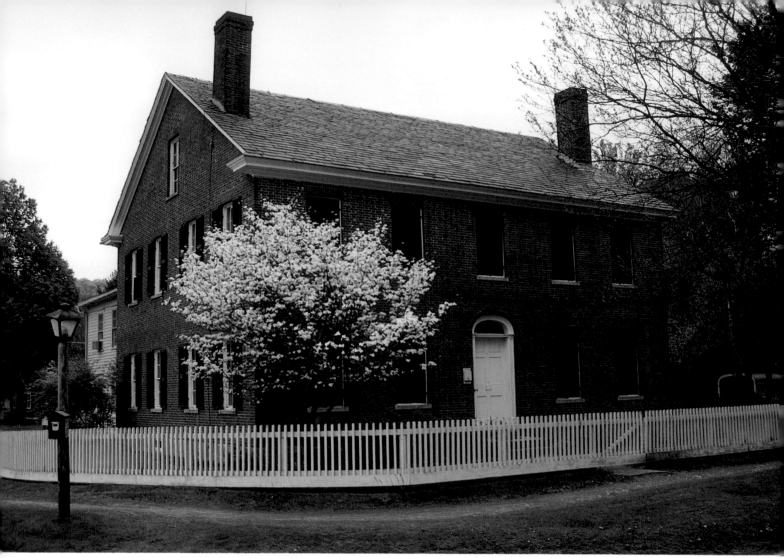

91. Wright House, built 1824, as it looks today. The Victorian porches are gone, allowing the splendid fanlights over the doors to be seen again, and the white picket fence is back. Although it seems strange today to see a house with its shutters closed most of the time, Philip Zea says that it was quite usual to follow this practice during the summer in the nineteenth century. Closed shutters not only prevented damage from rain and wind, but they also kept insects and other wildlife out when the windows were open. Bugs, says Zea, will usually not fly into darkened spaces.

The Wright House

Built in 1824, the Wright House is among the latest of Historic Deerfield's houses, given by Asa Stebbins to his son Asa Jr. upon the occasion of the latter's marriage. Many years later town historian George Sheldon recalled the occasion: "At the wedding party held on their arrival [at the new house], I attended as bearer of the sugar and cream, in the wake of the tea and coffee tray. This was my early entrance into the social life of Deerfield...."[1]

Asa Stebbins had built his own house of brick in 1799, at a time when that was an uncommon building material in Deerfield. He must have been very pleased with his choice, for he advocated the use of brick twice in 1824, as a member of the building committee of the new meetinghouse, and again for his son's home. Both of these buildings were in fact constructed of brick in a simple Federal style. Their ornament is confined to brick arches above doors and windows, fanlights above doors, and shutters at the windows. The unusual elliptical fanlights of Wright House are ornamented with cast-pewter swags, rosettes, and classical figures, and are thought possibly to be the work of Greenfield pewterer Samuel Pierce or of his son and partner, John Joyce Pierce.[2] The calm two-

dimensional exteriors of the neoclassical brick buildings contrast markedly with the more dramatic three-dimensional outlines of Deerfield's earlier Georgian-inspired clapboard houses.

Like his father and other members of the Stebbins family, Asa Jr. was both an active farmer and an energetic office holder. He served the town for many years as selectman, moderator of the town meeting, and town treasurer. He had a number of children, and the house remained in the hands of his heirs until 1908, when George and Jane Wright acquired it. By the time the Flynts bought it in 1948, the house was occupied by Jane Wright and several members of Deerfield Academy's faculty, who lived in apartments within the building. The Flynts apparently continued to rent space to the Academy for some years after buying the house. They decided to continue to use the name Wright House, even though they planned to restore it to the period of Asa Stebbins, Jr., for they felt that it would be confusing for Historic Deerfield to have two Stebbins Houses.

The Stebbinses were a prosperous Deerfield farming family, and a nineteenth-century print shows the house surrounded by barns and other out-buildings, rather than by sweeping lawns and gardens (see fig. 92). During Asa Stebbins, Jr.'s, occupancy, the house was probably furnished in a variety of styles both old and new, as would have been usual in an affluent farmer's home. Asa would certainly have been familiar with high-style neoclassical furnishings, and may well have ordered such things for himself and his family.[3] As the Flynts furnished the house for opening to the public in 1962, however, the relatively plain interiors became a backdrop for high-style furniture from an outstanding private collection.

This was the creation of George Alfred Cluett, a discriminating collector of the finest American furniture, mainly of the Federal period. His family owned the Cluett, Peabody Company of Troy, New York, manufacturers of shirt collars in the nineteenth and early twentieth centuries and later of Arrow Shirts. The company had some difficulty during its transition from the position of leading producer of separate collars to that of leading maker of whole shirts. "By 1927 the detached-collar business was visibly sour," wrote one reporter. "As the twenties faded, when everyone else in the country was prospering feverishly, the Cluett, Peabody situation worsened." There was a dispute within the company as to how to reverse the situation, and as a result George Alfred Cluett retired as president in 1929. His successor, Chesley Palmer, led the company to renewed prosperity by producing "a good shirt at a moderate price with a name that was to be famous, and never mind any other kind of shirt."[4]

George Alfred Cluett was born in 1873 in Troy, New York. He grew up there, graduated from Williams College in 1896, and entered the family business. He first began collecting furniture in 1901, a couple of years after his marriage, as a means of furnishing his house on First Street in Troy, and he continued until 1925. Although he eventually focused on American furniture, Cluett seems to have begun by buying Renaissance furniture, ironwork, and paintings of Spanish and Italian origin, which he ultimately gave to Williams College. In 1930, the year after he retired as president of Cluett, Peabody, Cluett turned his attention to creating the perfect house for his collection on a 178-acre tract in Williamstown, Massachusetts.

According to Philip Zea, who has looked into Cluett's background and motives, Cluett was interested in rarity, bold design, and technological achievement, rather than the origins and associations of the objects he collected.[5] Cluett's "principal supplier" of American antiques, according to Zea, was Francis Hill Bigelow, a Boston collector and dealer who shared Cluett's passion for neoclassical objects of the Federal period. Cluett also bought from the New York dealer Charles Woolsey Lyon, from the legendary Israel Sack of Boston and New York, and from Katrina Kipper. He collected numerous pieces attributed to three of the most fashionable and famous furnituremaking names of the 1820s—Duncan Phyfe of New York, John and Thomas Seymour of Boston, and Samuel McIntire of Salem—and Zea notes that his collection "became representative, almost encyclopedic" as a result. Cluett himself placed his collection on the same level as those of Maxim Karolik and Henry Francis du Pont. Karolik was the dramatic Russian émigré who formed an extraordinary collection of American furniture for the Museum of Fine Arts, Boston. Du Pont is probably the all-time greatest connoisseur/collector in the history of American decorative-arts collecting, and his objects may be seen at the Winterthur Museum in Delaware.

Cluett and Henry Flynt were fellow trustees of Williams College, so they came to know one another at meetings and at other events in Williamstown, where Cluett had taken up permanent residence in 1930. After Cluett died in 1955, Henry Flynt suggested to his heirs that they lend elements of the collection they couldn't use personally to the Heritage Foundation. The heirs, who were George Cluett's four children, gave the Williamstown house and considerable property to Williams College and agreed to lend a substantial portion of the collection to Deerfield.

"One of the first events that I remember from when I first came to Deerfield," said Peter Spang, "was going with [the Flynts] and Lloyd Hyde on a Sunday...over to Williamstown. Lloyd Hyde appraised the entire contents of the house. It was really a fabulous experience seeing all these great pieces, including the labeled Seymour secretary, the labeled Lannuier pier table, and others."[6]

Residence of Asa & E.W. Stebbins

92. This lithograph by Benjamin A. Clark, published in Philadelphia in 1855, shows the homes and outbuildings of Asa Stebbins, Jr., and his son Edward. As the family stopped farming the land, the outbuildings disappeared. Present-day Wright House may be seen on the far right.

93. Wright House with Victorian porches; this pre-restoration photograph presents an excellent view of the meadows to the north of Deerfield.

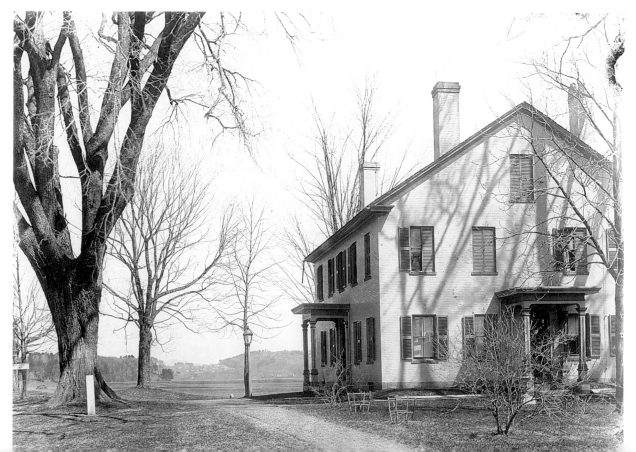

Saying that Cluett's collection had been "fifty years in forming and [was] selective to the highest degree," Helen Comstock described and pictured it in an article in *The Magazine Antiques* for November 1954. "The house [in Williamstown] is a work of art in itself," wrote Miss Comstock, "offering a perfect architectural setting designed around the collection." The Chippendale furniture was displayed in a library based on "the ballroom from the Samuel Powel house in Philadelphia, built in 1768, and now in the Philadelphia Museum of Art.... The Hepplewhite and Sheraton pieces, which are in the majority, are arranged in a series of rooms inspired by Samuel McIntire."[7]

It is true that the Cluett collection was composed of urban high-style pieces, while the Flynts' Heritage Foundation focused on the kinds of things that would have been found in a rural New England town—most of them less sophisticated and expensive than Cluett's. But Philip Zea points out that putting the Cluett pieces on exhibition in Deerfield enables the staff to expand its teaching role by making significant comparisons and contrasts between the products of northeastern coastal cities and those of the affluent and important, though admittedly more isolated, Connecticut Valley region. The Cluett collection, Zea says, serves as a foil for locally owned things in the other houses. "It means that you can look at a tall clock made by Daniel Clay [of nearby Greenfield] in the 1790s and then come here [to the Wright House] to see a great urban clock of that same period. This is unusual in an American museum."[8]

When the Cluett pieces arrived in Deerfield the Flynts and Peter Spang arranged them in period-room-style settings with many oriental rugs, early glass and ceramic objects, candlesticks, and suitable paintings. Also, says Spang, "A few pieces of Flynt furniture and a New York table from Mrs. Potter's collection were eventually moved to Wright so that most of the important furniture from the Northeast, but not related to Deerfield, would be together."[9]

The Flynts wanted George Cluett's children to feel free to visit Deerfield at any time and urged them to stay at the Wright House among their father's antiques. Therefore, according to Spang, "Beds were fixed up and towels put in the bathroom...[There was also] some...Cluett memorabilia." Some of the elaborate draperies from the Williamstown house dressed the Wright House windows, while others were hung with curtains the Flynts commissioned in 1961 from the ultrafashionable New York upholsterer Ernest LoNano.[10]

In preparing Wright House to receive the Cluett collection, the Flynts had relatively little major renovation to do, for the house had survived its century-and-a-quarter fairly intact. Although good early photographs existed and could have been very useful in restoring the house to its 1824 appearance, "unfortunately the Flynts and Bill Gass did not refer to these photographs when they decided to make changes...they removed the shutters and put small-paned windows in—twelve over twelve—which made the house look like something from Colonial Williamsburg."[11] Shortly after his arrival in Deerfield, however, Spang discovered the photographs and in the early 1960s he persuaded the Flynts to replace the window panes with more appropriate larger ones, to reinstate the shutters, and to build a white picket fence like the one that can be seen in a photograph of the 1860s.

The interior of Wright House was considerably plainer than that of Asa's father's house, but was "carefully designed and executed...with its symmetry, careful thought to windows for light, doors for privacy, and space for storage.... [It] bespeaks the hand of a professional." The professional may have been Winthrop Clapp, the designer and builder of the Brick Meetinghouse, erected the same year.[12] Only a few adjustments were necessary inside the house. One important change was that the black-marble mantelpieces that had replaced the originals in the Victorian period were taken out and replaced by Federal examples from nearby houses.

Over the years the Cluetts took back some pieces, lent others, and gave still others. As their situations changed and they reduced their households, each of the four children eventually gave substantial amounts of their father's furniture to Deerfield. In the 1980s, when one of Cluett's daughters gave a splendid group of furniture that had previously been on loan elsewhere, "one of the great things that Phil [Zea] did...was to rethink the Wright House," says Peter Spang. "Since it was so plain, it was decided to put track lighting in the ceilings and to put only furniture and clocks and not many decorative elements.... Phil organized a plan and made it...a great study place for great American furniture from the East Coast."[13]

The house, which is the only one at Deerfield that does not employ period settings, groups furniture on platforms set against plain white walls in ways that are not possible in a period environment. For example, one group focuses on upholstery—on early techniques, and the underlying frame (see fig. 94). Another illustrates the different ways veneer and inlay can ornament different furniture forms made in different styles but in the same geographical region (see fig. 96). Other groups contain pieces with similar features: a splendid array of side chairs in the manner of Duncan Phyfe (see fig. 103), furniture with graceful outlines and rich carving in the style of Samuel McIntire (see fig. 102), and so on.

Some objects in the Cluett collection are so spectacular that they are displayed alone, in all their glory. George A. Cluett's own bed, with four magnificent carved claw-and-ball feet and detachable carved knees on the foot

posts, is one of only six known examples of its type (see fig. 101). In his Williamstown home Cluett had displayed together two demilune commodes that had been made in the Boston area in the most elaborate and expensive taste of the Federal period; they made a spectacular sight, but they are shown separately in Deerfield so that the viewer can fully appreciate the splendor of each without distraction (see fig. 97).

At the same time that they were planning to install the Cluett collection, the Flynts began to think about a unified display of their large collection of Chinese Export porcelain. Made in China for the foreign market, these wares were fashionable throughout Europe and America during the eighteenth and nineteenth centuries. The importation of Chinese Export ceramics into America increased markedly after the Revolutionary War, when American ships began to trade directly with China and other foreign countries. In 1786, George Washington purchased a set of Chinese Export porcelain described by the New York merchant from whom he obtained it as "1 Sett of Cincinnati China Contg, 1 Breakfast, 1 Table, 1 Tea Service of 302 ps."[14] This service, decorated with the emblem of the Society of the Cincinnati, cost $150.

The Flynts' Chinese Export ceramics were divided among several of the museum houses at this time, and a great deal remained at their Greenwich house. The Wright House presented an opportunity to gather much of this porcelain together in one place. As Peter Spang recalls, "it was decided to make Wright House also a gallery for its display. It seemed appropriate to have all this high-style ceramic ware in with the high-style furniture."[15]

As a result of this decision, a large first-floor pantry received a noteworthy assortment of ceramics made in China for the European and American markets (see fig. 98). A nearby cupboard held an even more impressive display—of a tea set bearing the rare and much coveted symbol of the Society of the Cincinnati (see fig. 99). Samuel Shaw, factor of the famous American ship *Empress of China*, had ordered this set in China in 1790 for his friend Dr. David Townsend of Boston, whose cypher also appears on the dishes. Both Shaw and Townsend were founding members of the Society of the Cincinnati, organized at the close of the Revolution by Washington's officers "for fraternal, patriotic, and allegedly nonpolitical aims."[16] Dr. Townsend's certificate of membership in the Society is displayed in the same room; his portrait hangs in an adjoining room. This kind of almost unheard-of richness—a rare and historic set of china and the Society of the Cincinnati certificate of the man for whom it was made *and* that man's portrait, as well as that man's own copy of the Massachusetts Society's rules and regulations and the letter Samuel Shaw wrote him advising him that he'd ordered the set—is characteristic of the Flynts' collecting at its best, according to Philip Zea. This group is "real Flynt—here's everything but the body," says Zea.

In his letter to Townsend, Shaw expresses his anticipation of seeing his old friend before long and of drinking tea from the new service. Let's "see whether a little good tea improves or loses any of its flavor in passing from one hemisphere to the other," he writes. Many years later, in commenting on this letter after procuring pieces of the Townsend tea set, Henry Flynt wrote a friend, "I am sure that tea will taste much better in a cup of such distinction."[17]

The Flynts' purchase of the Townsend pieces provides a good example of their collecting tastes and style. Although it is sometimes said to have been Mrs. Flynt who was particularly interested in collecting ceramics, it was certainly Flynt who was fascinated by antiques with historical as well as aesthetic credentials. The combination of Chinese porcelain made for the American market with the emblem of an elite Revolutionary society and its descent in an old and eminent New England family made the Townsend porcelain very attractive indeed to the Flynts. They bought the nucleus of the set from a well-known New York dealer and inquired whether they were buying everything that remained of the Townsend service; they were assured that they were. Within a short time a Connecticut picker and dealer offered the Flynts another group of objects from the Townsend set—at an astronomical price—but these were the imperfect pieces, marred by breaks and chips. Henry Flynt was outraged, feeling that the big-city dealer had sold off the defective pieces and then denied knowing about them. The next time he was in New York Flynt paid the dealer a call, "to say goodbye," he announced. The puzzled dealer inquired where Flynt was going, and Flynt informed him that he preferred to deal with sellers of integrity and would not be doing business in that particular shop again.[18]

Despite its complications, the purchase of the Townsend tea set gave the Flynts much pleasure. Elizabeth Lusk Childs, one of Deerfield's long-time guides, recalled that Flynt would often gaze appreciatively at one of the eagle-emblazoned wares and say, "Look at the feathers on that bird."[19]

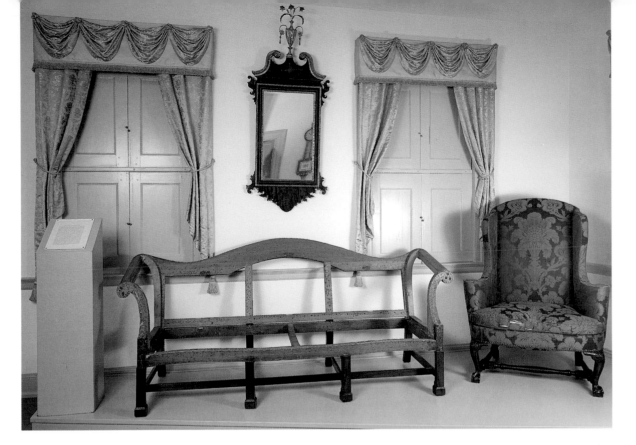

94. This group is arranged to illustrate some aspects of the upholsterer's task: he starts with a frame and ends with a finished product that is as much the result of his art as it is of the joiner/cabinetmaker's. Of the stripped sofa, Philip Zea says, "People love to see it. Some interpret it as sheer technique. Some interpret it as sculpture."

95. The arts of mid-Georgian New York are displayed in this group. This was a period when rich walnut veneers and mahogany, combined with the heavily elegant S-curves characteristic of New York Queen Anne and Chippendale styles, created a dignified and handsome body of high-style furniture. The sinuous side chairs have original needlework seats worked by Margaret Fayerweather Bromfield (1732–1761) of Boston (despite the fact that the chairs are from New York). They flank a five-legged card table that belongs to a distinguished group of New York tables with this feature. The looking glass is one of a small number of objects with a japanned finish that may be attributed to New York. It is inscribed "Heirloom through Hermanus Wendell 1700," and descended in the Wendell family of Albany.

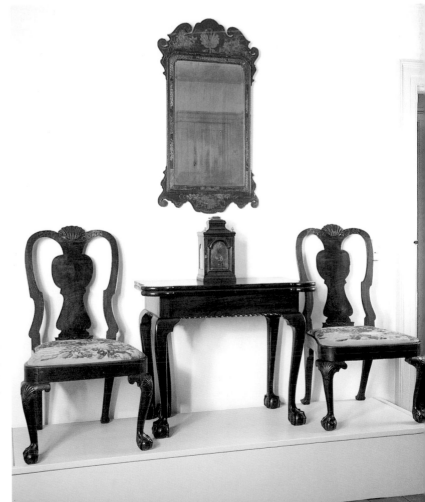

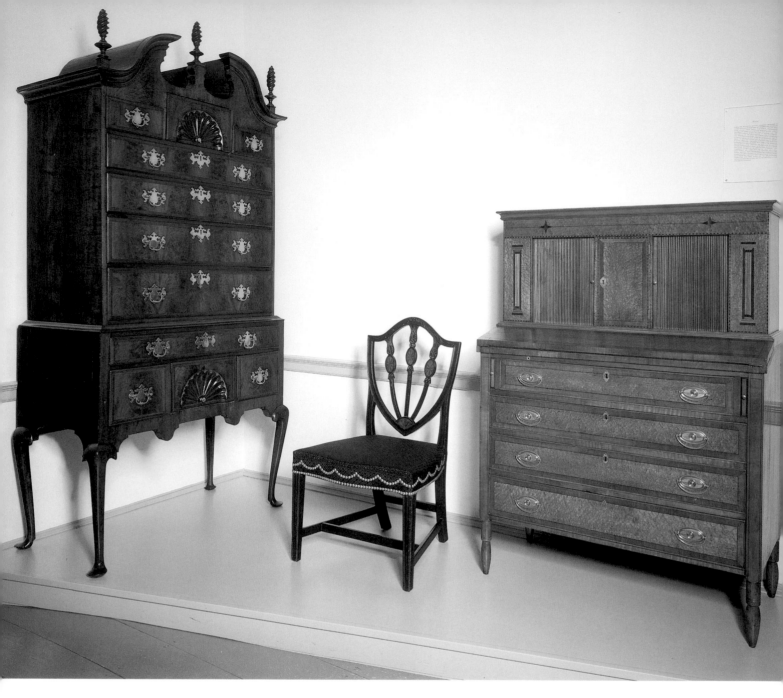

96. A splendid Queen Anne high chest; a tambour desk that is a country version of a stylish city form; and a mahogany side chair with light-wood inlay illustrate some of the uses to which veneer and inlay were put in different periods and places. The veneered high chest, probably made in Salem, represents the most sophisticated use of materials to enhance an equally sophisticated form; it is the best of its class. The Federal desk from the Merrimack Valley of New Hampshire illustrates the country craftsman's use of local materials like birch and maple to produce an inlaid and veneered form more characteristic in mahogany and satinwood in fashionable urban areas like Boston. The vase-back side chair, also of the Federal period but perhaps a little earlier than the desk, was made by William Fiske of Roxbury, Massachusetts, about 1790. In this case, however, mahogany is inlaid with satinwood paterae and a fan to suit the elegant parlors and dining rooms of wealthy port cities.

This chair also exemplifies Historic Deerfield's ongoing concern with "noninvasive" upholstery—that is to say, with types of upholstering that do no further damage to the chair or sofa frame in question. Iona Lincoln, Curatorial Associate for Textiles, has been working with conservator John Payson of nearby Conway to refine techniques for creating correct period upholstery without adding new nailholes to the frame. Since old chair and sofa frames are literally peppered with holes from successive upholsterings, it behooves their current owners to conserve them. It is with such cautions in mind that Historic Deerfield has embarked on a careful in-house reupholstery program.

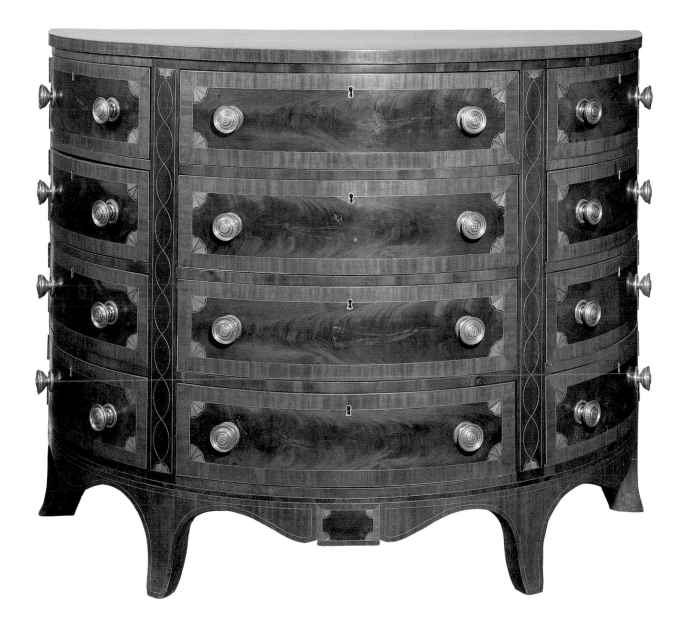

97. One of two demilune commodes that George Cluett collected and displayed at his Colonial Revival house in Williamstown. Of mahogany and mahogany and lightwood veneers, this may have been made by Stephen Badlam in Dorchester Lower Mills between 1795 and 1805. The demilune commode is one of the grandest forms of the Federal period.

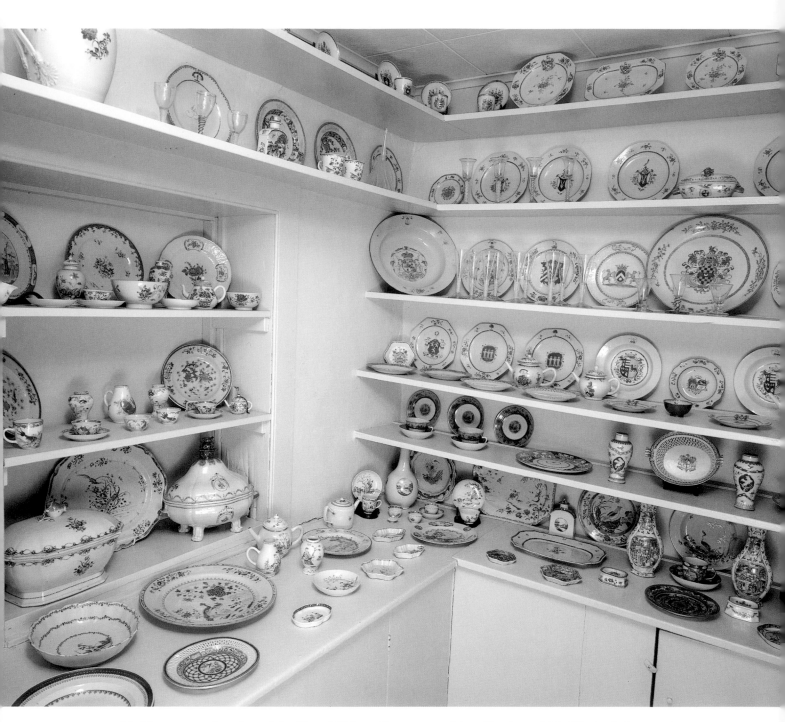

98. The range and variety of the Flynts' Chinese Export porcelain collection, which fills the shelves on three sides of this converted pantry, is apparent to any viewer. When the Cluett collection was first installed in Wright House in 1962, the Flynts decided to consolidate and install their Chinese Export porcelain as well. They gathered porcelains from the museum houses and from their Greenwich house and created impressive displays such as this.

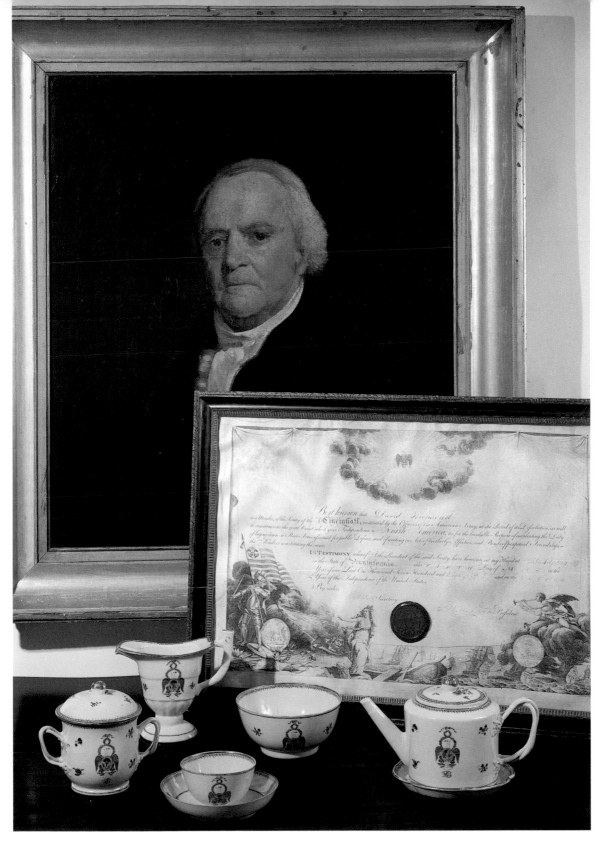

99. One of the Flynts' greatest treasures is the Townsend tea set, made in China in 1790; some pieces from the set are shown here beneath the portrait of its first owner. The tea set and portrait combine artistic and historical credentials that make them the kind of many-faceted artifacts Henry Flynt, particularly, loved. Samuel Shaw, factor of the famous American ship *Empress of China*, ordered this set for his friend Dr. David Townsend of Boston. Both men had served under Washington during the Revolution and were founding members of the Society of the Cincinnati. The tea set descended in the Townsend family along with this portrait of Dr. David, his Cincinnati certificate (also seen here), and a letter from Shaw about the tea set.

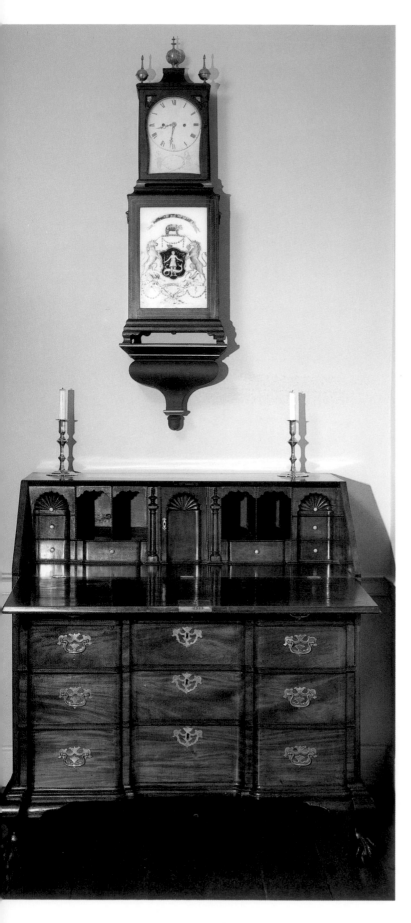

100. Among high-style furniture from the Flynts' own collection on display in Wright House is this imposing mahogany block-front desk labeled by Benjamin Frothingham, one of Boston's premier cabinetmakers. There are few types of documentation more impressive than a cabinetmaker's label. Add to that the splendor of the desk itself and you have a most admirable object. As Margaretta Lovell notes of the form in *Boston Furniture*, "These richly grained mahogany sculpturesque desks...imply by their grand scale of design the worldly competence and solidity of Boston's successful citizenry." And, one might add in this case, of their subsequent owners. Over the desk stands a regal shelf clock by Aaron Willard of Boston. The reduced scale of shelf clocks, which the Willard family introduced just after the Revolution, ensured their fitting well into elegant Federal parlors. This example, with bell-shaped dial, is enhanced by resplendent *églomisé* (reverse painting on glass) decoration consisting of the arms of the apothecary company on the lower case.

100a. Detail of the desk showing Benjamin Frothingham's label.

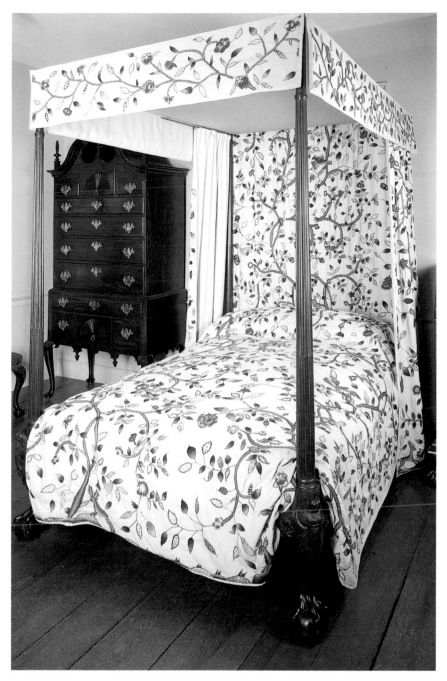

101. George Cluett's own bed is shown in Wright House surrounded by other luxurious products of wealthy Colonial New Englanders. The bed is one of a very small, select group of examples with detachable kneecaps, which can be removed to get at the bolts that hold the side and foot rails together. Another unusual and rare feature is that all four feet of this bed are carved into the claw-and-ball form and have the raked side claw characteristic of the finest eastern Massachusetts work. On most beds, the feet at the headboard are not carved because they are expected to be hidden by hangings. These crewel-embroidered fustian hangings are English, made about the middle of the eighteenth century.

101a. Closeup of the carved detachable kneecap on George Cluett's four-poster bed.

102. Although plainer than some of the other "McIntire" pieces in the Cluett collection, this server conveys the delicacy and richness of Federal furniture made in Salem, Massachusetts. The lush quality of the mahogany and the crisp and dainty carving of the basket of fruit are typical of Salem work during the Federal period. Because Samuel McIntire, an immensely gifted carver and designer, was working in Salem during this period, furniture of this kind has often been referred to as "McIntire." Although by now this has become an almost generic term, there were certainly other proficient craftsmen working in the style as well as McIntire.

103. One of the things it was possible to do when Philip Zea rearranged the Wright House in 1985 was to create groups with themes. Besides technical themes like upholstery, inlay, and veneer, there are others like regions, schools, and craftsmen. This group contains chairs all of which are of types associated with New York makers; except for the top row, they are also designs often associated with Duncan Phyfe, possibly America's most famous cabinetmaker. The vase- or shield-back chairs at the top are earlier than those on the two lower levels, which have the rounded lines and animal features (hairy shanks, dog's-paw feet) characteristic of the later Federal style. Phyfe, like McIntire, has been credited with making far more furniture than he could possibly have produced during his lifetime. He practiced a style that many other competent craftsmen were also making but Fate has decreed that *his* name and not theirs be attached to the style.

104. Both the kidney-shaped card table and the looking glass with *églomisé* decoration represent the finest achievements of American cabinetmakers of the Federal period. The mahogany and mahogany-veneer card table, made in Baltimore between 1795 and 1810, has five *églomisé* panels depicting classical figures mounted in its skirt. The looking glass with eagle finial, also with an *églomisé* panel, was made in New York City or Albany between 1795 and 1815. The *églomisé* landscape includes Mount Vernon, one of the most popular subjects of the Federal period.

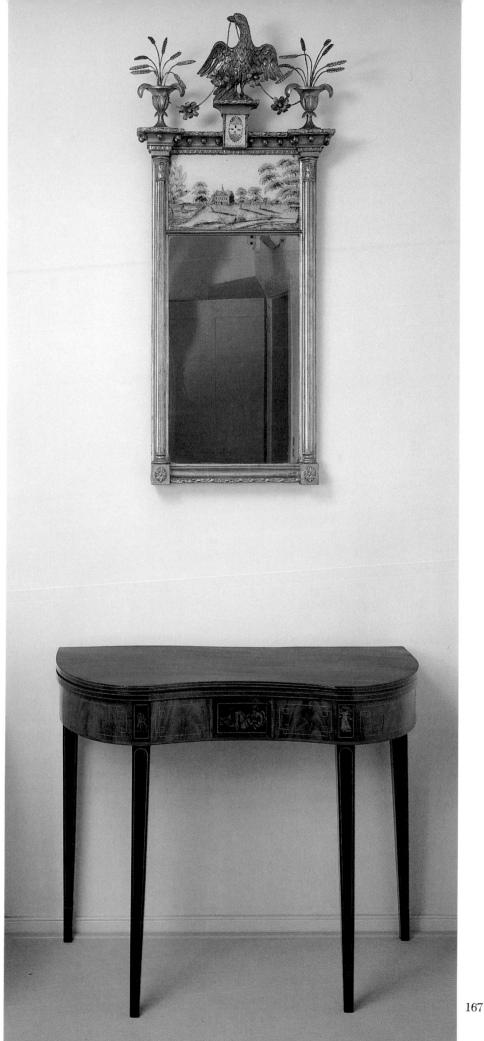

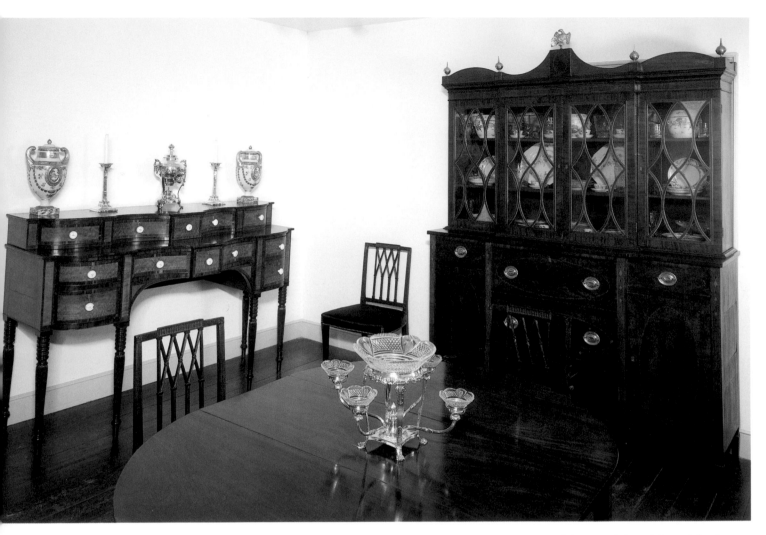

105. Two new and fashionable American furniture forms in the Federal period were the breakfront and the sideboard, both seen here. The Salem breakfront with finely veneered façade and eagle finial, attributed to Nehemiah Adams, contains examples of Chinese Export porcelain from the Flynts' vast collection. More of this ware, as well as English Sheffield-plated silver, may be seen atop the vividly veneered tiered sideboard.

Made in Boston between 1800 and 1815, the sideboard was a gift to President James Monroe from his son-in-law Samuel L. Gouveneur. It bears a silver plate engraved *J.M.* and is accompanied by documentation. The English epergne on the table in the foreground is a form collected by many Americans of the Flynts' generation; this example was a gift to the Flynts from Dudley Miller.

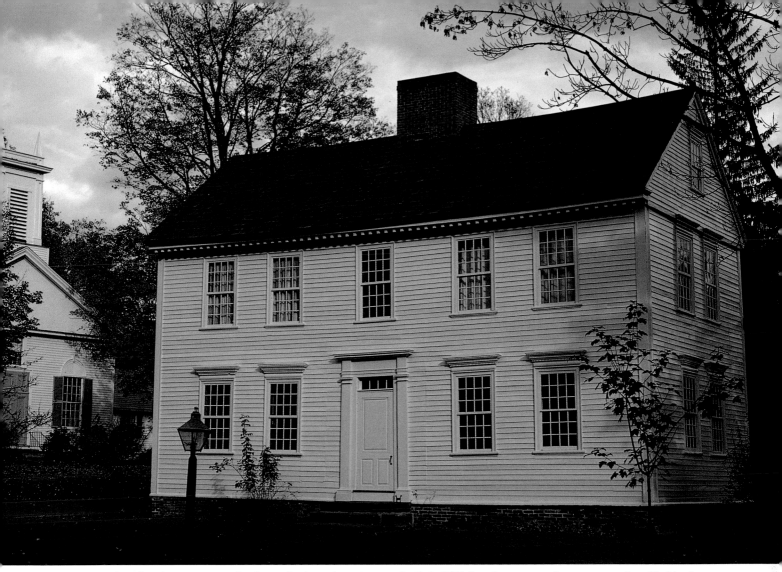

106. Exterior of Wells-Thorn House. The front clapboard section was built in 1751, but the present doorway was installed in the Federal period. When Architectural Conservator William Flynt and a consultant analyzed the paint colors on this section of the house in 1981, they discovered that the second color on the house had been a striking light sky blue. The decision was made to repaint the house in this color. "We were one of the first museums to get back to the correct colors," says Peter Spang. "They seem so shocking, but they really aren't. If you look at embroideries from Newport, Rhode Island, you find many blue houses depicted."

The Wells-Thorn House

One of the interesting things about old houses, aside from their venerable materials and hand craftsmanship, is that they are frequently made up of rooms and wings added at different dates. No house in Deerfield illustrates this point more graphically than the Wells-Thorn House. Its front section, built in 1751, consists of two stories; there are two parlors on the first floor, one on either side of the central chimney, and there is a bedchamber above each (see fig. 106). This wing is symmetrically organized, with large windows and a center doorway. It is painted a surprising "light sky blue"—a color of about 1800.

The back section, probably built in 1720, is of basically one story, though it has been called "one of the original split-level homes in America" because the kitchen was built a few steps down from the parlor and pantry to conform to the slope of the land (see fig. 107). This wing is covered with random-width siding that has never been painted. It has diamond-paned windows and a sturdy batten door fashioned to defend its occupants against intruders, rather than to provide a welcoming entrance as the later door does. Together, the two sections present a startling contrast, the defensive frontier mentality of the

106a. Detail of Wells-Thorn House, showing a portion of the rear unpainted wing that dates from about 1720.

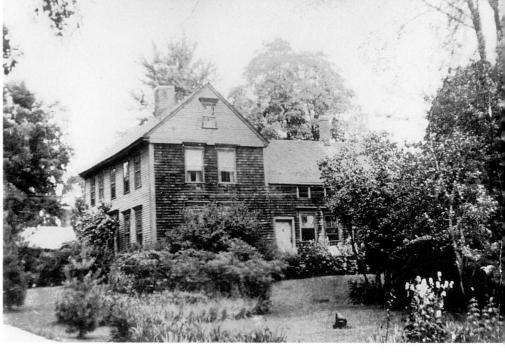

107. Dr. and Mrs. Edwin Thorn's house, early twentieth century. "You will notice quite a difference in the vegetation around the Thorn home when the Thorns occupied it," writes their daughter Elizabeth Thorn Welford. "Daddy had a rose bed and a peony bed. He made the grape arbor. We had many fruit trees and shrubbery with edible berries— raspberries, etc. Originally our garden plot extended to the line of what is now [Route 5]—six houses are now on that land."

108a. and 108b. Edwin and Luanna Thorn shown in photographs taken many years ago.

older one juxtaposed with the settled and prosperous outlook of the later one.

Ensign Ebenezer Wells bought the property in 1717. At that time either the early part of the present Wells-Thorn House or another house, later destroyed, was present on the site. George Sheldon, in his *History of Deerfield*, declared that the house that occupied the lot when Wells bought it burned down, but so far no one has been able to learn what Sheldon's source was and there seems to be no other indication of an earlier house on the lot. At any rate, the early part of the present house, whether or not it is the original, is of a seventeenth-century type. Its unpainted exterior surface, few windows and stout door, and center-chimney arrangement are all hallmarks of early New England architecture.[1]

Like many other early owners of Historic Deerfield houses, Ebenezer Wells was prosperous and community minded. He held the offices of selectman and general assessor for many years and served as town treasurer in the 1730s. He was also an "Innholder, taverner and common victualler of strong liquor by retail" during the years 1747–1752. About 1751, Ebenezer and Abigail Wells added the four-room front section to the west side of their first house, doubling the size of their dwelling.

The fashionable new addition had higher ceilings, larger windows, and much more light and air than the earlier wing. The hallways and the rooms on the south side of the house (the northern rooms weren't completed until later) were finished with paneling and paint, and there may also have been a pedimented Connecticut Valley doorway on the front like the one on the Sheldon-Hawks House. The present doorway was added later, during the Greek Revival period.

After Ebenezer's death in 1758, the house passed to his nephew and namesake, Ebenezer Wells, son of Deerfield's first doctor. He and his wife, Mercy Bardwell, compensated for the lack of children in the previous generation by filling the house with nine offspring. When this second Ebenezer died in 1783, Mercy continued to live in the house with their son Ebenezer and his wife until her death in 1801.

In that year Hezekiah Wright Strong, a lawyer who had been living and practicing law in Deerfield since 1794, bought the house from Mercy's heirs. There is evidence of an exterior staircase on the east side of the house, which Strong probably added so that his clients could enter a second-floor office without disturbing the rest of his household.[2] It was probably Strong, too, who made several other changes in the house, which he apparently bought for his new wife, Martha Dwight.

Among the improvements the Strongs made were finishing the north rooms of the 1751 addition and remodeling the stairs and banisters between the first and second floors. The newly finished north parlor sported elegant neoclassical moldings and trim, as opposed to the bolder and simpler paneling of the south parlor of 1751. Strong is also thought to have painted the front part of the house a striking light sky blue in an effort "to attract attention to himself and his practice," as he was relatively new in town.[3] It is possible that this work took place in 1803, for in that year Strong's real-estate taxes went up a hefty $42, indicating improvements to the house and/or property.

In 1808, Orlando Ware, a merchant, farmer, and livery-stable owner, bought the property. Although it is unclear at this distance what changes the Ware family made to the house during the century they owned it, it is probable that they added a Greek Revival mantelpiece (now stored in the attic) to the south parlor and the present doorway to the front door, probably in the 1820s or 1830s. Things went downhill in the latter part of the century, and by the time Dr. and Mrs. Edwin C. Thorn bought the house in 1905, it was run down and much in need of loving care.

To make the house habitable, the Thorns repaired the foundations, replaced rotted floors and windows, and replastered many rooms. They also partitioned what later became the keeping room to make a dining room and a doctor's office, and finished off some sleeping areas in the garret. The Thorns also added a workshop for the use of both the doctor, who was an avid amateur cabinetmaker, and his wife, who sold her weaving and other crafts there in her Deerfield Handicraft Shop.

The Thorns were very much interested in old houses and furniture, and they made an effort to use old wood, old glass, and whatever other old materials they could secure for their renovation. They furnished the house with antiques inherited from their families, or that they had collected, or that Dr. Thorn took in payment for medical services. The doctor enjoyed repairing and refinishing old pieces, as well as making reproductions (some of which are now in the collections of Historic Deerfield). Both Thorns were part of the local Arts and Crafts community, with an interest in reviving New England crafts, and this undoubtedly influenced their appreciation of early handmade furnishings.

Just after the Thorns had bought the house Mrs. Thorn went in on an inspection tour, and as she was walking about she heard noises coming from the stairway. Upon investigating, she found an old, old man staggering down the stairs under the weight of a heavy load of ledgers. It turned out to be eminent historian and notorious collector George Sheldon who, when he learned that the house had been sold, simply let himself in and proceeded to the attic with the intention of carrying away what he could. His purpose was to rescue old documents from newcomers who, he thought, might very possibly destroy them. In this case, he was making off with account books from the store run by the Ware family in the early nineteenth

century, which he intended to deposit in Memorial Hall library. What Mrs. Thorn particularly remembered of the incident was Sheldon's assumption that it was his right to salvage any aspect of Deerfield's history, with no thought of securing its lawful owner's permission.[4]

The Thorns raised a family of six children in the house. Dr. Thorn died at a relatively young age, but Mrs. Thorn continued there until she sold the house to Mrs. Flynt in 1962. She had had it on the market rather halfheartedly for a number of years, according to Peter Spang, but her price was too high for the Flynts. Finally, in the fall of 1962, just as they were preparing to return to Greenwich, Helen and Henry Flynt decided to make a real effort to come to terms with Mrs. Thorn. She agreed to negotiate, and they arrived at a price that very morning. While they were together, Henry Flynt, who loved to tease people, kidded Mrs. Thorn about her imminent trip to Florida. He said he knew she'd preserve her title as champion shuffleboard player. Seeming to enjoy the exchange, Mrs. Thorn gave back as good as she got.

The Flynts, pleased with the deal, set off for Greenwich, leaving their local lawyer and Peter Spang to finish up the details of the purchase. When Spang returned with the sale papers later that day, Mrs. Thorn greeted him with, "I'm not selling." Surprised and bewildered, Spang inquired what was wrong. "That man is too fresh," she declared, "he's just too fresh. I'm not going to sell to him." Spang retreated to his office and called the Flynts to apprise them of this startling turn of events. After some consultation with his wife, Mr. Flynt instructed Spang to inquire whether Mrs. Thorn would sell to *Mrs.* Flynt. Mrs. Thorn would be happy to, she replied, and the deal went through.[5]

The Thorns, having lived in Deerfield since nearly the turn of the century, had an understandable proprietary attitude toward the town. Since the Flynts' original involvement came from their association with Deerfield Academy, which the Thorns and others had turned against as a result of a dispute in the 1920s, they considered the Flynts "outlanders" and members of "that Academy crowd." Despite this and Mrs. Thorn's temporary snit over Henry Flynt's fresh behavior, she and the Flynts ended up good friends. Peter Spang remembers going to visit her with Mr. and Mrs. Flynt and drinking her delicious dandelion wine. "She was a charming little old lady with a wonderful laugh," he recalls, "a real old New England type."[6] He took pictures of her weaving at her loom, which she had set up in the back ell (see end of chapter).

Besides family furniture that Mrs. Thorn had brought with her from her native Vermont and that Dr. Thorn had inherited from his father, who was also a collector, the house contained all the other antiques that the Thorns had acquired over the years. Mrs. Thorn took Spang all through the house, telling him about their renovations and indicating which antiques she felt were important to Deerfield history. These the Flynts acquired for the restoration, although the Thorns also retained many things within the family.

The Wells-Thorn House, as the Flynts decided to call it after its first and last private owners, "was probably done with more research and care, given the limited amount of time [we had], than any of the other houses," says Spang.[7] Having learned by this time that research and careful investigation paid off, the Flynts had immediately called upon Spang, local researcher and architectural historian Amelia Miller, and contractor Bill Gass to begin a study of the house's architectural past. They also recruited Abbott Lowell Cummings, noted authority on early New England architecture, whom they had called upon during the restoration of the Sheldon-Hawks House.

Working together, this team avoided many of the mistakes made in earlier renovations. Even so, "a lot of educated guesses had to be made," says Spang. "I remember that we used to go over to the house and pull down parts of ceilings [so that] we could tell where there was smoke on beams, [because that indicated] that a fireplace had been there." It is Spang's belief that another of the reasons this restoration was more accurate than some previous ones is that he and Mrs. Miller were on the site checking up on Gass and his crew most of the time. During earlier projects, he says, "Bill Gass was pretty much left to his own devices."[8]

Henry Flynt, in commenting on the restoration to a newspaper reporter at the time of the opening of the Wells-Thorn House, said, "Much of the restoration work consisted of removing layers of paint, removing partitions that had been installed by later tenants and refinishing the pine panelled walls."[9] Chimneys and fireplaces also had to be reconstructed, which entailed a great deal of work. Some of the materials came from a man named Hugh Sloan, whom Bill Gass had originally trained. Sloan specialized in wood, bricks, and other material from old buildings. "He's got spotters all over New England and wreckers [who, if they have something of interest] call him up," Gass explained of Sloan. "He'll go look at it and if it's right he'll buy it." Another supplier of old materials was I. M. ("Iggy") Wiese of Connecticut, who furnished old wood for the keeping room, pantry, buttery, and kitchen, but whose prices Gass considered exorbitant. "Nice lumber," said Gass of the keeping room and pantry walls, "but we paid through the nose."[10]

The Thorns had put shingles on the exterior and had removed the back ell, replacing it with a smaller one. So the research team found a nineteenth-century photograph by the Allen sisters that showed the house in its pre-Thorn state. "Being archeologically minded," says Spang of Amelia Miller, Abbott Cummings, and himself, "we got

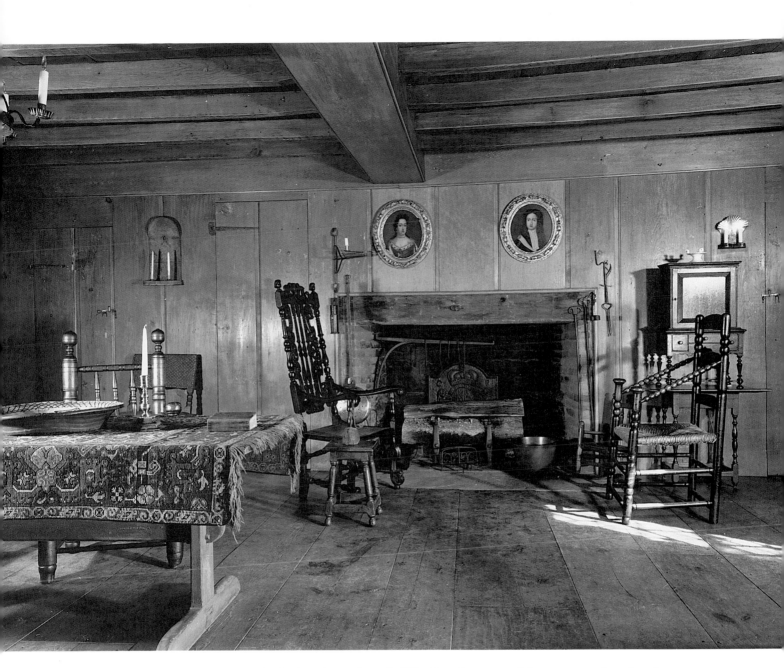

109. Keeping room shown as it looked in the 1960s and 1970s. Fine furniture of the seventeenth and early eighteenth centuries coexists with such desirable accessories as an English slipware plate, an oriental rug, a variety of lighting fixtures, and portraits of Queen Anne and Prince George of Denmark. Although extremely atmospheric, this room exemplifies a romantic twentieth-century vision rather than a realistic depiction of life on the Deerfield frontier.

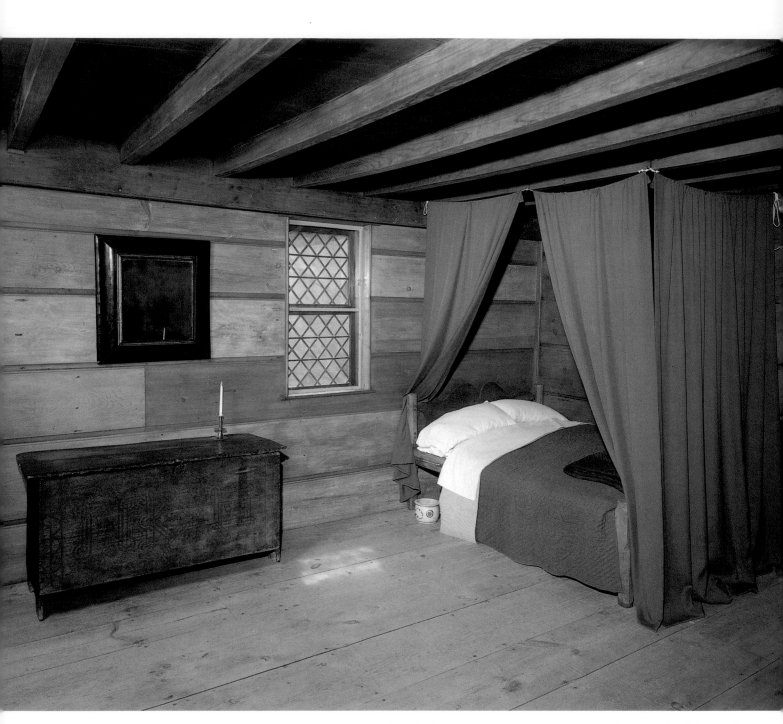

110. 1735 parlor (formerly the keeping room) as it was refurnished in 1987 to suggest the growing feelings of stability and permanence in Deerfield about 1735. It contains a modest assortment of forms that indicate the variety of activities that took place in the room: a bed, chests, and, out of sight here, a table and chairs and spinning wheel. There are neither carpet nor curtains, but the family's prosperity is suggested by the imported looking glass, brass candlestick, and full set of bed hangings suspended from the ceiling. Philip Zea notes that although there are relatively few things here, their sources are international: Germany, Holland, and England, as well as Boston.

Bill Gass to copy the [back ell] exactly from the Allen sisters photograph. It showed three doors [on the north side]; well, we put three doors in."[11] Once the shingles were removed, it was discovered that the original boarding had rotted, and "new" old clapboards were found and applied.

As was usual, the Flynts created an apartment in the ell to provide additional housing for Deerfield Academy. They put radiant heat in the ceilings and brought electricity and plumbing up to date. All told, it took from October of 1962 to October of 1963 to complete the work. Toward the end there was a great rush to get finished in time for the scheduled visit of the Walpole Society, the exclusive collecting group of which Mr. Flynt was a member. "The Flynts were going to entertain a highbrow antiques society," said Bill Gass. "And I had about ten days to get it ready.... So I did all the walls and everything here [in the kitchen] in about ten days...and we made it!"[12]

As Henry Flynt was waiting to receive Walpole Society members in the Wells-Thorn House, Gass recalled, he was overseeing the lighting of a fire in the kitchen fireplace. "They didn't open the damper," said Gass. "This place was filled with smoke. [Flynt was] havin' a fit."[13] The oversight was soon corrected, however, and when the illustrious Society arrived the smoke had cleared out.

"It was Abbott [Cummings] who said that since the house was so clearly of different periods, why not [restore] it to different periods," says Peter Spang. This plan was followed: seventeenth-century furniture filled the earliest rooms, while eighteenth-century pieces of the William and Mary, Queen Anne, Chippendale, and Federal styles filled the later rooms. Upstairs in the south chamber, furnished with William and Mary and Chippendale pieces, a mock patient leaning against a rare early wooden bedrest was attended by a seated "doctor." Both were dressed in early clothing from the Flynts' impressive collection. When Mr. and Mrs. Flynt asked him to supply more accessories, Spang placed a document headed "Observations on Some Fatal Mistakes" near the bedridden patient.[14]

Also on the second floor were the offices of a lawyer and his clerk, arranged to recreate the offices of Hezekiah Wright Strong as they might have looked when he practiced law here in the early nineteenth century. Carrying out the themes of illness and death were a mourning picture on the wall of the clerk's office and a will in process of being drawn up in the lawyer's office. "I'm not sure how authentic it was," recalls Spang, "but we all had a good time, and people seemed to be amused and interested. It also added a certain lively flavor to the restoration."[15]

Some of the furnishings the Flynts placed in the Wells-Thorn House were much too grand, says Spang. "[The Flynts] discovered Moustapha Avigdor, an oriental carpet dealer near Boston who had very fine rugs, and they couldn't resist buying a number [of them] for this house as well as Allen House. They were wonderful...but not at all appropriate for New England."[16]

This was the period when the Flynts associated with other leading collectors of American antiques with whom they had become friends. "Each of these collectors had a specialty that didn't conflict too much with the others'— they were all very friendly and learned from each other," says former *Antiques Magazine* Editor Alice Winchester.[17] And naturally they influenced each others' decorating styles, which surely explains the rare and beautiful—if inappropriate—oriental rugs, the lavish draperies in the parlors, and the high-style walnut and mahogany furniture throughout the 1751 part of the house. Such an opulent approach to furnishing was typical of this whole group of wealthy collectors.

Also characteristic of the group was the use of themes in room settings, a practice perhaps not originated but certainly perfected by two gifted collectors, Henry Davis Sleeper of Massachusetts and Henry Francis du Pont of Delaware. Although Sleeper died in 1934, du Pont was still very much part of the collecting scene in the 1950s and 1960s. The Flynts and their friends considered his home, Winterthur, with its dozens of exquisitely appointed period rooms, to be without equal. All of du Pont's fellow collectors revered his taste and knowledge, and all of them incorporated what they could of his style into their own rooms and houses.

Themes pop up frequently in Deerfield, including at the Wells-Thorn House. One just mentioned is that of ill health. Another was that of Hartford cabinetmaker Eliphalet Chapin and the Strong family. Hezekiah Wright Strong was the cousin of Caleb Strong of nearby Northampton, who had been governor of Massachusetts for twelve one-year terms. Peter Spang pointed out to the Flynts that they already owned the desk and bookcase Governor Strong was thought to have ordered from Chapin, and urged them to buy the governor's high chest, thought also to be the work of Chapin, which the New York firm of Ginsburg & Levy was offering for sale. True to form, says Spang, when Henry Flynt called to inquire about the high chest, he couldn't bring himself to pay the asking price without an argument. He "tried to see what else he could buy so that he could get a cheaper price overall," Spang remembers. Fortunately, the chest did enter the Deerfield collections. Together with the desk and bookcase and a set of chairs attributed to Eliphalet Chapin, it formed a part of the Strong/Chapin theme in the north parlor of Wells-Thorn.[18]

The Wells-Thorn House of 1963 presented a far different picture from that of the 1990s. Acting on his belief that "we've grown up with a decorative arts fantasy"[19] to some extent created and definitely perpetuated by the

Flynts and other collectors of their generation, Philip Zea and a staff committee have completely rethought the furnishing of the Wells-Thorn House. Research done by intern Barbara Batson centered on house inventories from upper-middle-class homes in the Deerfield area between 1725 and 1850. This provided specific information about what people owned and where it was kept, and enabled the committee to form a much more accurate picture than had previously been possible of eighteenth- and nineteenth-century rooms in Deerfield houses.

The kitchen represents a particularly radical departure from mid-twentieth-century furnishing practices. It contains no furniture at all and only a minimum of cooking equipment and food. Wood is piled on the floor beside the fireplace and sacks of grain hang from the rafters to keep them from rodents. An axe, hoe, and gun testify to their owner's daytime activities, while a rolled-up mattress awaits his bedtime. Such a room represents the reality of life on the frontier as students now perceive it. By the period 1715–1725, the starting dates of the Wells-Thorn restoration, Deerfield had undergone two severe Indian attacks. These had basically depopulated the town, leaving any survivors poor and wary of future raids. They kept only the bare necessities in their houses, for they were leery of acquiring possessions that might be destroyed again. Not until mid-century did Deerfield residents feel assured of their safety.

The keeping room, now called the 1735 parlor, is furnished to represent the years around that date (see fig. 110). Increasing stability is reflected in the bed, table, chests, and few chairs that furnish the room, but there is no rug on the floor nor curtains at the windows. Furniture forms are foursquare and functional, and accessories are extremely limited. The south and north parlors, furnished to represent the styles of 1775 and 1800 respectively, show increasing levels of assurance and comfort, though neither has a carpet or curtains (see fig. 112). Fashionable case pieces such as the high chest and the desk and bookcase indicate substantial prosperity in the second half of the century. Lively colors such as plum and pink brighten these rooms, and wallpaper is seen for the first time in the north parlor. Wall treatments and colors as well as other aspects of the architectural restoration were the responsibility of Architectural Conservator Bill Flynt. He relied on evidence supplied by the building itself in making choices about wall colors and wallpaper patterns.

Upstairs, chambers are furnished to represent the Federal period of about 1815 and the Empire period of about 1830 (see fig. 113). Wallpaper, bedhangings and curtains of matching fabric, sets of painted chairs, inlaid chests, looking glasses, and pictures indicate the increasing availability of a variety of furnishing materials formerly available only to the wealthiest segment of society. The garret, arranged to represent 1850, speaks of a society that relegates old or out-of-date furnishings to the attic, a situation that didn't exist in frugal New England until the age of the Industrial Revolution (see fig. 114).

The staff committee focused on a number of points that used to be ignored in creating period rooms. They considered the subjects of eighteenth- and nineteenth-century consumerism and room use. They thought, too, about seasonality and planned to store certain objects, such as fireplace equipment and carpeting, during the summer months. "Attics," says Curator Zea, "used to be more a part of the working household," and this is pointed up by the use of the Wells-Thorn garret for seasonal storage. Other subjects that contributed to the furnishing plan include attitudes toward display and sources of heat and light.

Taken as a whole, the Wells-Thorn House now summarizes attitudes and traditions of earlier periods, as well as the span of changing styles from the early eighteenth century to the mid-nineteenth. The Flynts' generation created charming and evocative interiors that expressed their own tastes and attitudes toward living. The new generation of scholars and curators, represented by Philip Zea, ignores its personal likes and dislikes as much as possible and tries to immerse itself in the culture and outlook of each period of the past. Their goal is to understand how people thought as well as what they owned. Although the new approach is sometimes iconoclastic and offends some people who grew up with the "decorative-arts fantasy" embodied by earlier period rooms, many visitors respond to it. When asked whether people like Wells-Thorn, Evelyn Stuart, Historic Deerfield guide, replied, "Oh, they love it. People who [can see only] one house, see this because it covers so much."[20]

111. South parlor as it looked in the Flynts' day. Valanced curtains; oriental rugs on table and floor; imported glass, china, and brass; and a variety of chairs create a luxurious-looking room. Of her father's (Dr. Edwin Thorn's) acquisition of the chest-on-chest with sharply scrolled pediment Elizabeth Thorn Welford says, "He was taking care of a patient in his own home (not done by doctors now) and saw a piece he admired and the man was willing to sell it, but said the other half had been left to another member of the family in Whately. They journeyed to Whately and the two pieces were joined together, refinished and repaired...."

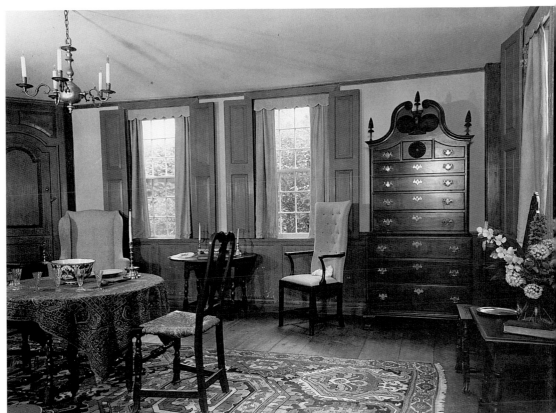

112. South parlor as it was furnished in 1987 to represent the period of 1775. The Flynts' sense of a comfortable, indulgent life is replaced here by a view of eighteenth-century Deerfield as a place where there were nice things, but not in large numbers. *Things* were scarce in the Colonial period, and nice things required hard work and considerable money. Even the well-to-do seldom had such luxuries as oriental carpets and upholstered furniture, and as late as 1775 well-off Connecticut Valley citizens had beds in their parlors. Luxuries a Deerfield citizen *might* have had include rich plum-colored paint such as that which covers paneling and moldings here, a tester bed with a set of hangings and a bed rugg, and a high chest of drawers. The one seen here is signed by Simeon Pomeroy of nearby Northampton.

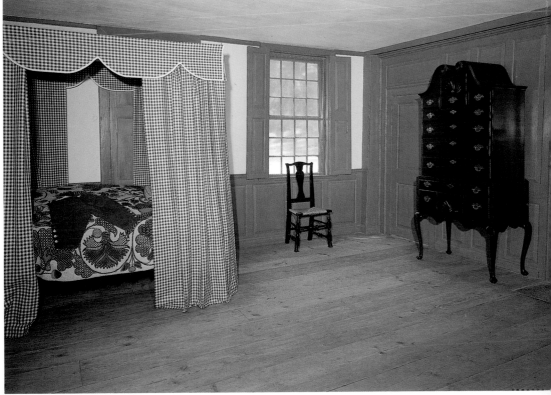

113. The 1830 bed chamber, furnished in 1987, reflects the enormous changes being wrought by the Industrial Revolution; this chamber could be anywhere in the Northeast. From our point of view it is the most fully furnished room in the house, with plentiful evidence of the vastly increased ease of securing imported items and of the effects of mass production. Machines cut veneer for the chest and turned knobs and legs, they printed wallpaper and wove fabric. Factories like that of Hitchcock of Connecticut produced the set of yellow fancy chairs seen here; Lambert Hitchcock was one of the first to use assembly-line methods to produce attractive, affordable goods, and the pair of black chairs in this room are from his factory. The grass matting that covers the floor was imported from China. Oil lamps, which give good bright light, replace the dim candles of earlier years. Furnishings in this room are based on Historic Deerfield's study of forty-four household inventories compiled between 1825 and 1835.

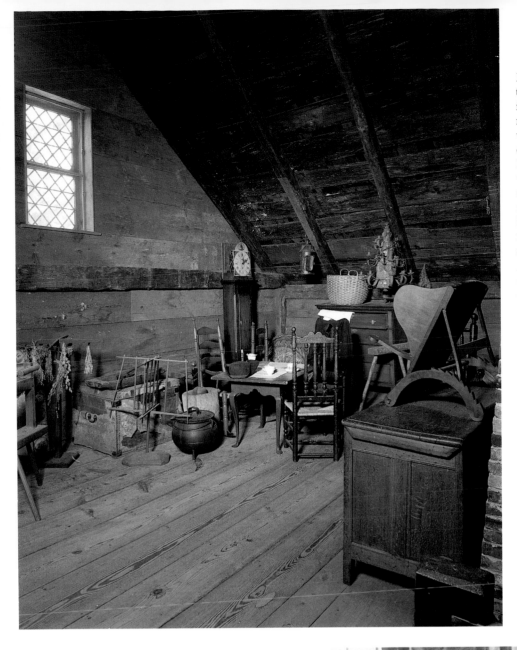

114. The attic is furnished to reflect the period around 1850, when the immensely expanded pool of material goods had created a world in which obsolete styles and forms could be relegated to the attic. Never before in the history of the world had ordinary people been able to afford to set aside outmoded furnishings. Since New Englanders have always been famous for their frugality, however, they usually saved their old things rather than getting rid of them—much to the joy of later generations of antiques collectors. Probate inventories of the 1850s are not detailed enough to indicate the contents of an attic, so this space was furnished by referring to literary sources such as Sarah Orne Jewett's books.

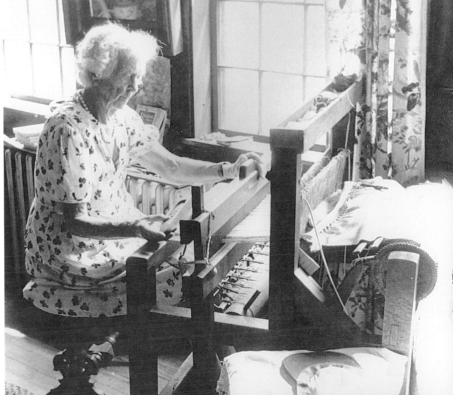

Luanna Thorn at her loom.

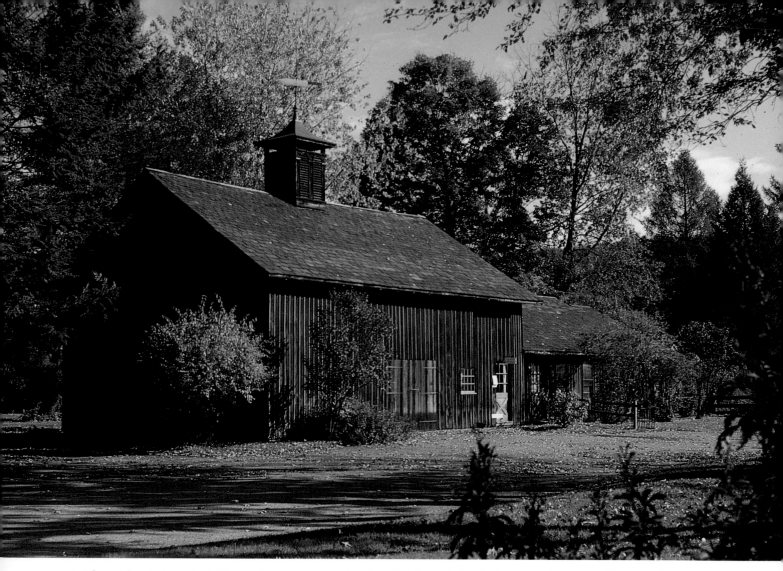

115. The Helen Geier Flynt Textile Museum occupies the 1872 barn behind the Silver Museum. The cupola and knife weathervane were rescued when the Russell Cutlery Company building in nearby Turners Falls was being demolished. The Textile Museum opened to the public in June 1965.

The Helen Geier Flynt Textile Museum

"Through the years Mrs. Flynt kept saying that she wanted to have a barn," says Peter Spang. "She wanted to be able to display old textiles and to save old buildings." And since Henry Flynt was naturally very much in agreement with these aims, he and his wife decided to convert the Victorian barn on the silver-museum property into an exhibition space for early textiles and clothing (see fig. 115).[1]

There was no question that there was a real need for a new textile-exhibition space, for the impressive collection Helen Flynt had been gathering (with some help from her husband) was displayed here and there throughout the museum houses, in an area under the eaves in a wing of Hall Tavern, in a closet at Dwight House, and in the former "sempstresses' shop" at Sheldon-Hawks. As with the silver

before the opening of the silver museum, the absence of a consistent and comprehensive display made it impossible to gauge the quality of the textile and clothing collection. As the booklet "Surprise in a Barn" stated, "Mrs. Flynt has been gathering fabrics for a couple of decades [but] few people realized the extent of her interest, the variety of her accomplishments or the breadth of her taste until this building was opened...."[2]

Built in 1872, the barn behind the silver museum seemed an ideal exhibition space. Since this was to be a special display area, there was no need for extensive interior restoration. The south wall, which was rotted, was replaced with sympathetic materials and an old staircase was installed between the main floor and the hayloft (which remained only on the east side of the barn). Gray

linoleum tile went down to simulate a floor paved with stone, a wing in the same style as the barn was added to the east side to provide much needed curatorial office space, and a workroom was created in which Mrs. Flynt could oversee repairs and cleaning.

Trying to be thrifty, Helen Flynt often brought up an old fixture she had replaced in Greenwich to install in one of the Deerfield buildings. In this case it was her kitchen sink, which she asked the maintenance department to hook up in the textile workroom. Peter Spang recalls that Mrs. Flynt was very particular about this room—"it was going to be *her* room, for *her* work." Her vehemence was very likely the result of her feeling, often expressed to Spang and others, that her husband always got the credit for whatever work they did at Deerfield. Despite Henry's consistently making it clear that they worked together and his often making joking statements such as "She's the real worker—I just do all the talking," Helen's feeling of being left out persisted.[3] A workroom specifically for her own projects must have seemed an affirmation of her importance and usefulness.

Other improvements included the addition of a bathroom and of electricity, heating, and air conditioning. This was one of the first installations of central air conditioning in Franklin County, says Peter Spang, and naturally there were some bugs in the system. But proper humidity control was crucial for the conservation and preservation of textiles, which are the most fragile of the decorative arts, so even though it's hard to insulate a barn, the effort had to be made.

Once the space was ready, it was time to create the displays. Great wooden arms crafted by Edward Gritz, Director of Maintenance, were attached to a massive post in the middle of the old barn so that coverlets and other large pieces could be hung from them (these have recently been replaced by an apparatus designed by Iona Lincoln and William Flynt taking into account recent advances in knowledge and technology; see figure 117). Mannequins, originally from Wilson's department store in Greenfield and later carefully created for this exhibit, were placed amidst fine furniture and rugs at the west end of the building to simulate a party (see fig. 116). A magnificent oriental rug the Flynts had bought from dealer Moustapha Avigdor of Brookline, Massachusetts, was laid down, and furniture (mostly English) with old needlework or fabric coverings was gathered here. Mannequins stood about in small groups as if talking or listening to a woman playing the piano. Viewing this display some years later, contractor Bill Gass vouched for its verisimilitude when he said, "The mannequins look kinda real. If men had to dress like that today, it'd be kinda fun."[4]

Three large rococo looking glasses hung on three sides of the exhibit, the one on the west wall being enormous. Charles Carroll of Maryland, signer of the Declaration of Independence, originally bought this very important glass for his daughter. Peter Spang says that Connecticut dealer Harry Arons had it for sale and Henry du Pont wanted it in the worst way. It was too tall for any of the rooms at Winterthur, however, so the Flynts got it for their textile barn in Deerfield. "Mr. Flynt was delighted," says Spang, "to get something that Winterthur couldn't accommodate."[5]

When the installation phase was complete, the Flynts held a party late in the afternoon on June 3, 1965, "for the construction force who had done the work of restoring the old barn…local residents and the staff." The next day the Helen Geier Flynt Fabric Hall opened to the public. Besides hanging coverlets and the exhibit with mannequins, "large and small fabric items (yards of painted silk and red velvet…and tiny objects of lace, hats, stomakers & embroidery) [were] displayed in cases on the ground floor or on the balcony—the old hay loft." Outside, the spruced-up building sported a cupola "with a weathervane made in the shape and appearance of a large knife," which was preserved when the Russell Cutlery factory was torn down. The Russell Cutlery Company had descended "through several generations of local and family ownership [from] one of Deerfield's original silversmiths," John Russell.[6]

Helen Flynt had taken on the responsibility of keeping the costume and textile records herself. Peter Spang remembers that "while she tried very hard, she was not an organized person." Mrs. Flynt's cataloguing method involved using a letter, at first "F" for fabric, plus a number to identify each item—F1, for example, was the number of the first accession. When she began to run short of numbers, she added another letter—"V" for Victorian and began cataloguing everything after 1800 (where her own interest began to falter) with that letter plus a number. The collection came to include many "V's," as Mrs. Flynt's friends donated clothing and other items made between 1830 and 1930 in considerable numbers. Much of this later part of the collection is now stored in the back wing of Wright House.[7]

Helen Flynt herself often worked on the textile and clothing collection and she was aided by Margery Burnham Howe, a Deerfield resident who was a gifted needlewoman and a protégée of the founders of the Blue and White Society, and by Margaret Wood, who "was for many years a part-time cook in the household of Mr. and Mrs. Henry Flynt in Greenwich." When Mrs. Wood went to Deerfield with the Flynts, "there was little cooking to do and she was happy to busy herself washing and mending textiles in Mrs. Flynt's then growing collection."[8]

Mrs. Wood helped a great deal in getting things ready for the opening of the fabric hall, and after she retired to her native Scotland in 1970, she would return every year to help Mrs. Flynt in both Greenwich and Deerfield. In 1977, for example, she "washed and mended over 100 textile

items in 8 of the 12 Historic Deerfield exhibition buildings.... She worked from early morning until late at night on everything from delicate lace caps to small hearth rugs, bed coverlets and sheets."[9]

Despite the help of these two experienced needlewomen, the Historic Deerfield textile and clothing collection needed to be put on a professional basis. When Mrs. Flynt's active involvement with the organization ended as a result of a stroke in the mid-1970s, Peter Spang made this collection a priority. With the help of Curatorial Assistant for Textiles Iona Lincoln and Registrar Sylvia Wells, he began to conserve and organize the fabrics and accessories. They secured a grant and called upon a conservator from the Metropolitan Museum's Costume Institute, who helped them to decide on what types of storage receptacles they needed. They ordered cabinets with drawers for items that could be laid out flat and cupboards for such things as shoes, umbrellas, and fans. Since then, Iona Lincoln has been working on organizing, conserving, and rotating this major collection. Now called the Helen Geier Flynt Textile Museum, this is one of the few places in America where visitors can see "considerable numbers of eighteenth-century costumes" on display throughout the year (see figs. 116 and 120).[10]

116. The west end of the Textile Museum as it looked in the Flynts' day, when it was called the Fabric Hall. Helen Flynt arranged the mannequins to look as though a party were in progress, with partygoers wearing fashionable European clothing. Because few people thought of saving it, men's clothing has not survived in nearly the amounts that women's clothing has; nevertheless, Historic Deerfield has an excellent collection of men's wear. The splendid carpet that is too grand for Deerfield even at its most prosperous was acquired by the Flynts when they discovered Brookline, Massachusetts, dealer Moustapha Avigdor, whose stock included many superb rugs. They simply couldn't resist this one and several others that remain in Allen House. Henry Flynt was particularly delighted to secure the magnificent rococo looking glass, probably of English manufacture, on the back wall, as he knew Henry du Pont coveted it.

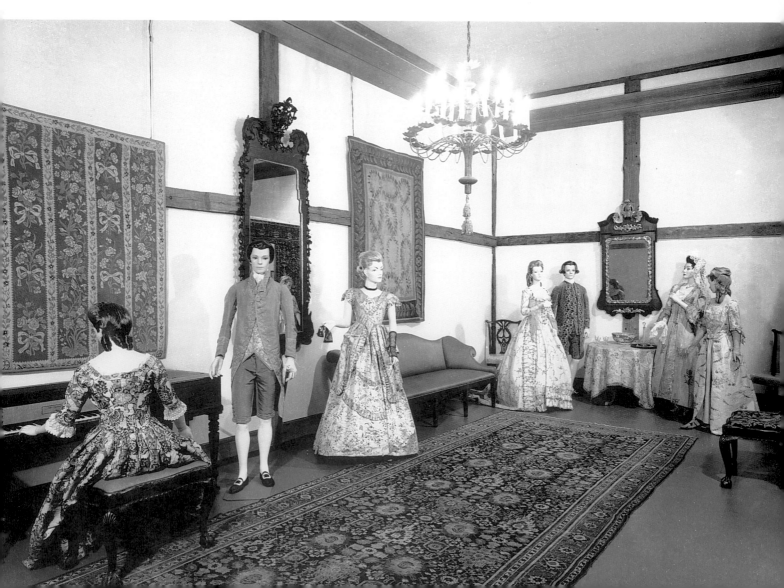

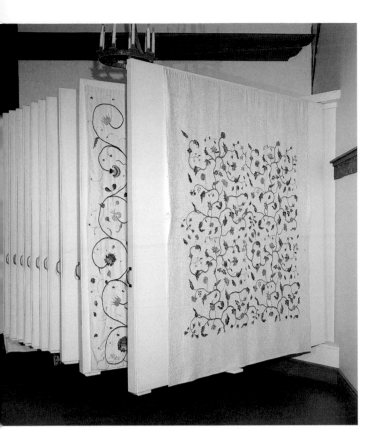

117. This coverlet display, designed by Architectural Conservator William Flynt and Curatorial Associate for Textiles Iona Lincoln, has replaced the original one, which featured coverlets hanging from wooden arms. Here, in a very safe and protective arrangement, coverlets and other large pieces can be displayed and changed as the curators wish. On the front panel is eighteenth-century crewelwork originally embroidered on linen that has been cut from its deteriorating background and reappliquéd onto a cotton ground and then quilted.

118. The partylike atmosphere Helen and Henry Flynt created continues to dominate the south end of the building. Here a gentleman sits on an English sofa as other mannequins appear to stroll about the room. Because of its precise fit, it is obvious that the canvaswork covering was fashioned specifically for this sofa. It could have been made in a shop or by a lady of the period.

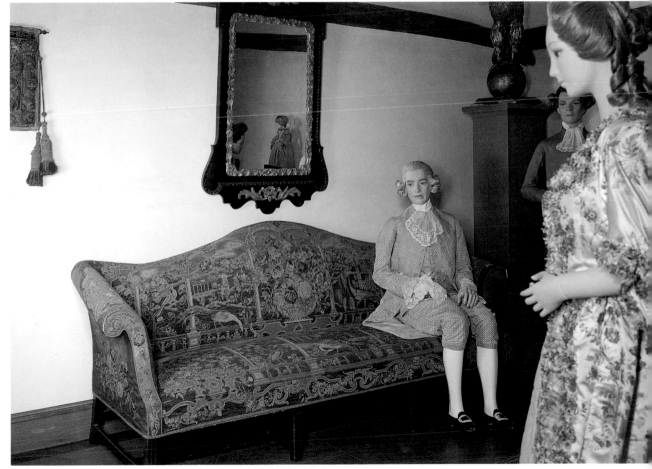

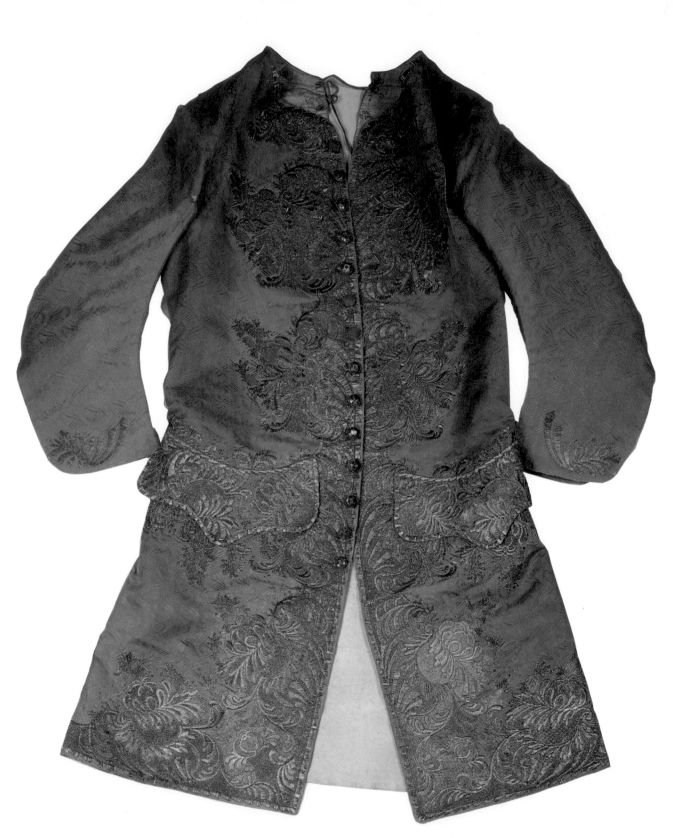

119. When the Heritage Foundation received this imported waistcoat in 1967 it was described in the *Quarterly* as one of "the most important gifts to the Foundation of the last few years." It is the salmon-colored silk wedding waistcoat embroidered with silver thread that John Worthington of Springfield wore on the occasion of his marriage to Hannah Hopkins, whose wedding clothes have also been presented to Deerfield. Worn first in 1759, the clothes descended in the Dwight family, successive members of which wore them in the Dwight House, which the Flynts rescued from Springfield wreckers and rebuilt on Deerfield's main street in 1954.

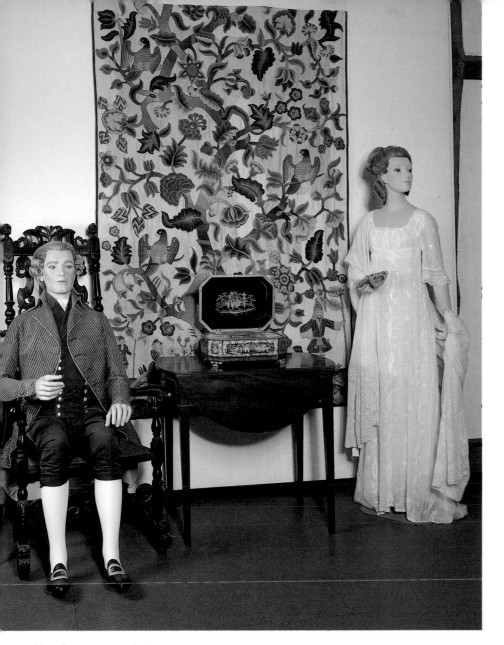

120. This group includes a woman wearing an American dress of white Indian cotton mull hand-embroidered with an overall floral design; made about 1810 for a member of the Pomeroy family of Belmont, Massachusetts, this dress was purchased with a fund contributed by friends and family in memory of Helen Flynt. The Empire period, when the dress was made, is not well represented in the collection, and this selection was made to help to fill in the gap. The man's coat and britches were made in the late eighteenth century for Samuel Dexter of Boston.

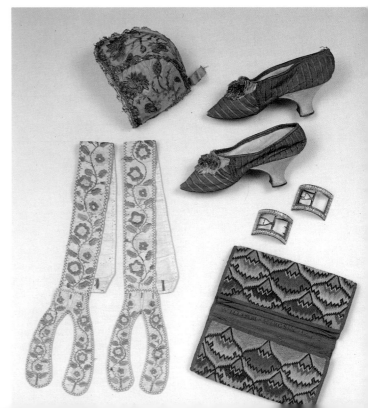

121. This group gives a sampling of the kinds of accessories Helen Flynt collected: embroidered silk suspenders; child's cap with gold lace and silk embroidery; lady's silk shoes, c. 1790; eighteenth-century paste shoe buckles owned by Revolutionary War General Nathaniel Green; and a man's American flamestitch pocketbook marked "William Kingsley, 1773."

122. This quillwork picture of c. 1700, said to be of Queen Anne, is a tour de force—a remarkably well-preserved example of a rare type of object. Made of rolled strips of paper painted and/or gilded and combined with other materials such as shells, beads, and mica and arranged into elaborate designs, this type of work is called quillwork in America, paper filigree in England. It was a popular collectible among Americans at mid-century but since American examples are very rare, collectors often filled in with an English specimen, as Mrs. Flynt did in this instance.

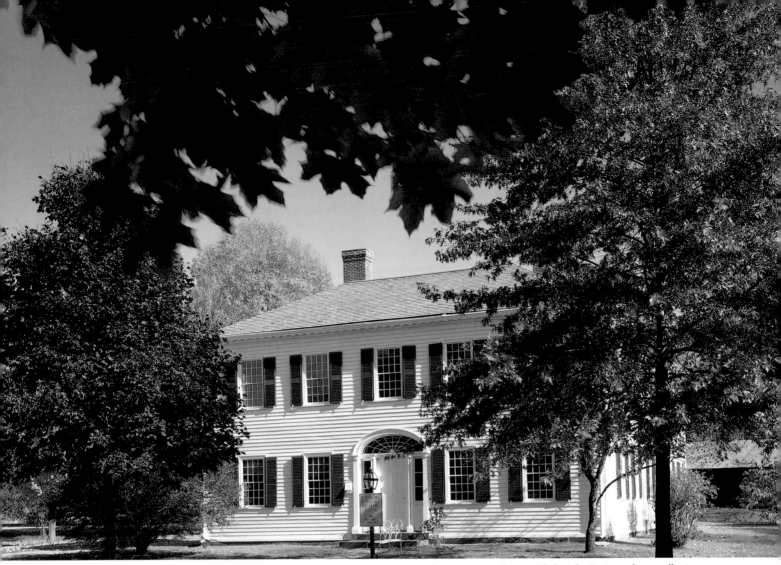

123. The Ebenezer Hinsdale Williams House as it looks today. The colors of the house, white with bright "mineral green" trim, are the ones Ebenezer Hinsdale Williams chose when he renovated the house between 1816 and 1820.

The Ebenezer Hinsdale Williams House

"Historic Deerfield's major project for the 1980's is the Ebenezer Hinsdale Williams House, a Restoration-in-Progress," wrote Henry N. Flynt, Jr., the founders' son and the president of Historic Deerfield's board of trustees.[1] During the several years that elapsed after this announcement, the E. H. Williams House served as the vehicle for the implementation of a fascinating new approach to house restoration and preservation. Visitors have been able to tour the house during all stages of work; Architectural Conservator William Flynt (grandson of the founders and son of the current board president) and Assistant Curator for Interpretation Anne Digan kept guides up to date on the purposes and goals of each successive stage of restoration.

Ebenezer Hinsdale, the first to build on this lot, inher-ited the land from his father, a prominent Deerfield resident who owned several homelots on Deerfield's old street. Ebenezer was ordained into the ministry and appointed missionary and chaplain to the Indians at Fort Dummer in 1732. According to town historian George Sheldon, Hinsdale was not successful in this calling, for he left the ministry and in 1750 "'offered a confession before the church' for the 'Sin of Intemperate Drinking.'"[2] His career in the colonial forces during the French and Indian War, from which he emerged a colonel, seems to have been more successful.

It appears that the colonel built his Deerfield house in the mid-eighteenth century, and Peter Spang has wondered "whether [it] didn't look like the Sheldon-Hawks House across the street" at that time. Colonel

Hinsdale occupied it only part of the year, alternately residing at his other home in Hinsdale, New Hampshire, a town on the Connecticut River that he founded. He is said by Sheldon to have been "extensively engaged in farming and trading" in Hinsdale while at the same time he "engaged in trade and farming" in Deerfield. Sheldon reports that there was a store on the Deerfield property for many years and that "in 1756 tailoring was carried on here also." The Colonel's slave Meshick operated the business in one location when Hinsdale was in the other.[3]

After Hinsdale's death in 1763, the property was sold and passed through a number of hands until it reached those of Hinsdale's namesake and grandnephew, Ebe-nezer Hinsdale Williams. Williams, known affectionately as "Uncle Hinsdale," was a graduate of Harvard and a successful farmer and landowner. "By 1816," according to one historian, "Williams was one of the wealthiest men in the area, and his house reflected his aspirations as well as his status in the community (he served as representative to the state legislature for six years and as selectman for six years)."[4] It is to the period of Williams's occupancy that the house has been restored.

Williams elected to modernize the Georgian-style house his great-uncle had built. Between 1816 and 1820 he replaced what was possibly a pedimented Connecticut Valley doorway with a Federal one in which the focal

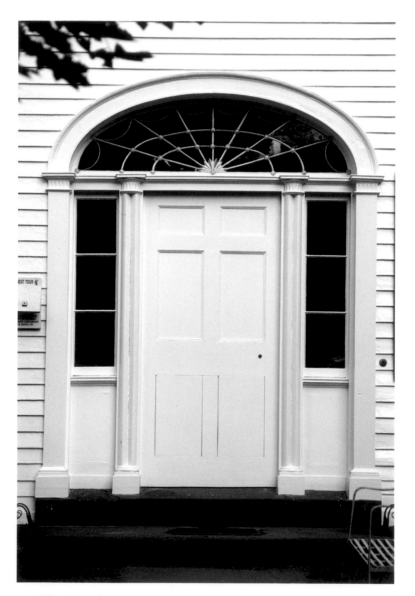

123a. Detail, E. H. Williams House doorway, with splendid gilded-pewter fanlight, 1816–1820.

point was an ornate neoclassical fanlight. He added a hipped roof and a refined cornice in the fashionable Federal style, attached an ell, and remodeled some of the interior in the Federal taste. The north parlor acquired handsome wallpaper depicting scenes of the Venetian Republic. "From the outside the whole thing looks very Federal," says Peter Spang, "and you'd never know that there was an earlier part."[5]

Although some changes were made to the dwelling by subsequent owners after Williams's death in 1838, it was in remarkably unaltered condition when Historic Deerfield purchased it in the 1960s. It had passed from the Williams family to the Stebbinses and then to the Cowles family. When the Flynts became active in Deerfield, the house was known as the Cowles House after its then-current owners, Russell and Glenna Cowles. Peter Spang recalls being told that Russell Cowles was considered a great catch in his youth, and that after his marriage he lived in style in the old house during the 1920s. He was not suited to a career as a farmer, however, and by the 1940s he was being outdistanced by more enterprising local farmers who began to buy his farmland.[6]

Russell was perhaps more energetic indoors than out, for he was extremely industrious when it came to stripping walls of old paper. When Conservator Bill Flynt began research into early wall treatments, it seemed that Russell had assiduously removed all the wallpaper except for that in the north parlor. Flynt even removed light fixtures, hoping to find a scrap of wallpaper underneath. Finally, when he decided a hall doorway was of a later period and removed it, he found early wallpaper beneath the frame. Another break came when work began in a second-floor chamber. "Luckily," says Spang, "the northeast room was so cold that [Russell Cowles] or a predecessor must have covered it over with extra layers.... Bill Flynt found lots of early papers that had been recycled there. Presumably extra rolls that had been in the attic had been applied layer over layer to try to insulate the room."[7]

There was one paper that was a source of great pride to the Cowleses, however—the French scenic wallpaper in the north parlor, which Ebenezer Hinsdale Williams had installed about 1816 (see fig. 127). They were delighted to show it to special guests and when it was damaged in the great flood of 1936, Russell went to the Museum of Fine Arts in Boston to learn how to restore it. He took each panel down, cleaned it, and remounted it, preserving it for future generations.

Eventually the Cowleses took in paying guests, calling their home Hinsdale House. After the Flynts restored the Wilson Printing Office, they asked Russell to learn about printing and to take on the job as printer and guide to visitors. He did so, and sometimes printed Christmas cards for the Flynts (these often took the form of stories about Deerfield and the houses, which were printed up

and presented as booklets) and a variety of other ephemera. He "was certainly a New Englander, though," recalls Spang. "When he didn't have to give a tour, he was a man of few words."[8] Glenna eventually became a Historic Deerfield guide, too, particularly for Sheldon-Hawks House, which was just across the street from her own house.

After Russell's death in 1981, Historic Deerfield, which had previously purchased the house, came into full possession of the property. When you bought a house in Deerfield in those days, Spang explains, you got the house, lot, and out-buildings, acreage in the meadows, and a woodlot on the hill. Good early barns are becoming rarer and rarer, and the Cowles example was the best of those the Flynts had acquired as a result of their house-buying activities in Deerfield. So it had been devastating when the barn burned down in 1971. Henry Flynt had recently died, and Mrs. Flynt was terribly worried that the shock of losing his barn would kill Russell Cowles, who by this time was old and ailing. She asked Ed Gritz, Deerfield's Superintendent of Grounds, to look for a suitable replacement. He found an old barn nearby and had it brought to Deerfield piece by piece and reconstructed behind the Cowleses' house. Later, when Frank Boyden's family offered Historic Deerfield the headmaster's collection of carriages and sleighs, they were installed in this barn, where they may be seen by the public.

"When Russell died and Glenna left [to live with a sister], there was great debate among trustees and staff as to what to do with the house," recalls Spang. "Should it be a museum, or should it be rented, or even sold?"[9] The decision eventually reached was to make the house a museum, but to take a long time doing it and to involve the public every step of the way.

Noting that "the Williams house has remained relatively intact since the early years of the nineteenth century [and] is a remarkable surviving document of that time...," Architectural Conservator Flynt laid out three phases for the restoration project. The first involved study, research, evaluation, and making necessary repairs. During this period, Flynt said, "as late nineteenth- and early twentieth-century alterations (bathrooms, a pantry, wallpaper, and four layers of flooring in the kitchen) were removed, we discovered numerous clues in answer to our questions concerning room configuration, missing architectural elements, and decorative treatments."[10]

The second phase focused on returning altered parts of the house to their appearance during the period E. H. Williams occupied the house, from 1816 until his death in 1838. Further research and study resulted in reconstruction of parts of the kitchen, pantry, dining room, and first-floor bedroom. "Bill [Flynt] made all sorts of interesting discoveries," says Peter Spang. "He found doors and shelves that Russell had dismantled and he has put them

back in the proper way. For example, the pantry was... changed by Russell, but Bill figured it all out and found doors and shelves elsewhere [in the house]."[11] This phase also saw the installation of heating and plumbing, as well as additional structural repairs.

The third phase, which falls in the early 1990s, involves painting inside and out and papering interior walls. Wallpapers had to be searched out and reproduced; hardware had to be reproduced from "nail and outline evidence found on the doors as well as from existing 18th-century hardware found in the house";[12] front- and south-entry fanlights had to be taken down, repaired, repainted, and regilded; and many other more practical details had to be attended to.

"This unusual sharing of behind-the-scenes activity is a new educational venture," says Director Donald Friary. "Visitors with a practical turn of mind enjoy knowing what is happening and how. Some are curious about what is discovered as architects, carpenters, researchers, curators, and conservators expose the building's past."[13] Guides are informed of the purposes and methods of restoration, of what products and companies supply materials, and of many technical facets of the work. They can thus pass on the kinds of information owners and restorers of old houses avidly seek but practically never find at a museum restoration.

When the structure is fully repaired and newly decorated, the curators will begin their work. "We know how the Williams house was furnished," wrote Philip Zea, "because of the extraordinary richness of surviving objects and documents in the collections of local families, Historic Deerfield, the Memorial Hall Museum, and the Memorial Libraries."[14] Zea adds that Williams family inventories and archeological research supply detailed and specific information about how this particular family lived between 1816 and 1838.

Besides the scenic wallpaper in the north parlor, a stunning survival of the Williams years, Historic Deerfield acquired two fireboards (found on the premises) covered in exquisite French wallpapers that are another testimony to Williams's fashionable taste. Among Williams furnishings that survive in Deerfield are examples of ceramics, furniture, and paintings, which will allow the curators to present an up-to-the-minute interpretation of "how people lived, thought, and in some cases felt about their Connecticut Valley world."[15]

The inventory taken upon Williams's death in 1838 is an important tool in building a picture of the Williams family's life in the house. Curators Zea, Skerry, and Lincoln have found some objects in the Historic Deerfield collection to match inventory listings, and they also have glass and ceramics shards and other fragments recovered by students in the archeological digs the University of Massachusetts has conducted on the site (see fig. 126). When identified as to period of use, the shards and fragments will be immensely helpful in determining what table and kitchen wares the Williams family used.

Recently Zea also bought "an unusual group of objects from an 1816 Hadley dwelling—unusual because the 21 pieces had remained in a single household for 170 years. And important to us in particular because they belonged to E. H. Williams' contemporary, Charles Porter Phelps, who, along with Williams, was a member of the Connecticut Valley elite."[16] Such local finds are of the utmost importance in producing as accurate a picture as possible of E. H. Williams's home environment in western Massachusetts. Philip Zea had another amazing bit of luck a few years ago when he went to an auction to inspect some chairs that sounded like a set in Williams's inventory. It turned out that there was a full set of twelve "fancy chairs" of the kind the 1838 probate inventory mentioned, and that except for color they were identical to the Williams-owned fancy chair that survives in Memorial Hall (see fig. 128). Zea bought the set.

Of the finished house Zea says, "We intend the restored and furnished house to offer a sharp and interesting contrast to today's domestic settings and to what many expect to find in period rooms." This requires research into many facets of life in the mid- to late Federal period in New England. In the Flynts' generation, research would very likely have been restricted to the physical and occupational history of the house, with perhaps special emphasis on one family or period. Although the Flynts always made an effort to secure furnishings known to have been used in a house and paid attention to the work of local craftsmen, they still ended up creating very personal interior settings that reflected their own tastes rather than the tastes of the family or period they were recreating.

Today, with many more sources of information and a broader approach to the problem of furnishing a period house, Zea and his associates rely on facts obtained from research into such topics as the Williamses' economic status, peers in the community, activity as consumers, sources of household items, and sources of income, to name a few. "We want to learn about the 'real' Williamses—all four of them—but also about the class of people whom they historically represent," says Zea. "Our goal is to teach an era in local history through a case study rather than to illustrate the eccentric circumstances of a single time in the life of a family or individual."[17]

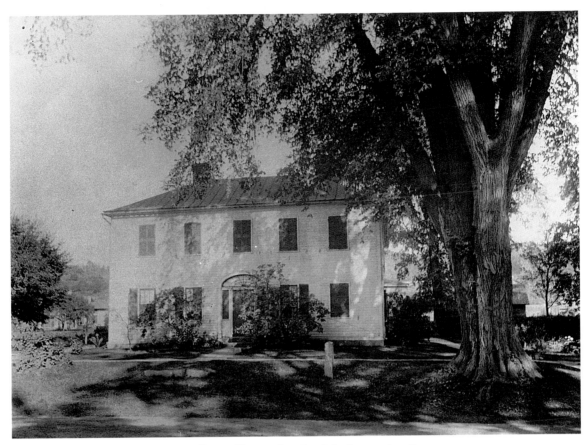

124. Archival view of the E. H. Williams House, showing it before restoration.

125. Pantry, E. H. Williams House, showing old boards that Russell Cowles had used elsewhere in the house returned to their original location and supplemented with new boards to recreate the pantry of E. H. Williams's day. Architectural Conservator Bill Flynt figured out the configuration of the original space and Restoration Carpenter Julian Goralski did the work. Peter Spang compares the skill required to piece the original pantry back together to that necessary to put together a difficult jigsaw puzzle.

126. Archeological dig conducted by University of Massachusetts students on the E. H. Williams site. Objects retrieved in the dig have been of great help in ascertaining what types of ceramics, glasswares, and metalwares the Williamses used in the period 1816 to 1838.

127. The north parlor, seen here in its "restoration-in-progress" phase, has been called "one of the finest Federal rooms in western Massachusetts." It has neoclassical features that were introduced to New England by architect Charles Bulfinch and popularized by Asher Benjamin. The French wallpaper, applied during E. H. Williams's renovation of 1816–1820, is called *Venetian Scenes*. The fireboard in front of the fireplace, also from Williams's day, exhibits another early-nineteenth-century French paper.

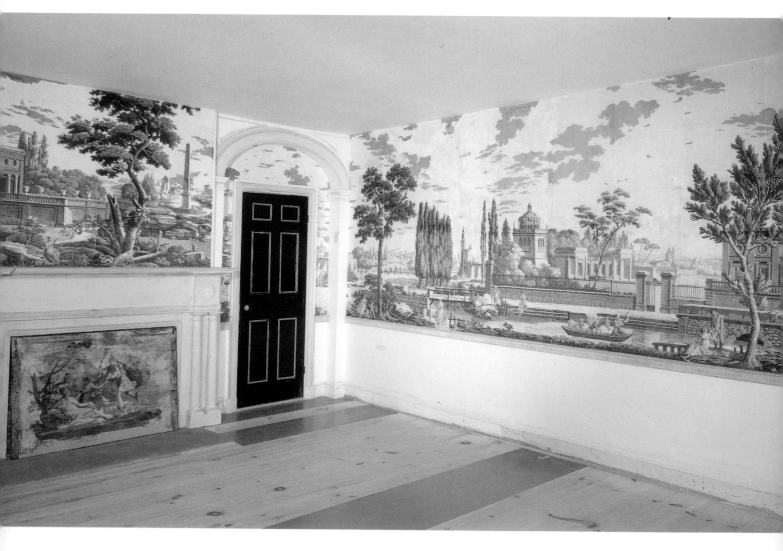

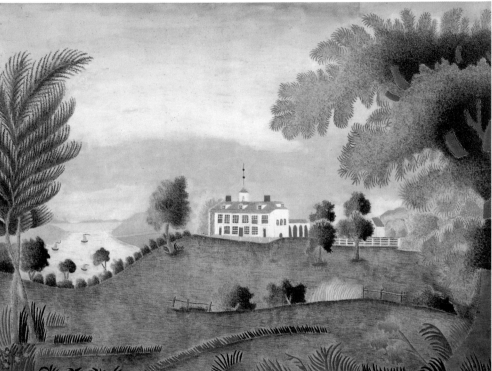

129. This cheerful watercolor of Mt. Vernon, George Washington's home in Virginia, was painted by E. H. Williams's daughter Anna when she was a student at Deerfield Academy. According to Suzanne Flynt in *Ornamental and Useful Accomplishments*, Anna used "several different painting techniques...with much of the foliage stencilled, and the fields painted with narrow horizontal strokes which appear to simulate embroidery stitches." Anna painted this in 1811 when she was only eleven years old. Depictions of Mt. Vernon were nearly as common as those of its owner, and Anna copied hers from an aquatint of 1800 by Francis Jukes after a painting by Alexander Robertson. When the Williams House is furnished, Anna's watercolor will return to one of the walls there.

130. "Swan and Urn," detail of one of several wallpapers reproduced from fragments found in the E. H. Williams House. The original dates from about 1815.

128. This fancy chair is part of a rare survival, a set of twelve that closely match the "16 Flagg bottomed Chairs" in E. H. Williams's 1838 probate inventory. They are of putty color with yellow, brown, black, and green decoration.

Bibliography

This is a listing of both general works and those that I have referred to often; specialized works appear in the endnotes. Most of the material for this book has been derived from unpublished sources, however. One of the most fruitful was Henry Flynt's correspondence, which is in the Historic Deerfield Archives (Helen Flynt left very little correspondence relevant to the work in Deerfield). Also in the Archives are scrapbooks from the 1940s onward that were kept by Henry Flynt's secretaries and others and that provided another excellent source of information about the Flynts, their preservation efforts, and their collections. Over the years summer fellows have produced many papers on various topics relating to Historic Deerfield and these, too, have provided much useful information; they are available in the Historic Deerfield Library. The Deerfield Academy Archives, which Headmaster Robert Kaufmann very kindly allowed me to use and Archivist Tina Cohen guided me through, contains a gold mine of information about the Flynt-Boyden relationship. The papers of John Kenneth Byard, on microfilm at the Archives of American Art, provided insight into the interests and attitudes of that very influential figure in the Flynts' collecting career.

A very important resource was taped interviews with retired Historic Deerfield Curator Peter Spang. He and I spent many hours with Volunteer Kim Gregory making the series of tapes on Deerfield's old street and architecture called "On the Street" and another series on the interiors and furnishings of the museum houses called "Inside [name of house]"; in addition I made separate tapes of Peter's accounts of the Flynts' and his own work in Deerfield during the more than thirty years he has lived there. Others with whom I taped interviews were Historic Deerfield Guide Jennie Danielski and former *Antiques Magazine* Editor Alice Winchester. I also interviewed the Flynts' son Henry N. Flynt, Jr., and his wife Mary, former Historic Deerfield Guide Lee Boyden, Architectural Conservator William Flynt, Executive Director Donald Friary, Public Relations Officer Grace Friary, Curatorial Associate Iona Lincoln, Researcher Amelia Miller, Librarian David Proper, Assistant Curator Janine Skerry, Curator Philip Zea, collector and consultant Ralph Carpenter, and antiques dealers Elinor Gordon, Bernard Levy, and Harold Sack. Bill Flynt's series of interviews with Bill Gass, which are on tapes in the Historic Deerfield Library, were full of interesting and pertinent information and provided much insight into Bill Gass's ideas and outlook.

Barton, Bruce. 1929. *Deerfield Academy.* Deerfield, Mass.: Deerfield Academy.

Chamberlain, Samuel, and Flynt, Henry N. 1952. *Frontier of Freedom.* New York: Hastings House.

_____. 1979. *Historic Deerfield: Houses and Interiors.* One of several successive updated editions of *Frontier of Freedom.* New York: Hastings House.

Coleman, Emma Lewis. 1907. *A Historic and Present Day Guide to Old Deerfield.* Boston: The Plimpton Press.

_____. n.d. *Concerning Frary House.* Unpublished scrapbook at Historic Deerfield Library.

Fales, Dean A., Jr. 1976. *The Furniture of Historic Deerfield.* New York: E.P. Dutton.

Flynt, Henry N. 1938. *On Horseback from Connecticut to Canada.* Privately printed.

_____. 1955. "Old Deerfield: A Living Community." *Art in America,* vol. 43, no. 2, 40-75.

_____. 1963. "Deerfield, Mass., Its Meaning." Ellis Memorial Antiques Show catalogue, 35-39.

_____. 1969. "From Tomahawks and Arrows to Atomic Bombs." Delaware Antiques Show catalogue, December 1969, 87-93.

_____. 1969-1970. Family Letters: Personal Reminiscences and Autobiographical Writings, in a Series of Letters Addressed to Members of His Family. Greenwich, Conn. Privately held.

_____ and Fales, Martha Gandy. 1968. *The Heritage Foundation Collection of Silver; with Biographical Sketches of New England Silversmiths, 1625-1825.* Deerfield, Mass.: Heritage Foundation.

Friary, Donald. 1980. "To Collect or Not to Collect: Helen and Henry Flynt at Historic Deerfield." Paper read at the Colonial Williamsburg Antiques Forum, January 1980. Xeroxed.

Gunther, John. 1951. "The Most Unforgettable Character I've Ever Met." *Reader's Digest,* vol. 59, no. 356, 31-36.

Heritage Foundation. 1970. *The Centennial of the PVMA and Dedication of the Heritage Foundation Library.* Deerfield, Mass.: Heritage Foundation.

Heritage Foundation Quarterly, vol. 1 (May 1962)-vol. 11 (October 1972). Deerfield, Mass.: Heritage Foundation.

Historic Deerfield. *Annual Report.* 1971-1990. Deerfield, Mass.: Historic Deerfield.

_____. 1984. *The Ebenezer Hinsdale Williams House: A Restoration-in-Progress.* Deerfield, Mass.

Historic Deerfield [formerly Heritage Foundation] Quarterly. January 1973-present. Deerfield, Mass.: Historic Deerfield.

Howe, Margery Burnham. 1976. *Deerfield Embroidery.* Deerfield, Mass.: PVMA.

Magazine Antiques, The. 1985. *Antiques at Historic Deerfield.* Reprinted from *The Magazine Antiques,* September 1956, January 1982, and March 1985.

McPhee, John. 1966. *The Headmaster.* New York: Farrar, Straus, and Giroux.

Miller, Amelia. 1983. *Connecticut River Valley Doorways: An Eighteenth Century Flowering.* Boston: Boston University for the Dublin Seminar for New England Folklife.

PVMA. 1972. *The First 100 Years of the Pocumtuck Valley Memorial Association.* Deerfield, Mass.: PVMA.

Sheldon, George. 1895-96. *A History of Deerfield.* Reprint (2 vols.). Deerfield, Mass.: PVMA, 1983.

Spang, Joseph Peter. 1962. The Parker and Russell Silver Shop in Old Deerfield. *The Magazine Antiques,* vol. LXXXI, no. 6, 638-41.

Sweeney, Kevin. 1984. Mansion People: Kinship, Class, and Architecture in Western Massachusetts in the Mid Eighteenth Century. *Winterthur Portfolio,* vol. 19, no. 4, 231-255.

Wadsworth Atheneum. 1985. *The Great River: Art & Society of the Connecticut Valley, 1635-1820.* Hartford, Conn.: Wadsworth Atheneum.

Notes

A SENSE OF PLACE

1. *The Diary of William Bentley, D.D., Pastor of the East Church, Salem, Massachusetts*, vol. 2 (January 1793–December 1802).

Bentley's statement that the Old Indian House was the only one to survive the 1704 attack is inaccurate. Many houses at the south end of the village survived the assault, although they may have disappeared at a later date.

2. This and the previous quotation are from David J. Russo's excellent *Keepers of Our Past, Local History Writing...*, (New York: Greenwood Press, 1988), which David Proper very kindly called to my attention. Russo's view of Sheldon's work has shaped my own thinking.

3. This and Henry Flynt's following reminiscences are from "Family Letters," privately held.

4. *A Guide to the Museum of the Pocumtuck Valley Memorial Association*, 2d ed. (Deerfield, Mass.: 1920), 8.

5. *Catalogue of the Collection of Relics in Memorial Hall...* 3d ed. (Deerfield, Mass.: PVMA, 1920), 3.

6. "The First 100 Years of the Pocumtuck Valley Memorial Association," (Old Deerfield, Mass.: 1972), 20.

7. Mary E. Allen, "Old Deerfield," New England Magazine (N.S.), September 1892, 40.

8. Quoted in Margery Burnham Howe, *Deerfield Embroidery*, 32.

9. *The Headmaster*, 7.

10. *Deerfield Academy*, planned and written by Bruce Barton, Boyden's fellow Amherst College alumnus and a staunch supporter of both Boyden and the Academy. Barton was a partner in the well-known New York advertising firm of Batten, Barton, Durstine and Osborn, and he used his skills to great advantage in this compelling presentation.

The student quoted here and later on is Christopher Monkhouse, Deerfield '65, former curator of the Museum of Art, Rhode Island School of Design, speaking in an interview with the author in New York City on 2 February 1991. Mr. Monkhouse also remembers that antique interior embellishments were important to Frank Boyden, who accepted collections of antique pewter and ceramics for the school. The ceramics were displayed in a breakfront placed in the entrance to the dining room, where students would pass them every day. "That's how I learned the difference between creamware and pearlware," says Mr. Monkhouse.

Bruce Barton, "Deerfield and the New England Conscience," [undated manuscript], Deerfield Academy Archives.

11. "Family Letters."

PRESERVING A SCHOOL, A TOWN, AND A WAY OF LIFE

1. These and the following reminiscences are from the "Family Letters" Henry Flynt wrote to various members of his family during the last two years of his life.

2. Interview with the author, 10 October 1990.

3. "Family Letters."

4. Interview with the author (Interview II), October 1990.

5. "Family Letters."

6. *Men of Purpose* (Cincinnati, Ohio: The Cincinnati Milling Machine Company, 1964), III.

7. Donald R. Friary, "To Collect or Not to Collect," 2.

8. *Christian Science Monitor*, 18 November 1969, 8.

9. "Family Letters."

10. Interview with the author, 10 October 1990.

11. The Academy already owned the historic John Williams House, which became a dormitory in 1916.

Frank L. Boyden to W. S. Appleton, 22 April 1924, SPNEA Archives.

12. Frank L. Boyden to W. S. Appleton, 22 April 1924, SPNEA Archives.

13. Phone conversation with the author, 18 October 1991.

14. W. S. Appleton to Frank L. Boyden, 24 April 1924, SPNEA Archives.

15. Phone conversation with Amelia Miller, 19 October 1991.

16. Note to the author, 18 October 1991.

17. These and the following quotes are from Henry N. Flynt's letter to Frank L. Boyden, 7 October 1939, Deerfield Academy Archives.

18. The letter to Henry Ford, to which I could find no response, is dated 8 September 1941, Deerfield Academy Archives. Flynt writes Ford that he would like his advice "in connection with the possible restoration of a small town in New England in which I am very much interested."

Ray Dovell, "Rehabilitation of Stony Brook, Long Island," *The American City*, January 1944, 45-47. The clipped article bears this handwritten note: "Frank—This is the place I've talked about. HNF." Deerfield Academy Archives.

19. Henry N. Flynt to Mrs. Matthew Astor Wilks, 19 July 1946, Flynt correspondence, Historic Deerfield Library.

20. H. N. Flynt to Helen and Frank Boyden, 20 June 1952, Flynt correspondence, Historic Deerfield Library.

Note to the author, 18 October 1991.

21. Kenneth Chorley to Henry Flynt, 25 June 1946. Colonial Williamsburg Archives.

22. When the Flynts bought the Rossiter House, it was covered with brown shingles. Underneath were faded red clapboards that the Flynts may have thought of as pink, for the house has been painted pink and called the Pink House ever since.

Henry N. Flynt to Mr. and Mrs. Frank Boyden, 20 June 1952, Deerfield Academy Archives.

23. Flynt to Boydens, 20 June 1952.

24. Jennie Danielski, in an interview with the author 13

September 1991. Mrs. Danielski grew up next door to the Fullers, and was often at their house.

Grace Friary, Historic Deerfield's Public Relations Officer, was a devoted friend of Elizabeth Fuller from 1969 until Miss Fuller's death in 1979. She spoke about Elizabeth and her family in an interview with the author 21 August 1991.

Historic Deerfield Quarterly, vol. XIII, no. 3, July 1974, 3.

25. Henry N. Flynt to Miss Elizabeth Fuller, 19 October 1945, Flynt correspondence, Historic Deerfield Library.

26. Flynt to Miss Fuller, 19 October 1945.

27. Henry N. Flynt to Mrs. Matthew Astor Wilks, 19 July 1946, Flynt correspondence, Historic Deerfield Library.

Chamberlain and Flynt, *Frontier of Freedom*, 7.

28. Henry N. Flynt to Mrs. Matthew Astor Wilks, 19 July 1946, Flynt correspondence, Historic Deerfield Library.

29. "Family Letters."

30. Henry N. Flynt to Frank L. Boyden, 17 January 1945, Deerfield Academy Archives.

31. Frank L. Boyden to Henry N. Flynt, 19 June 1939, Deerfield Academy Archives.

32. "Family Letters."

Peter Spang, interview with the author, 10 October 1990.

33. "Family Letters."

34. Peter Spang, interview, 10 October 1990.

35. "Family Letters."

36. "Family Letters."

37. "Family Letters."

Handwritten invitation dated 29 January 1946 in the Flynt files, Deerfield Academy Archives.

38. *Historic Deerfield Quarterly*, vol. XIII, no. 2 (April 1974), 4.

This story was related by Peter Spang on the tape "Inside Wells-Thorn."

39. H. N. Flynt to H. F. du Pont, 1 November 1946, Flynt correspondence, Historic Deerfield Archives.

40. "A Salt-Box House in Connecticut," *The Magazine Antiques*, October 1943, 170.

41. 25 September 1949.

42. *Historic Deerfield Quarterly*, vol. XIII, no. 3 (July 1974), 4.

43. Flynt/Gass tapes.

44. J. M. Arms Sheldon to William Sumner Appleton, 4 December 1933.

"Family Letters."

45. "Family Letters."

46. Henry N. Flynt to William E. Gass, 2 July 1946, Flynt correspondence, Historic Deerfield Library.

Bill Gass to Henry Flynt, 12 January 1954, Flynt correspondence, Historic Deerfield Library.

47. Frank Boyden to "Henry [Flynt] and Bob [Maynard?]," June 1951, Deerfield Academy Archives.

48. "Inside Dwight House," 6 February 1991.

Flynt/Gass tapes.

"Inside Dwight House."

"Inside Hall Tavern."

49. Walter A. Dyer, *The Lure of the Antique* (New York: Century Co., 1910), 446, quoted in David R. Proper, "The Fireplace at Memorial Hall, Deerfield, Mass., 'Picturesque Arrangements; Tender Associations'" (unpublished lecture delivered to the PVMA). I am indebted to Mr. Proper for sharing this excellent paper with me.

50. These characteristics of Gass's working method are noted in Frederick G. Livesay, "Restorer, Rebuilder, Contractor and Friend: a Biography of William E. Gass," Historic Deerfield summer fellowship paper, 1989.

Flynt/Gass tapes.

51. Flynt/Gass tapes.

52. "On the Street," cassette 8, side 1.

Henry N. Flynt to Mrs. Matthew Astor Wilks, 19 July 1946, Flynt correspondence, Historic Deerfield Library.

53. Henry N. Flynt to William Edward Gass, 17 April 1946, Deerfield Academy Archives.

"On the Street," cassette 8, side 1.

54. See *Antiques* for October 1943, 170.

55. Flynt/Gass tapes.

56. Flynt/Gass tapes.

57. "William E. Gass, 84, had restored historic buildings," *Daily Hampshire Gazette*, 21 February 1986.

Phone conversation with the author, 29 October 1991.

58. Flynt/Gass tapes.

59. "Family Letters."

60. "Family Letters."

61. Henry N. Flynt to Mrs. Eleanor Williams Wesson, 22 October 1946, Flynt correspondence, Historic Deerfield Archives.

62. George H. Bean, *Yankee Auctioneer* (Boston: Little, Brown and Co., 1948), 164.

"On the Street," tape 1, side 1, 28 November 1990. Spang says that the Flynts later sent a number of less good pieces from the Hawks auction over to Williamstown to help their newly married son and his wife furnish their house. Ever since, the younger Flynts have liked to say that their house is furnished with his parents' mistakes.

63. Typed transcript of an interview with Mr. and Mrs. Stephen G. Maniatty, 21 July 1975, included in Janie L. Brown, "Miss Louisa Hubbard Billings: Her Biography and Estate," Historic Deerfield summer fellowship paper, 1975.

64. *The Reverend Jonathan Ashley House* (Deerfield, Mass.: Heritage Foundation, 1962), 109.

65. Henry N. Flynt to Dr. Harwood W. Cummings of Greenfield, 15 June 1950, Flynt correspondence, Historic Deerfield Archives. Flynt refers to the clock "made by Daniel Clay which you are so kindly and courteously giving up because of our endeavor to get some of the Daniel Clay pieces back to Deerfield."

Henry N. Flynt to Mrs. Mary Nichols Howe, 27 June 1956, Flynt correspondence, Historic Deerfield Archives.

66. Interview with Jennie Danielski.

67. "Family Letters."

"The Second Fifty Years of the Pocumtuck Valley Memorial Association," *The First 100 Years of the Pocumtuck Valley Memorial Association* (Old Deerfield, Mass.: PVMA, 1972), 24 ff.

68. Henry N. Flynt to Harry D. Nims, 10 March 1949, Flynt correspondence, Historic Deerfield Library.

69. "Close Deerfield Silver Show," *Greenfield Recorder and Gazette*, 7 November 1950.

70. "The Second Fifty Years of the PVMA," 28-29.

71. "Family Letters."

72. Winchester interview.

73. Maniatty tape.

74. Maniatty tape.

75. Maniatty tape.

76. "Family Letters."

77. "Family Letters."

78. Henry Flynt to Helen and Frank [Boyden], 23 April 1947, Flynt correspondence, Historic Deerfield Library.

79. Frank Boyden to Henry Flynt, 18 August 1950, Flynt correspondence, Deerfield Academy Archives.

80. Henry N. Flynt to Helen and Frank Boyden, 20 June 1952, Flynt correspondence, Deerfield Academy Archives.

81. These and the above quotes are from H. N. Flynt to Helen and Frank Boyden, 20 June 1952, Flynt correspondence, Deerfield Academy Archives.

82. "Family Letters."

83. *Heritage Foundation Quarterly*, vol. I, no. 3 (October 1962), 5.

84. *Heritage Foundation Quarterly*, vol. VIII, no. 1 (January 1969), 1.

85. Interview II (October 1990).
Interview, Mary and Henry N. Flynt, Jr., Williamstown, Mass., 12 December 1990.

86. Sale No. 1957, Parke-Bernet Galleries, New York, 3, 4, 5 March 1960.

87. Henry N. Flynt to Benjamin Z. Stebbins, 10 December 1946, Flynt correspondence, Historic Deerfield Library.
J. K. Byard to Ellerton Jette, 8 April 1957, Byard correspondence, Archives of American Art.
Byard to Ellerton and Edith Jette, 19 May 1957, Byard correspondence, Archives of American Art.

88. Henry N. Flynt to John K. Byard, 16 January 1953, Flynt correspondence, Historic Deerfield Archives.

89. Vol. III, no. 3A (December 1955).

90. *Historic Deerfield Quarterly*, vol. XIII, no. 3 (July 1974), 4.

91. Interview with the author, 23 April 1991.

92. Interview with Bernard Levy, 23 April 1991.

93. Levy interview.

94. Israel Sack to Henry N. Flynt, 2 February 1950, H. N. Flynt correspondence, Historic Deerfield Archives.
H. N. Flynt to Israel Sack, 10 February 1950, Flynt correspondence, Historic Deerfield Archives.
Israel Sack to Henry Flynt, 30 November 1953, Flynt correspondence, Historic Deerfield Archives.
H. N. Flynt to Israel Sack, 4 December 1953, Flynt correspondence, Historic Deerfield Archives.

95. Robert C. Vose, Jr., to Elizabeth Stillinger, 29 August 1991.

96. "Family Letters."

97. Levy interview.

98. Alice Winchester, interview with the author, 25 May 1991.

99. Winchester interview.

100. Elizabeth Stillinger, "Profile of a Collector: Katharine Prentis Murphy," *Maine Antique Digest*, November 1983, 18B-19B.

101. Telephone interview with Ralph Carpenter, 29 September 1983. Mr. Carpenter, who is now a consultant to Christie's department of American Furniture and Decorative Arts, has very kindly lent me the photographs of a birthday party for Mrs. Murphy.
Interview with Christopher Monkhouse, 2 Febuary 1991.

102. Winchester interview.

103. Ima Hogg to Henry N. Flynt, 28 August 1959, Flynt correspondence, Historic Deerfield Archives.

104. *Walpole Society Notebook*, 1951.
Newspaper clipping for 3 May 1964, Flynt scrapbook (1964–1970), Historic Deerfield Archives.

105. Helen Geier Flynt to Richard Cheek, 14 November 1963, Deerfield Academy Archives.

106. Peter Spang notes that while no one *should* have eaten dinner on this table, Helen Flynt did make the attempt once or twice after Henry's death. Spang recalls that he and Director Donald Friary dined rather uncomfortably amidst the pewter display on one or two occasions.

107. H. N. Flynt to Alice Winchester, 23 May 1956, Flynt correspondence, Historic Deerfield Library.

108. Henry N. Flynt to John B. Morris, 20 July 1956, Flynt correspondence, Historic Deerfield Archives.

109. Interview with the author, 21 August 1991, Deerfield, Mass.

110. H. N. Flynt to W. O. Hay, Jr., December 1954, Flynt correspondence, Historic Deerfield Library.

111. H. N. Flynt to Alice Winchester, 23 May 1956, Flynt correspondence, Historic Deerfield Library.

112. *Historic Deerfield Quarterly*, vol. XXX, nos. 2 and 3 (Spring/Summer 1991), 1-2.

113. H. N. Flynt to Morrison Heckscher, 13 November 1963, H. N. Flynt correspondence, Historic Deerfield Library.

114. *Historic Deerfield Quarterly*, vol. XVI, no. 4 (October 1977), 18.

115. Henry N. Flynt to William Hutton, 17 August 1956, Flynt correspondence, Historic Deerfield Library.

116. "Woman of the Day: Remarkable Mrs. Flynt," *Greenfield Recorder*, 20 October 1970.

117. Vol. VII, no. 3 (July 1968), 1.

118. Amelia F. Miller, phone interview with the author, 15 September 1991.

119. *Heritage Foundation Quarterly*, vol. IX, no. 1 (January 1970), 1.
"Family Letters."

120. Henry N. Flynt to Elizabeth Fuller, 19 October 1945, Flynt correspondence, Historic Deerfield Library.
Historic Deerfield Quarterly, vol. XIII, no. 2 (April 1974), 5.

FROM PRIVATE VISION TO PUBLIC TRUST

1. Wilmarth Sheldon Lewis, "Address," *The Centennial of the PVMA and Dedication of the Heritage Foundation Library* (Deerfield, Mass.: Heritage Foundation, 1970), 16.

2. Edgar Bingham, interview with the author, Boston, 28 October 1982.

3. Henry N. Flynt to Samuel Chamberlain, 18 December 1950, Flynt correspondence, Historic Deerfield Library.

4. "Curator's Report," *Annual Report*, 1971, 9-10.

5. H. N. Flynt to H. F. du Pont, 1 November 1946, Flynt correspondence, Historic Deerfield Library.

6. Donald Friary, interview with the author, 22 August 1991.

7. Interview with the author, 22 March 1991, Sarasota, Florida.

8. Interview with the author, 13 September 1991, Greenfield, Mass.

9. *Historic Deerfield Quarterly*, vol. XIV, no. 2 (April 1975), 1.

"Old Deerfield: Where History Unfolds Daily," *Greenfield Recorder*, 10 November 1983.

10. This story was related to me by David Proper.

11. *Annual Report*, 1972, 14.

12. *Annual Report*, 1978, 5.

13. *Annual Report*, 1976, 9.
 Annual Report, 1978, 6.

14. "Introduction," 3.

15. "Preface," 9.

16. Interview with the author.

17. *Annual Report*, 1982, 8.

18. William Flynt lecture, 14 September 1991, Deerfield, Mass.

19. Flynt lecture.

20. "What can a Chair and a Box Do for You?" *Maine Antique Digest*, April 1987, 10C-13C.

21. Travel Section, *New York Times*, 2 October 1988.

22. *Historic Deerfield, Inc., Newsletter*, May 1990–April 1991, 1.

23. *Union-News*, 9 September 1991, 10-F.

THE ALLEN HOUSE

1. "Family Letters."

2. Quoted in Nancy Locke Doonan, "The Allen House," (Historic Deerfield summer fellowship paper, 1978), 3.

3. Amelia Fuller [Miller], "Hannah Beamon Lifts the Latch, A Story of The Allen House in Old Deerfield, Massachusetts," privately printed, 1947, 6. The following history of the Allen House is based on this account, on Doonan, "The Allen House," and on *Antiques at Historic Deerfield*, March 1985.

4. Quoted in Doonan, "The Allen House."

5. Quoted in Ed Polk Douglas, "Frances and Mary Allen, A Biography," (Historic Deerfield summer fellowship paper, 1969).

6. Henry N. Flynt to Frank L. Boyden, 23 August 1945 and 20 December 1946, Flynt correspondence, Deerfield Academy Archives.

7. Flynt/Gass tapes.

8. Flynt/Gass tapes.

9. Flynt/Gass tapes.

10. Flynt/Gass tapes.

11. "Early Allen House furnishings (c. 1946–1951)," wrote Peter Spang in a note to the author, August 1991, "may reflect the fact that the Joneses [managers of the Deerfield Inn] lived there too—with their heirlooms, which were simple New England things, with some Victorian."

Mrs. Jones was Henry Flynt's cousin, and the Flynts shared Allen House with her and her husband.

12. Henry N. Flynt to Benjamin Z. Stebbins, 10 December 1946, Flynt correspondence, Historic Deerfield Archives.

13. "Family Letters." A tyg (which Henry Flynt refers to as a "tig") is an early earthenware drinking vessel with one or more handles.

14. Peter Spang, interview with the author, 10 December 1990; Barbara Hoadley, senior Allen House guide, in a tour on 8 June 1991.

15. Personal interview with former Historic Deerfield guide Lee Boyden.

16. Peter Spang, personal conversation with the author, 10 December 1990.

17. "Old Deerfield: A Living Community," *Art in America*, vol. 43, no. 2 (1955), 75.

18. I am indebted to Barbara Hoadley for calling my attention to Mrs. Flynt's picking up du Pont's "standing candlestand fetish."

Former curator Peter Spang adds that "Henry was always interested in early lighting—he tried to have as many varieties as possible at Ashley House." (Note to the author, August 1991)

19. "Family Letters."

THE REVEREND JONATHAN ASHLEY HOUSE

1. See Amelia F. Miller, *The Reverend Jonathan Ashley House*, for an excellent discussion of Ashley, his house, and his life and times.

2. Kevin M. Sweeney, "Mansion People...," 233.

3. See Miller, *Connecticut River Valley Doorways*, for the standard work on this feature.

4. Sweeney, 244.

5. See "The Reverend Jonathan Ashley House: An Interpretive Guide," (Historic Deerfield summer fellowship paper by Nancy E. Smith, 1977), 47.

6. Miller, *Ashley House*, 23.

7. Letter from William E. Gass to Henry N. Flynt, 28 August 1945, Flynt correspondence, Deerfield Academy Archives.

8. Miller, *Ashley House*, 135, fn. 5.

9. Henry N. Flynt to William E. Gass, 17 April 1946, Flynt correspondence, Historic Deerfield Archives.

10. Flynt/Gass tapes. Although Gass mentioned the *Parson House* in Hadley, he may have meant the Porter House, because there is no Parson House in Amelia F. Miller's *Connecticut River Valley Doorways*.

11. In a note to the author of August 1991, Peter Spang writes that "the Flynts/Gass had to totally reconstruct the wing for the apartment. It did not survive the 1869 move. So Gass designed the wing—really a substantial house of perhaps 8 rooms—very luxurious for masters who formerly had dorm space."

12. Flynt/Gass tapes.

13. Henry Flynt to Frank Boyden, 7 October 1939, Deerfield Academy Archives.

14. Henry Flynt to Frank Boyden, no date, Flynt correspondence, Deerfield Academy Archives.

15. Note to the author, August 1991.

16. See, for example, Kevin M. Sweeney, "Mansion People..." and *The Great River*.

17. *The Ashley House in Old Deerfield, Massachusetts*, a booklet the Flynts produced for Christmas 1948, and sent to their friends.

Important period manuscripts such as Parson Ashley's handwritten sermons are no longer exhibited in the houses.

18. "'Parson Ashley' House Restoration Recalls Old Deerfield Colonial Days," 5 May 1948, unidentified clipping from the Jones scrapbook for c. 1945–c. 1950, Historic Deerfield Archives.

THE ASA STEBBINS HOUSE

1. Sheldon, *A History of Deerfield*, vol. II, 321.

2. *Greenfield Recorder*, 14 April 1950.

3. See David W. Dangremond, "A Perspective on the Asa Stebbins House: The House as Measure of the Man," (Historic

Deerfield summer fellowship paper, 1973); *The Country Builder's Assistant* (1797; reprint ed., Boston: Applewood Books, 1989), title page.

4. See Dangremond, *A Perspective on the Asa Stebbins House*, 21-22.

5. Chamberlain and Flynt, *Historic Deerfield* (1979), 88.

6. 22 March 1890.

7. *Historic Deerfield Quarterly*, vol. XIII, no. 2 (April 1974), 4-5.

8. See Nina Fletcher Little, *American Decorative Wall Painting, 1700–1850* (Sturbridge, Mass.: Old Sturbridge Village in cooperation with Studio Publications, 1952), 86-92.

9. Catherine Lynn, *Wallpaper in America* (New York: W.W. Norton & Company, Inc., 1980), 170-71 and 222-23.

10. Lynn, *Wallpaper*, 276, fig. 12-1; *Historic Deerfield*, 1979 ed., 94.

11. From the tape "Inside Stebbins House."

THE HALL TAVERN

1. Quoted in Bradley L. Taylor, "Hall Tavern: An Architectural Analysis," (Historic Deerfield summer fellowship paper, 1976), 24-30.

2. Helen and Henry Flynt, "Hall Tavern in Old Deerfield," privately printed c. 1950 and sent as a Christmas card, 7 and 6.

3. Peter Spang, "Inside Hall Tavern."

4. See Bradley L. Taylor, 24-30.

5. "Fortunately," wrote Helen and Henry Flynt in *Hall Tavern*, "there remained one section of the picket gate to the bar so we reproduced the rest...," 10.

6. H. and H. Flynt, "Hall Tavern," 10.

7. This and the following paragraph are from Spang, "Inside Hall Tavern."

8. H. and H. Flynt, "Hall Tavern," 10.

9. Quoted in Nancy Harmon Jenkins, "Giving Thanks with Porridge and Oysters," *The New York Times*, 21 November 1990, section C1.

10. Peter Spang recalls that Helen Flynt was "starry eyed" when she talked about visiting Beauport. Conversation with the author, Deerfield, 6 March 1991.

11. H. and H. Flynt, "Hall Tavern," 11.

12. "Inside Hall Tavern."

13. Spang, "Inside Hall Tavern."

THE FRARY HOUSE AND BARNARD TAVERN

1. "Frary House Restoration, Started by Descendant, To Be Continued by Flynt," unidentified, undated clipping from the Flynts' scrapbook of c. 1948–1954, Historic Deerfield Archives.

2. Emma L. Coleman, "Frary House—1685," *History and Proceedings of the Pocumtuck Valley Memorial Association, 1930–1938*, Deerfield, 1950, vol. VIII, 75. I am indebted to Peter Spang for calling this most interesting firsthand account of Miss Baker's restoration to my attention.

3. Donald R. Friary and Joseph Peter Spang, "Architectural Interiors," *Antiques at Historic Deerfield*, reprint, 642 and 644.

4. C. G. Muenchinger, "A New Look at Frary House," (Historic Deerfield summer fellowship paper, 1970), 11-12.

5. Frank Boyden to Henry N. Flynt, 19 August 1951, Flynt papers, Deerfield Academy Archives.

6. "Frary House Ready for Public Opening," *Greenfield Recorder Gazette*, 20 April 1950, in Flynt scrapbook for c. 1948–1954, Historic Deerfield Archives.

7. *Deerfield Embroidery*, 7.

8. Quoted in Vicki Giles, "C. Alice Baker: Driven by the Two-Edged Sword of Poverty and Ambition," (Historic Deerfield summer fellowship paper, 1976).

9. Quoted in Muenchinger, "A New Look," 16.

10. Coleman, "Frary House," 75-76.

11. "Frary House," 78.

12. "Frary House," 79.

13. Giles, "C. Alice Baker," 28.
"Frary House," 76.

14. Coleman, "Frary House," 81.

15. Laura Naus, "'Their Own Labor, Their Thought and Good Taste,' The Restoration of Frary House," (Historic Deerfield summer fellowship paper, 1987), 51.
Coleman, "Frary House," 82.

16. Giles, "C. Alice Baker," Appendix IV, 42.

17. I am indebted to Muenchinger, "A New Look," whose thinking along these lines influenced my own.

THE DWIGHT HOUSE

1. *The Springfield Union*, Springfield, Mass., Thursday, 30 November 1950, clipping from Raymond and Eudocia Jones's scrapbook, Historic Deerfield Archives.

2. Flynt/Gass tapes.

3. "Inside Dwight House."

4. *The Springfield Union*.

5. "Inside Dwight House."

6. "Inside Dwight House."

7. *Greenfield Recorder Gazette*, undated clipping, 1954, scrapbook, Historic Deerfield Archives.

8. Flynt/Gass tapes.

9. "Inside Dwight House."

THE SHELDON-HAWKS HOUSE

1. See Sumpter Turner Priddy, III, "Sheldon-Hawks House: Architectural Analysis and History," (Historic Deerfield summer fellowship paper, 1974), [date of construction] 2.

2. This and all other information on the house's architectural history is based on Priddy, "Sheldon-Hawks," and on Peter Spang's reminiscences in the tape "On the Street."

3. George Sheldon, *A History of Deerfield*.

4. This and the following quotations are from Margaret Whiting, "Recollections of George Sheldon," typescript at the Deerfield Library.

5. This and the story about Mr. Signor and the chest are from Priddy, "Sheldon-Hawks," [20th century occupancy] 2.

6. Susan B. Hawks, "A Deerfield Chest, Dated 1699," *American Collector*, September 1941.

7. In the tape Interview II, Spang refers to the unfortunate plight of the aging lady who "gets a man friend who gets everything in the end. That's what happened to Susan Hawks... there's a very important early chest that belonged to Susan Hawks and was to be willed to Memorial Hall. Of course, all of

her furniture went to this man [this was not Frederick P. L. Mills, who will appear shortly, but another friend].... But the man sold it and it went elsewhere." The present owner of the chest is Nina Fletcher Little; it is pictured on 187 and discussed on 191 and 192 of her book *Little by Little* (New York: E. P. Dutton, 1984).

8. Little, Brown and Co., Boston, 1948, 163-64.

9. Interview II.

10. This and the following quotations from Peter Spang are from "Inside Sheldon-Hawks."

11. Henry N. Flynt to Mrs. Mary Nichols Howe, 27 June 1956, Flynt correspondence, Historic Deerfield Archives.

12. The account of the sewing room is taken from Peter Spang in "Inside Sheldon-Hawks."

13. Philip Zea in an interview with the author, 9 May 1991, Deerfield, Mass.

14. "Inside Sheldon-Hawks."

15. *Historic Deerfield Quarterly*, vol. II, no. 1, 4.

16. *Historic Deerfield Quarterly*, 5.

THE HENRY NEEDHAM FLYNT SILVER AND METALWARE COLLECTION

1. Joseph Peter Spang, III, "The Parker and Russell Silver Shop," reprint, July 1962.

2. The Gass quote is from the Flynt/Gass tapes.
The Spang quote is from the tape "Inside Silver Museum."

3. "Inside Silver Museum."

4. Flynt/Gass tapes.

5. The Flynts apparently didn't know where the fireplace paneling had come from when they installed it. Peter Spang relates the story of his discovery of its origins in "On the Street," cassette 8, side 1: When antiques dealers Reginald and Rachel French of Amherst were visiting the silver collection in the early 1980s, they informed Spang that the woodwork had come from Preserved Clapp's house in Amherst, which they had almost bought when they moved to town in the 1930s. They were glad they hadn't made the purchase, however, for the house was so damaged during the hurricane of 1938 that this paneling was sold to a salvager. Spang thinks the Flynts must have bought it sometime later from a dealer who had acquired it from the salvager.

Historic Deerfield owns a tall clock by Preserved Clapp now on exhibition in the lower hall of the Sheldon-Hawks House.

6. I am indebted to Janine Skerry, Historic Deerfield's Associate Curator, for calling the *New York Sun* article to my attention and for discussing the Flynts' silver collecting with me.

7. Flynt and Fales, 58.

8. *Heritage Foundation Quarterly*, vol. I, no. 3 (October 1962), 5-7.

9. The first quote is from an unidentified clipping of 27 October 1950, in the Flynts' scrapbook of c. 1948-1954; the second is from a clipping of 7 November 1950, from the *Greenfield Recorder and Gazette* in the same scrapbook; Historic Deerfield Archives.

10. "To Collect or Not to Collect, Notes About Old Deerfield and Its Collections," in *The Walpole Society Notebook* for 1963, 50.

See also Janine E. Skerry, "American Colonial Silver found in England: the Watson-Crichton Collection at Historic Deerfield" [forthcoming].

11. "To Collect or Not to Collect," 50.

12. "Inside Silver Museum."

13. "To Collect or Not to Collect," 51.

14. Flynt and Fales, 78-79.

Peter Spang notes, however, that Mr. Flynt "really bought the spoons in order to acquire four sucket forks by Bartholemew Le Roux—a great rarity, as only about sixteen American ones are known."

15. Flynt and Fales, 81.

16. "Inside Silver Museum."

17. "Silver Shop to Add Glitter to Old Deerfield," Richard Shanor, 27 September 1961.

THE WRIGHT HOUSE

1. From George Sheldon, "Mrs. Lydia Cutler Stebbins," *PVMA Proceedings*, vol. 5, 11-12, quoted in June Sprigg, "The Wright House, Deerfield, Mass.," (Historic Deerfield summer fellowship paper, 1973), A-65.

2. See Sprigg, *Wright House*, 7.

3. See Mary Plant Spivy, "The Wright House: An Interpretive Guide" (unpublished manuscript, Historic Deerfield, 1976).

4. These quotations are from "Your Neck is Their Business," by Arthur W. Baum, in *The Saturday Evening Post* for 24 November 1951, 90.

5. I am very much indebted to Philip Zea for sharing with me a xerox of "The Connoisseurship of George Alfred Cluett, A Pioneer Collector" (unpublished research and lecture outline).

6. "On the Street." J. A. Lloyd Hyde was an antiques dealer of considerable knowledge and taste who had significant influence on the Flynts and their circle.

7. *Antiques*, November 1954, 382-386.

8. Interview, Philip Zea and the author, 31 May 1991, Deerfield, Mass.

9. "On the Street," cassette 9.

10. "Inside Wright House."

11. "On the Street," cassette 9.

12. This information is from June Sprigg's excellent "Wright House."

13. Peter Spang in "On the Street," cassette 9.

14. See Susan Gray Detweiler, *George Washington's China-ware* (New York: Harry N. Abrams, 1982), 86.

15. "On the Street," cassette 9.

16. *The Columbia Viking Desk Encyclopedia*, William Bridgwater, ed. (New York: The Viking Press, 1968).

17. Elinor Gordon, eminent dealer in Chinese Export porcelain, in an interview with the author, New York, 31 January 1991.

18. Gordon interview.

19. See Miss Childs's article, "The Society of the Cincinnati," *Heritage Foundation Quarterly*, vol. 2, no. 3, July 1963.

THE WELLS-THORN HOUSE

1. Much of the information on the history and architecture of the house is taken from Rachel D. Carley, "The Wells-Thorn House" (Historic Deerfield summer fellowship paper, 1976). See also Joseph Peter Spang, "The Wells-Thorn House in Deerfield, Massachusetts," in *Antiques*, May 1966, 730-33 . I am also very grateful indeed to Elizabeth Thorn Welford, Dr. and Mrs.

Thorn's eldest daughter, for writing me her reminiscences about her family and life in Deerfield early in the century. (Letter to the author, 3 July 1991).

2. For a discussion of the location of the second-floor office, see Carley, "The Wells-Thorn House," 17-19.

3. *Historic Deerfield Annual Report*, 1981, 9. The blue color was revealed by the paint analysis Architectural Conservator Bill Flynt and visiting paint analyst Frank Welsh of Bryn Mawr, Pa., undertook in 1981.

The first year the house was repainted its amazing early nineteenth-century color, says Peter Spang in "On the Street," "commencement time came at Deerfield Academy. In the morning when people got up and looked out, they saw that the boys had cut out enormous paper clouds and tacked them all over the house."

4. This anecdote was related by Peter Spang in the tape "On the Street," cassette 5.

5. This incident is related by Peter Spang in "On the Street."

6. "On the Street."

7. "Inside Wells-Thorn."

8. This and the previous quotation are from "Inside Wells-Thorn."

9. "Old Split-Level in Deerfield," *Greenfield Recorder-Gazette*, 10 June 1964.

10. Flynt/Gass tapes.

Peter Spang adds that suppliers furnished only some of the wood for these rooms. "Much of the wood for the keeping and other rooms," says Spang, "was recycled from the partitions made from old wood found in Deerfield by the Thorns at the time they did over the house." (Note to the author, August 1991)

11. "On the Street."

12. Flynt/Gass tapes, cassette 4. Peter Spang expands on Gass's statement: "The Flynts were amazed on a September visit to find how much work remained to be done. They were very critical of Bill Gass's tardiness. They pressed him to finish. So he had to rush to have the house ready by the October visit of the Walpole Society." (Note to the author, August 1991)

13. Flynt/Gass tapes.

14. "Inside Wells-Thorn."

15. "Inside Wells-Thorn."

16. "On the Street."

17. Interview with the author 25 May 1991.

18. "Inside Wells-Thorn." Spang believes that Flynt did end up with a package deal that included a five-legged high chest formerly in the collection of early Boston collector and Walpolean Chauncy Nash, as well as the Strong high chest. The five-legged chest was used in the Wells-Thorn keeping room.

Although the Strong high chest is still considered to be possibly by Eliphalet Chapin, Philip Zea writes that the desk and bookcase is "*not* Chapin. The characteristic latticework pediment is early twentieth century and is attached with wire nails." (Note to the author, August 1991)

19. Quoted in Diana McCain and Dione Longley, "Visiting the Past At Historic Deerfield," *Early American Life*, June 1989 (reprint). Much of the following information is taken from that excellent article.

20. Flynt/Gass tapes.

THE HELEN GEIER FLYNT TEXTILE MUSEUM

1. The quotes and information are from the tape "Inside Textile Museum."

2. Privately printed, 1965.

3. "Inside Textile Museum"; unidentified clipping from the Flynts' scrapbook for 1964–1970.

4. Flynt/Gass tapes.

5. "Inside Textile Museum."

6. *Heritage Foundation Quarterly*, vol. IV, no. 15 (July 1965), 5.

7. "Inside Textile Museum." Peter Spang notes that Mrs. Flynt told him on numerous occasions that she "always hoped to have another barn exhibit with the later clothing and accessories, possibly incorporating the Frank L. Boyden carriage collection, given to Historic Deerfield by his family after his death in 1972."

8. *Historic Deerfield Quarterly*, vol. XVI, no. 2 (April 1977), 15.

9. *Historic Deerfield Quarterly*, 15. Although Mrs. Wood was energetic and well meaning in her attention to the textile collection, her methods would not be considered representative of the best conservation practices today.

10. Margaret C. S. Christman, "Costumes," *Antiques at Historic Deerfield*," 680.

THE EBENEZER HINSDALE WILLIAMS HOUSE

1. *The Ebenezer Hinsdale Williams House*, 3.

2. Sheldon, vol. II, 204.

3. Peter Spang's comment is from "On the Street," cassette 8, side 2; Sheldon's information is from his *History*, vol. II, 204, and vol. I, 626.

4. Ritchie Garrison, "History and Significance of the Ebenezer Hinsdale Williams House," in *The Ebenezer Hinsdale Williams House*, 5.

5. "On the Street."

6. "On the Street."

7. From the tape "Inside Wright, E. H. Williams, & Wells-Thorn."

8. "On the Street."

9. "Inside Wright, E. H. Williams..."

10. Both quotes in this paragraph are from *Ebenezer Hinsdale Williams House*, 6.

11. "On the Street."

12. Memorandum to E. H. Williams House guides from Bill Flynt, 23 May 1991.

13. *Ebenezer Hinsdale Williams House*, 4.

14. *Ebenezer Hinsdale Williams House*, 8.

15. *Ebenezer Hinsdale Williams House*, 8.

16. *Historic Deerfield Newsletter*, May 1988–April 1989.

17. Everyone who has written about the period room and/or period house in recent years concedes that no curator can ever completely remove himself from his interpretation. Our environment shapes our perceptions in ways that we're often not aware of until much later.

Zea's comments are from a memo he sent to Donald Friary and the Williams House Committee on 22 June 1990.

Photograph Credits

Except as noted, Arthur Vitols took all the color photographs. Also except as noted, the black-and-white photographs are courtesy of Historic Deerfield, Inc.; Amanda Merullo made copies of many of them for use in this book. Other people and institutions who have allowed us to reproduce photographs, as well as photographers whose work appears in these pages, include:

Allen Sisters (courtesy the Pocumtuck Valley Memorial Association): pp. 3 (top), 4, 6 (top), 17, 27 (bottom), and figs. 12, 70.

Richard Benson: p. 56.

Samuel Chamberlain: pp. 27 (top), 45 (bottom), and figs. 5, 38, 109, 111.

Emma Coleman: pp. 9, 14 (bottom), 34, 36 (top right), figs. 45a, 45b.

Deerfield Academy: pp. 7 (top), 7 (center), 8.

Henry N. Flynt, Jr.: pp. 11, 13, 14 (top).

Grace Friary: fig. 126.

William E. Gass: fig. 56.

Myrna Kaye (*Fake, Fraud, or Genuine?*): p. 33.

Amanda Merullo: pp. 22 (bottom), 40 (top), 59, 60 (top), 63 (top), and fig. 130.

Amelia Miller: fig. 80.

Pocumtuck Valley Memorial Association: figs. 42, 124.

David R. Proper: p. 12.

Society for the Preservation of New England Antiquities: p. 9, figs. 45a, 45b, 68 (photograph by the Halliday Historic Photograph Co.), 93 (photograph by the Halliday Historic Photograph Co.).

Joseph Peter Spang: back jacket, pp. 15, 36 (top left), 179.

Taylor & Dull: p. 65, and figs. 7, 15, 39, 116.

Muriel Thorn: figs. 107, 108a, 108b.

Henry Francis du Pont Winterthur Museum: fig. 9.

Index

This subject index includes proper nouns (other than personal names) and selected personal names.
Boldface page numbers indicate illustrations.